11.10.00

Lynette-

One in a great while
one crosses paths with a person
that proves to be a true inspiration.
I happened to be fortunate enough
a few years ago to cross your path and
will never be the same. You are one of those
rare souls that possesses a zest for life that
borders on infectious. This book is hopefully but a teaser
for what you will surely see out your front door.

Much love,
Chris.

THE ROCKIES

DAVID MUENCH

MARC MUENCH

essay JAMES R. UDALL

GRAPHIC ARTS CENTER PUBLISHING®

THE ROCKIES

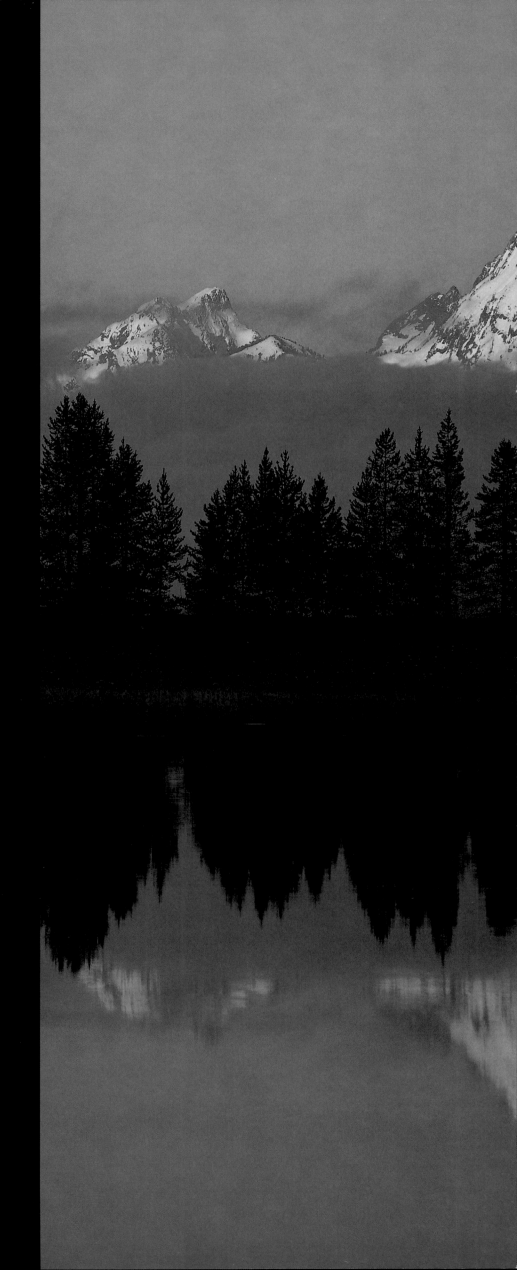

INTERNATIONAL STANDARD BOOK NUMBER 1-55868-308-9

LIBRARY OF CONGRESS CATALOG NUMBER 97-70195

SEE PAGE 207 FOR PHOTO COPYRIGHT INFORMATION.

OMPILATION OF PHOTOGRAPHS AND ESSAY © MCMXCVII BY

GRAPHIC ARTS CENTER PUBLISHING COMPANY

P.O. BOX 10306 • PORTLAND, OREGON 97296-0306

PRESIDENT • CHARLES M. HOPKINS

EDITOR-IN-CHIEF • DOUGLAS A. PFEIFFER

MANAGING EDITOR • JEAN ANDREWS

PHOTO EDITOR • DIANA S. EILERS

DESIGNER • BONNIE MUENCH

PRODUCTION MANAGER • RICHARD L. OWSIANY

CARTOGRAPHER • ORTELIUS DESIGN

BOOK MANUFACTURING • LINCOLN & ALLEN CO.

PRINTED IN THE UNITED STATES OF AMERICA

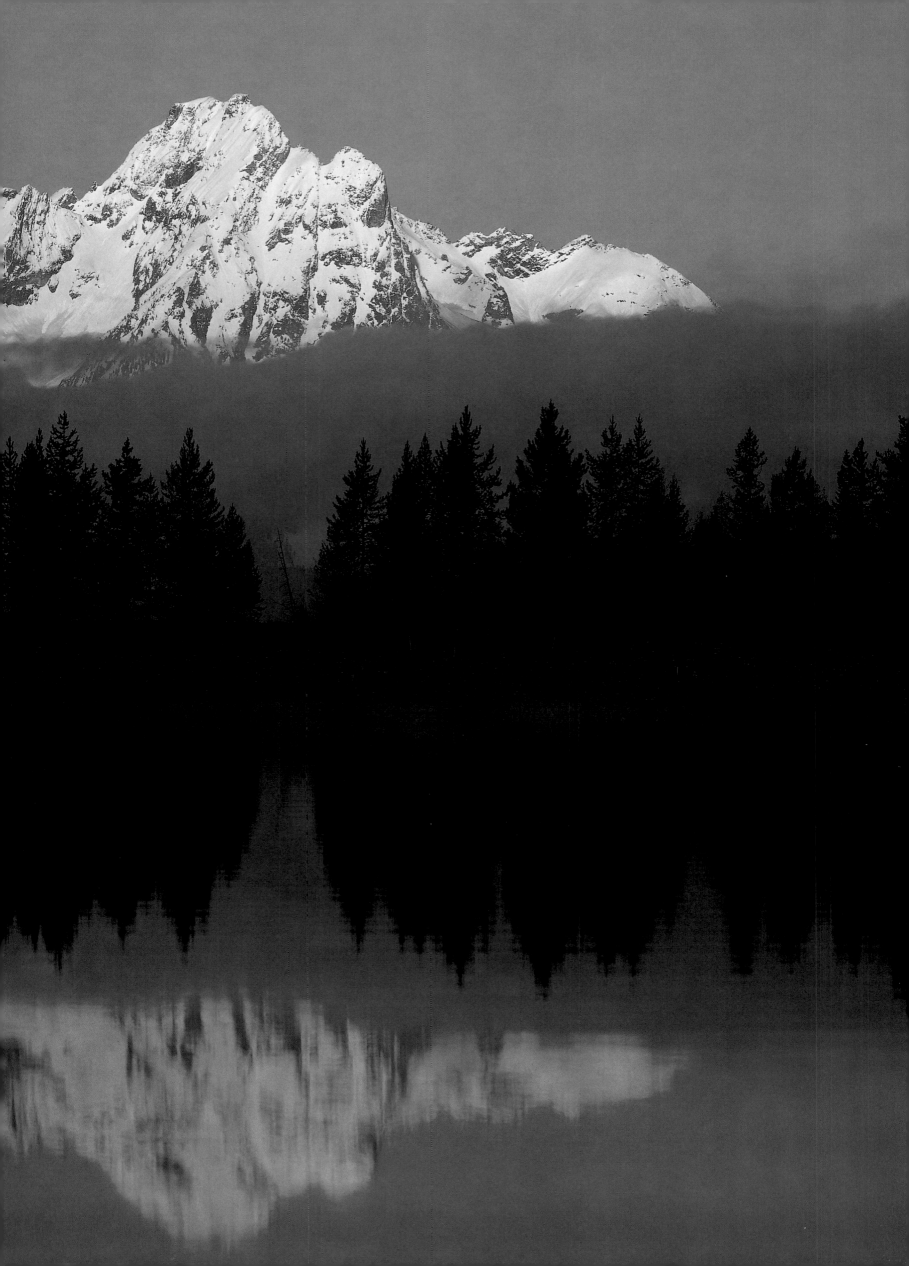

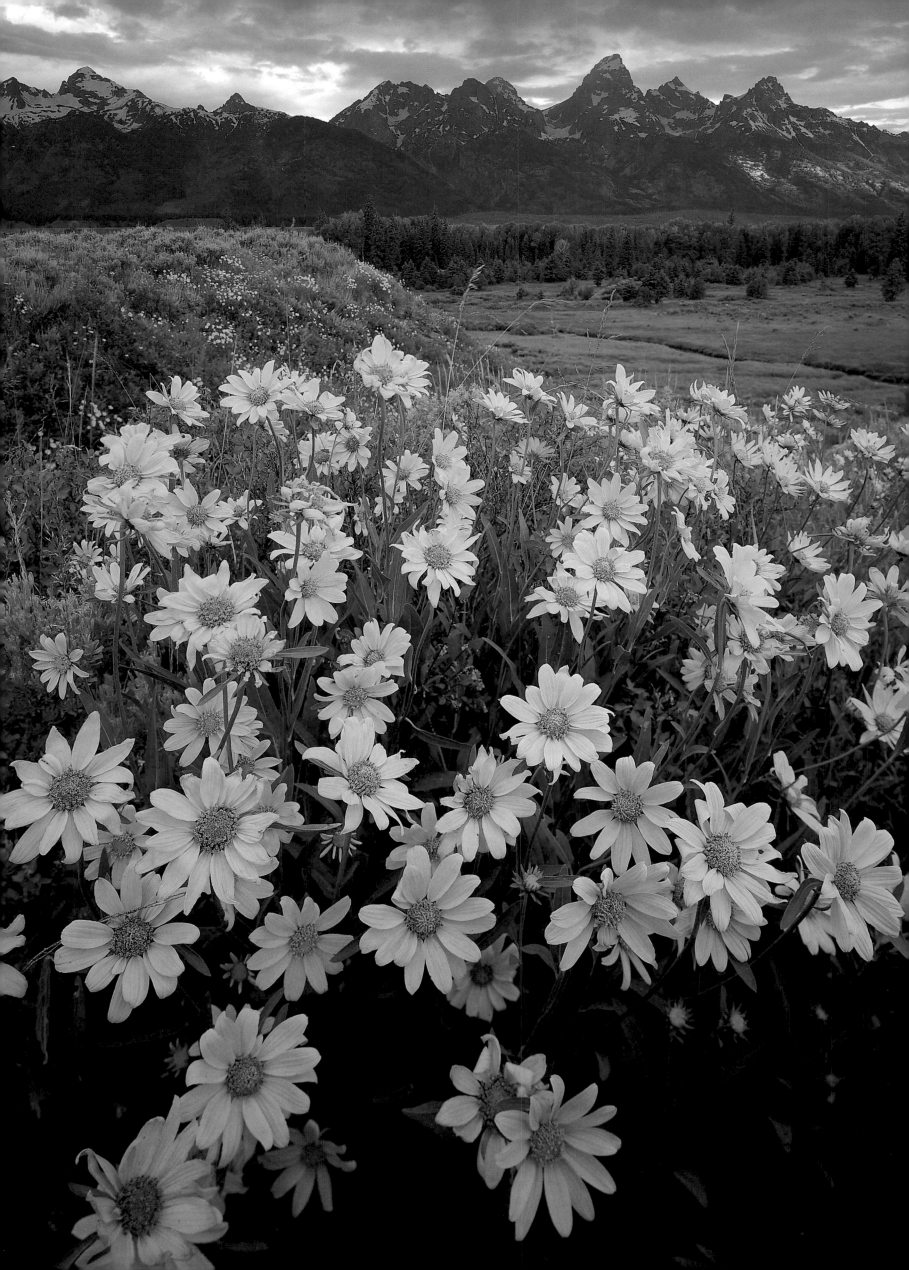

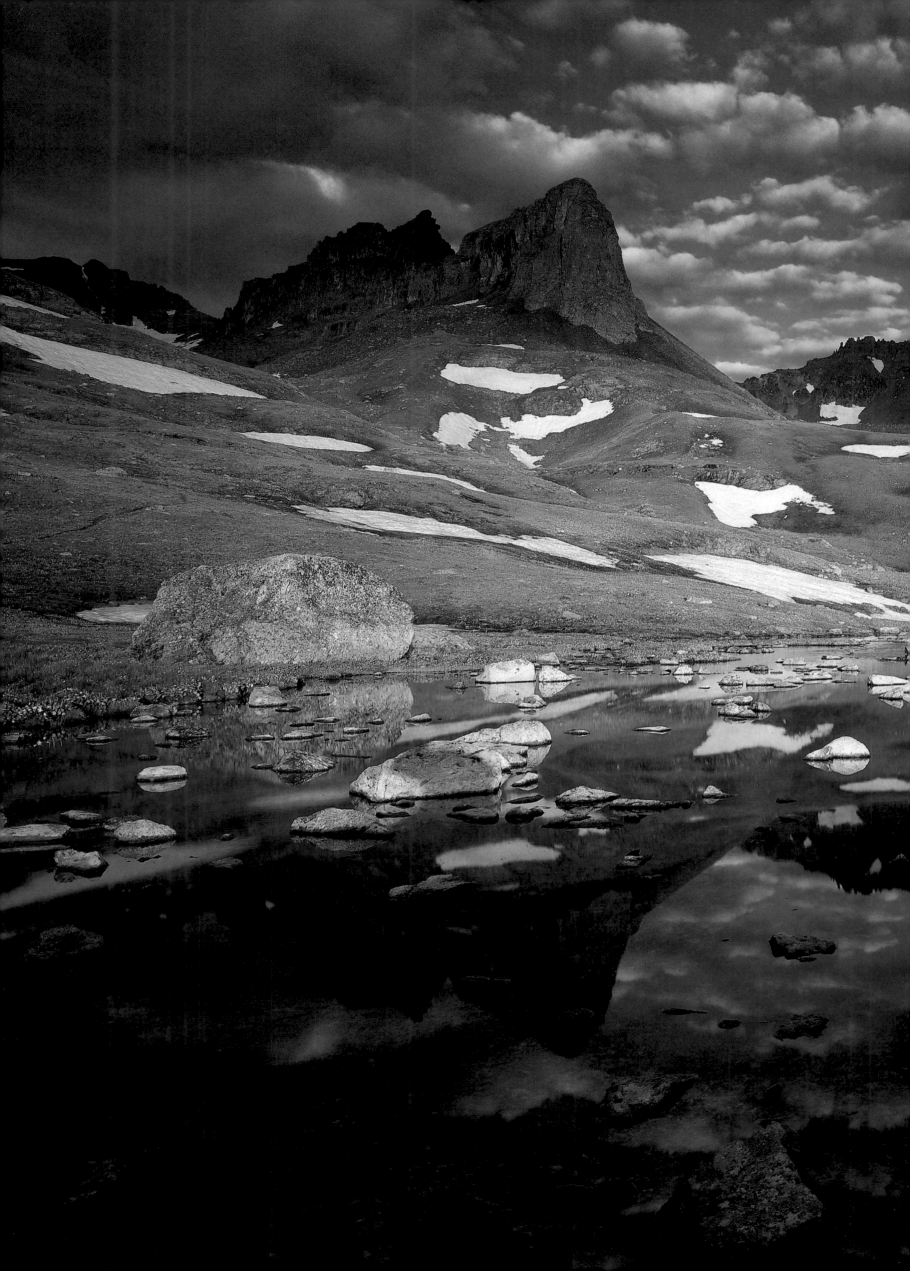

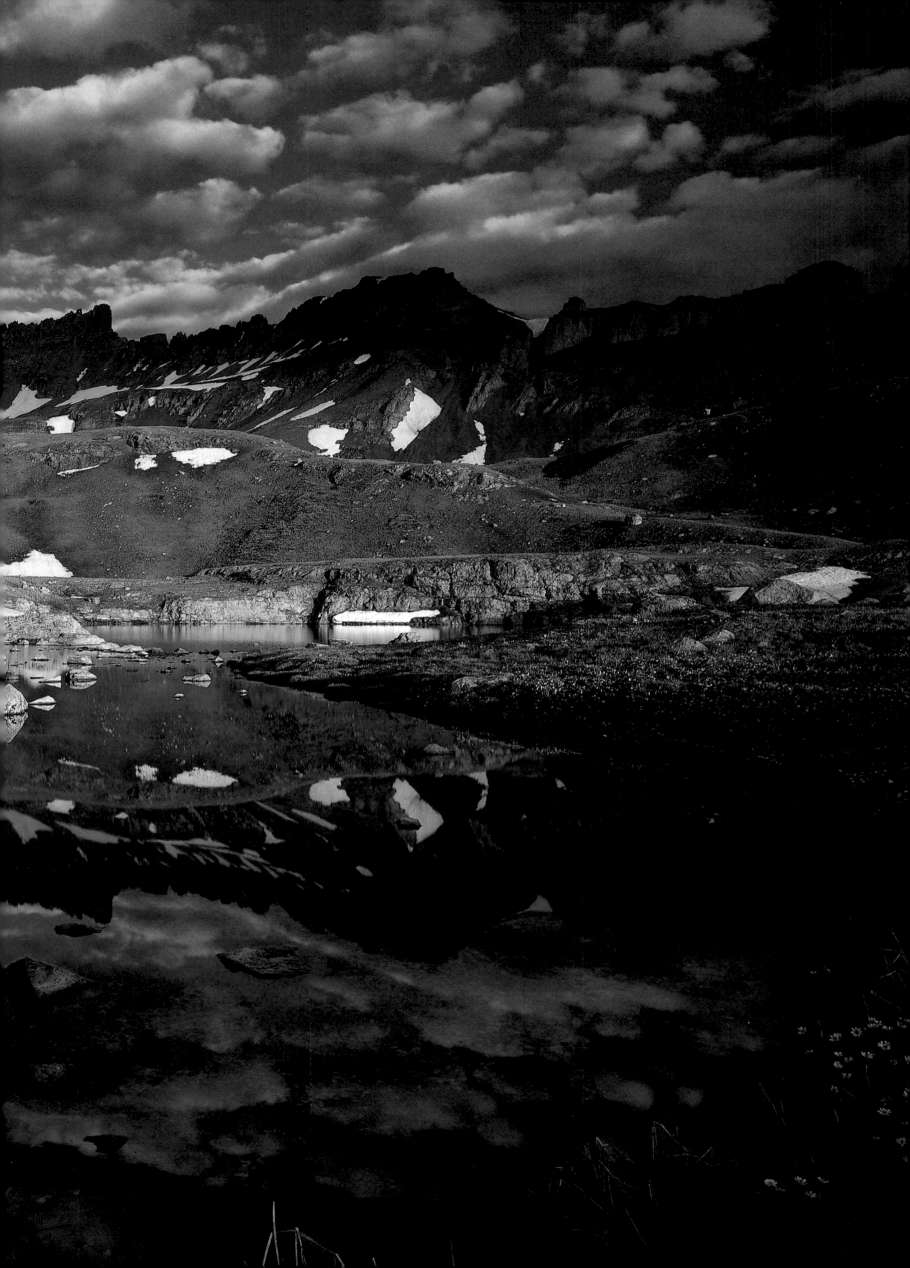

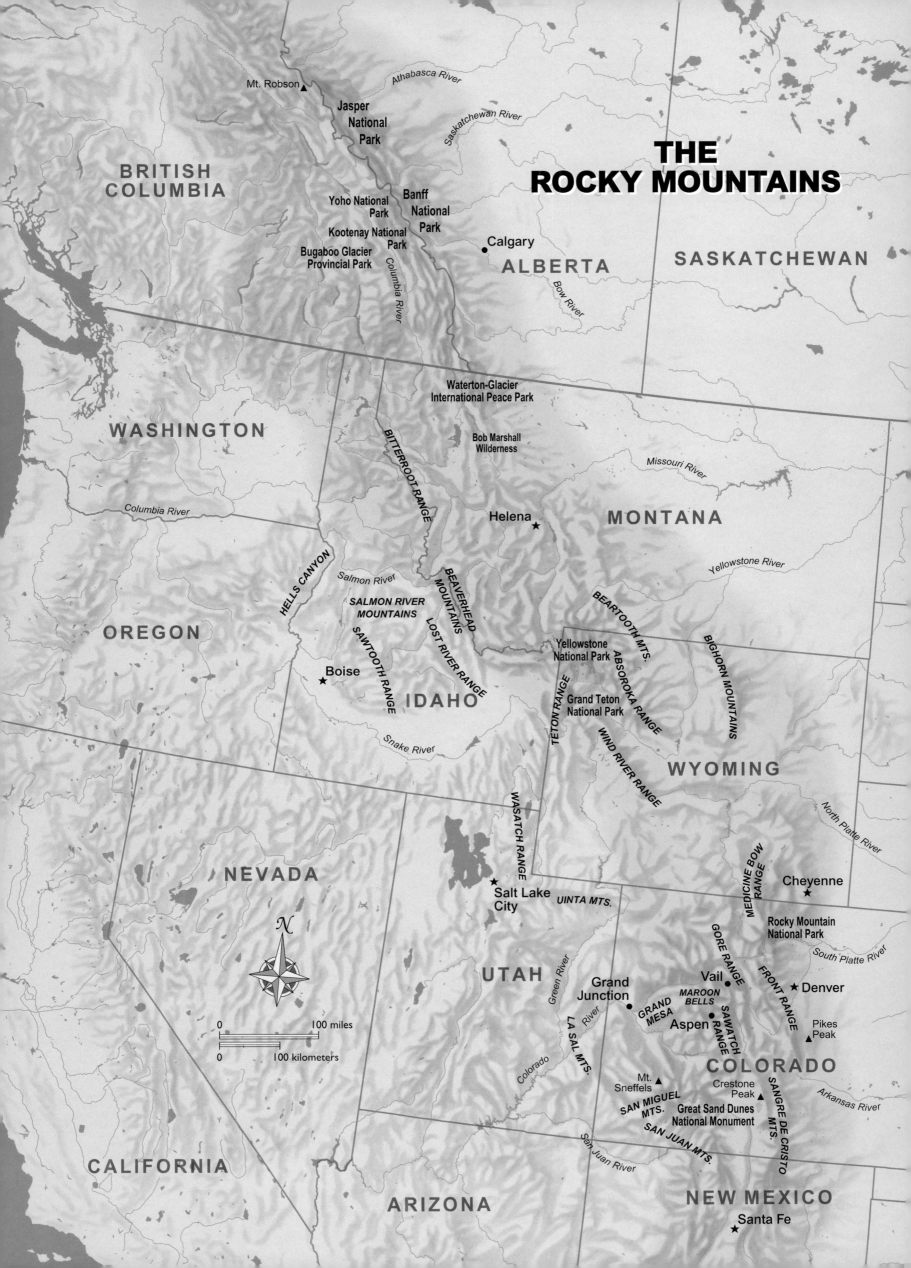

THE ROCKY MOUNTAINS

BRITISH COLUMBIA

Mt. Robson ▲

Athabasca River

Jasper National Park

Saskatchewan River

Yoho National Park

Banff National Park

Kootenay National Park

Bugaboo Glacier Provincial Park

● Calgary

ALBERTA

Columbia River

Bow River

SASKATCHEWAN

WASHINGTON

Waterton-Glacier International Peace Park

BITTERROOT RANGE

Bob Marshall Wilderness

Missouri River

Helena ★

MONTANA

Columbia River

Yellowstone River

OREGON

HELLS CANYON

Salmon River

SALMON RIVER MOUNTAINS

BEAVERHEAD MOUNTAINS

BEARTOOTH MTS.

SAWTOOTH RANGE

LOST RIVER RANGE

Yellowstone National Park

ABSOROKA RANGE

BIGHORN MOUNTAINS

Boise ★

IDAHO

TETON RANGE

Grand Teton National Park

WIND RIVER RANGE

Snake River

WYOMING

North Platte River

MEDICINE BOW RANGE

WASATCH RANGE

Cheyenne ★

NEVADA

N

Salt Lake City ★

UINTA MTS.

Rocky Mountain National Park

South Platte River

0 100 miles

0 100 kilometers

UTAH

Green River

Grand Junction ●

GRAND MESA

MAROON BELLS

GORE RANGE

Vail ●

FRONT RANGE

Denver ★

Colorado

LA SAL MTS.

Aspen ●

SAWATCH RANGE

Pikes Peak ▲

COLORADO

Mt. Sneffels ▲

Crestone Peak ▲

SANGRE DE CRISTO MTS.

Arkansas River

SAN MIGUEL MTS.

Great Sand Dunes National Monument

San Juan River

SAN JUAN MTS.

CALIFORNIA

ARIZONA

NEW MEXICO

Santa Fe ★

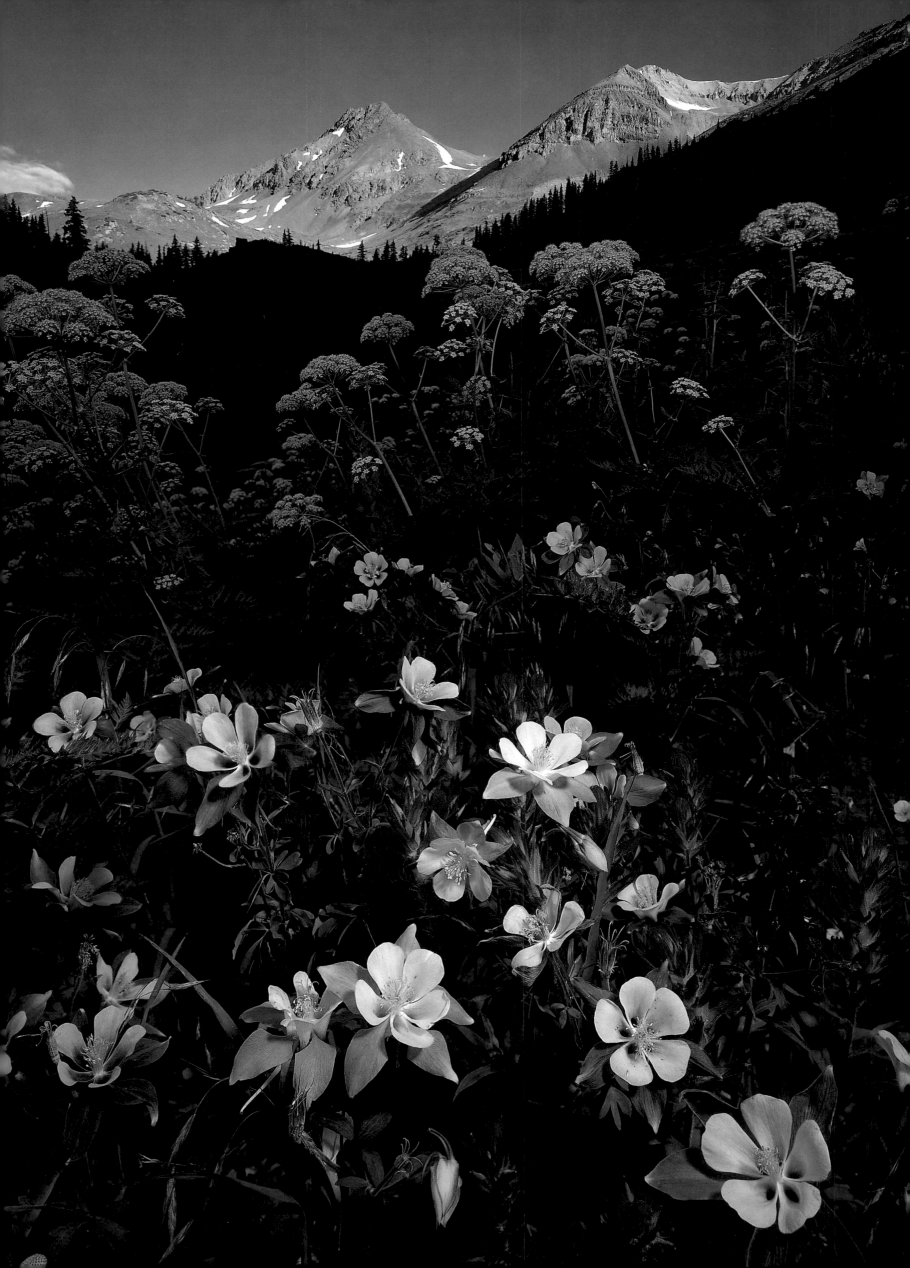

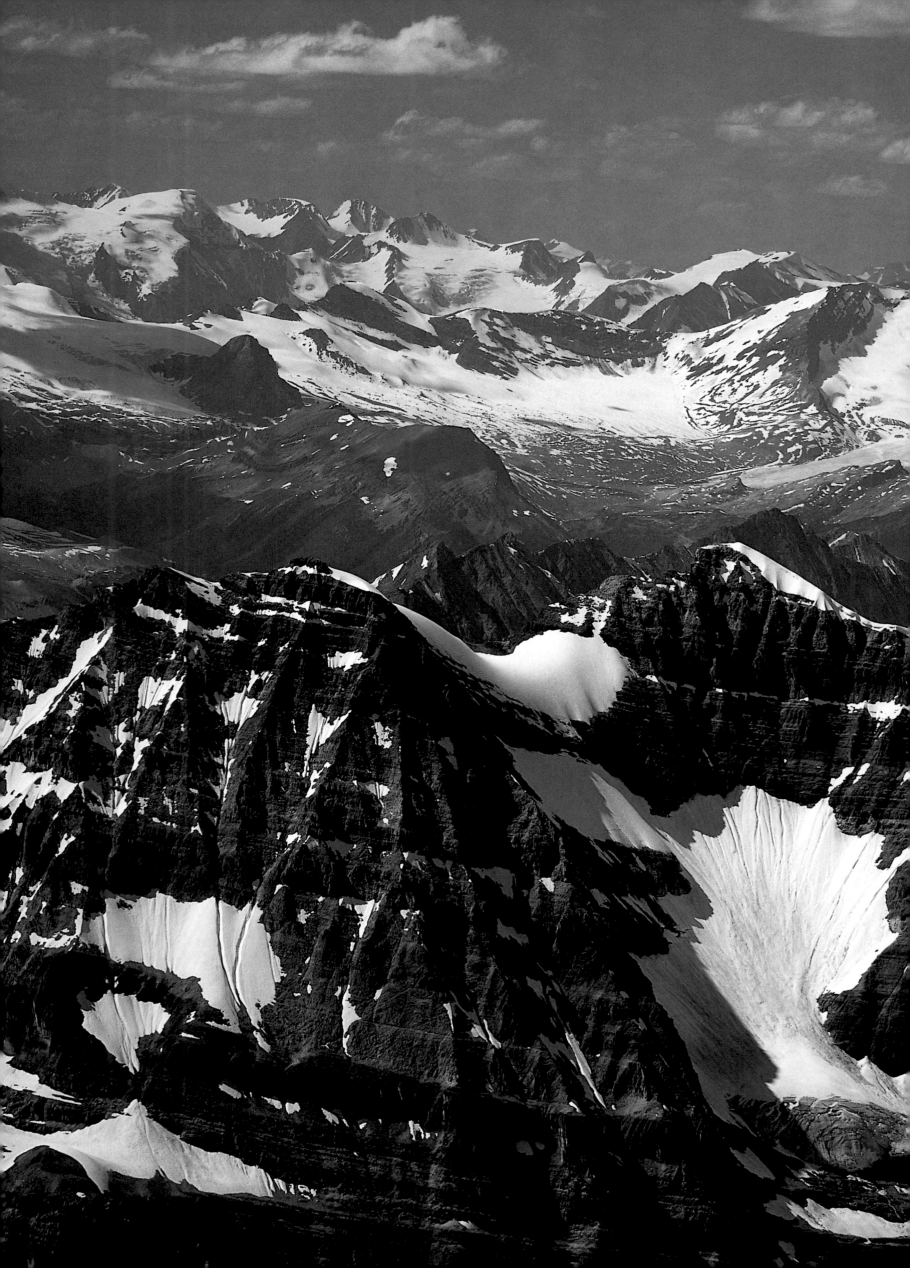

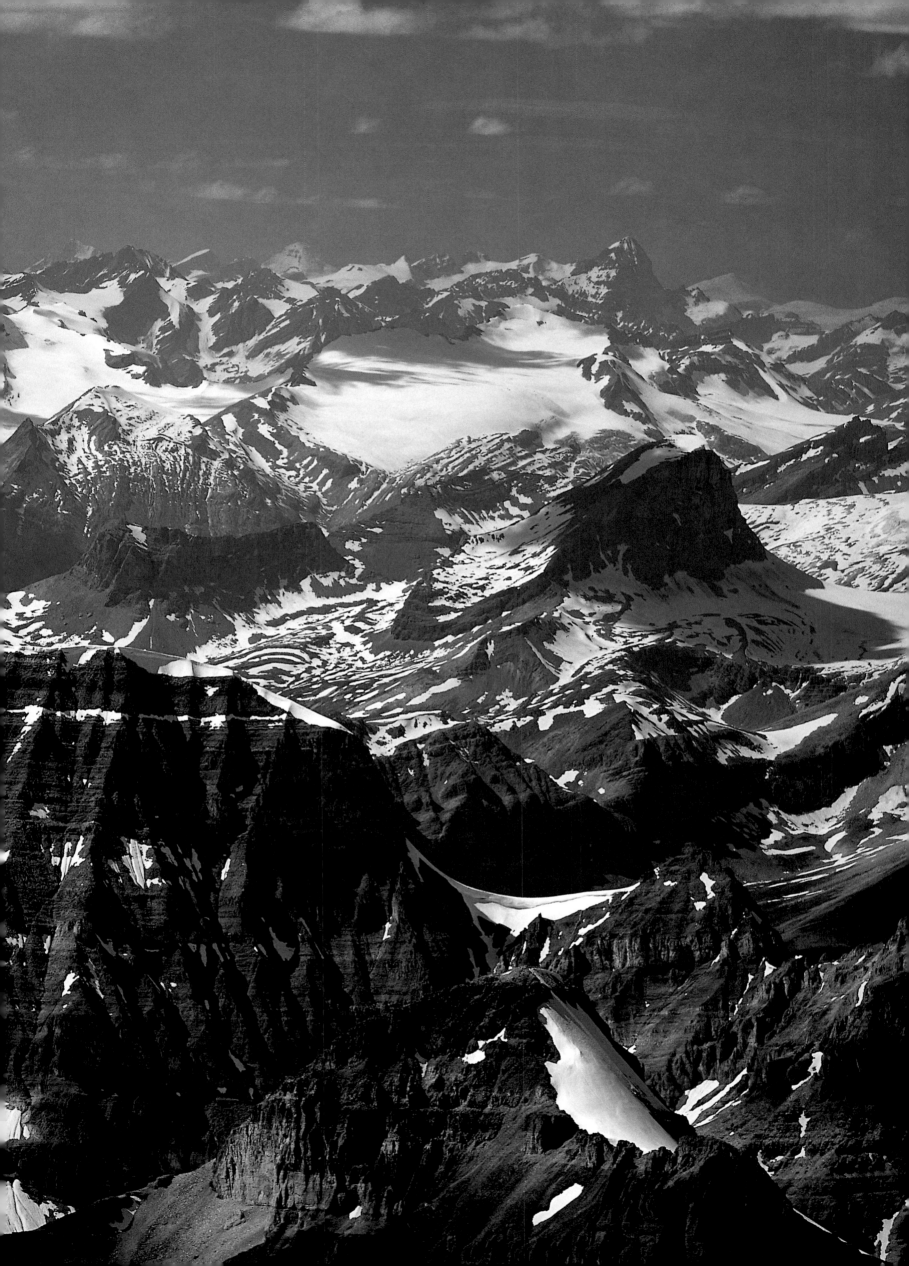

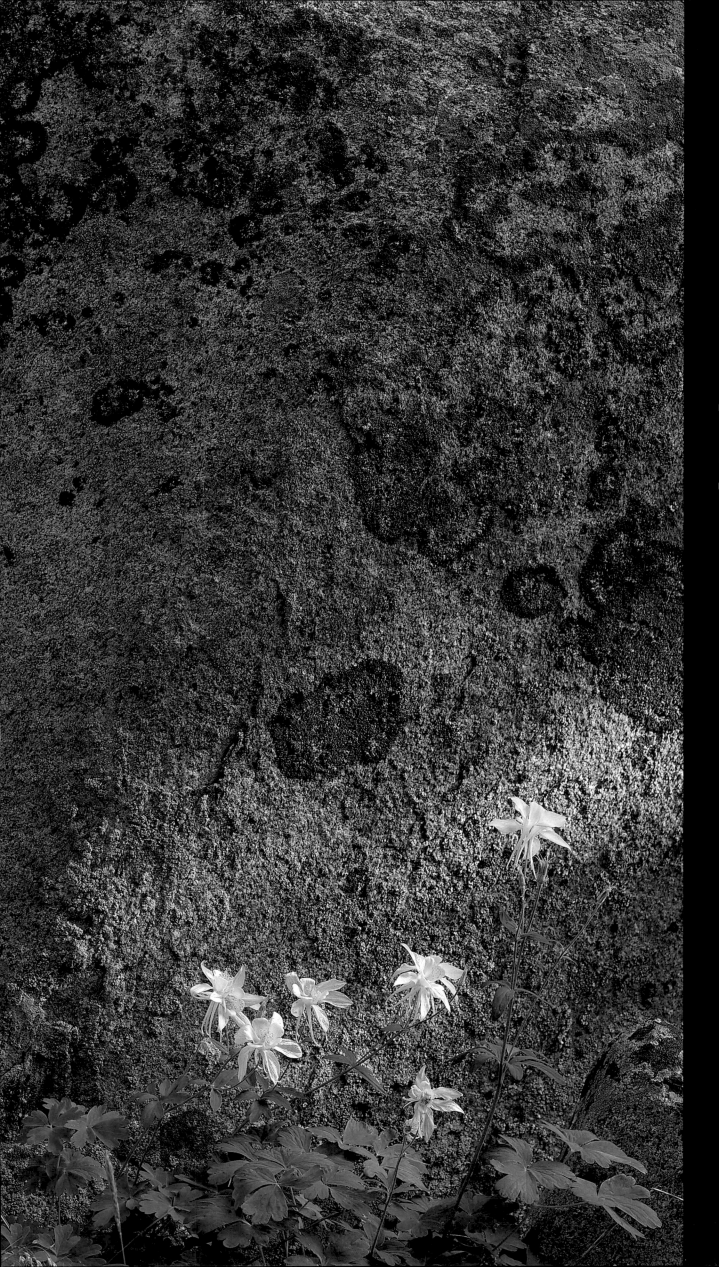

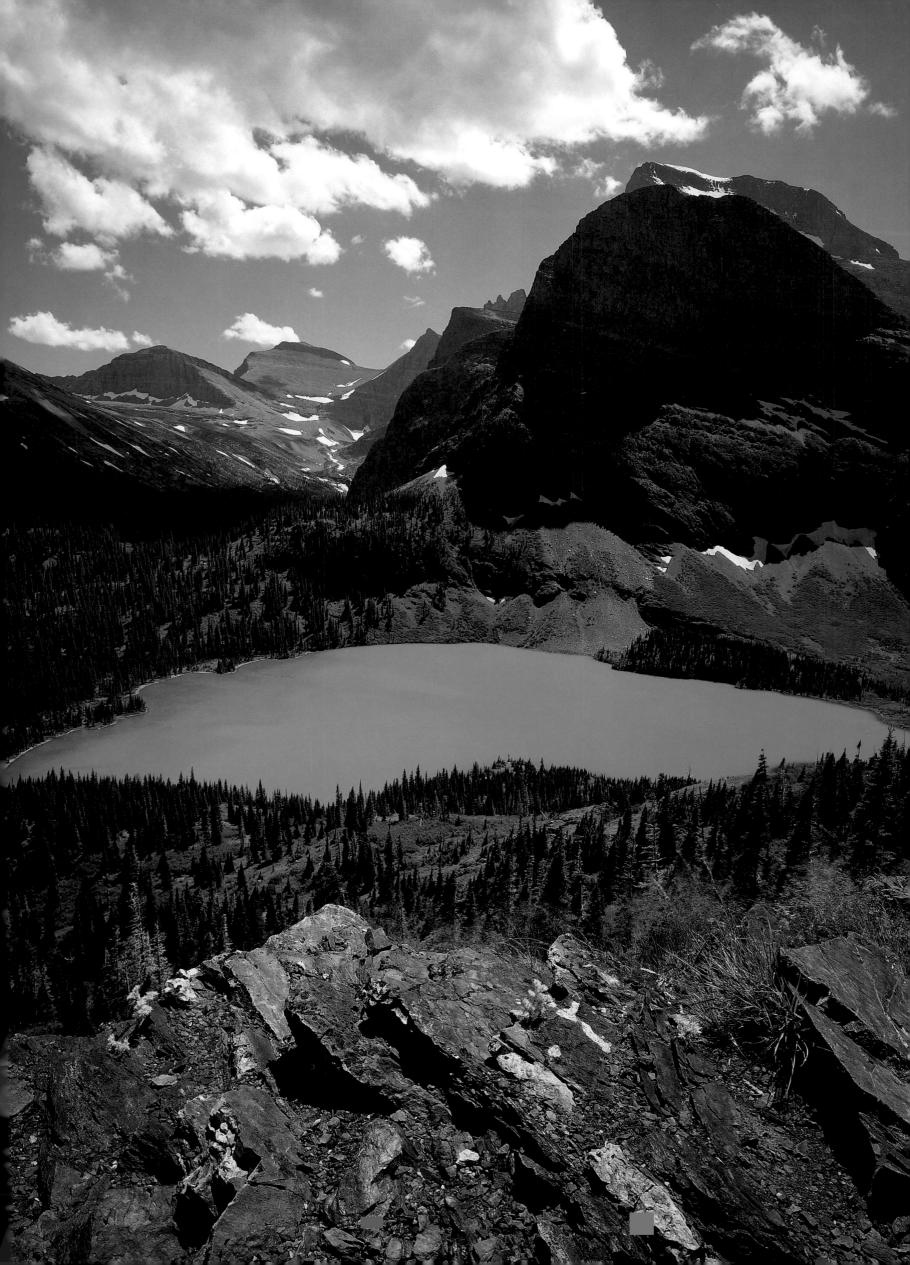

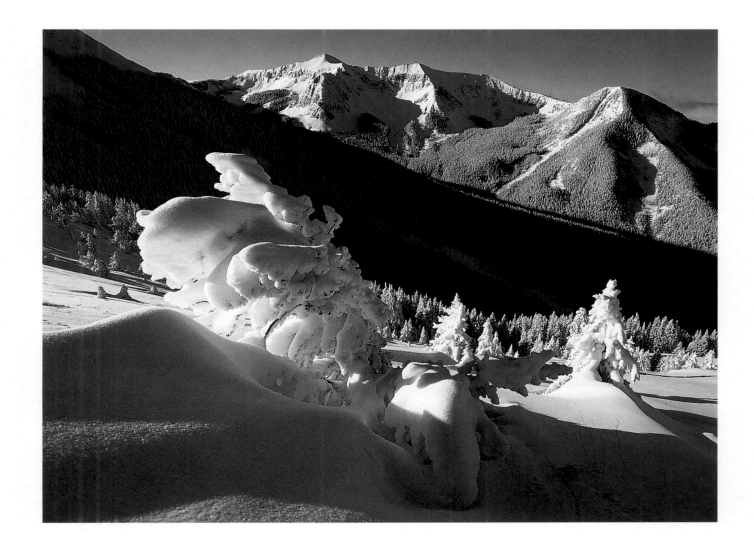

△ A JANUARY SNOWSTORM LEAVES

MORE THAN FOUR FEET OF SNOW IN

WHEELER PEAK WILDERNESS

IN THE SANGRE DE CRISTO

MOUNTAINS OF NEW MEXICO.

▷ TUMBLED BOULDERS AND

THE CRESTONE PEAKS MAKE

IMPRESSIVE SETTINGS FOR

COLORADO COLUMBINE.

CRESTONE NEEDLE (14,191 FEET)

AND CRESTONE PEAK (14,294 FEET)

ARE PART OF COLORADO'S

SANGRE DE CRISTO MOUNTAINS.

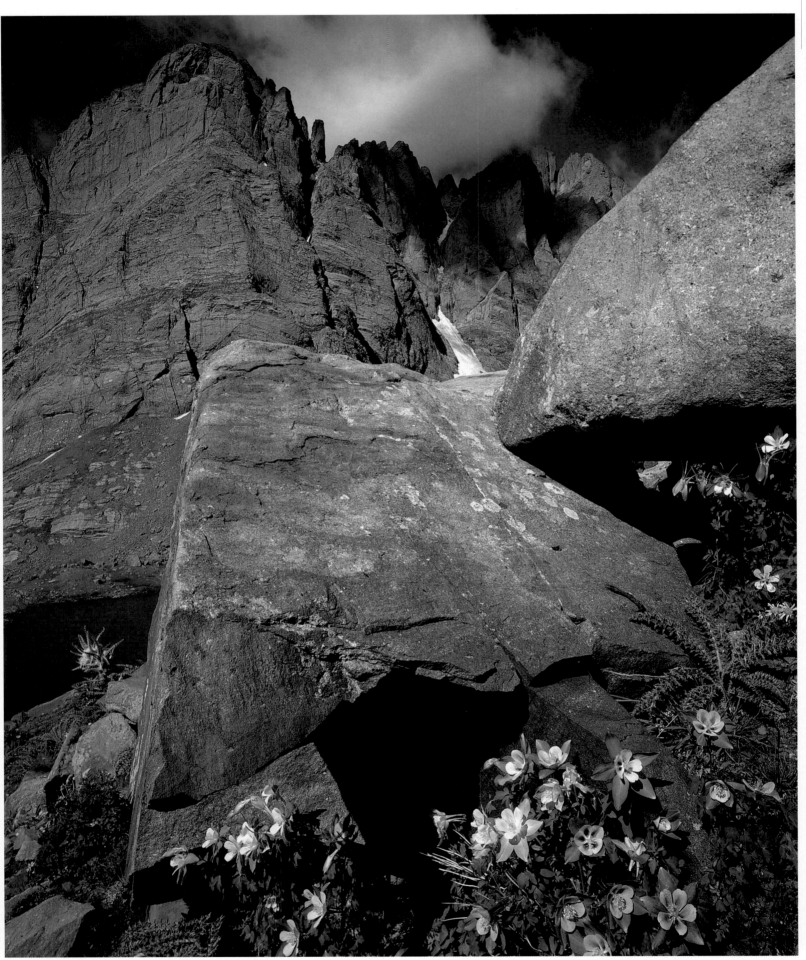

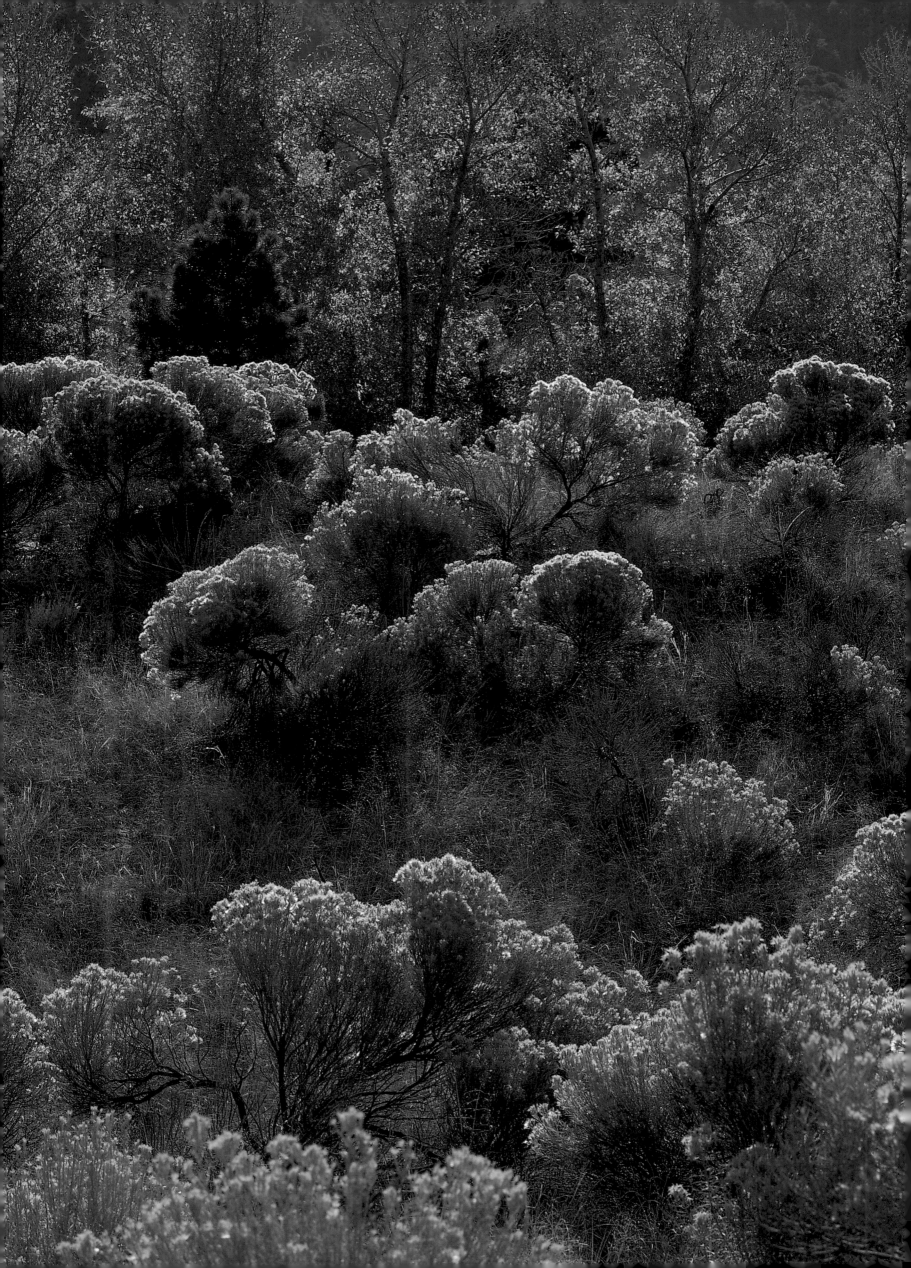

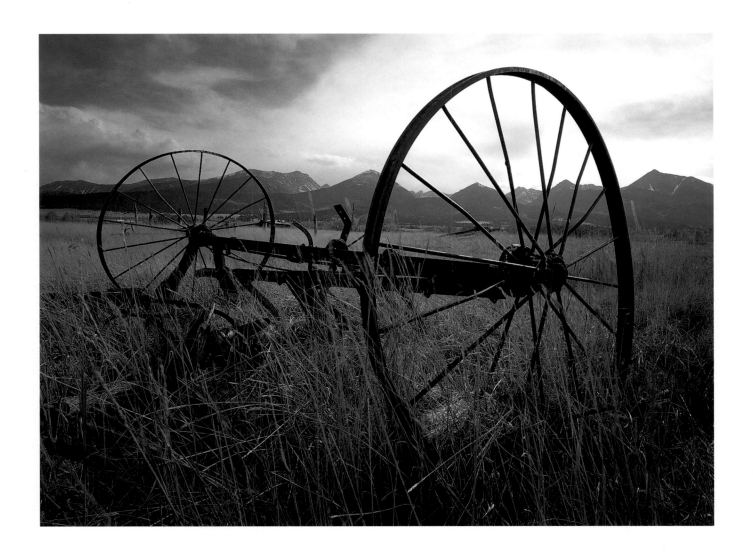

◁ NOVEMBER MORNING LIGHT

SPLASHES THROUGH COTTONWOODS

AND RABBITBRUSH ON THE

SLOPES OF CARBONATE MOUNTAIN

IN GREAT SAND DUNES NATIONAL

MONUMENT, COLORADO.

△ A RELIC HAY RAKER STANDS

IDLE IN A FIELD IN

WET MOUNTAIN VALLEY

AT THE FOOT OF THE SANGRE

DE CRISTO MOUNTAINS, COLORADO.

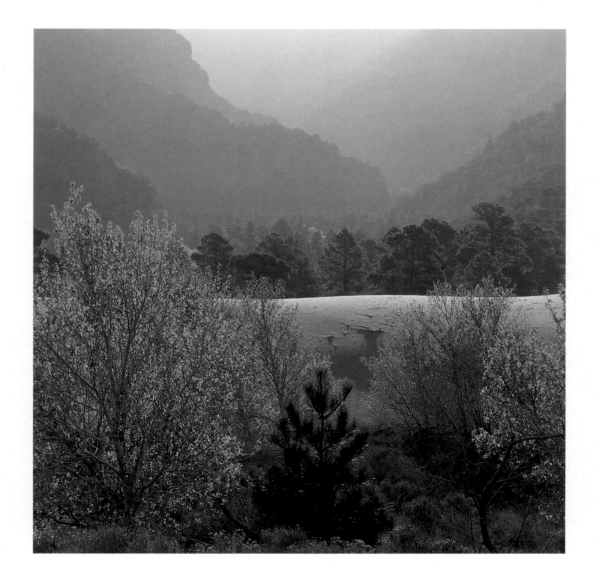

△ A SPRING MOOD ENVELOPES

A CANYON IN THE SANGRE DE

CRISTO MOUNTAINS. THE SAND

RIDGE IS PART OF NORTH

AMERICA'S TALLEST SAND DUNES,

GREAT SAND DUNES

NATIONAL MONUMENT, COLORADO.

▷ TAOS MOUNTAIN IS SEEN ON A

NOVEMBER MORNING FROM

ARROYO SECO IN NEW MEXICO'S

SANGRE DE CRISTO MOUNTAINS.

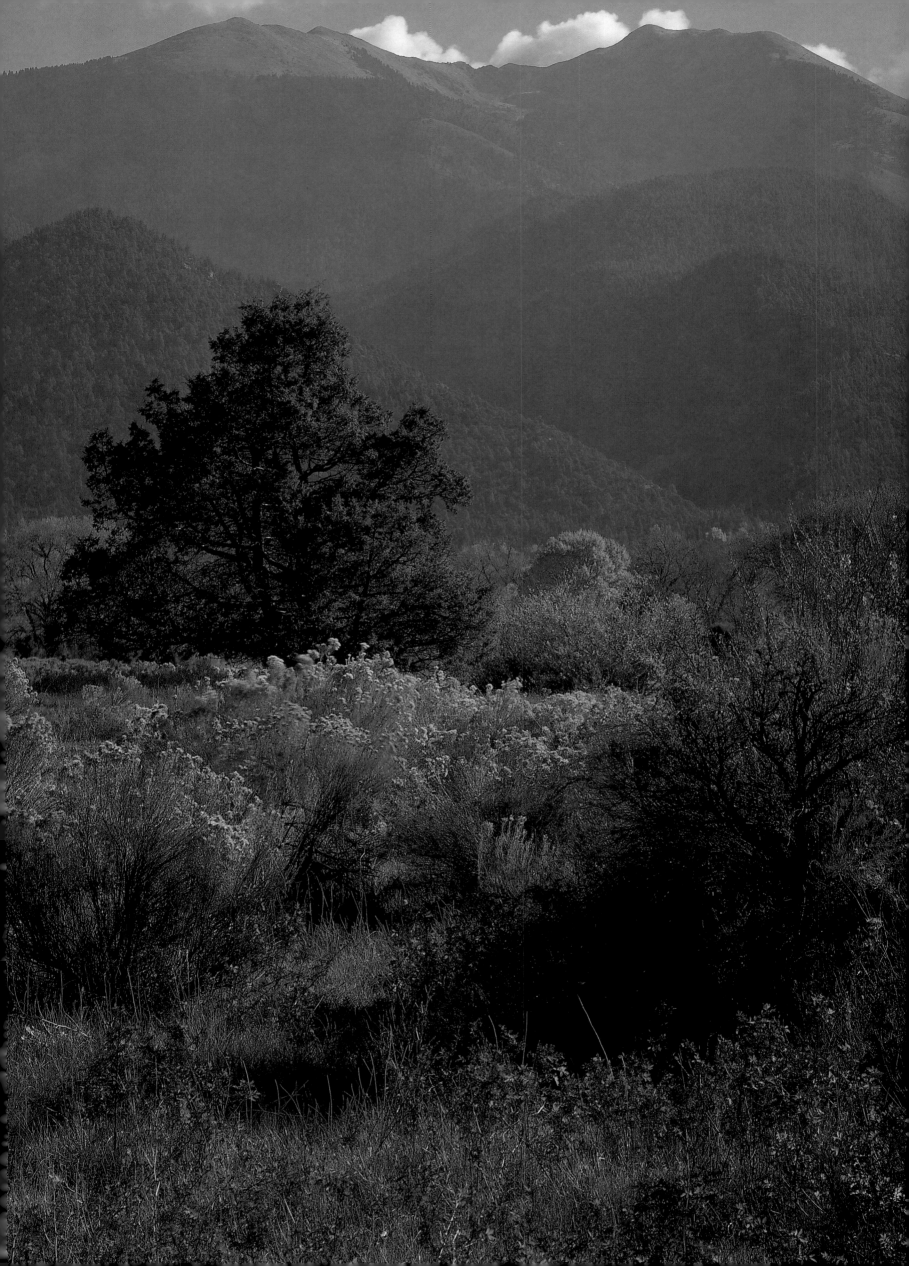

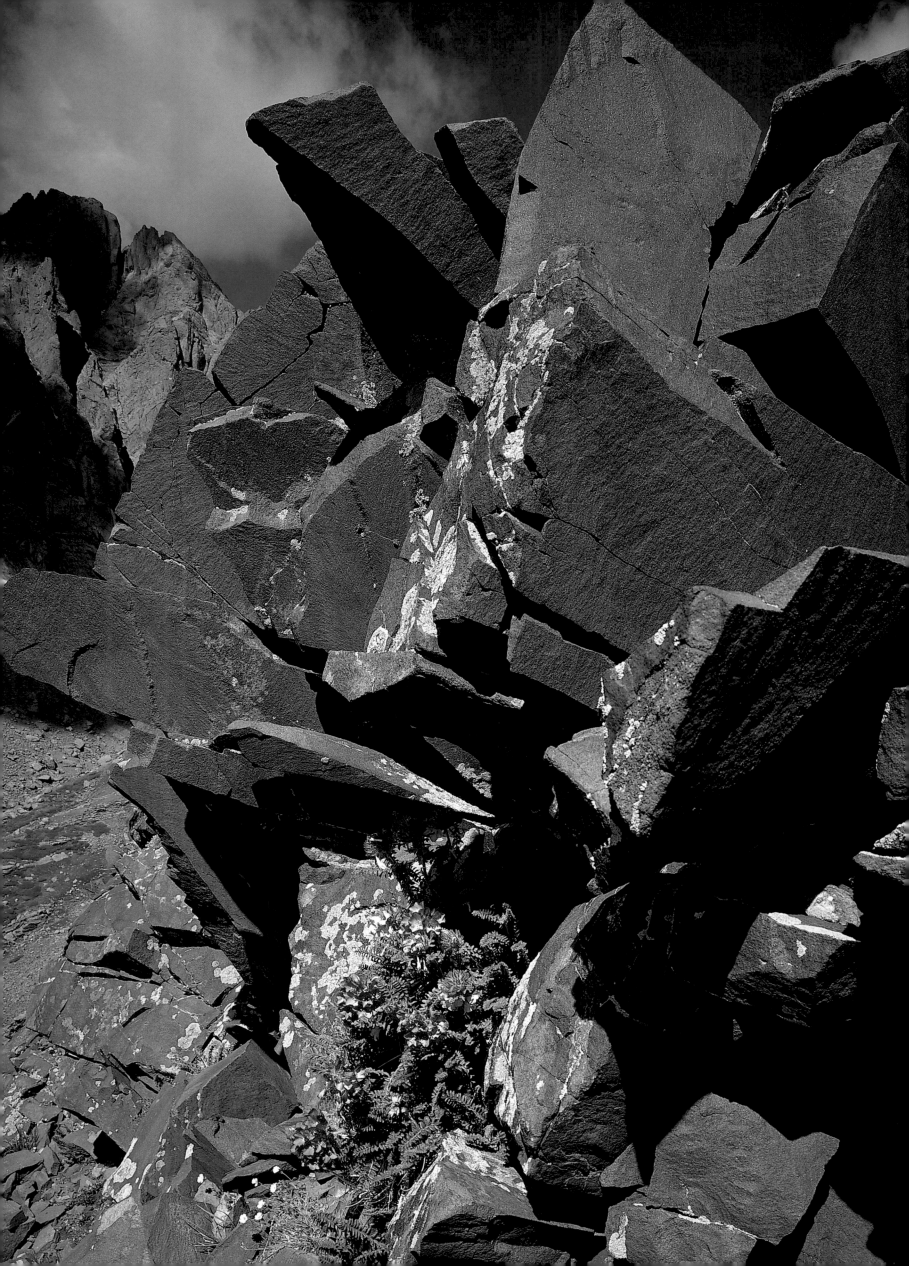

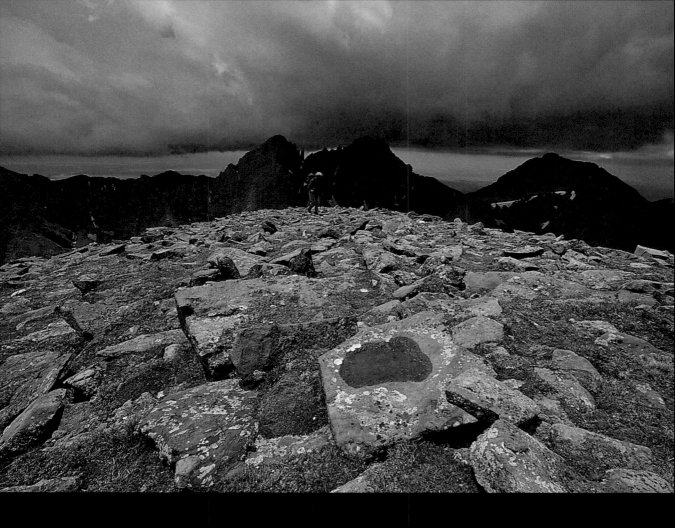

◁ SKY PILOT BLOOM IN A JAGGED
TEMPORAL ROCKY SLOPE BELOW
CRESTONE PEAK IN THE SANGRE DE
CRISTO MOUNTAINS OF COLORADO.
△ A LONE HIKER STROLLS ACROSS
THE ROUNDED TOP OF 14,064-FOOT
HUMBOLDT PEAK BETWEEN SUMMER
STORMS. THE SKYLINE ABOVE

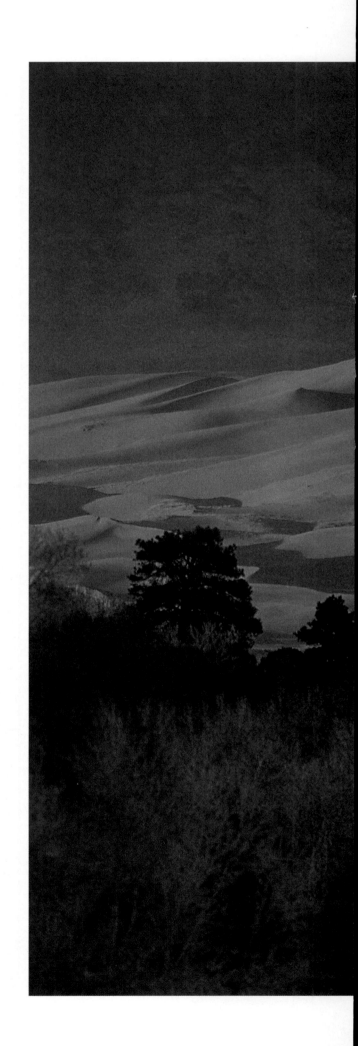

▷ GREAT SAND DUNES NATIONAL

MONUMENT NESTLES UNDER THE

SANGRE DE CRISTO MOUNTAINS

IN COLORADO'S SAN LUIS VALLEY.

▷ ▷ (INSET) WESTERLY WINDS HAVE

ETCHED SANDS ALONG MEDANO

CREEK AT GREAT SAND DUNES

NATIONAL MONUMENT, COLORADO.

▷ ▷ (BACKGROUND) A

RANDOM DESIGN IN ICE.

▷ ▷ ▷ THIS VIEW IS EVERY SKIER'S

DREAM: TO GET OFF THE CHAIRLIFT

AT THE TOP OF TAOS SKI VALLEY AND

LOOK OVER AT KACHINA PEAK

BLANKETED UNDER NEW SNOW.

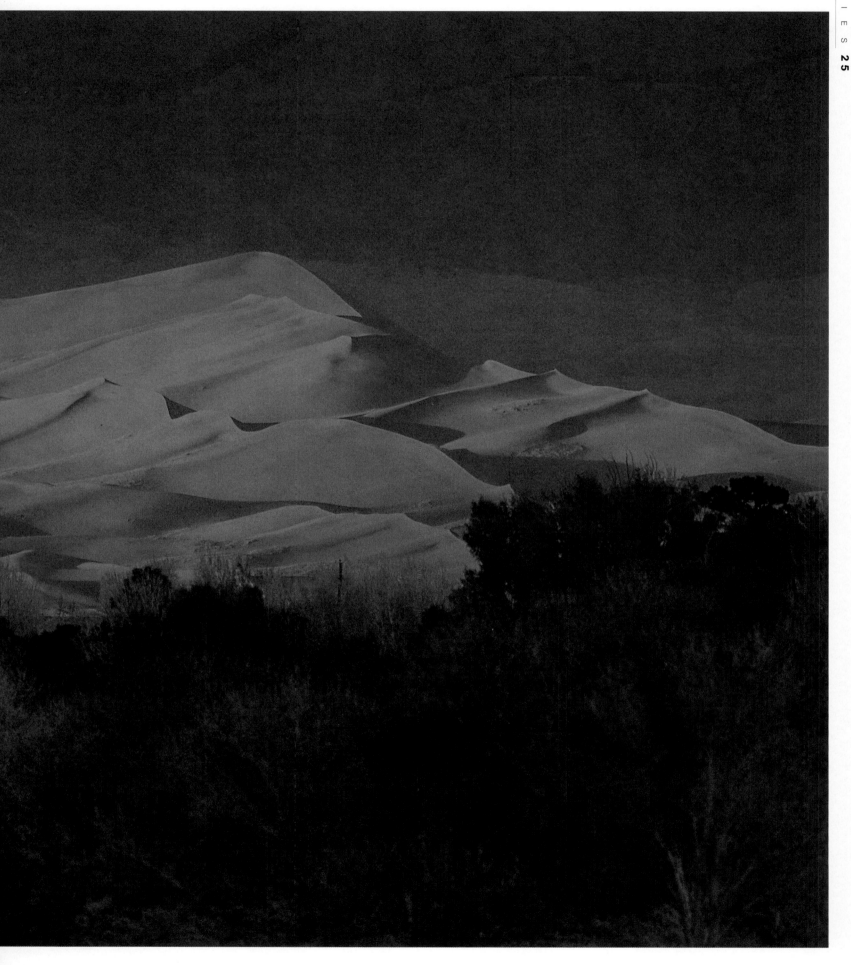

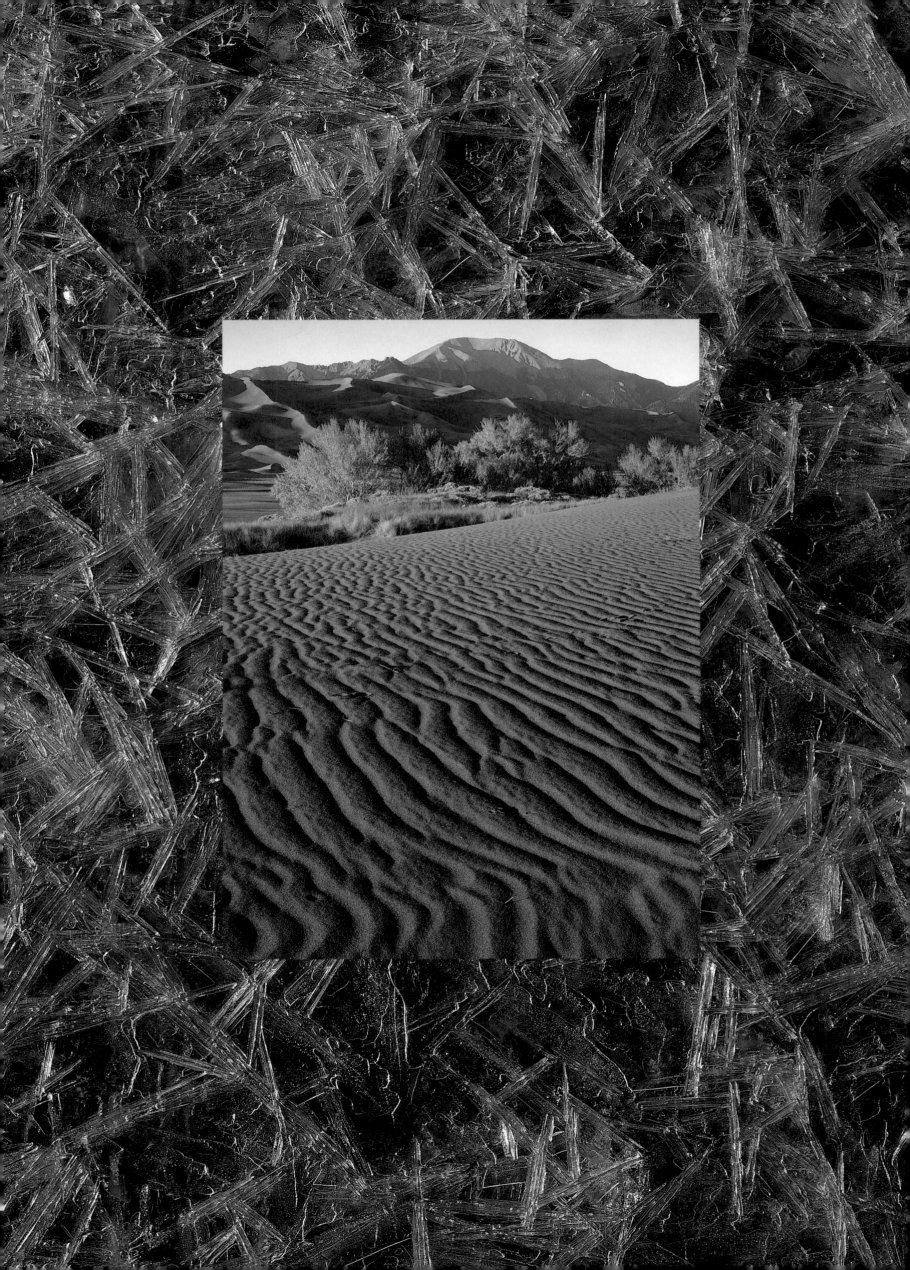

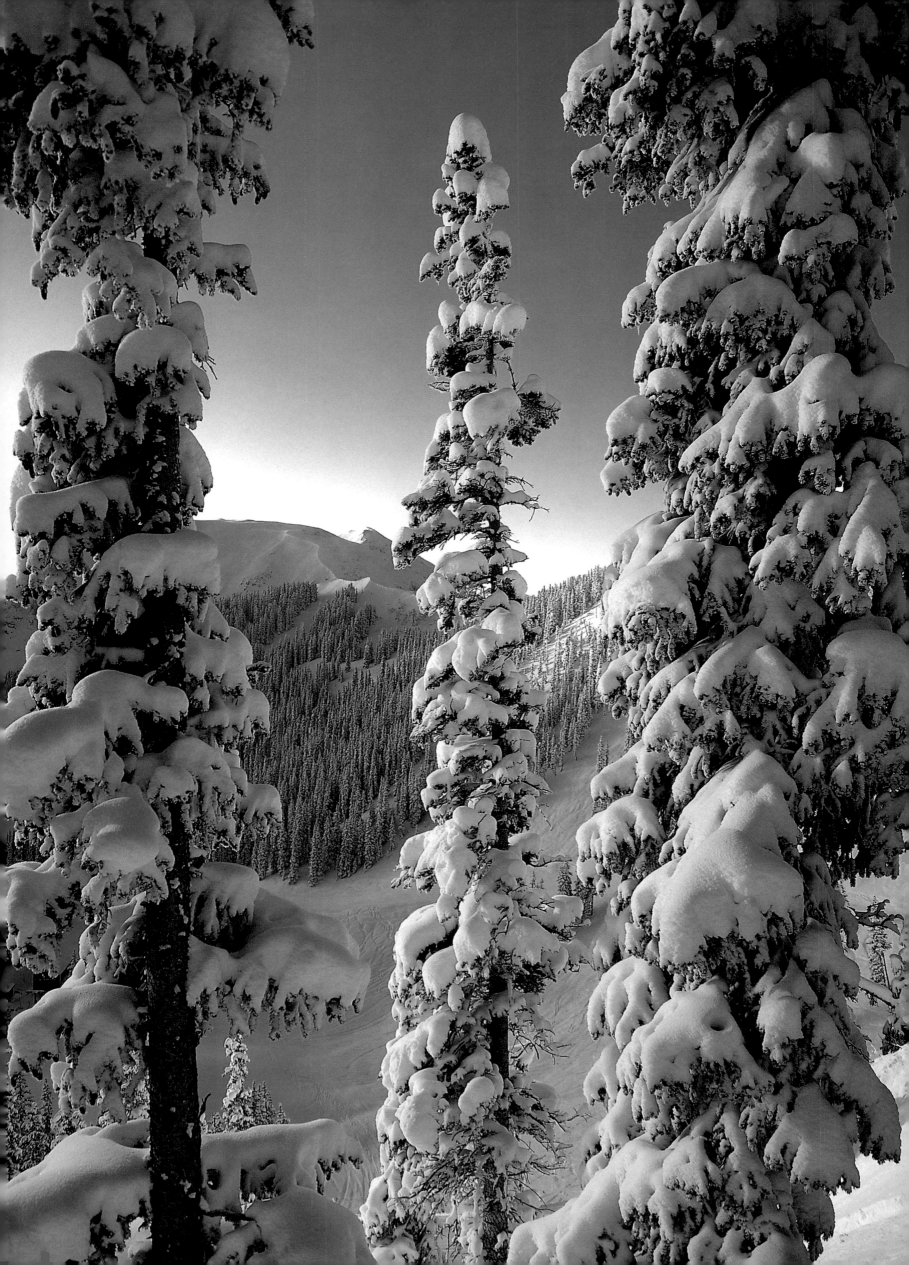

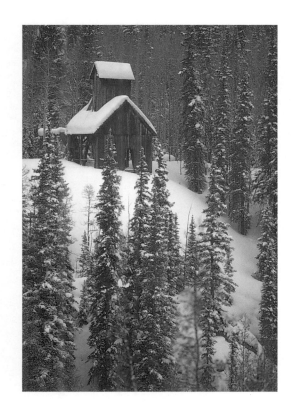

△ THE REMNANTS OF MINING
AROUND RED MOUNTAIN PASS IN
COLORADO ARE FADING AS HARSH
WINTER ELEMENTS TAKE THEIR TOLL.
▷ HIGH PEAKS OF THE LA PLATA
MOUNTAINS HOLD AN ALPINE
FLORAL DISPLAY OF THE
HIGH COUNTRY'S "FIFTH SEASON"
IN CUMBERLAND BASIN,
SAN JUAN MOUNTAINS, COLORADO.

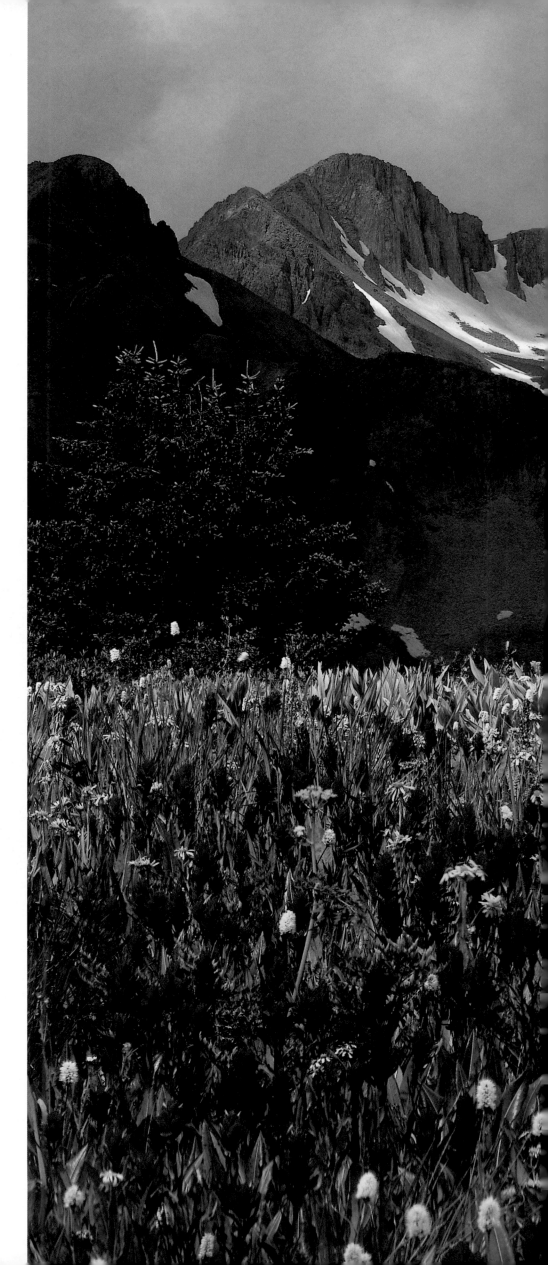

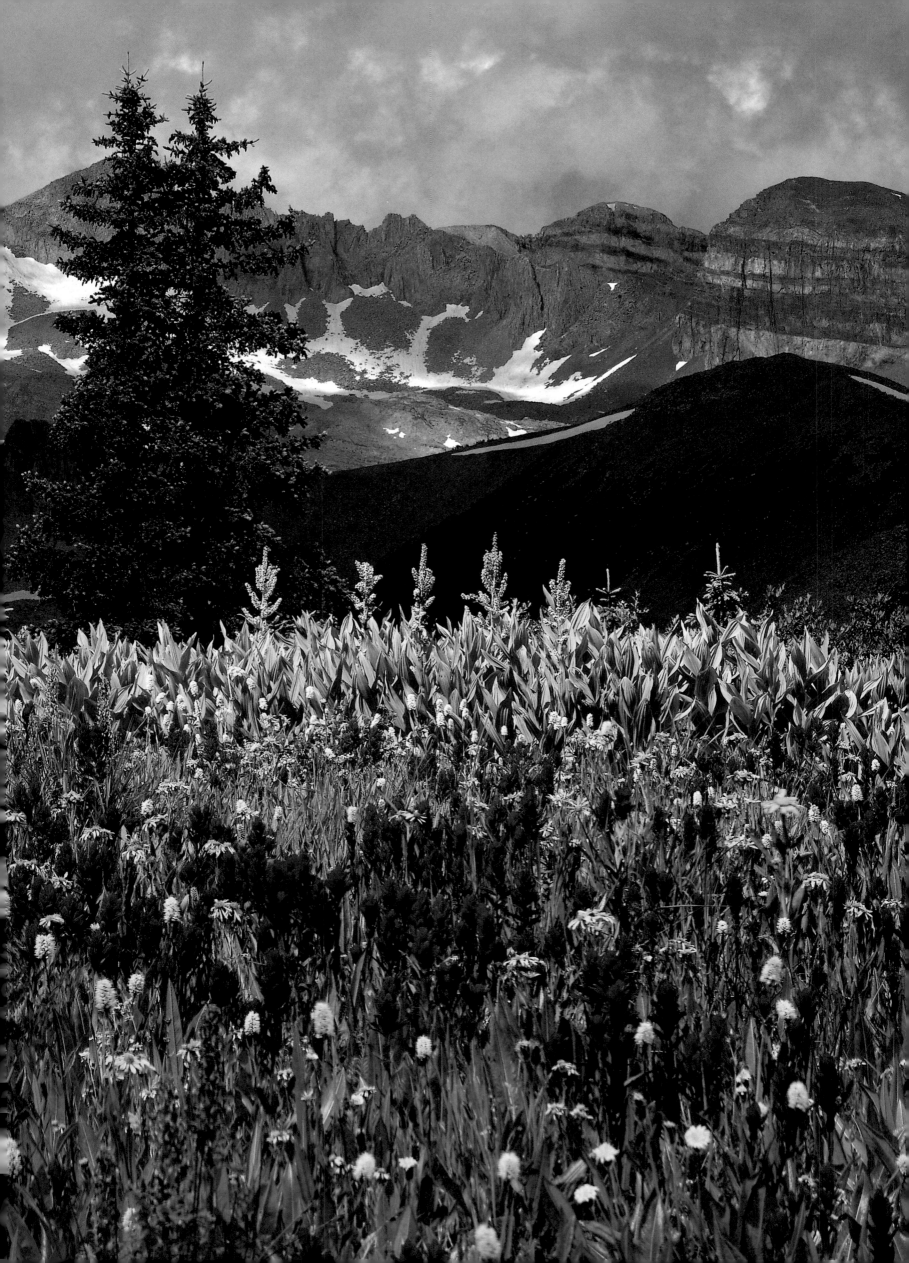

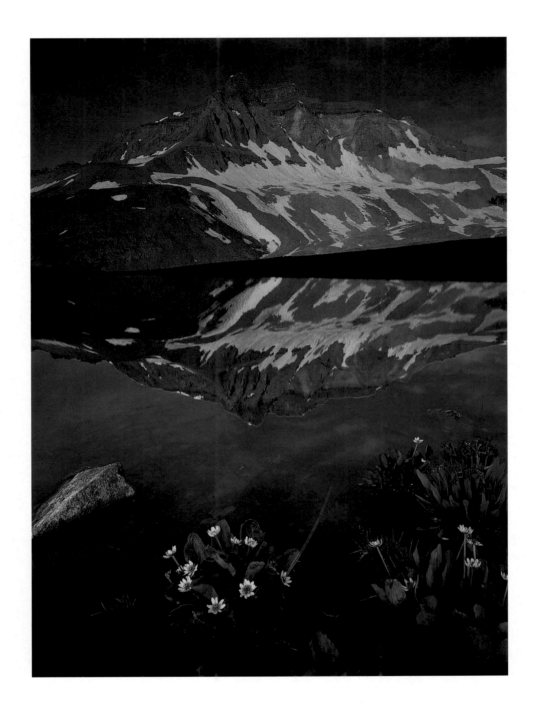

△ COLORADO'S MOUNT GILPIN

IS REFLECTED IN AN ALPINE POOL

LINED WITH MARSH MARIGOLDS.

▷ A FLOATING LILY PAD AND

GRASSES SPARKLE IN THE WARM

MORNING SUN ON MOLAS DIVIDE

IN THE SAN JUAN MOUNTAINS

OF COLORADO.

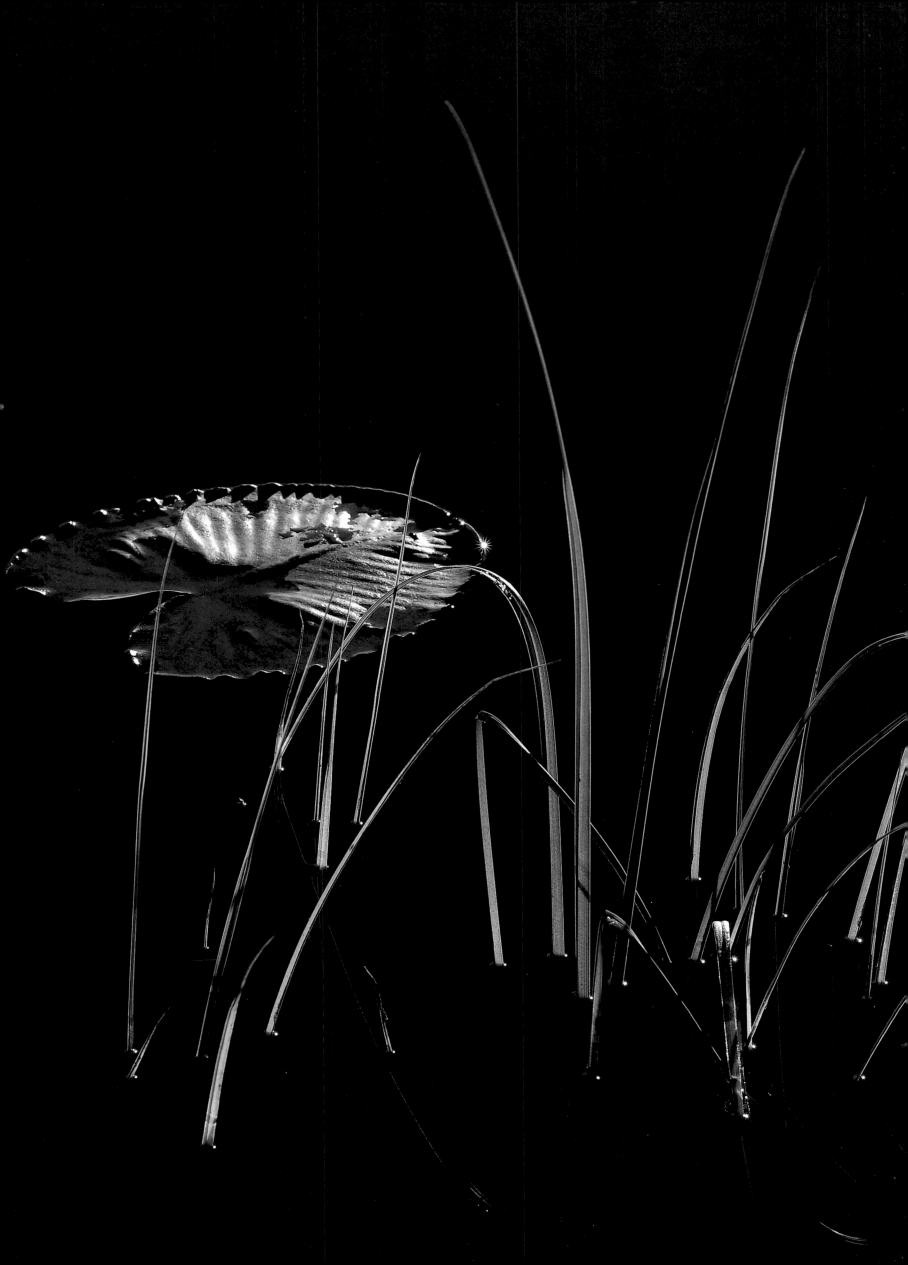

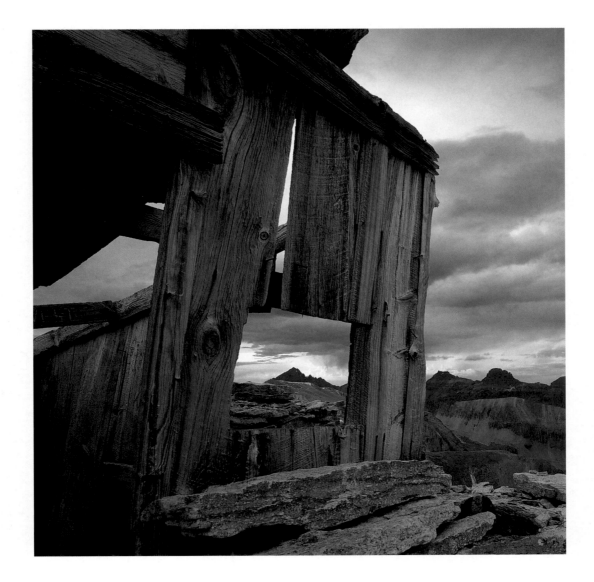

△ THE MINER WHO LIVED IN THIS

SHACK HIGH ON THE RIDGE

BETWEEN TELLURIDE AND OURAY,

COLORADO, MUST HAVE HAD

AN INCREDIBLE VIEW OF

14,000-FOOT MOUNT SNEFFELS

THROUGH HIS KITCHEN WINDOW.

▷ A MAY DAWNING HIGHLIGHTS THE

WILSON PEAKS IN LIZARD HEAD

WILDERNESS ABOVE A WEATHER-

BEATEN FENCE NEAR TELLURIDE IN

COLORADO'S SAN JUAN MOUNTAINS.

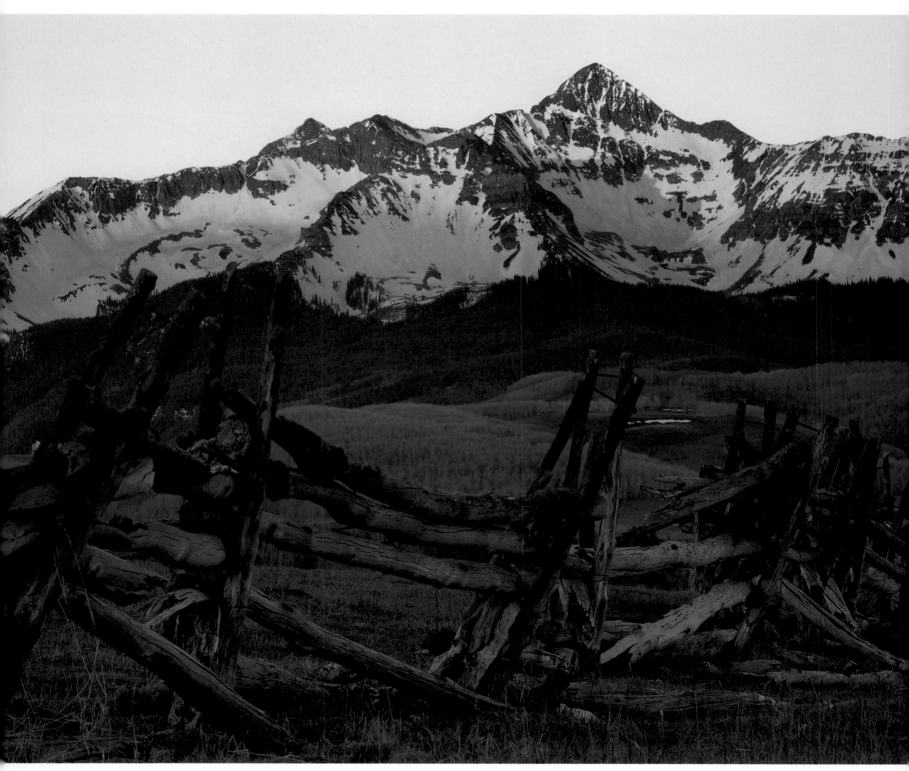

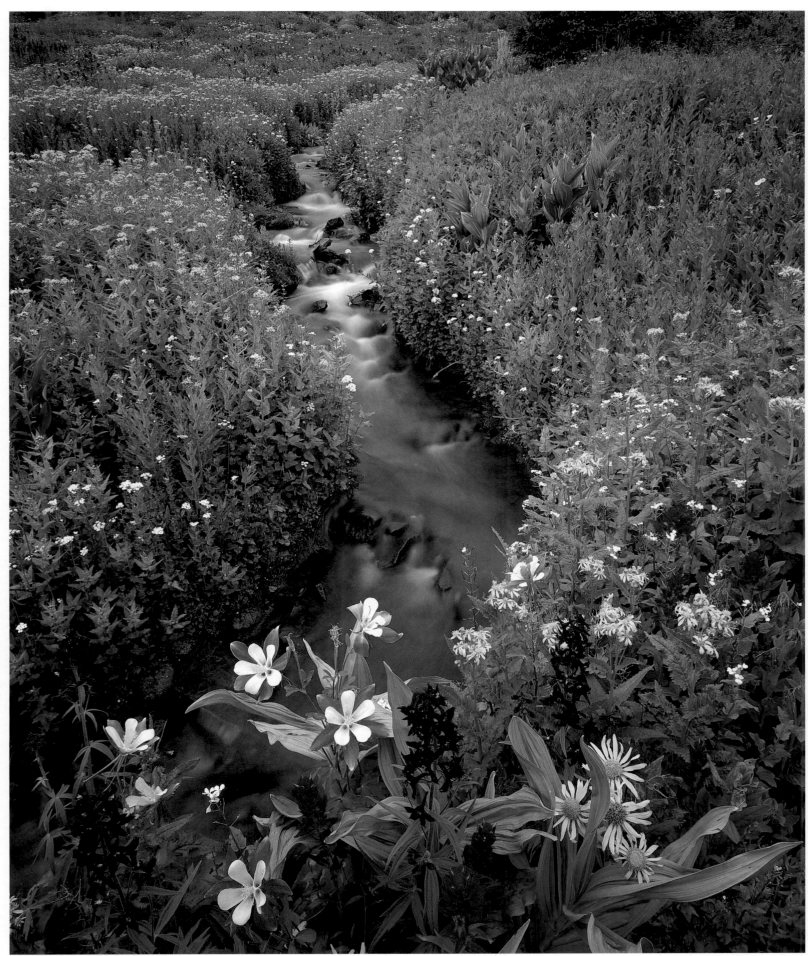

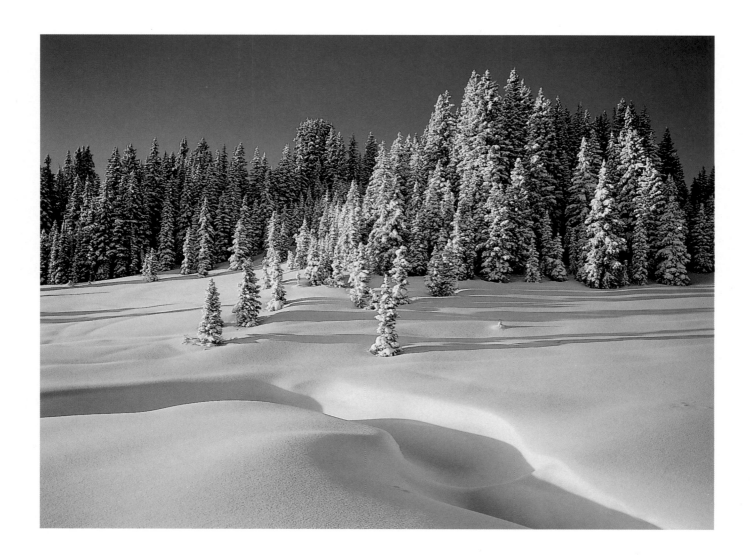

◁ AN ALPINE FLORAL DISPLAY

OF BLUEBELL, COLUMBINE,

LARKSPUR, ARNICA, AND OTHER

POST SNOWMELT FLOWERS

LINE A GENTLE CREEKSIDE IN

YANKEE BOY BASIN, SAN JUAN

MOUNTAINS, COLORADO.

△ DUE TO ITS LOCATION IN

COLORADO'S SOUTHERN SAN JUANS,

WOLF CREEK PASS RECEIVES

OVER FIVE HUNDRED INCHES

OF SNOW EACH WINTER.

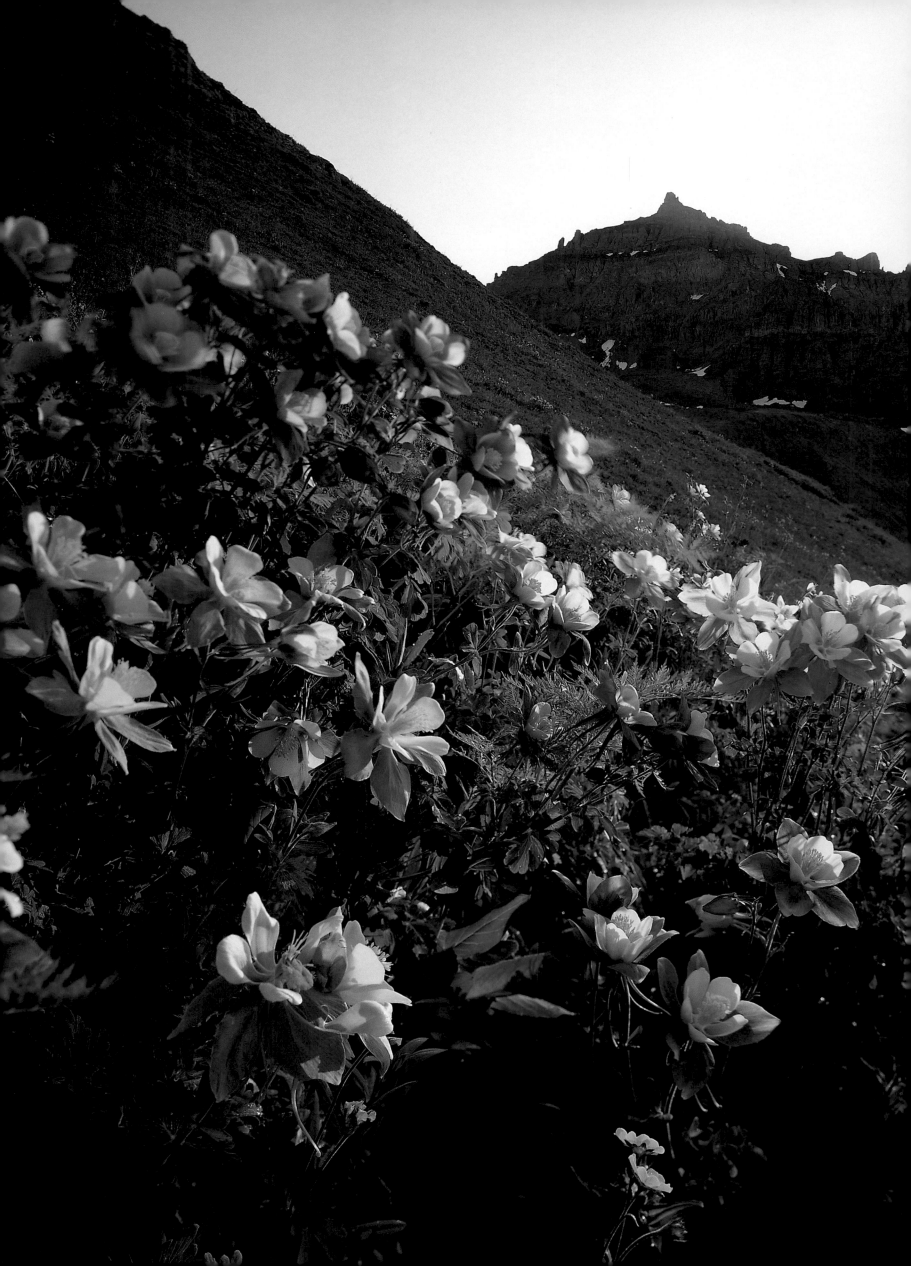

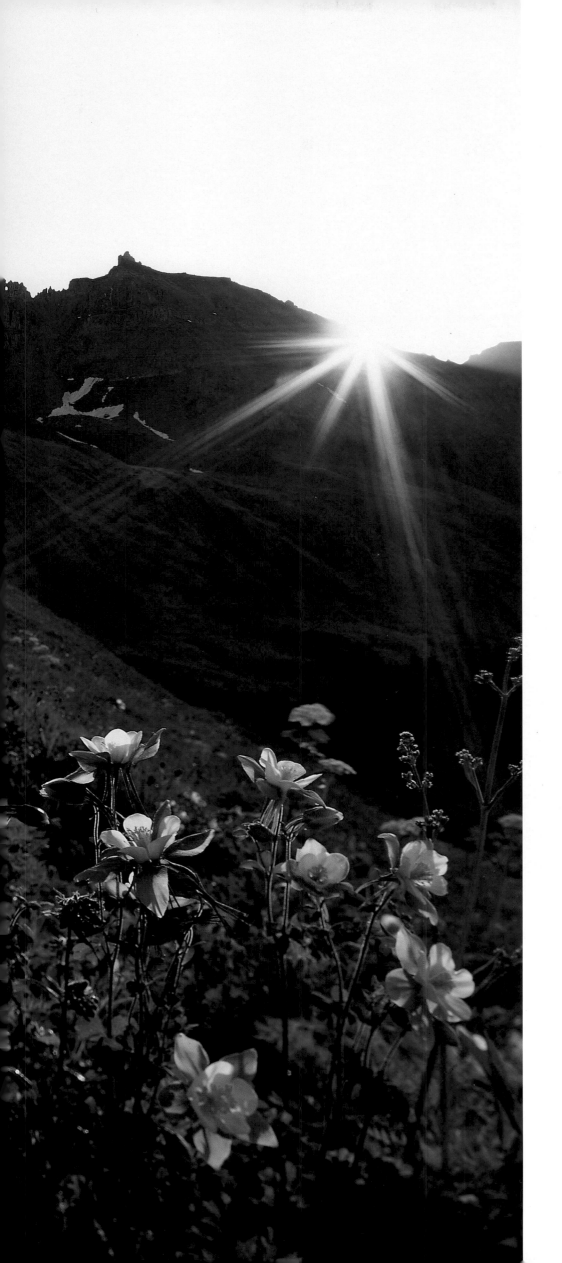

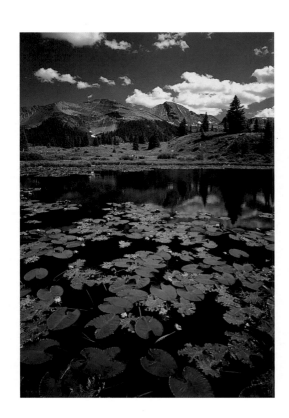

◁ COLUMBINE, SEEN HERE
IN YANKEE BOY BASIN, IS
COLORADO'S STATE FLOWER.
△ A POOL, SURROUNDED
BY WILLOWS AND COVERED WITH
LILIES, REFLECTS THE WARM
SUMMER DAY IN MOLAS DIVIDE
OF COLORADO'S
SAN JUAN MOUNTAINS.

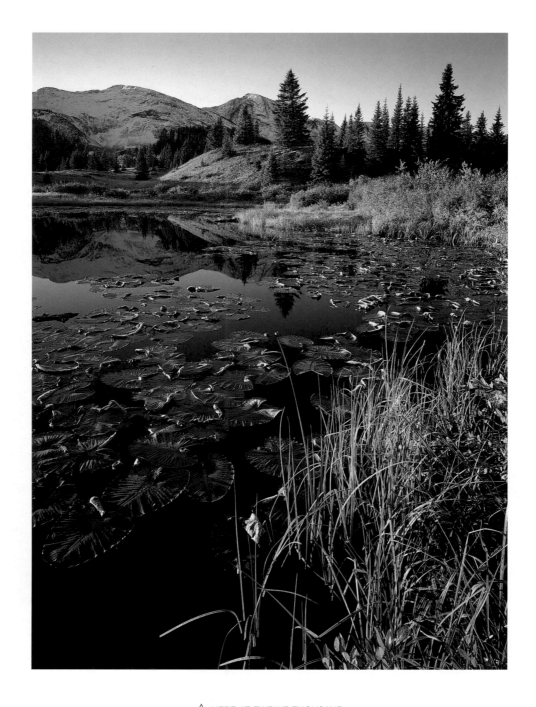

△ HERE AT TWELVE THOUSAND

FEET IN COLORADO'S SAN JUAN

MOUNTAINS, AUTUMN

BEGINS IN MID-SEPTEMBER.

▷ ON THE ROAD SOUTH

FROM TELLURIDE, COLORADO,

JUST BELOW LIZARD HEAD PASS,

IS TROUT LAKE, WHOSE NAME

IMPLIES THE OBVIOUS.

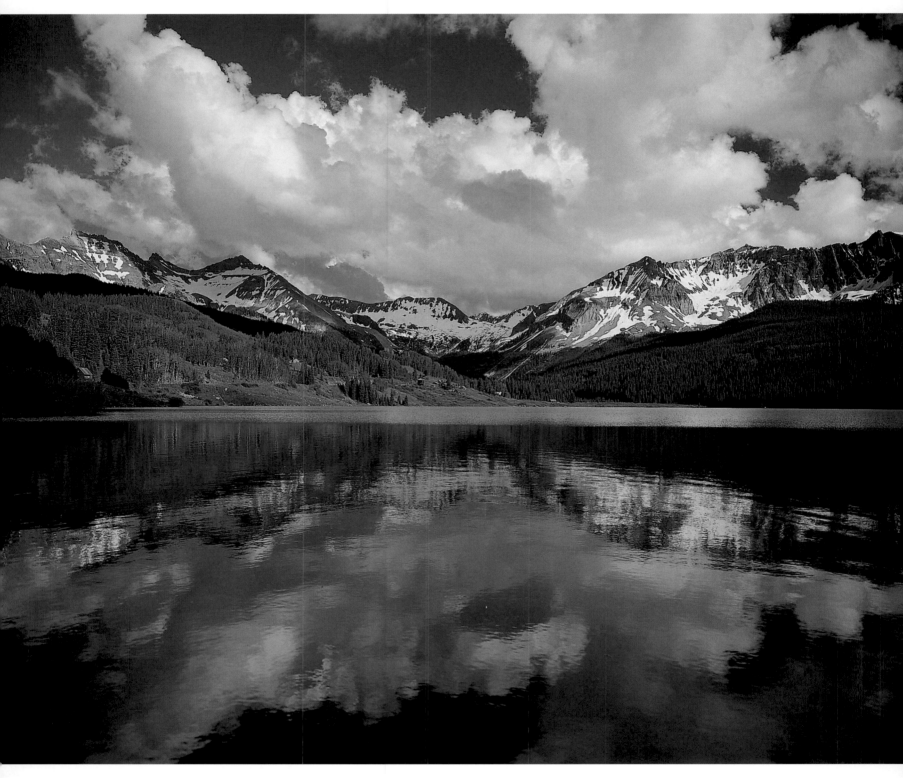

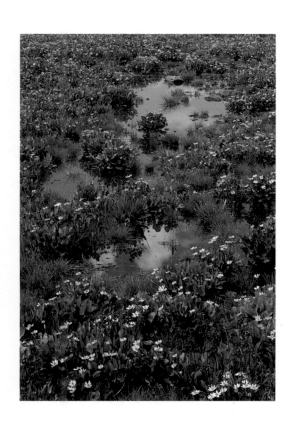

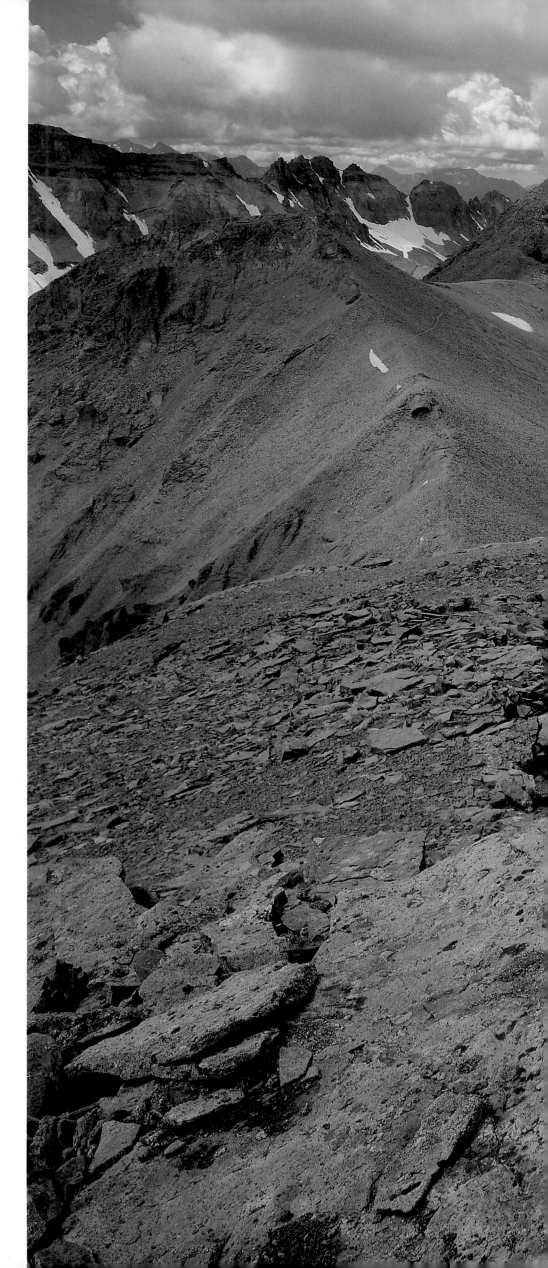

△ A RECEDING SNOWBANK

NOURISHES A MIX OF MARSH

MARIGOLD AND PARRYS

PRIMROSE IN COLORADO'S

LA PLATA MOUNTAINS.

▷ MOUNT SNEFFELS (14,150 FEET)

BOLDLY DRAMATIZES

THE TOP OF THE SAN JUAN

MOUNTAINS IN VIEW ALONG

THE CREST OF COLORADO'S

MOUNT SNEFFELS WILDERNESS.

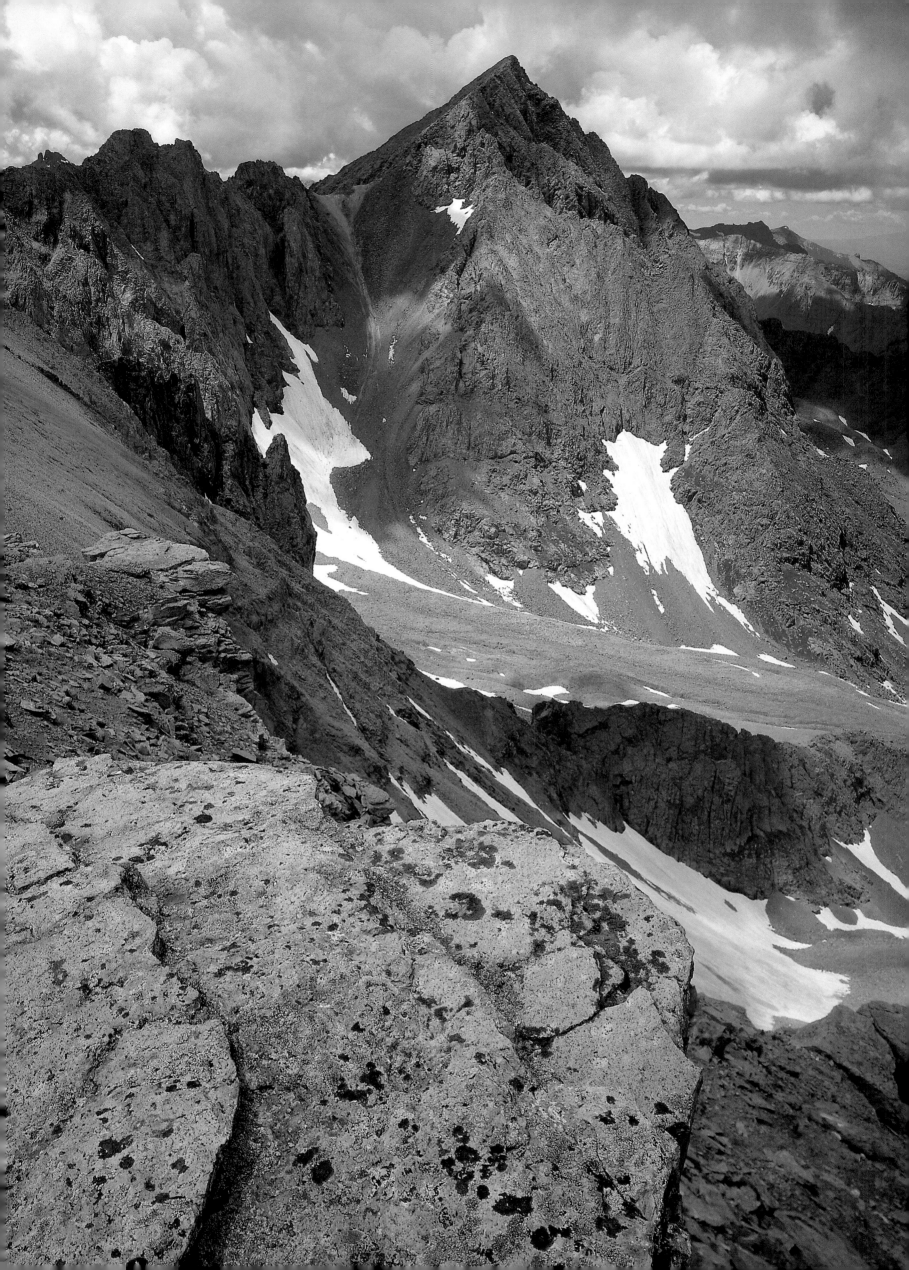

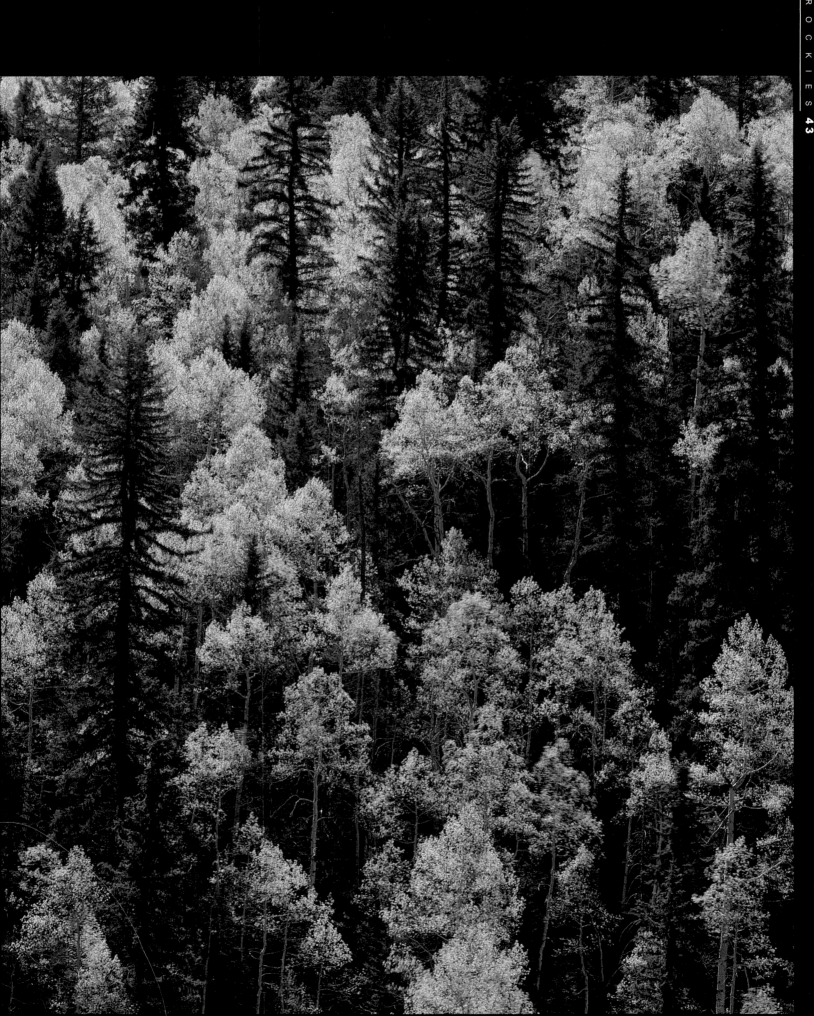

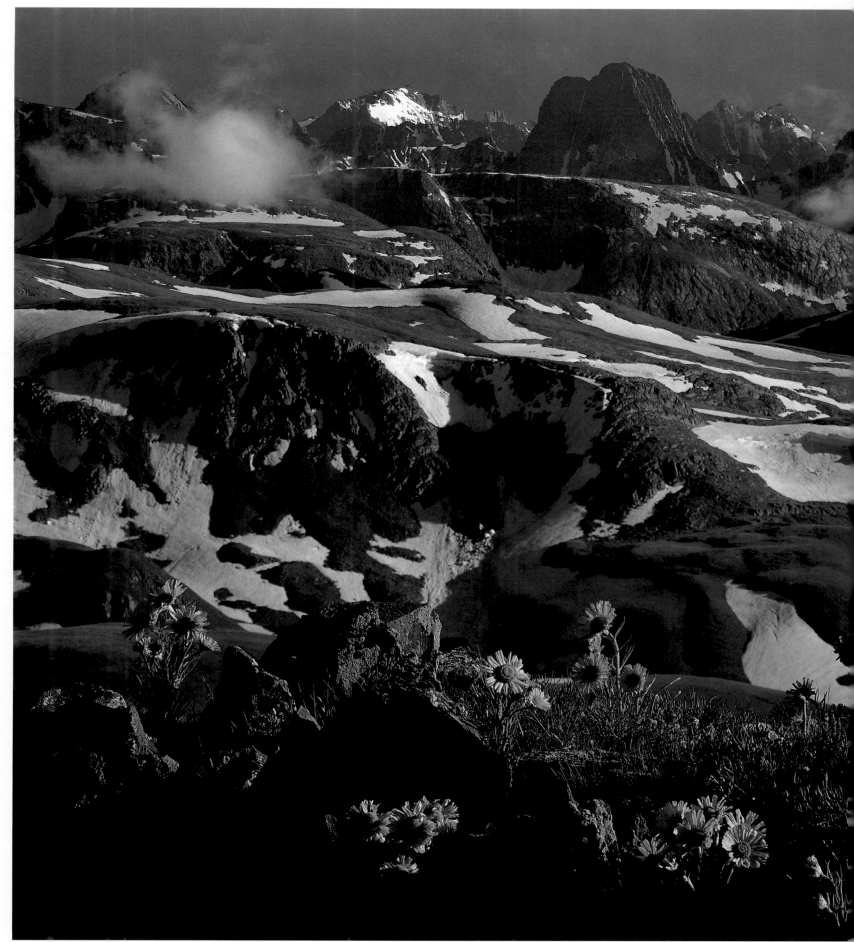

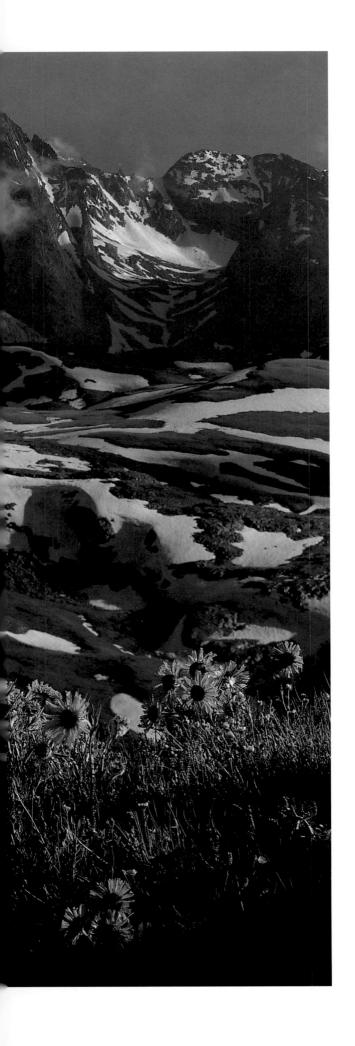

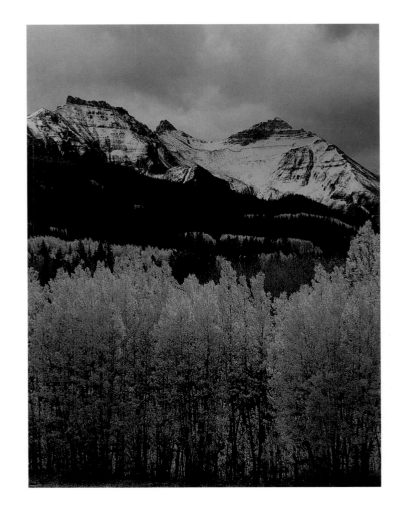

◁ ◁ ◁ ASPEN LEAF OUT IN MAY IN

COLORADO'S SAN MIGUEL MOUNTAINS.

◁ ◁ LATER IN SPRING, MATURE

ASPEN STAND WITH GIANT CONIFERS

IN COLORADO'S DALLAS DIVIDE.

◁ THE NEEDLE MOUNTAINS RISE

ABOVE ALPINE SUNFLOWERS ON

COLORADO'S CONTINENTAL DIVIDE.

△ ASPEN SHOW FINAL COLOR BEFORE

WINTER AT TWELVE THOUSAND FEET IN

COLORADO'S SAN JUAN MOUNTAINS.

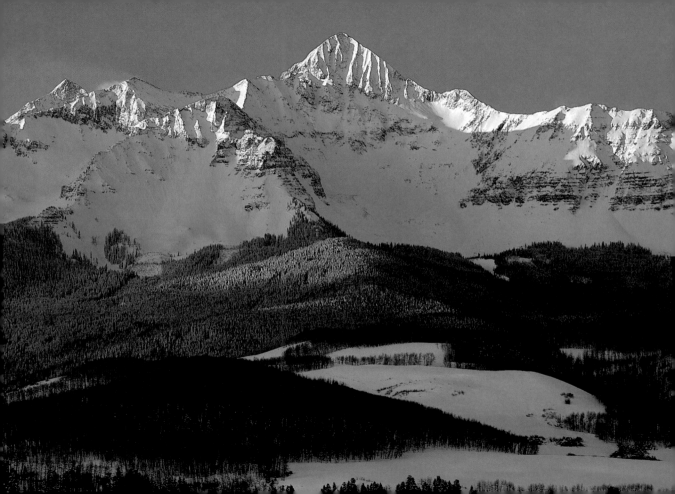

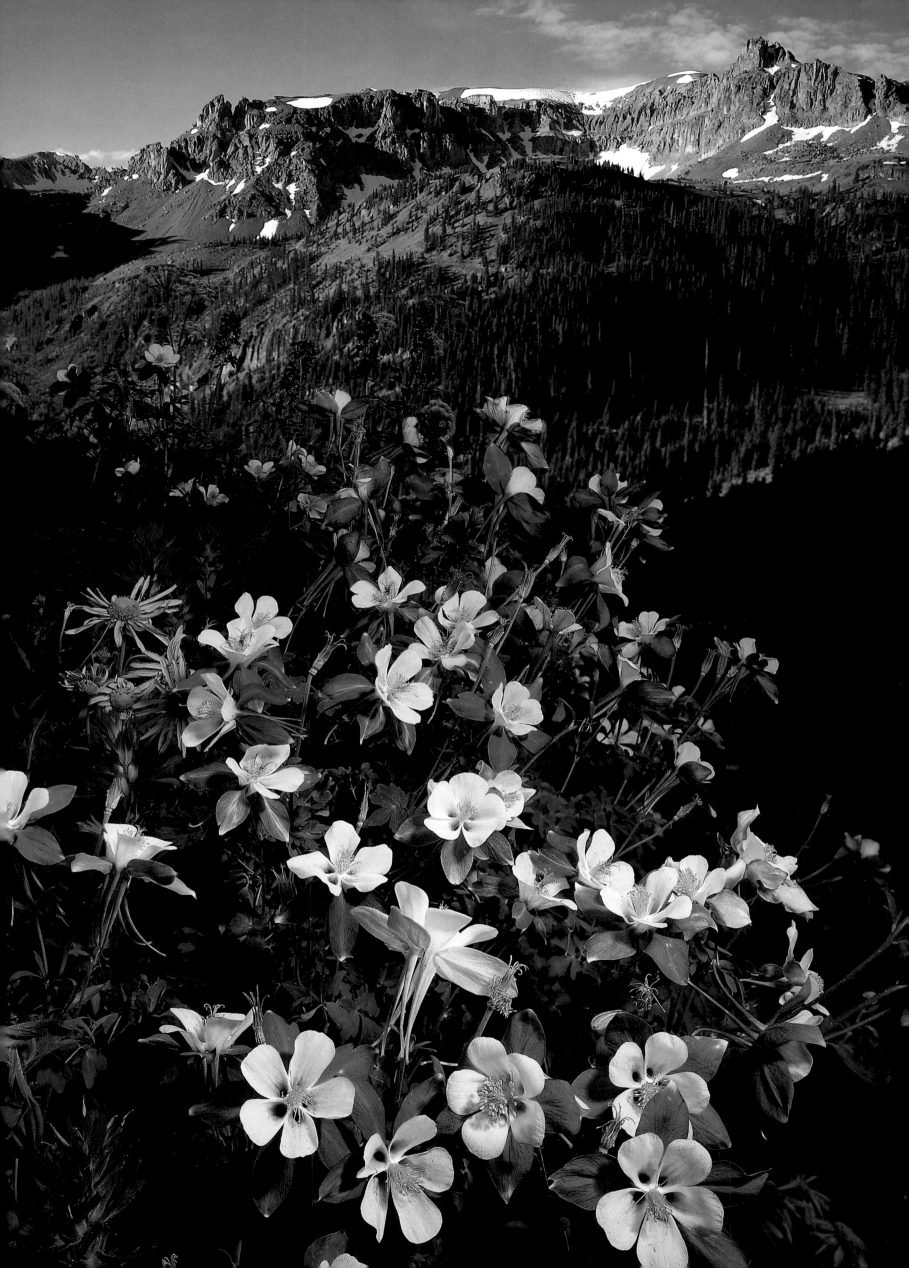

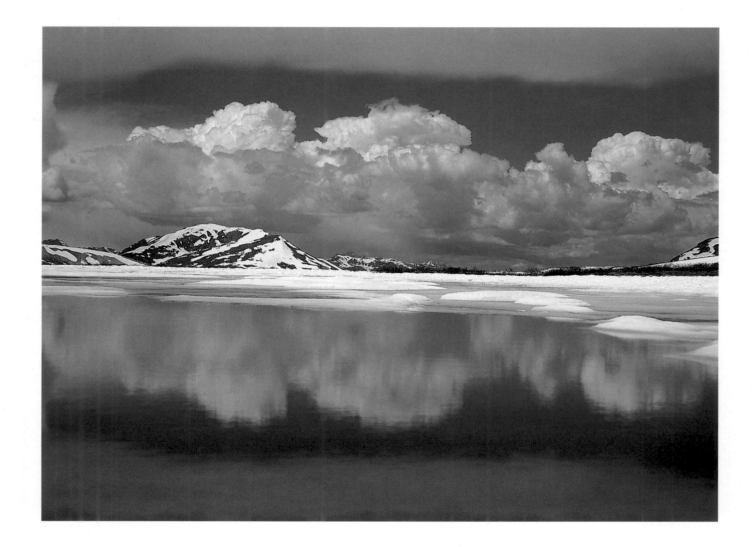

△ TWELVE-THOUSAND-FOOT

INDEPENDENCE PASS TAKES A WHILE

TO THAW OUT. THE PAVED ROAD—

BUILT TO CONNECT ASPEN,

COLORADO, TO THE EAST—ONLY

OPENS A FEW MONTHS EACH YEAR.

▷ SNOW-FLOCKED PINES STAND

HIGH IN THE ROUTT NATIONAL

FOREST AFTER A BLIZZARD. THIS

PART OF THE COLORADO ROCKIES

IS JUST ENOUGH NORTH TO

GET SOME OF THE EFFECTS OF

COLDER ARCTIC STORMS.

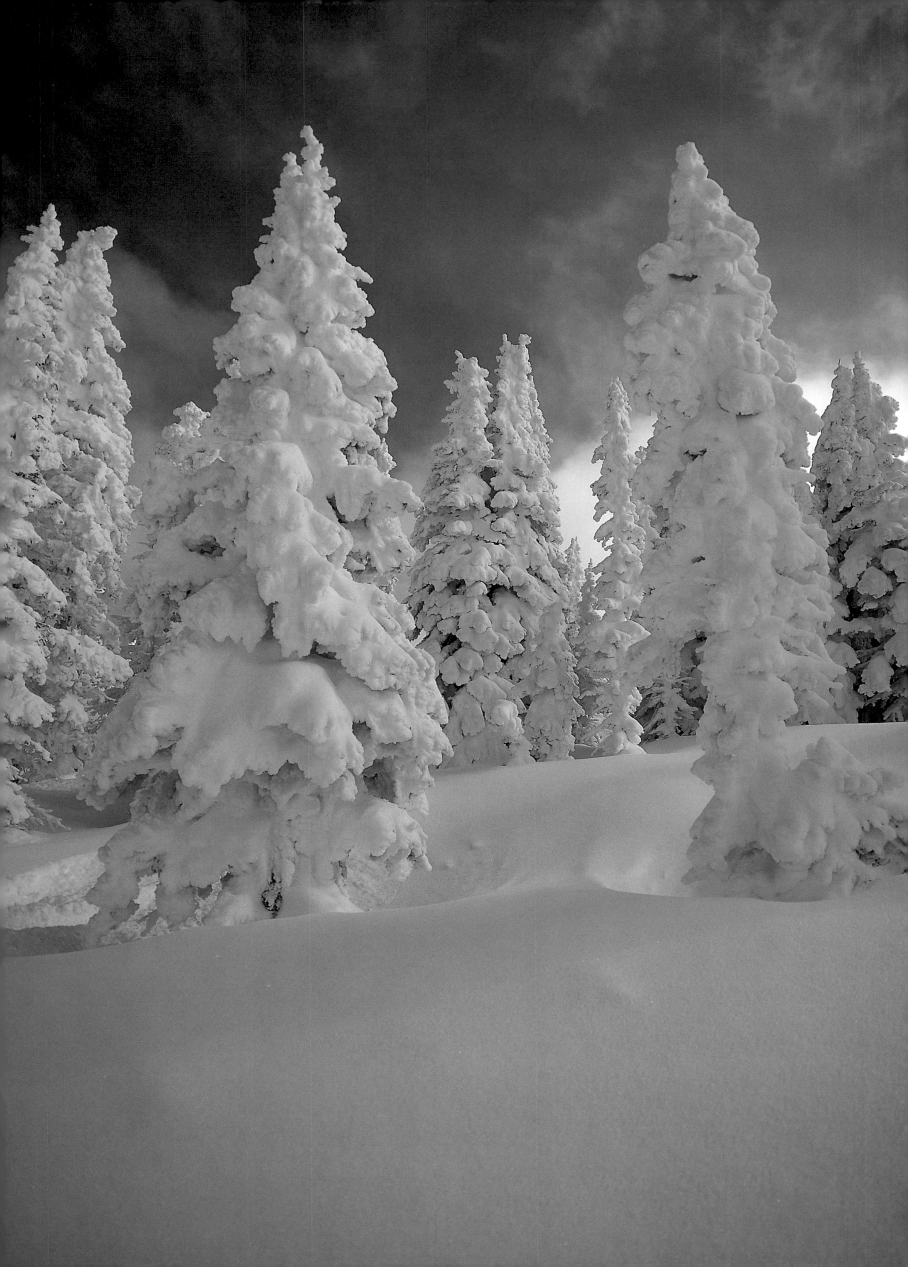

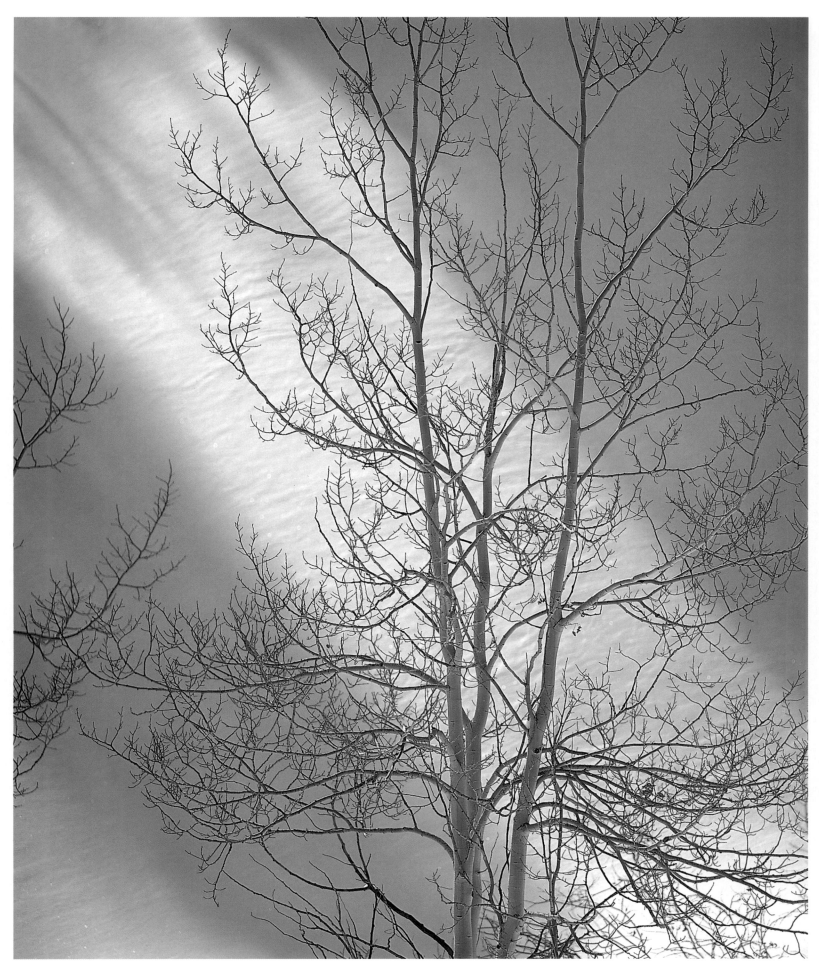

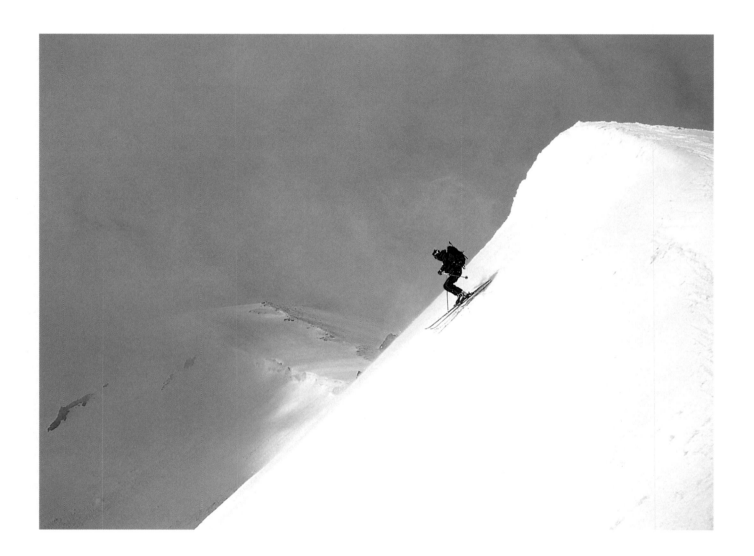

◁ JANUARY CAN BE MISERABLE IN

COLORADO'S GORE RANGE DUE TO

WIND, SNOW, AND ICE. THERE ARE

ALSO TRANQUIL MOMENTS, LIKE

THIS, WHEN THE WIND STOPS AND

THE LIGHT FILTERS DOWN THROUGH

THE LEAFLESS ASPEN TREES.

△ A LOCAL OUTDOOR ENTHUSIAST

SKIS ONE OF HIS MANY FAVORITE

LINES IN THE BACKCOUNTRY OFF

VAIL PASS, COLORADO.

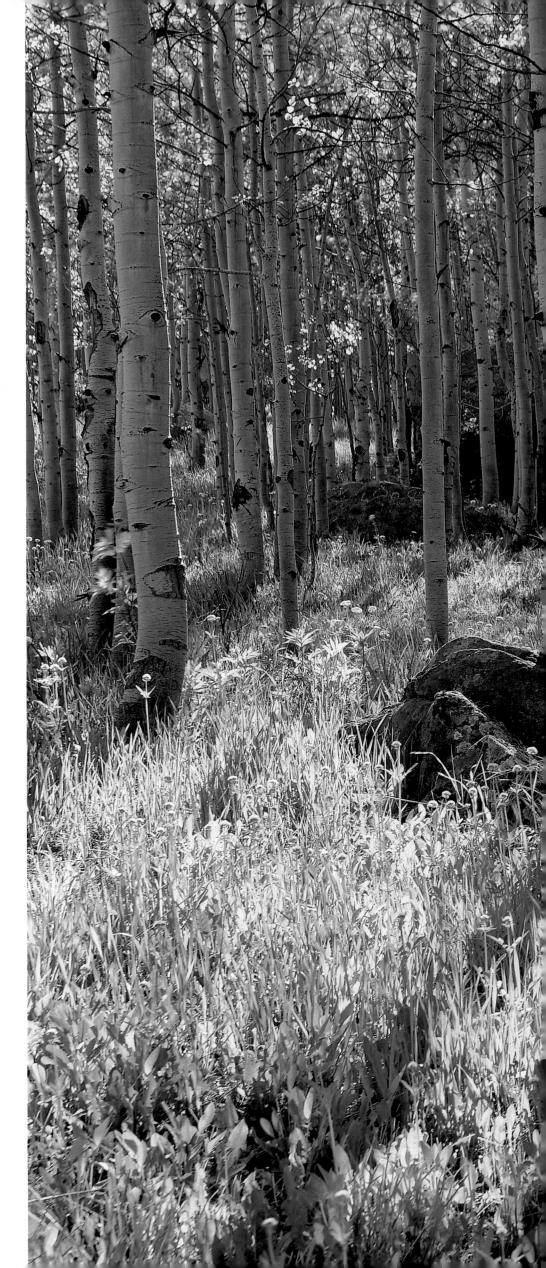

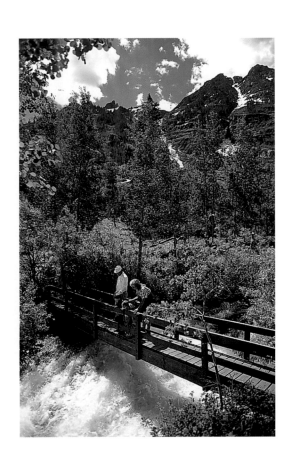

△ THE MAROON CANYON OF

COLORADO PROVIDES A GREAT

LOCATION TO EXPERIENCE

SEASONAL CHANGES WITH

THE GRANDCHILDREN.

▷ A GROVE OF ASPEN THAT

SURVIVED WINTER'S AVALANCHES

IN COLORADO'S MAROON CANYON

SHOWS FULL SPRING COLOR.

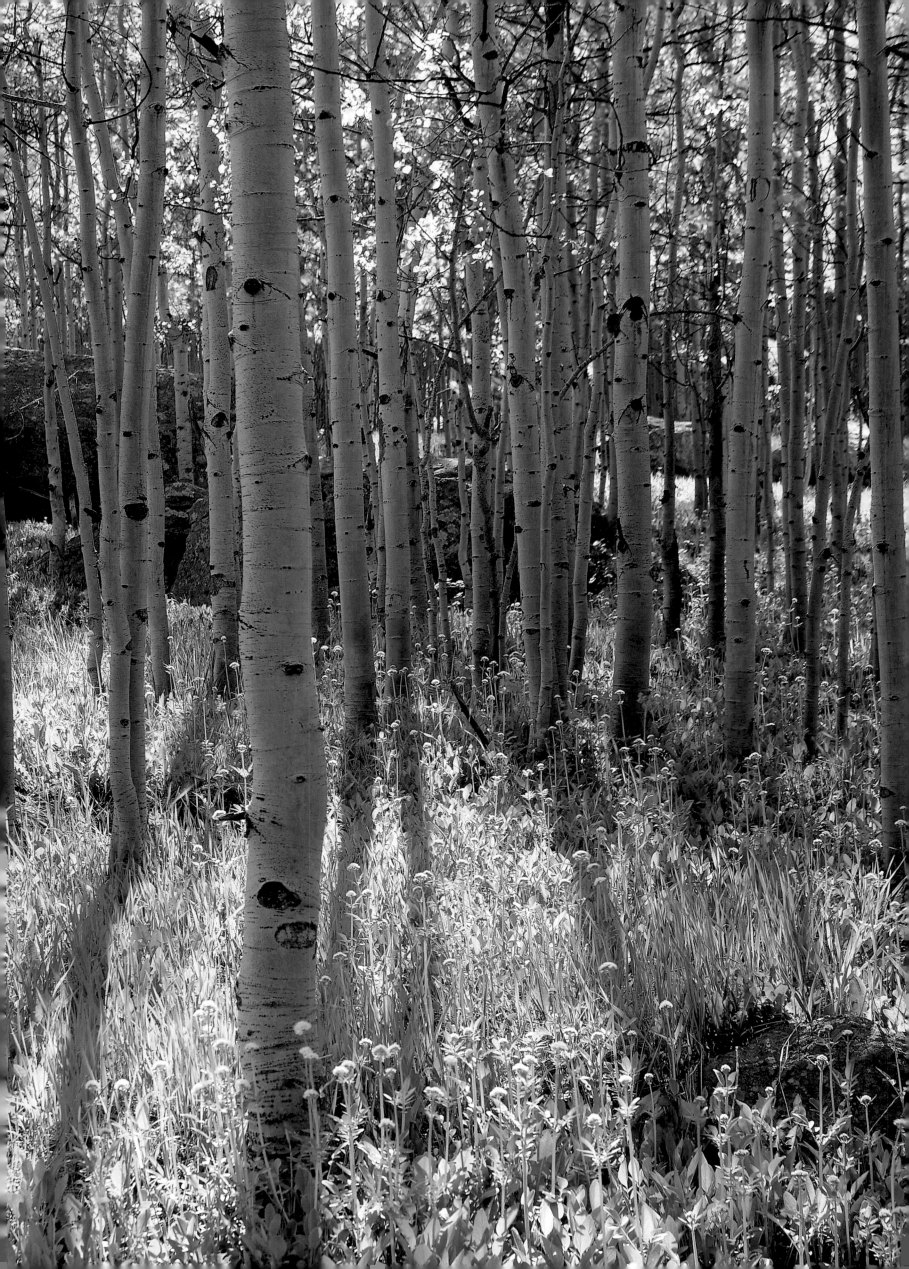

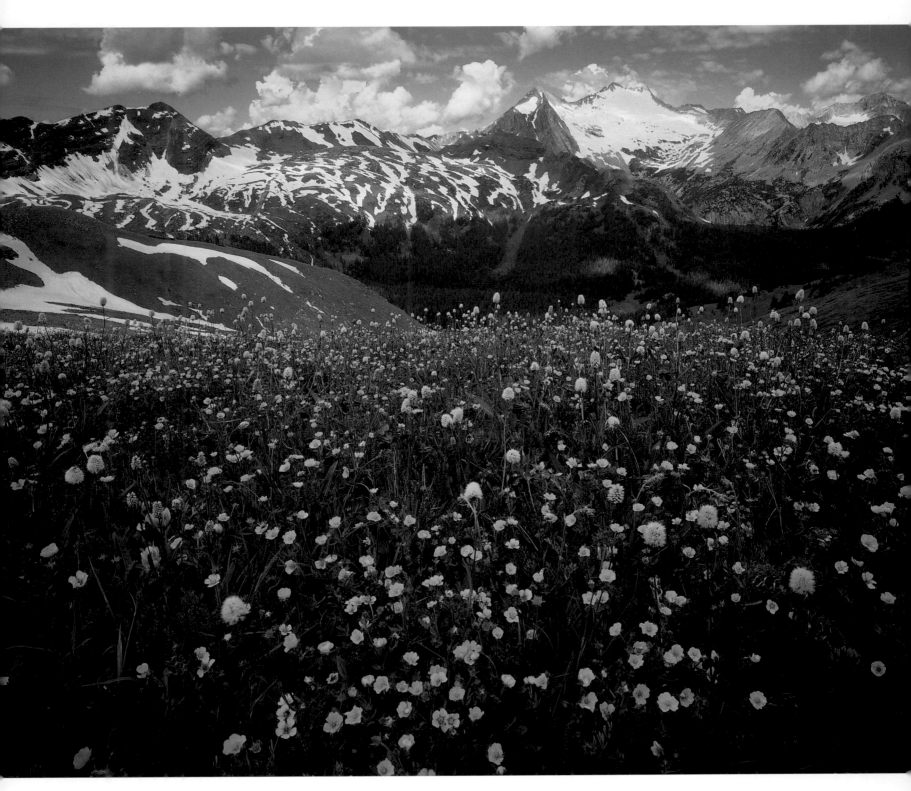

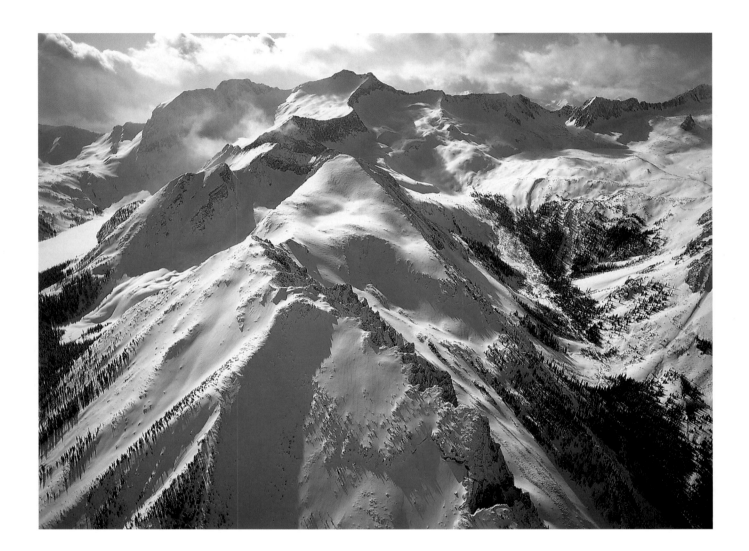

◁ ALONG BUCKSKIN PASS TRAIL,

ALPINE AVENS, AMERICAN BISTORT,

AND OTHER ALPINE FLOWERS

ENGAGE THE EYE IN VIEW OF

SNOWMASS MOUNTAIN (14,092 FEET)

AND CAPITOL PEAK (14,130 FEET)

OF COLORADO'S MAROON

BELLS / SNOWMASS WILDERNESS.

△ COLORADO'S FOURTEEN-

THOUSAND-FOOT SNOWMASS

MOUNTAIN LIVES UP TO ITS NAME IN

WINTER. SNOW LASTS THROUGH

SUMMER MOST YEARS, COVERING

LARGE CIRQUES NEAR THE SUMMIT.

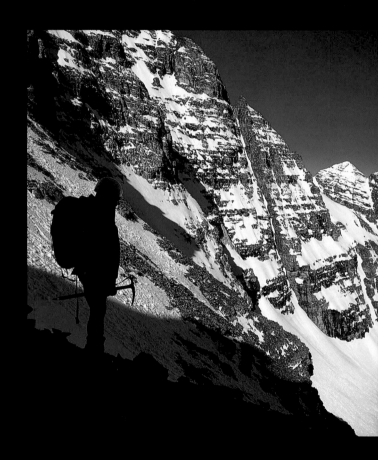

◁ DAWN APPROACHES 14,104-FOOT

NORTH MAROON PEAK

AND 14,156-FOOT MAROON

PEAK WITH A MAY MOONSET

IN MAROON BELLS / SNOWMASS

WILDERNESS, COLORADO.

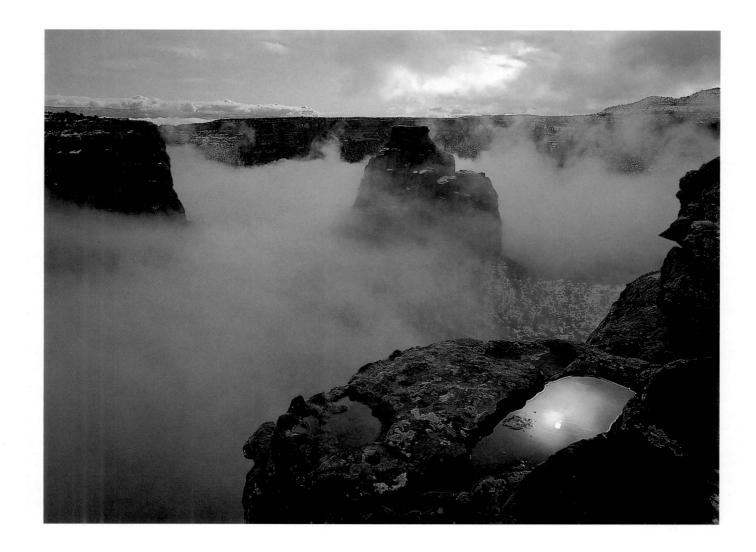

△ THE SANDSTONE OF

COLORADO NATIONAL MONUMENT

CONTRASTS THE GEOLOGY OF THE

ROCKY MOUNTAINS. SOMETIMES

THE WEATHER HERE CAN BE

THE SAME AS ON THE FOURTEEN-

THOUSAND-FOOT SUMMITS.

▷ DARK, SOMBER SCHIST AND

GNEISS WALLS FRAME THE

GUNNISON RIVER EIGHTEEN

HUNDRED FEET BELOW THE SOUTH

RIM IN BLACK CANYON

OF THE GUNNISON NATIONAL

MONUMENT, COLORADO.

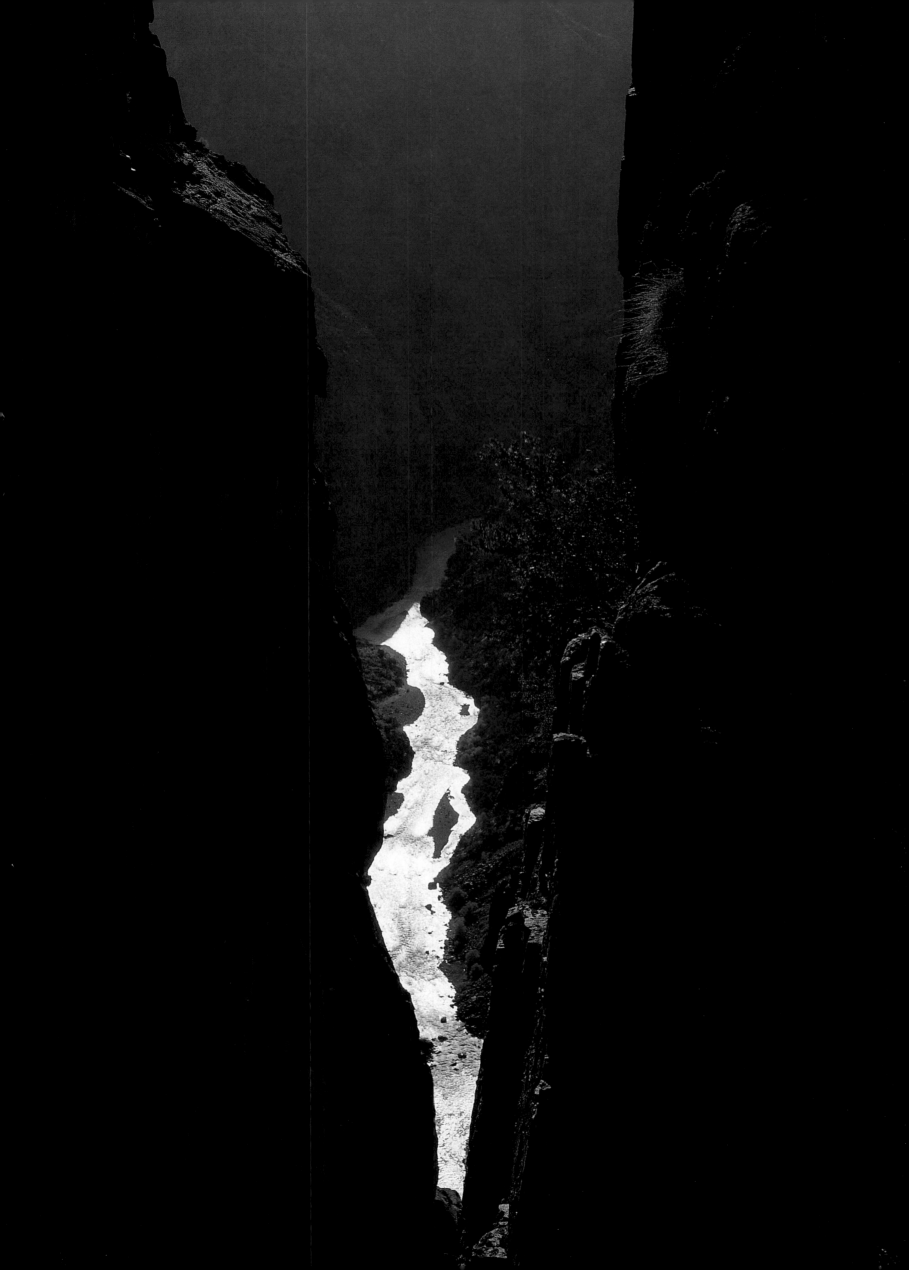

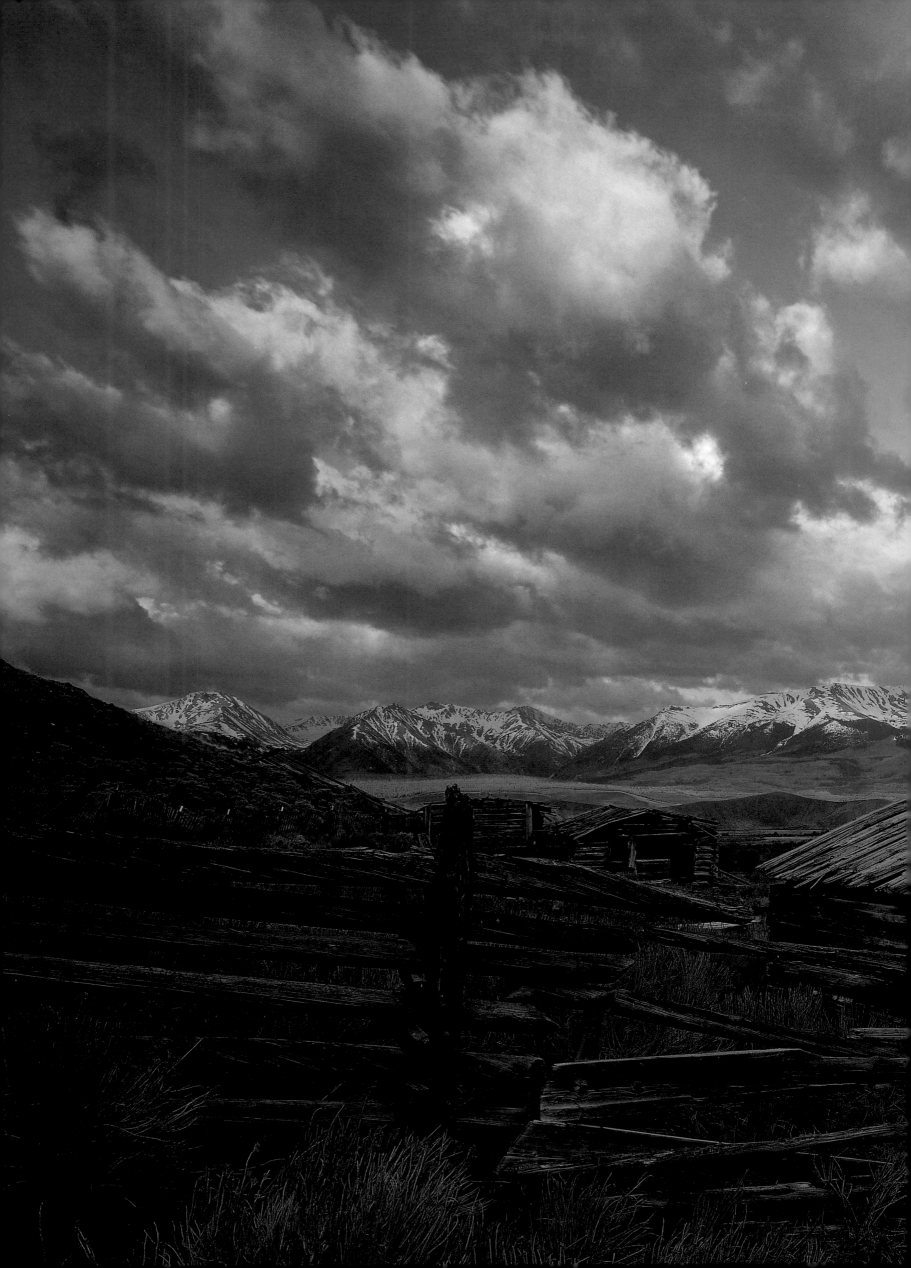

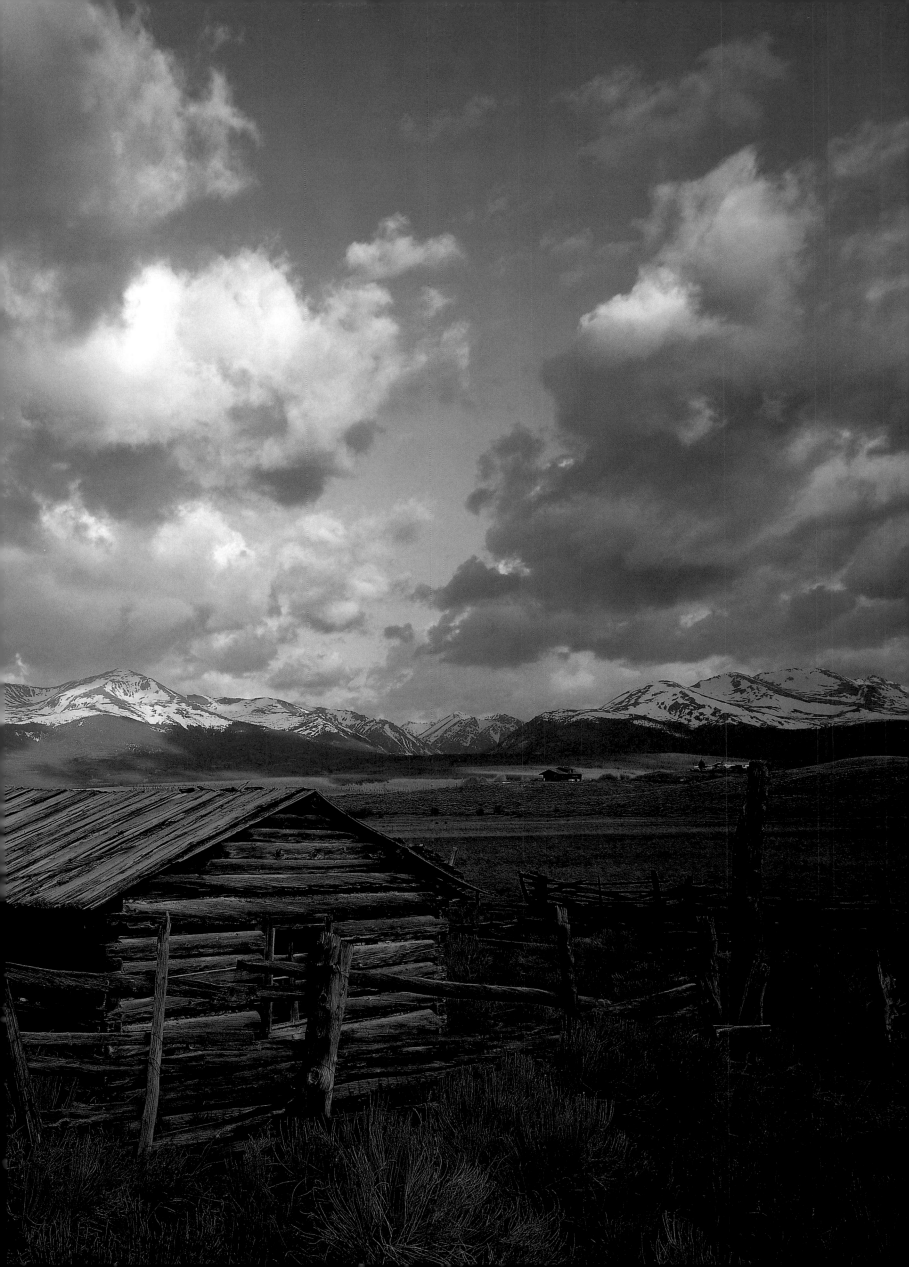

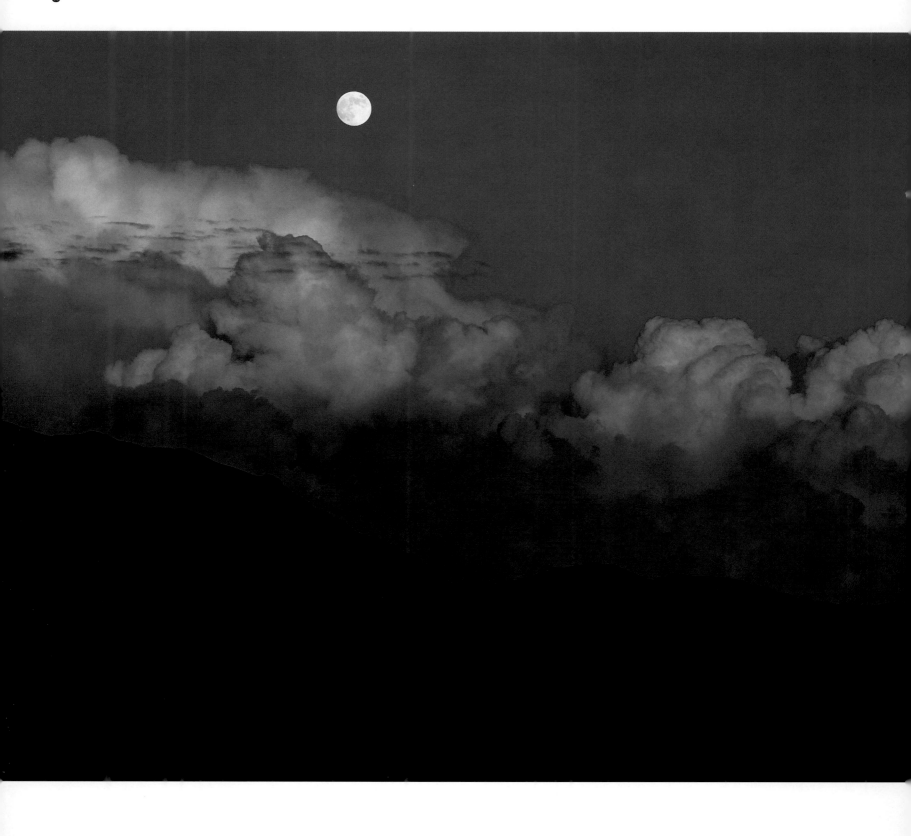

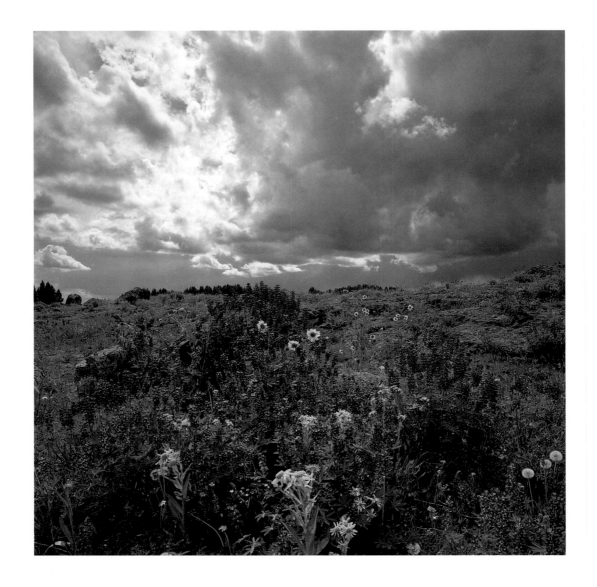

◁ ◁ A RAMBLING HISTORIC FENCE

AND BUILDINGS DEFY HARSH

ELEMENTS BEFORE COLORADO'S

HIGHEST—MOUNT ELBERT (14,433

FEET) AND MOUNT MASSIVE

(14,421 FEET), SAWATCH RANGE.

◁ A FULL MOON RISES OVER

AFTERNOON CUMULUS CLOUDS, AS

SEEN FROM INDEPENDENCE PASS.

△ SUMMER CUMULUS CLOUDS BUILD

OVER ALPINE FLOWERS SPREAD HIGH

ON GRAND MESA, COLORADO.

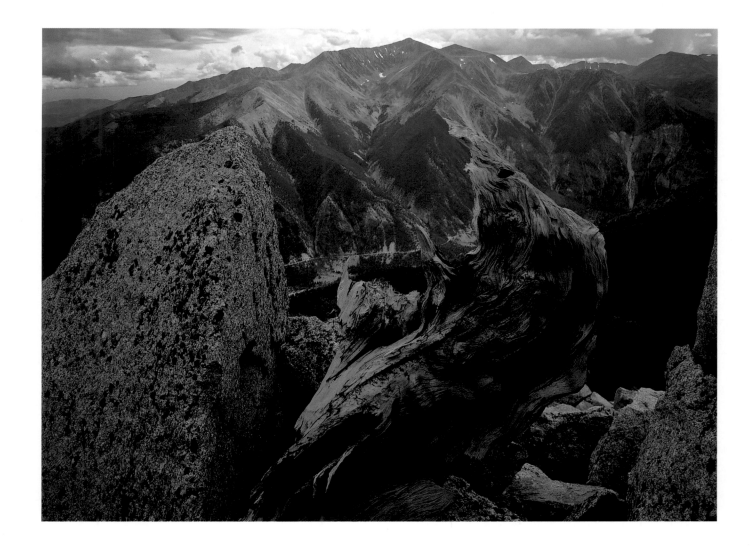

△ AN ANCIENT BRISTLECONE PINE

HOLDS TENACIOUSLY TO A

ROCK-STREWN ENVIRONMENT AT

THE EDGE OF LIFE ON 14,197-FOOT

MOUNT PRINCETON, WITH

14,269-FOOT MOUNT ANTERO

DOWNRANGE IN COLORADO.

▷ AN IRON RESIDUE LINES

A SPLATTER POOL ON GRANITE

BEFORE A CASCADE ON

THE ROARING FORK RIVER IN THE

COLLEGIATE PEAKS

WILDERNESS OF COLORADO.

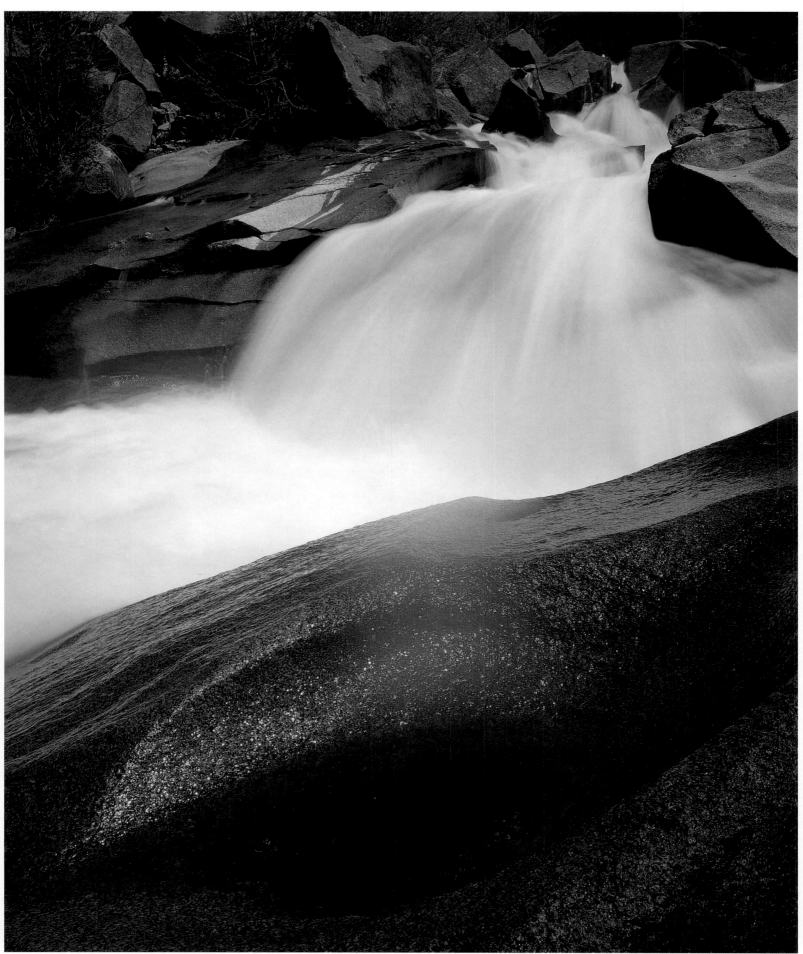

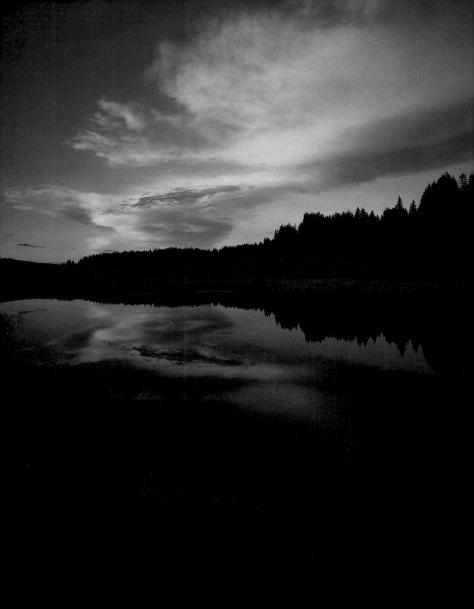

△ AN IMAGE IS REFLECTED IN

ONE OF THE NUMEROUS PONDS

DOTTING COLORADO'S TEN-

THOUSAND-FOOT ALPINE LANDSCAPE

NAMED GRAND MESA.

▷ THE ROARING FORK RIVER HAS

CARVED THESE CONVOLUTED FORMS

IN A GRANITE PLACE CALLED ICE

CAVES, NEAR ASPEN, COLORADO.

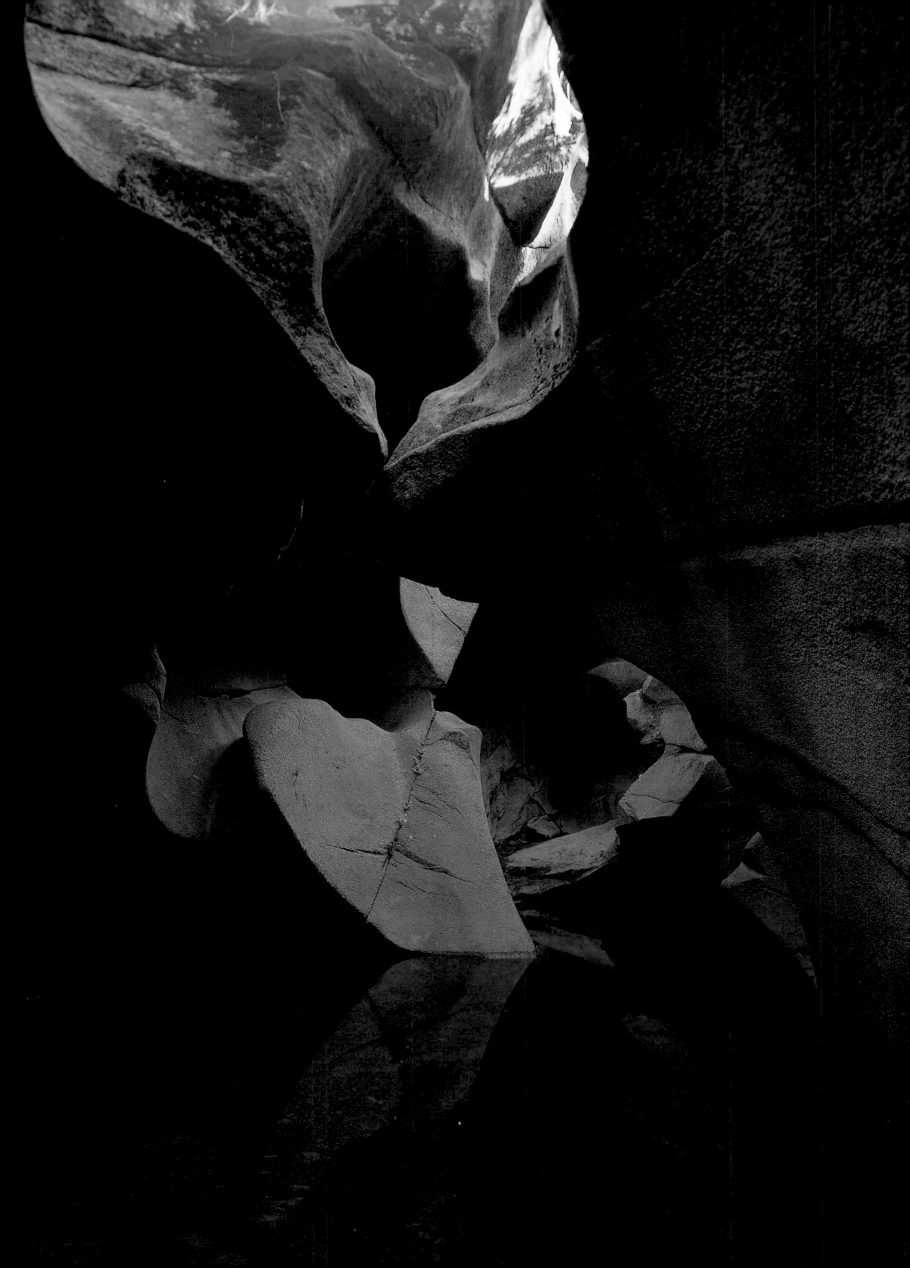

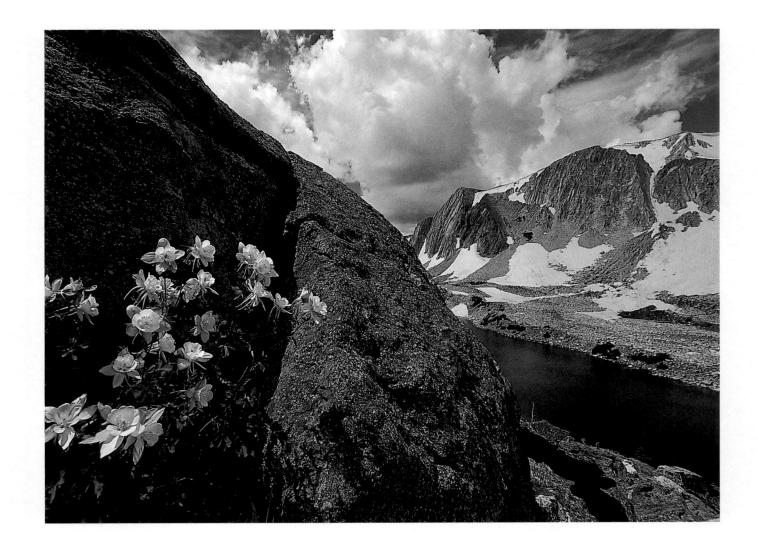

△ A COLUMBINE CLUSTER HOLDS

ON PROTECTIVE GRANITE

WALLS BEFORE MEDICINE BOW

PEAK (12,001 FEET) OF

THE SNOWY RANGE

WEST OF LARAMIE, WYOMING.

▷ A FRAGMENTED ROCK WORLD

PREDOMINATES HIGH ALONG THE

CONTINENTAL DIVIDE AT ROCK CUT.

LONGS PEAK (14,255 FEET)

NOTCHES THE DISTANT SKYLINE

IN COLORADO'S ROCKY

MOUNTAIN NATIONAL PARK.

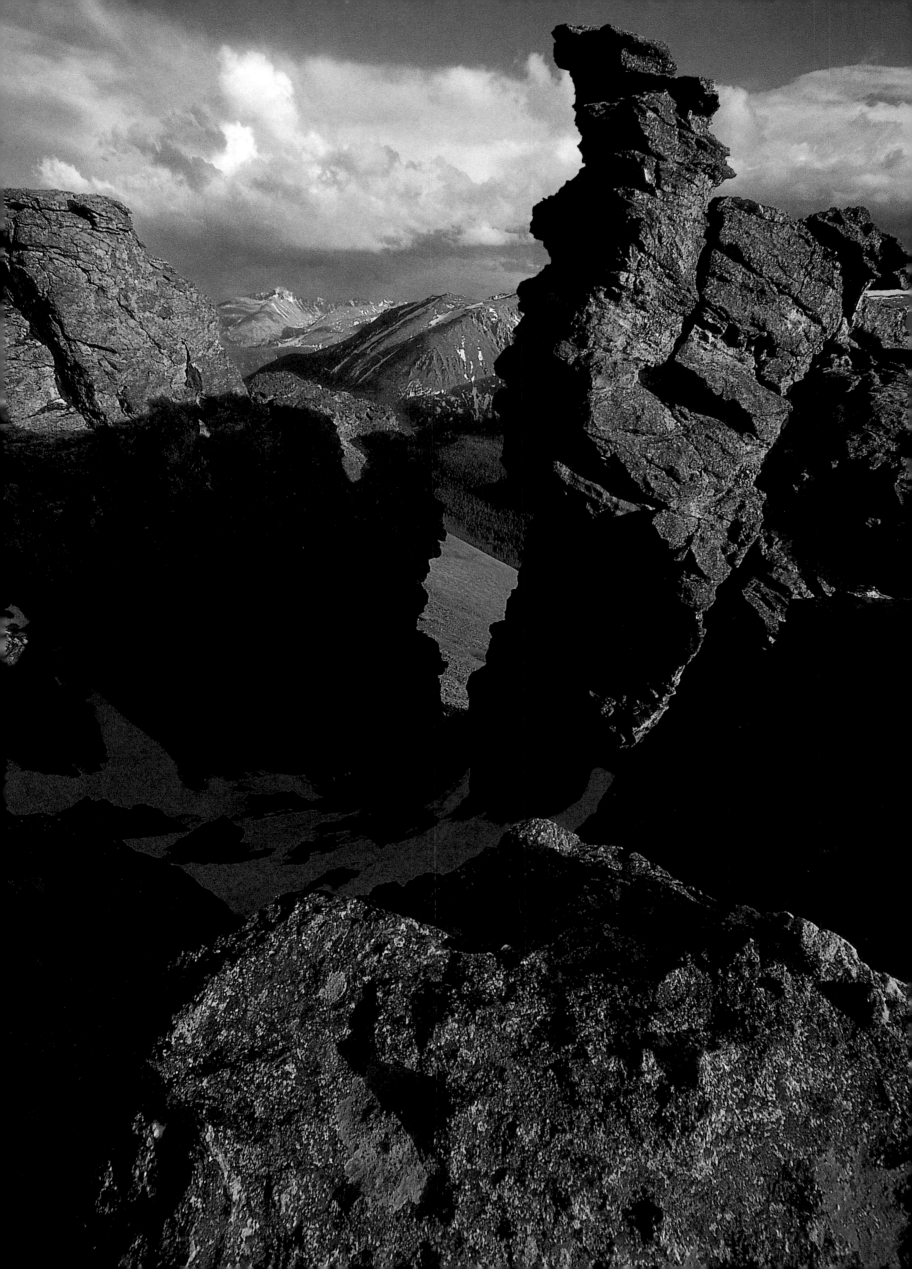

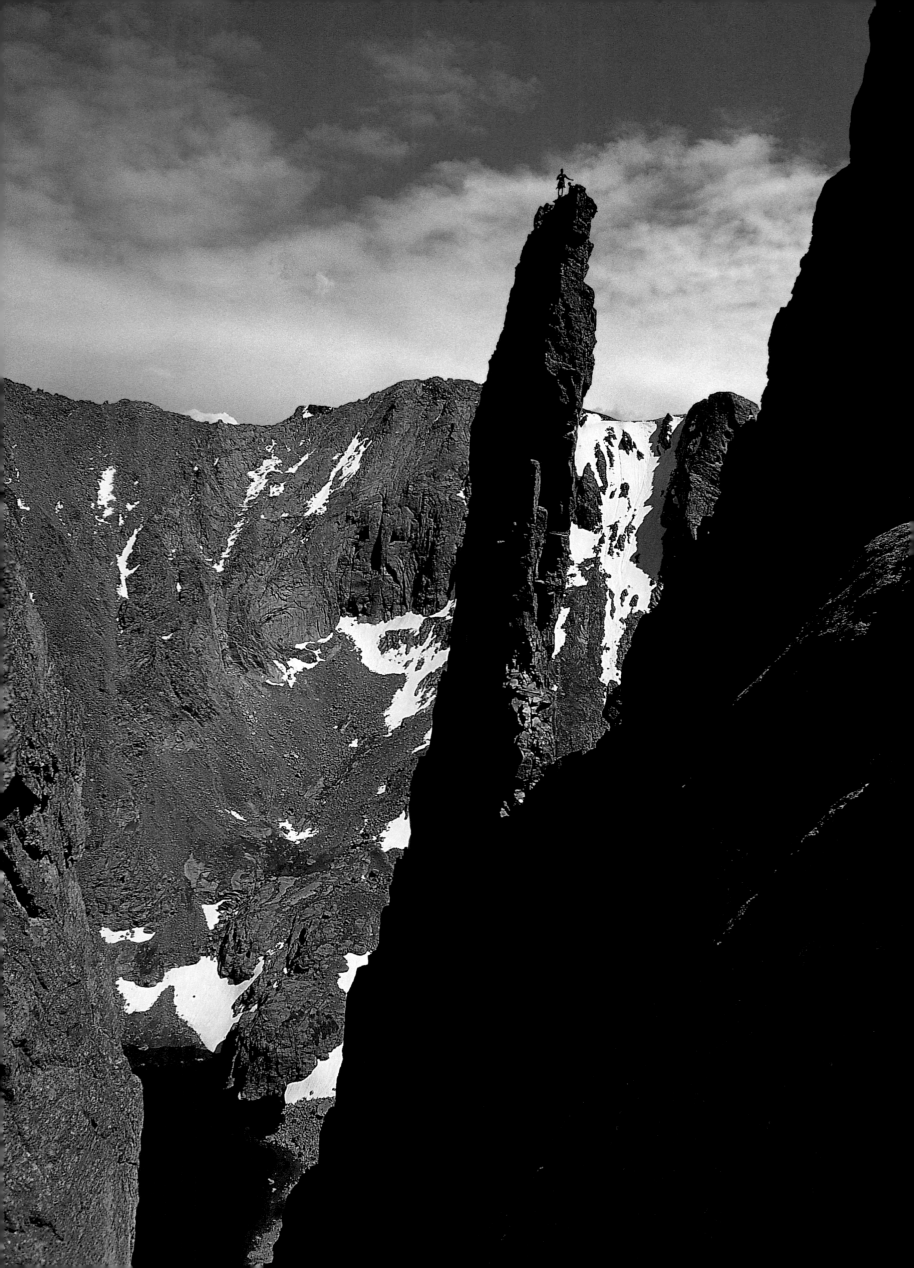

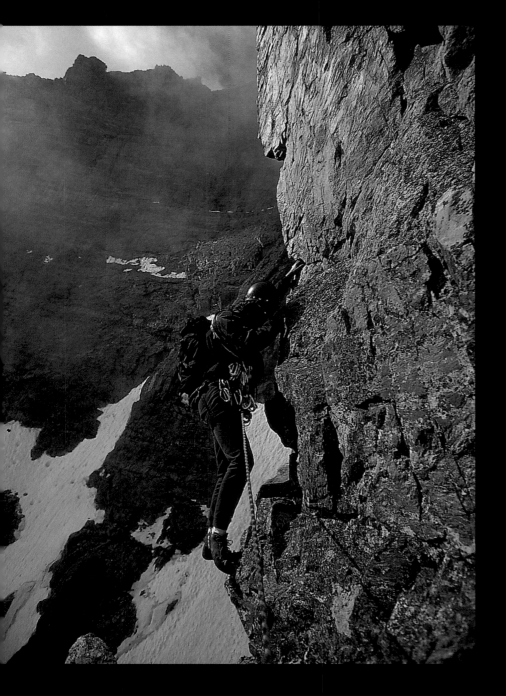

◁ THE "PETIT GREPON" IS ONE OF

MANY CLIMBING DESTINATIONS

IN COLORADO'S ROCKY

MOUNTAIN NATIONAL PARK.

A CLIMBER RESTS ON THE SUMMIT.

△ A CLIMBER SETS HIMSELF

FOR THE NEXT MOVE

ON THE FLYING BUTTRESS OF

COLORADO'S MOUNT MEEKER.

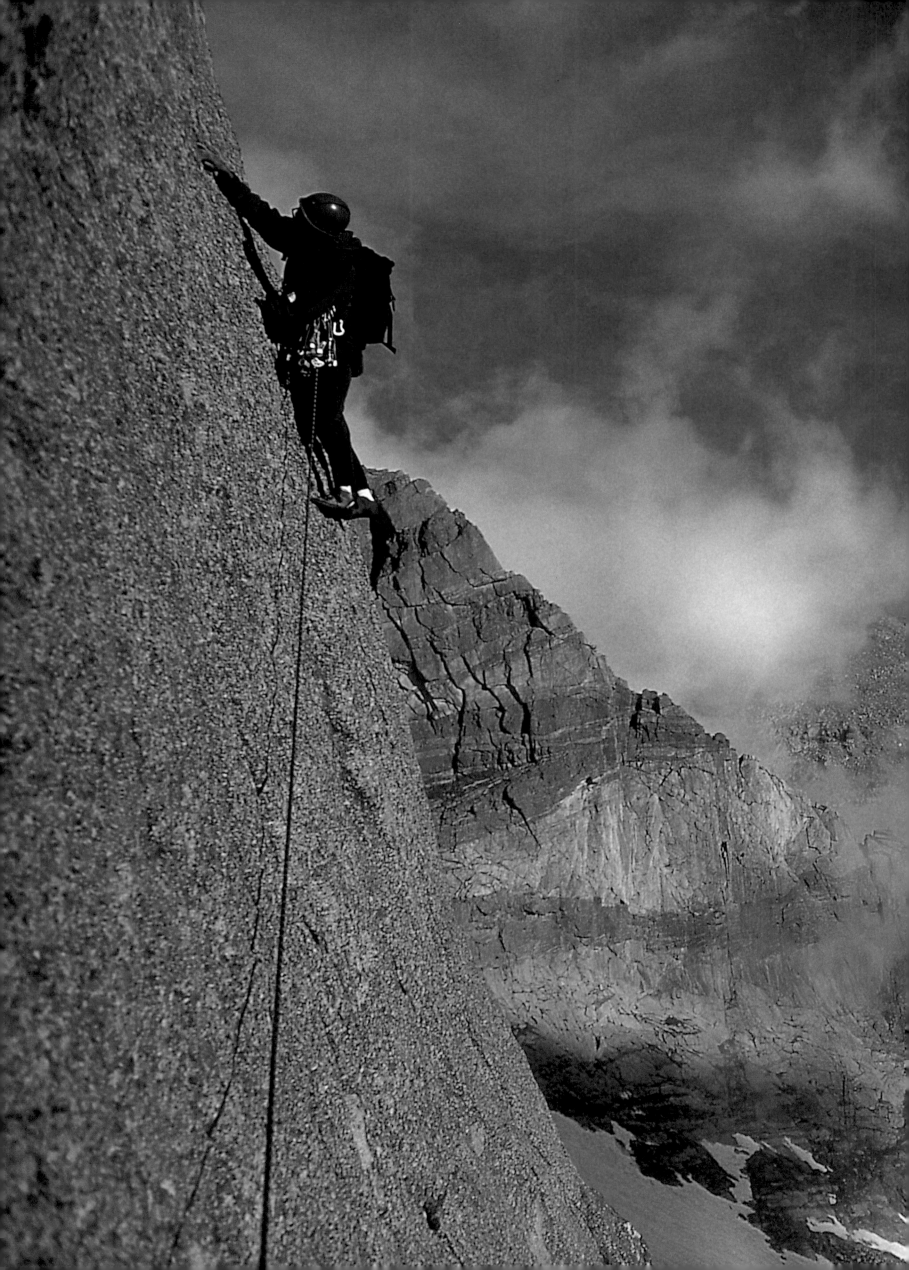

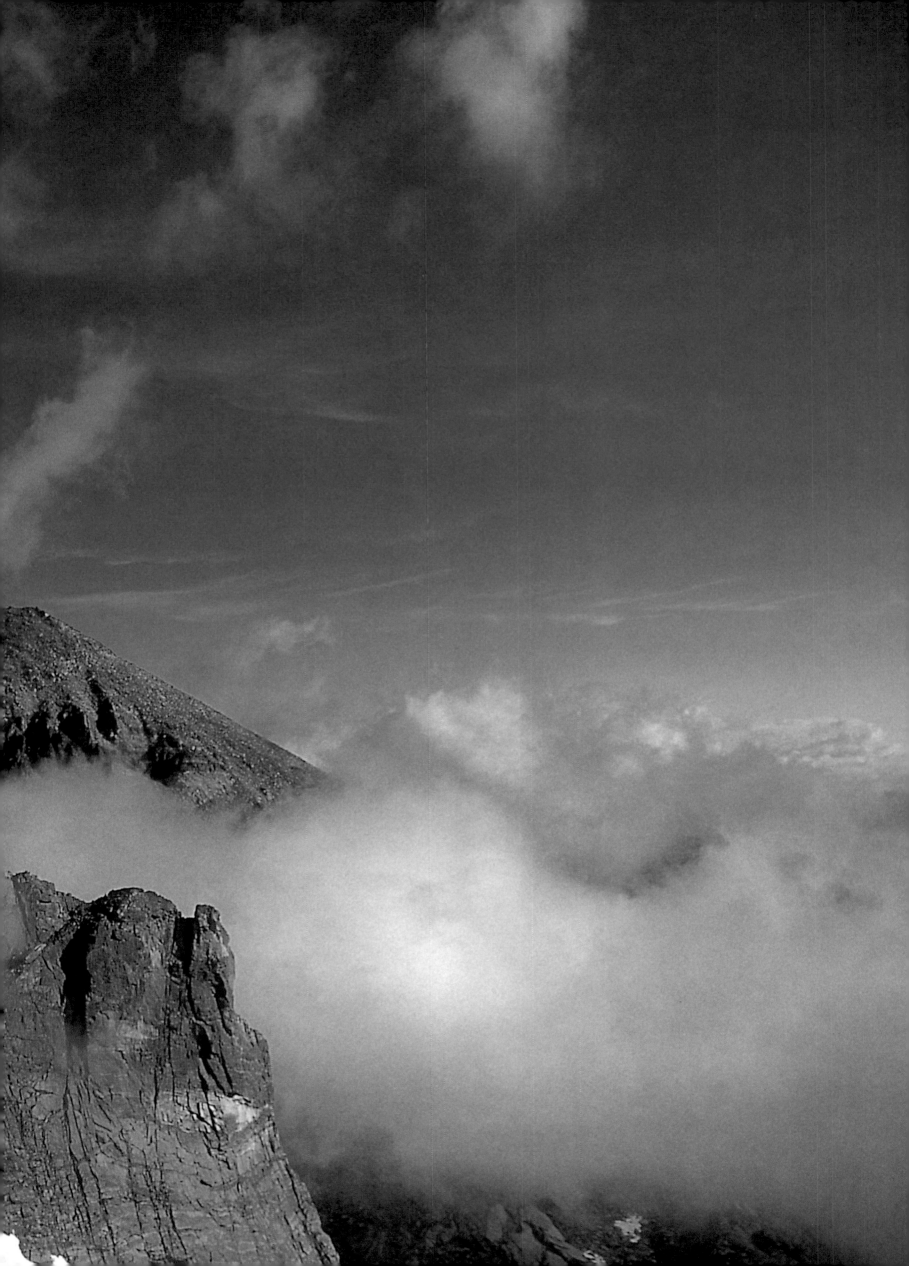

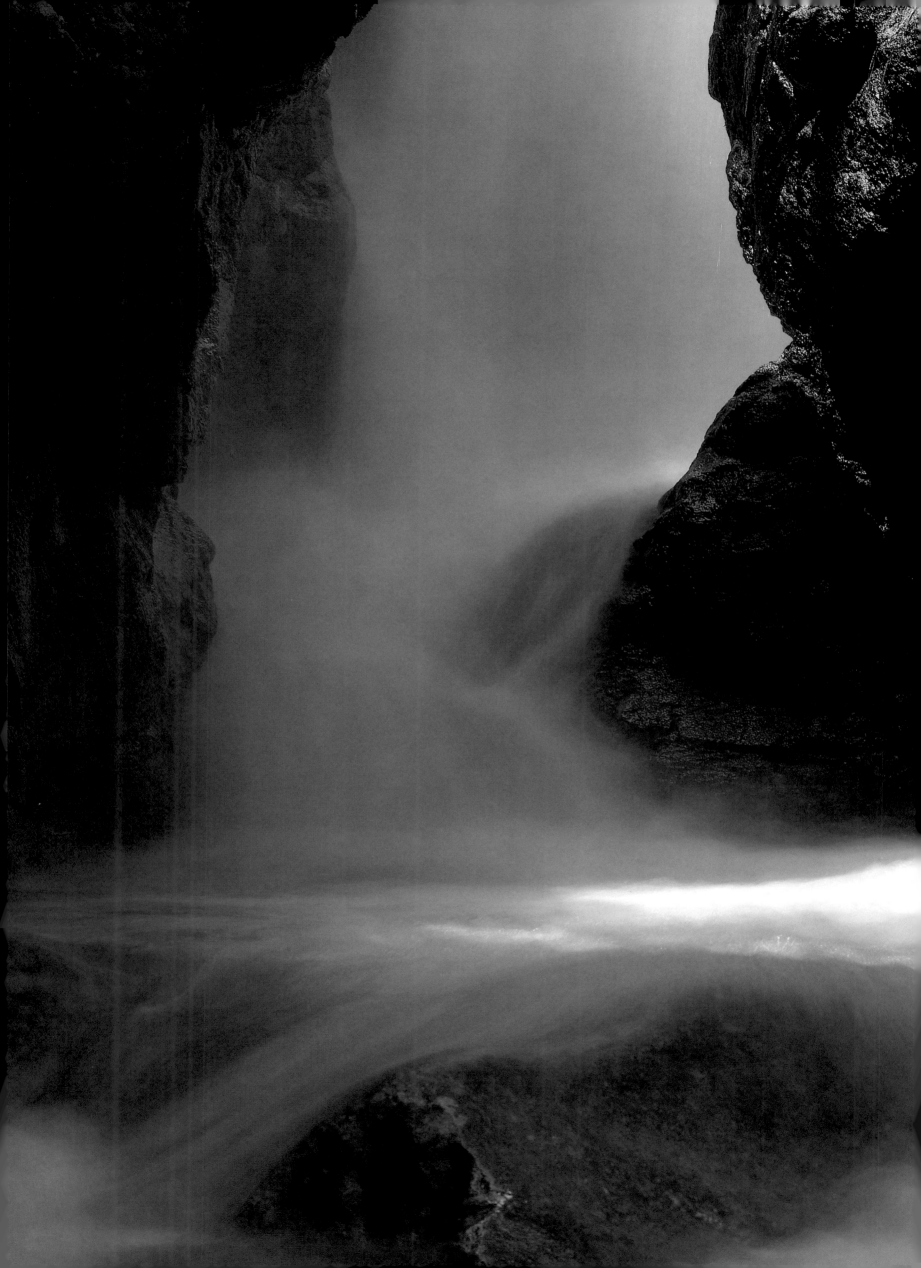

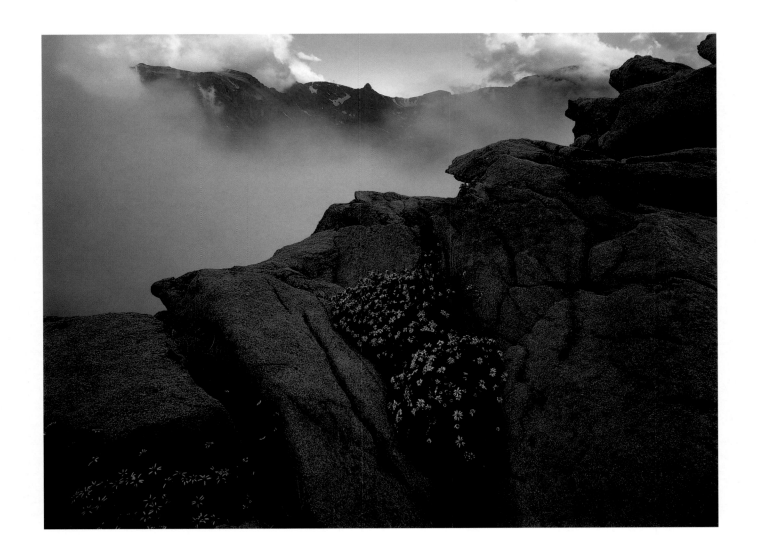

◁ ◁ A CLIMBER PLACES AN

ANCHOR AT 13,000 FEET ON THE

"VARIATIONS ON A THEME" ROUTE

OF MOUNT MEEKER'S FLYING

BUTTRESS IN ROCKY MOUNTAIN

NATIONAL PARK, COLORADO.

◁ SPRING SNOWMELT SPLASHES

DOWN THROUGH THE GRANITE

CHASM FALLS IN COLORADO'S

ROCKY MOUNTAIN NATIONAL PARK.

△ THE CONTINENTAL DIVIDE

EMERGES FROM THE FOG IN BLACK

FOREST CANYON OF ROCKY MOUNTAIN

NATIONAL PARK, COLORADO.

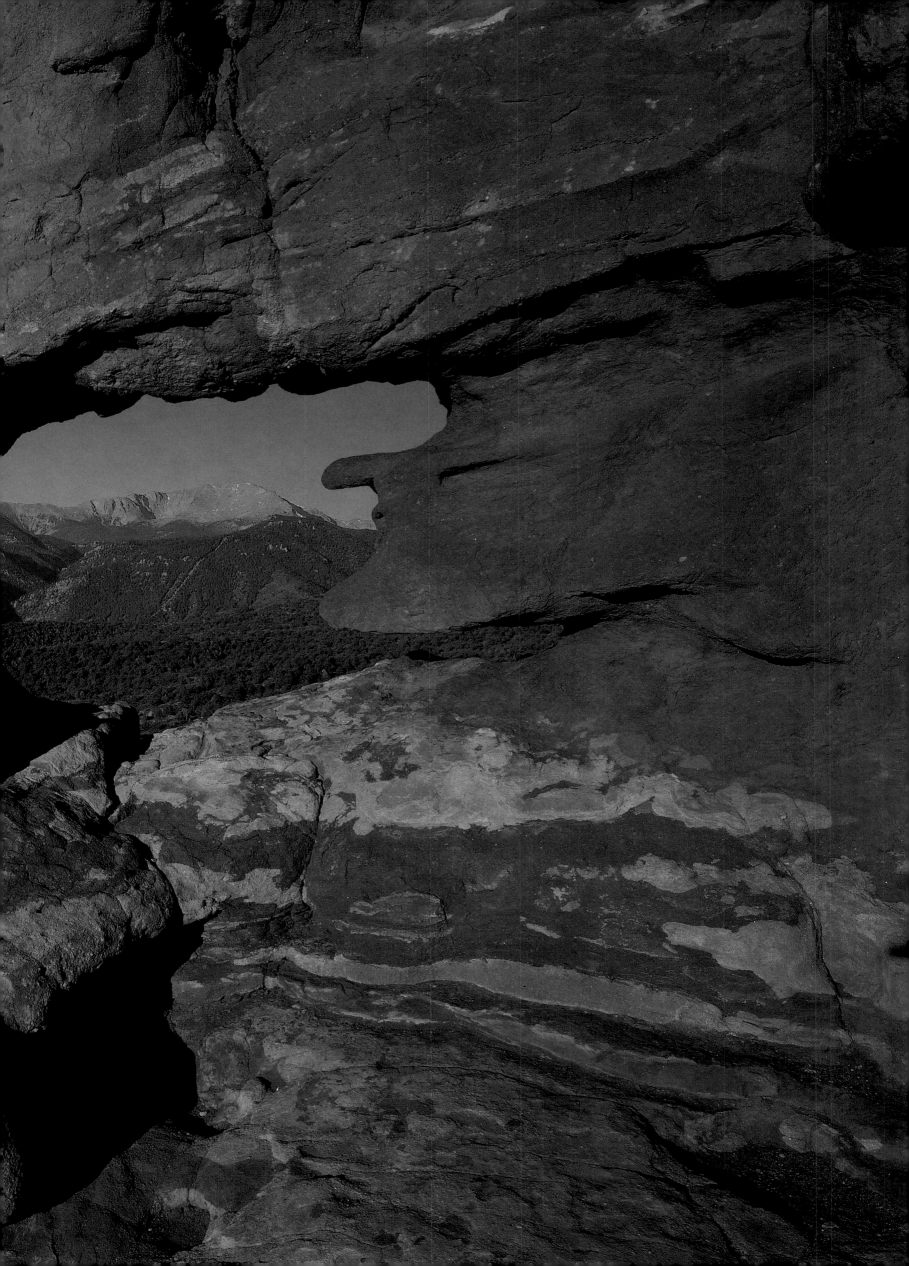

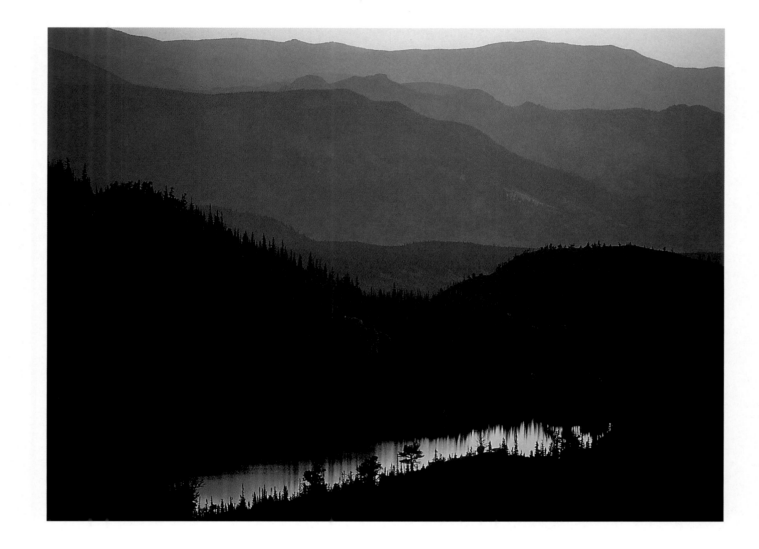

◁ ◁ SANDSTONE AND GRANITE

UNITE IN A VIEW THROUGH TIME.

PIKES PEAK (14,110 FEET) IS

SEEN THROUGH A WINDOW IN THE

GARDEN OF THE GODS, COLORADO.

△ LOCH LAKE REFLECTS DAWN GLOW

OVER MOUNTAIN RIDGES IN THE

NORTHERN PART OF ROCKY MOUNTAIN

NATIONAL PARK, COLORADO.

▷ CAMP CREEK GRACES

THE EASTERN SLOPES OF

PIKES PEAK IN THE

GARDEN OF THE GODS, COLORADO.

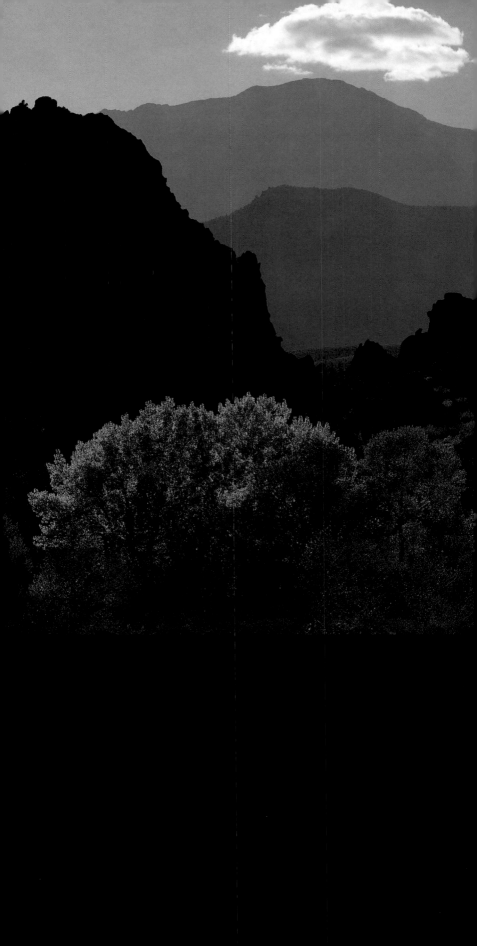

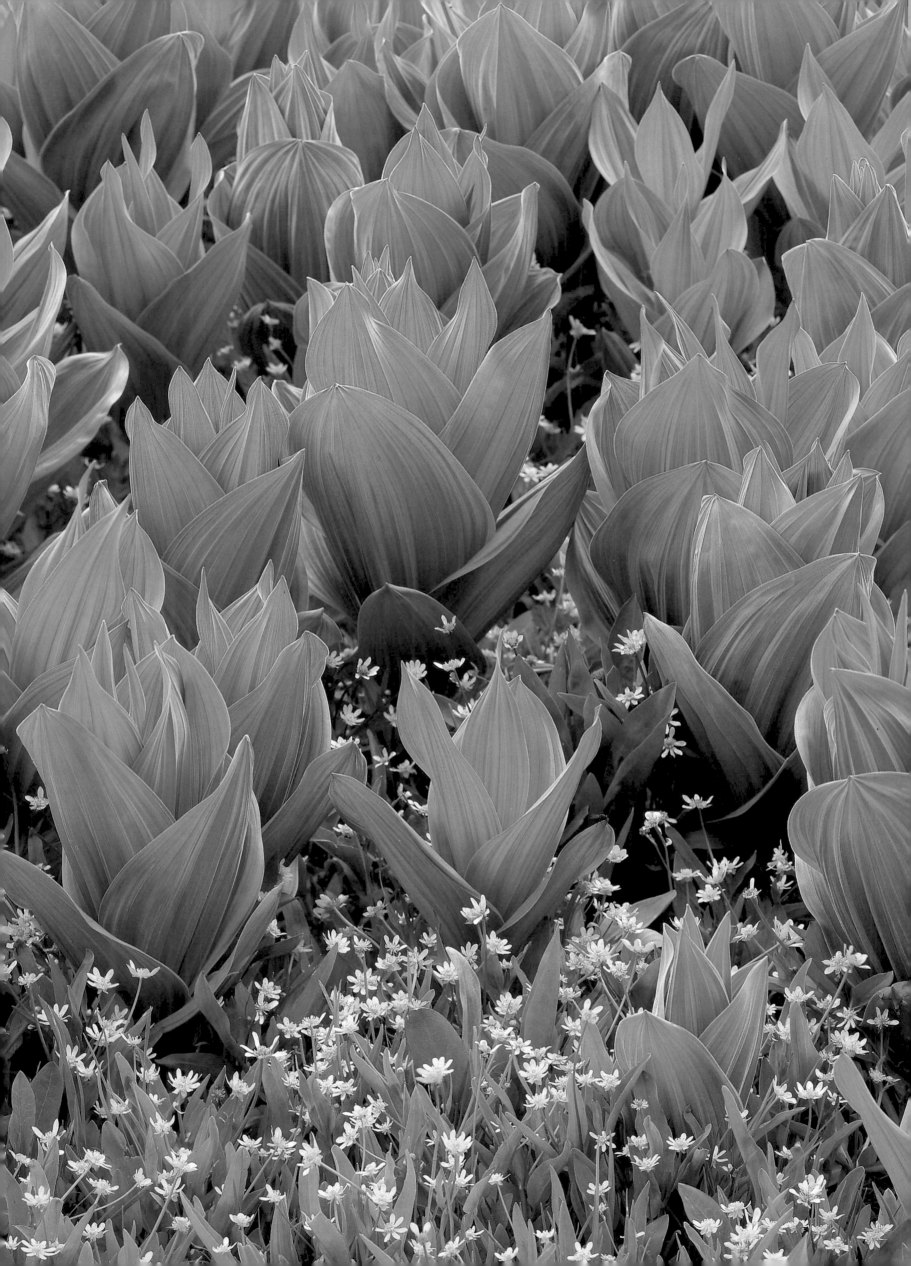

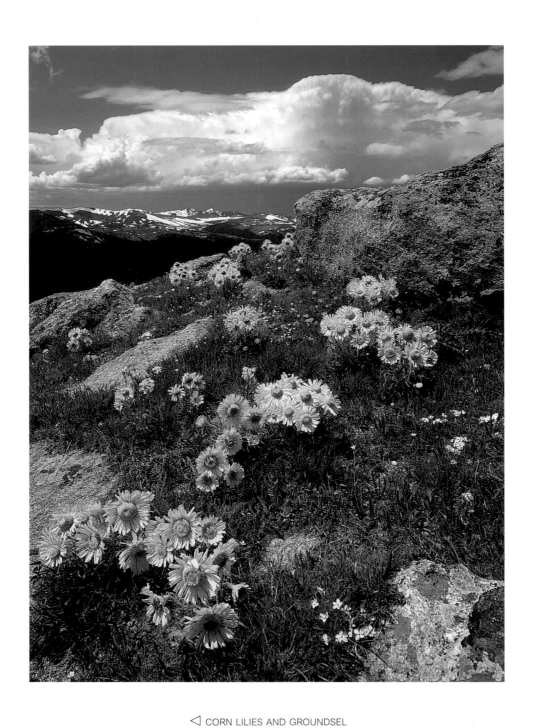

◁ CORN LILIES AND GROUNDSEL

DOT THE HIGH MEADOWS

OF COLORADO'S ROCKY

MOUNTAIN NATIONAL PARK.

△ TRAIL RIDGE, IN ROCKY

MOUNTAIN NATIONAL PARK, COMES

ALIVE IN SUMMER AS RYDBERGIA

FLOWERS ADD COLOR TO MUCH OF

COLORADO'S HIGH COUNTRY.

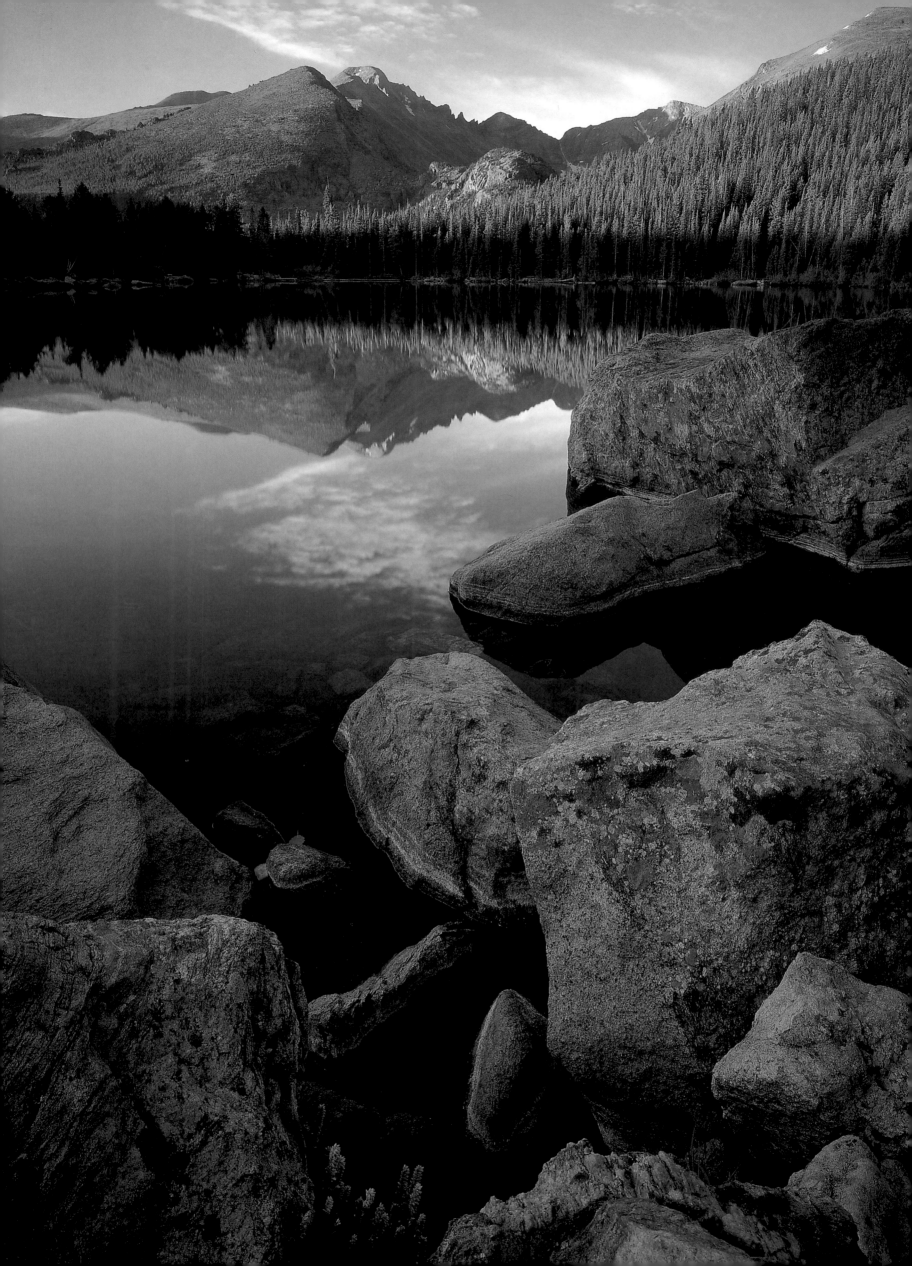

◁ LONGS PEAK IS REFLECTED IN

BEAR LAKE, ROCKY MOUNTAIN

NATIONAL PARK, COLORADO.

△ THE SINEWS OF SURVIVAL ARE

VISIBLE IN THIS HARSH ENVIRON-

MENT AT TIMBERLINE FEATURING

COLUMBINE AND A PROSTRATE

WHITEBARK PINE, MEDICINE

BOW MOUNTAINS, WYOMING.

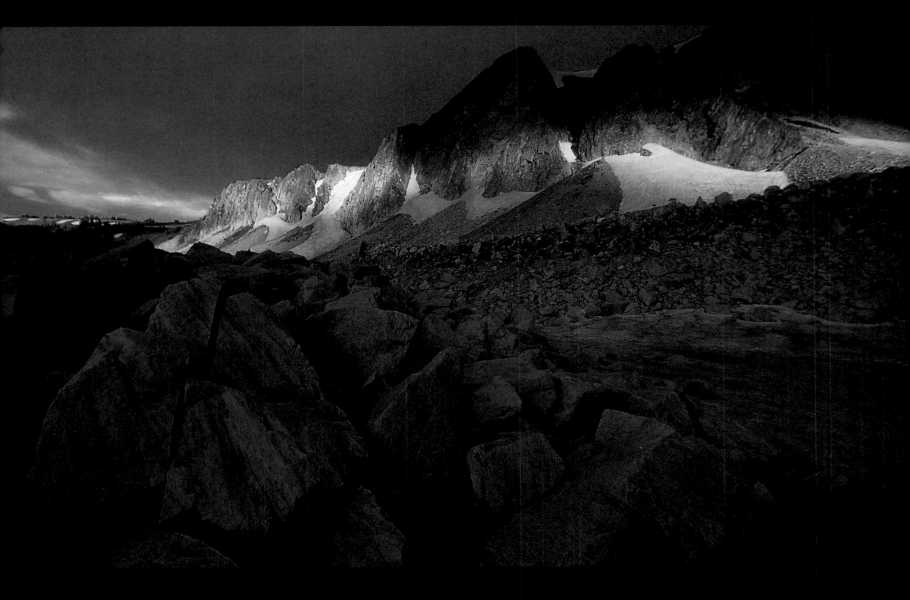

◁ THE FOG FRAMES THIS SUNSET

VIEW OF MOUNT IDA IN COLORADO'S

ROCKY MOUNTAIN NATIONAL PARK.

△ PASSING SUMMER STORMS ALLOW

A DAWN FLASH OF LIGHT ON

MEDICINE BOW PEAK, WYOMING.

▷ ▷ GRANITE BOULDERS DOT

LOST CREEK WILDERNESS,

TARRYALL MOUNTAINS, COLORADO.

▷ ▷ ▷ METAMORPHIC QUARTZ

AND SCHIST ROCK LINE COLORADO'S

CACHE LA POUDRE RIVER.

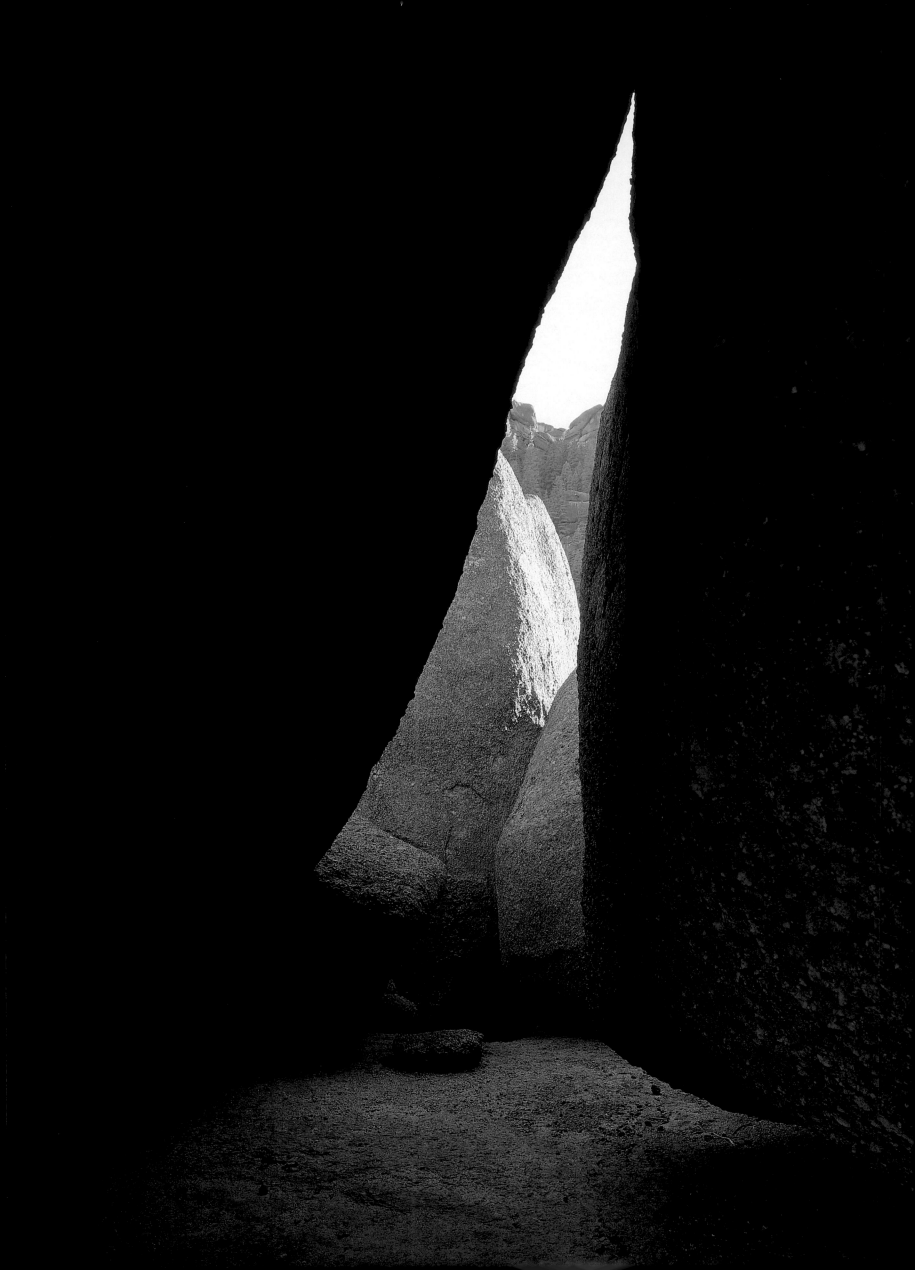

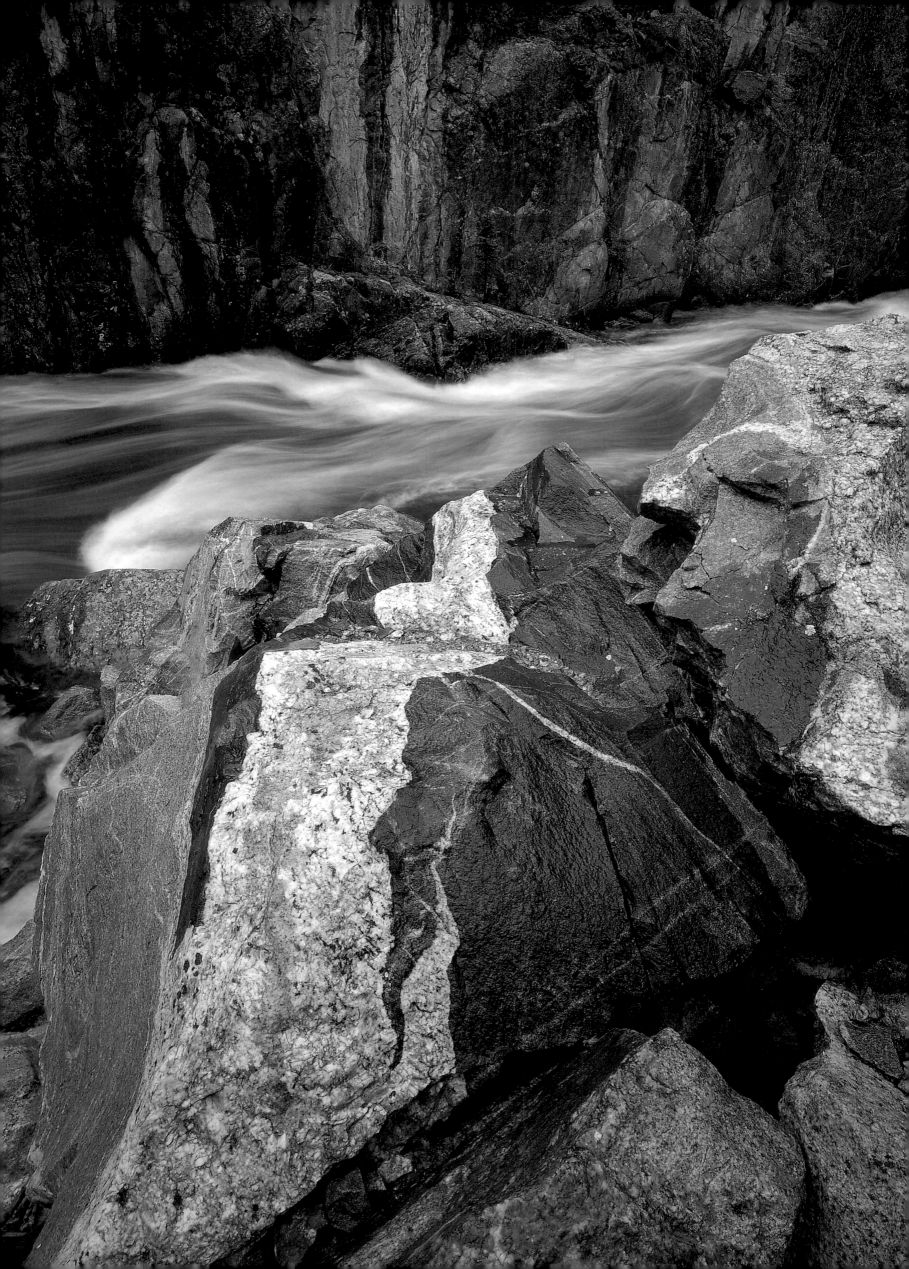

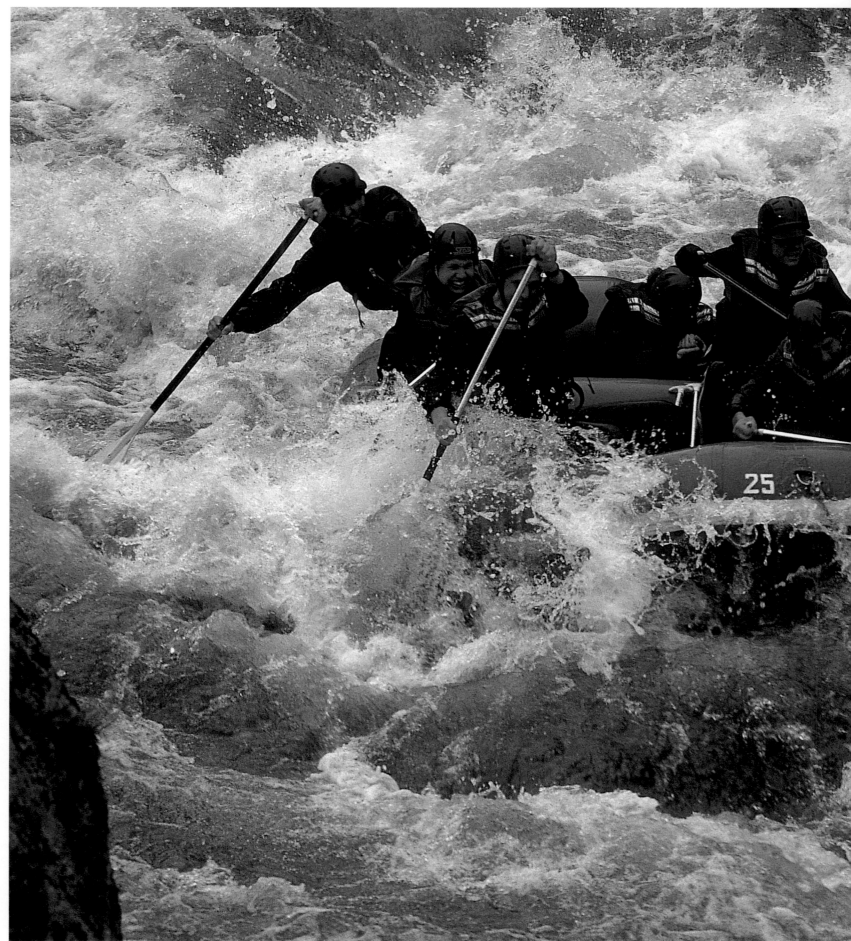

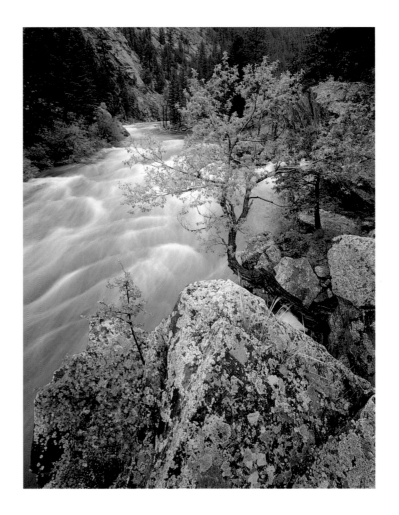

◁ DURING SPRING RUNOFF,

RAFTERS RUN INTO THE

HEART OF PINEVIEW FALLS ON

CACHE LA POUDRE

RIVER OF COLORADO.

△ LICHEN-COATED GRANITES LINE

A SPRING FLOW OF THE CACHE

LA POUDRE RIVER IN COLORADO.

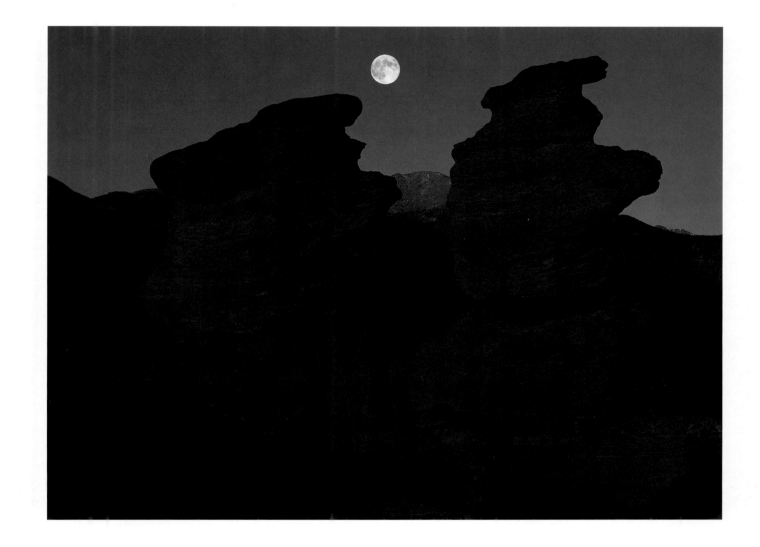

△ A DAWN MOON LOWERS OVER

THE SUMMIT OF PIKES PEAK

AND SANDSTONE FORMS IN THE

GARDEN OF THE GODS,

COLORADO SPRINGS, COLORADO.

▷ MOUNT YPSILON AND THE

MUMMY RANGE EMERGE FROM

THE CLOUDS OF A NOVEMBER

SNOWSTORM IN ROCKY MOUNTAIN

NATIONAL PARK, COLORADO.

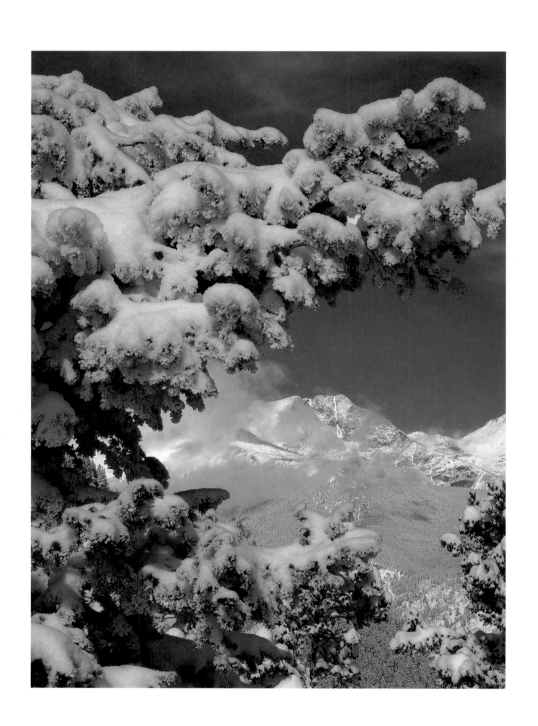

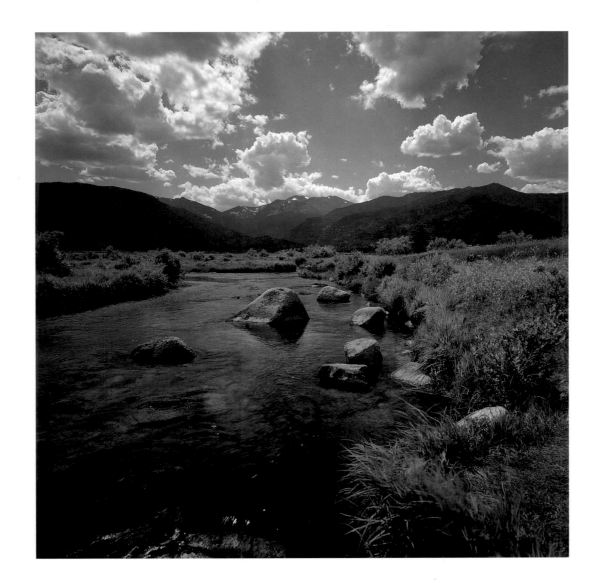

△ MORAINE PARK, IN COLORADO'S

ROCKY MOUNTAIN NATIONAL PARK,

IS HOME TO WILDLIFE, MEANDERING

STREAMS, AND INVITING TRAILS.

▷ (BACKGROUND) CLOUDS FORM

THEIR OWN BACKDROP.

▷ (INSET) ELK ABOUND ALONG

THE TRAIL RIDGE ROAD THAT

CROSSES THE CONTINENTAL DIVIDE

IN COLORADO'S ROCKY

MOUNTAIN NATIONAL PARK.

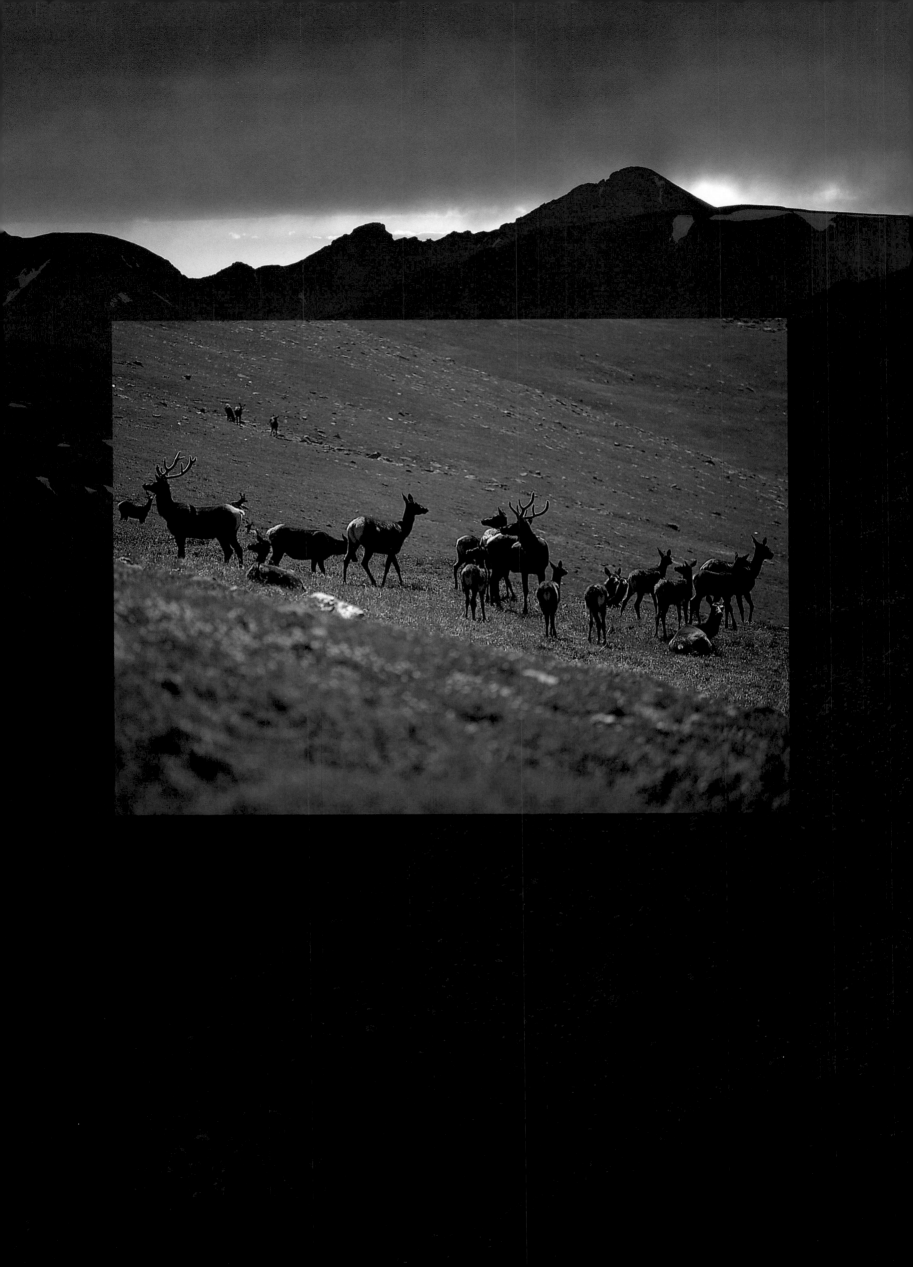

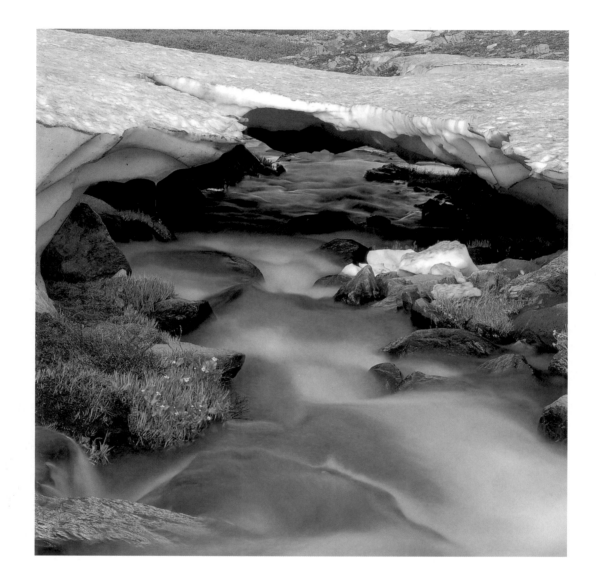

△ SNOWMELT FLOWS UNDER A

SNOWBRIDGE IN THE

MEDICINE BOW RANGE, WYOMING.

▷ ALPINE SUNFLOWERS GRACE

A MEADOWLANDS OF THE

MEDICINE BOW RANGE, WYOMING.

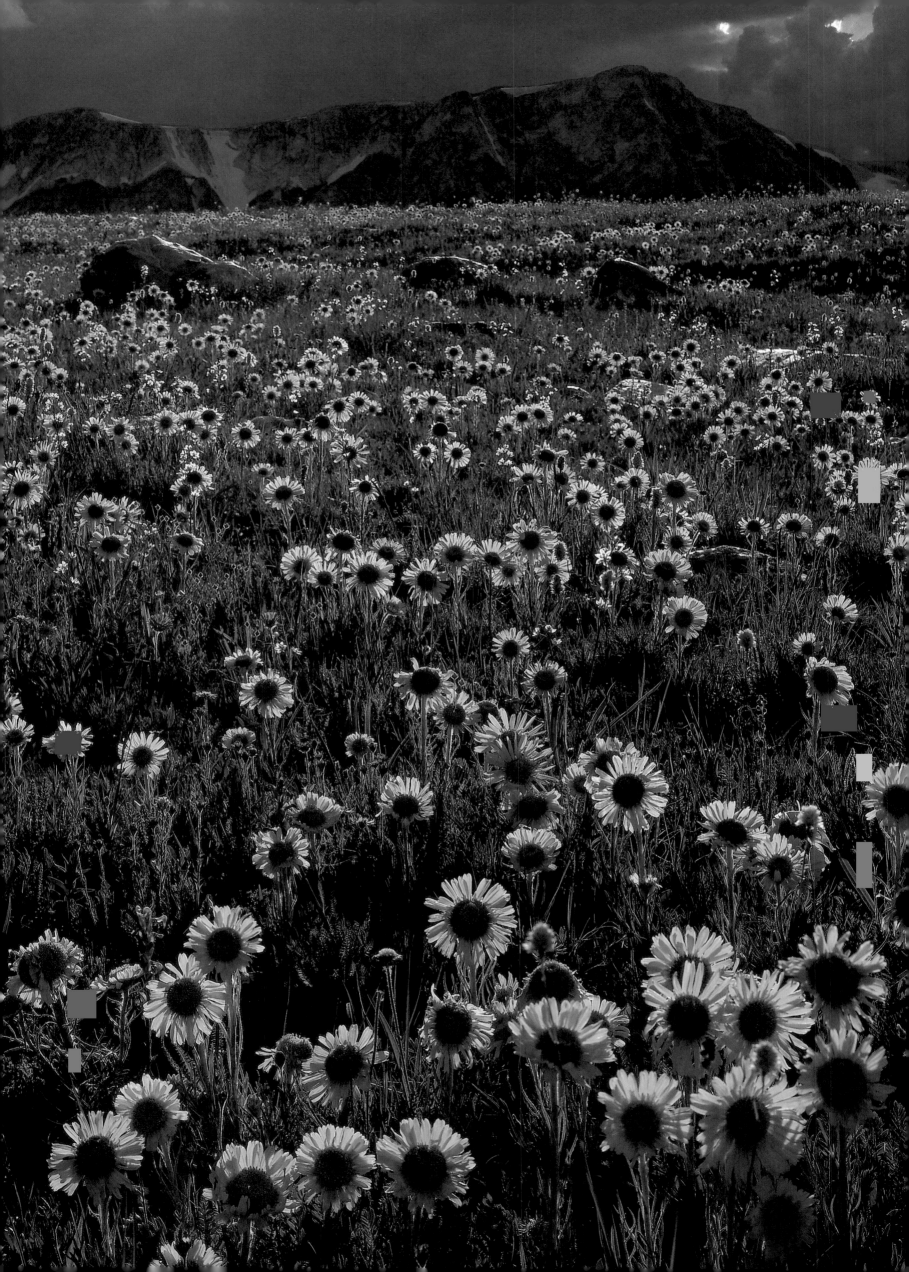

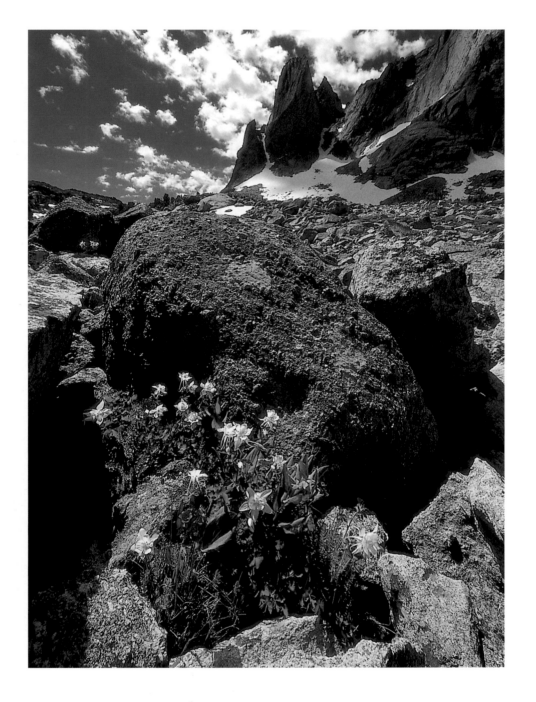

△ ICE-CARVED SPIRES AND PEAKS

GREET THE EYE IN ALL DIRECTIONS

IN CIRQUE OF THE TOWERS,

BRIDGER WILDERNESS, WYOMING.

▷ FREMONT PEAK (13,745 FEET)

DRAMATIZES A CRESTLINE ABOVE

GRANITE BOULDERS AROUND ISLAND

LAKE. BRIDGER WILDERNESS IS IN THE

WIND RIVER RANGE OF WYOMING.

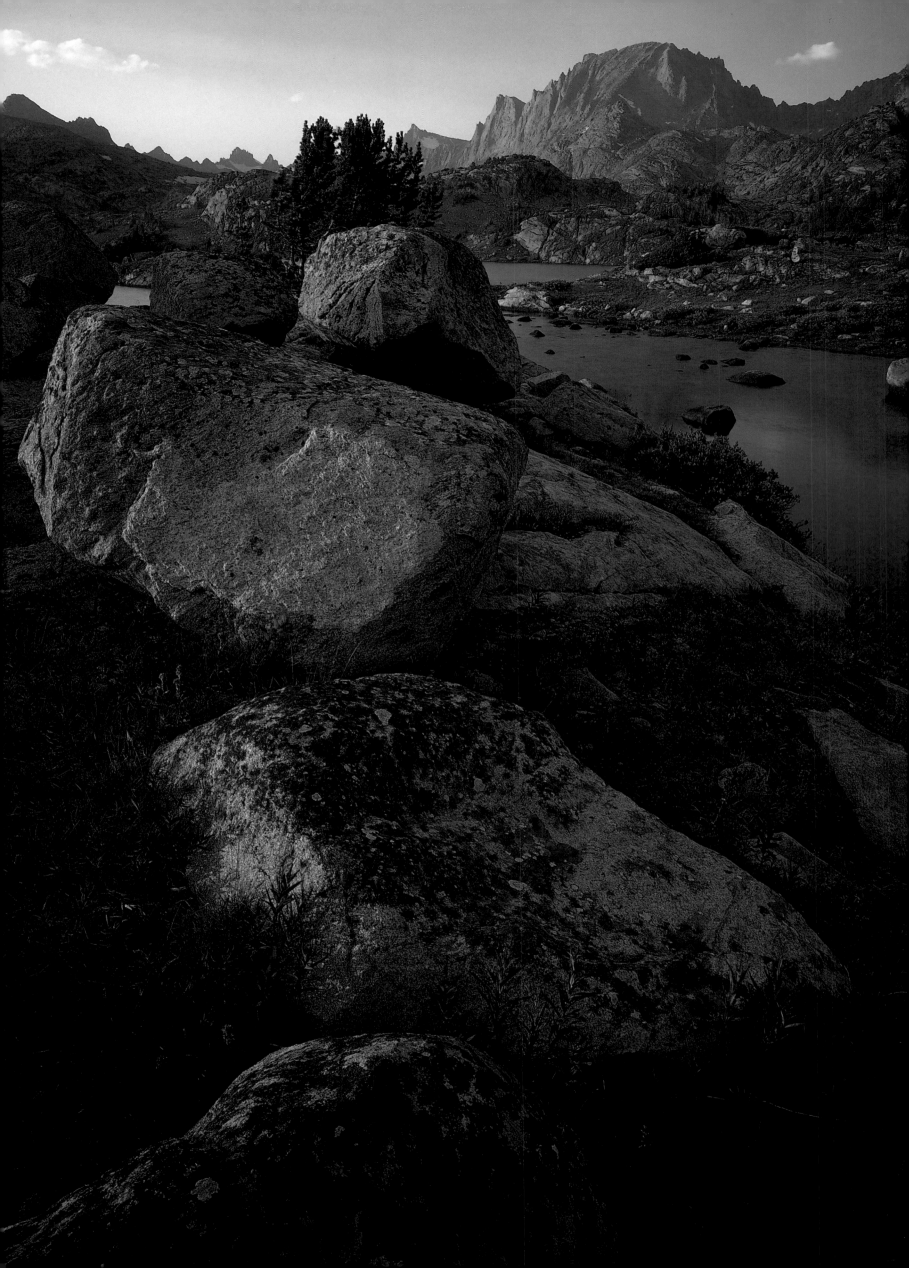

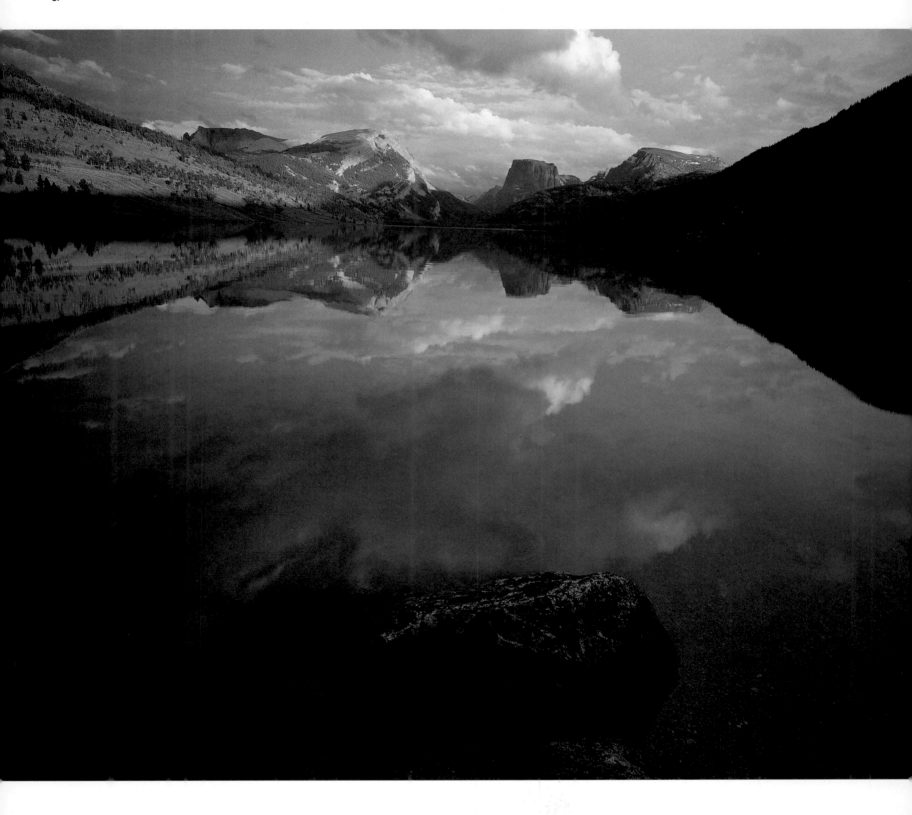

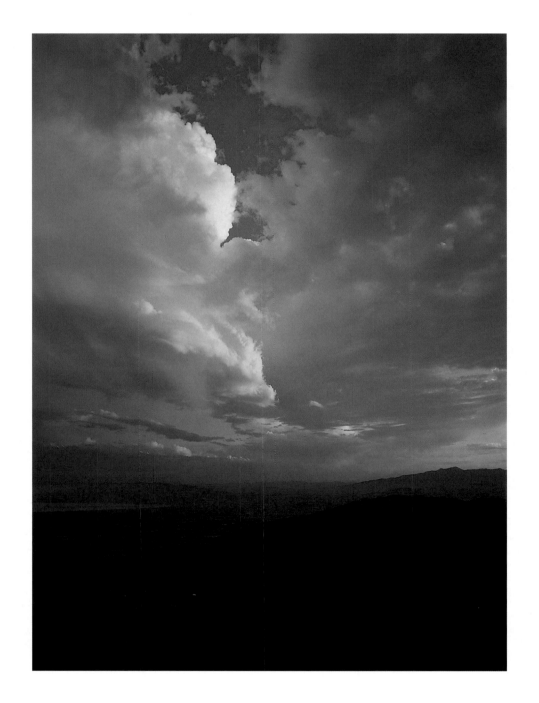

◁ SQUARETOP AND TABLETOP

MOUNTAINS MIRROR SOLITUDE

ON GREEN RIVER LAKE IN THE

BRIDGER WILDERNESS,

WIND RIVER RANGE, WYOMING.

△ A CLEARING AFTERNOON

STORM CATCHES LAST-MINUTE

RAYS OVER PROVO, UTAH.

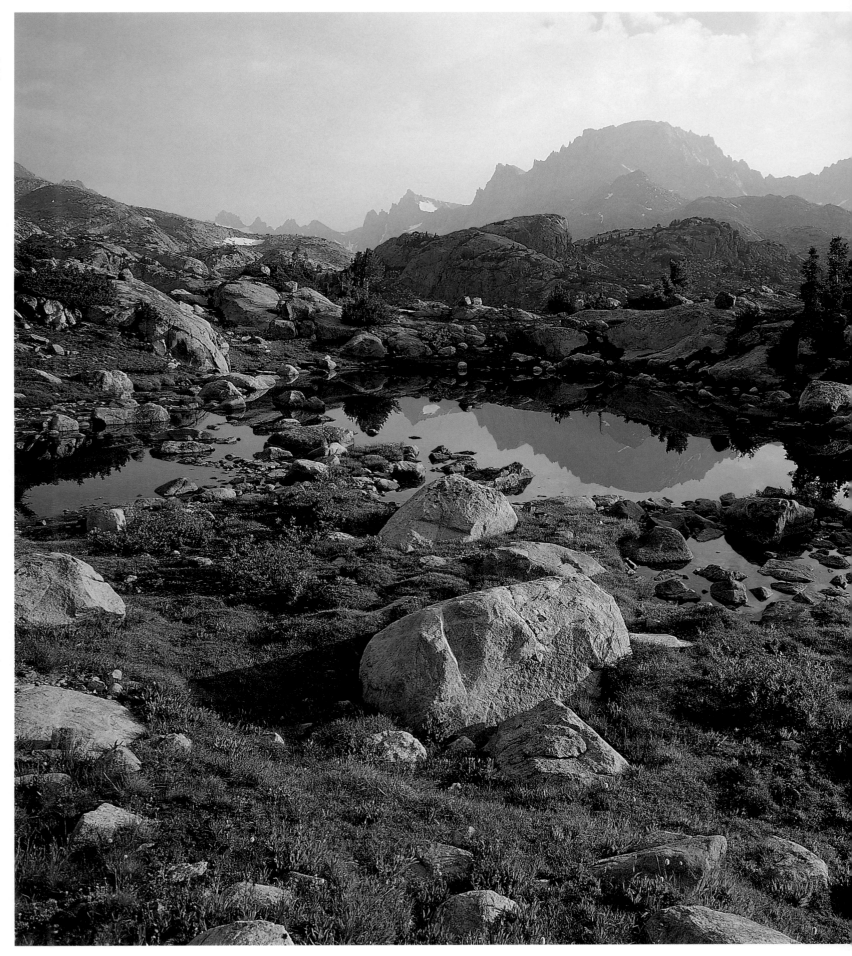

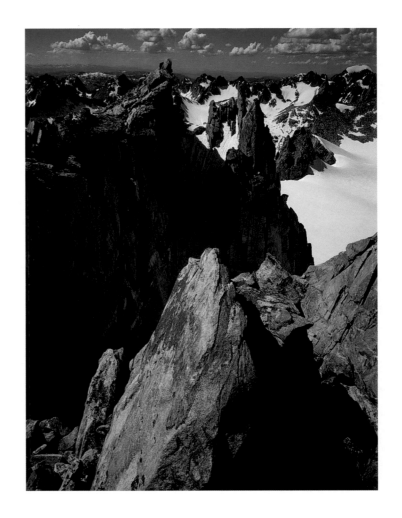

◁ ONE OF WYOMING'S TALLEST

MOUNTAINS, FREMONT PEAK

IS REFLECTED IN ONE OF

HUNDREDS OF POOLS IN THE

WIND RIVER RANGE, WYOMING.

△ A SERRATED RIDGELINE

MEANDERS NORTH FROM THE TOP

OF FREMONT PEAK TO

GANNETT PEAK (13,804 FEET),

WIND RIVER RANGE, WYOMING.

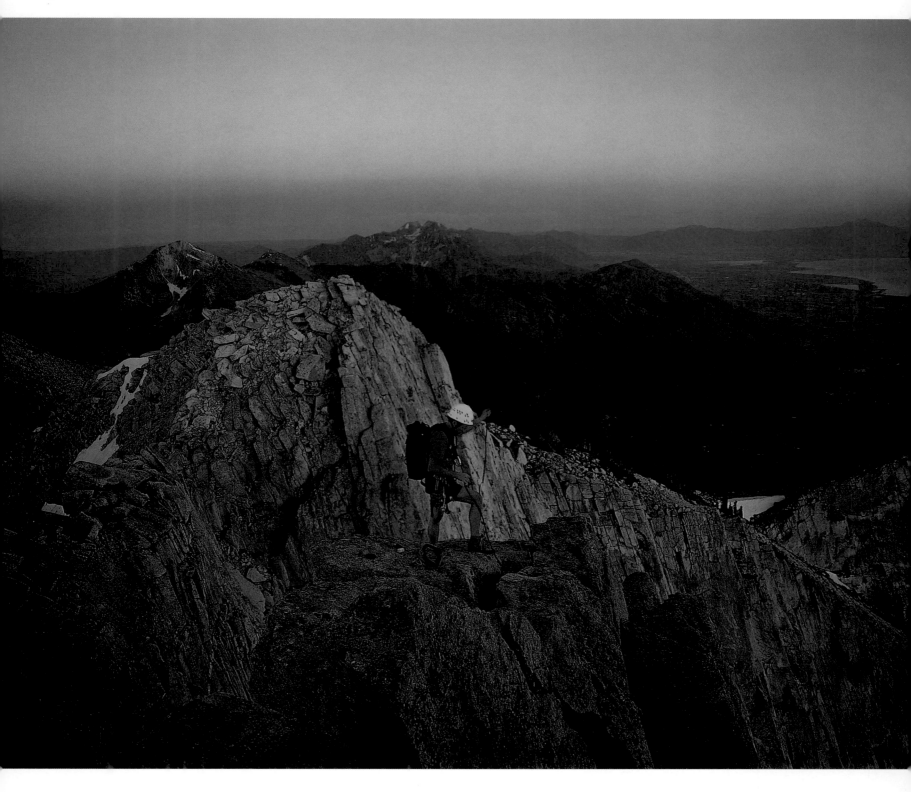

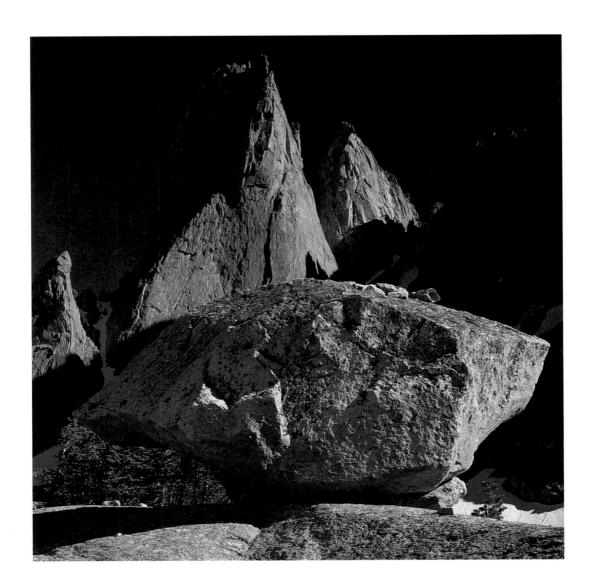

◁ A CLIMBER STOPS TO SORT HIS

CLIMBING RACK AFTER CLIMBING

THE WEST FACE OF 11,253-FOOT

LONE PEAK. MOUNT NEBO,

THE TALLEST MOUNTAIN IN UTAH'S

WASATCH RANGE, IS ON THE RIGHT.

△ CHISELED GRANITES GREET

THE EYE IN CIRQUE OF THE

TOWERS WITH WARBONNET PEAK

AND GLACIAL ERRATIC, BRIDGER

WILDERNESS, WYOMING.

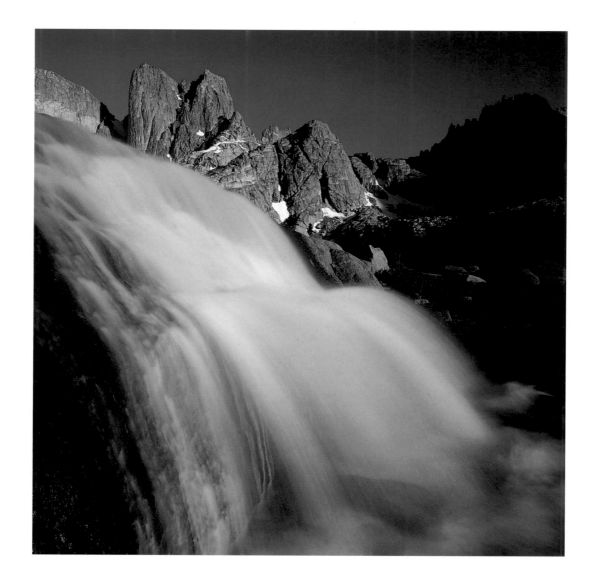

△ A CASCADE ON THE POPO AGIE

RIVER ROARS BELOW WOLFS HEAD

IN THE CIRQUE OF THE TOWERS,

POPO AGIE WILDERNESS,

WIND RIVER RANGE, WYOMING.

▷ A SCULPTURED WHITEBARK

PINE ROOT SYSTEM AND SHARKS

TOOTH CREATE A MONTAGE OF

WOOD AND STONE IN THE ALPINE

WORLD OF THE CIRQUE OF

THE TOWERS, POPO AGIE

WILDERNESS, WYOMING.

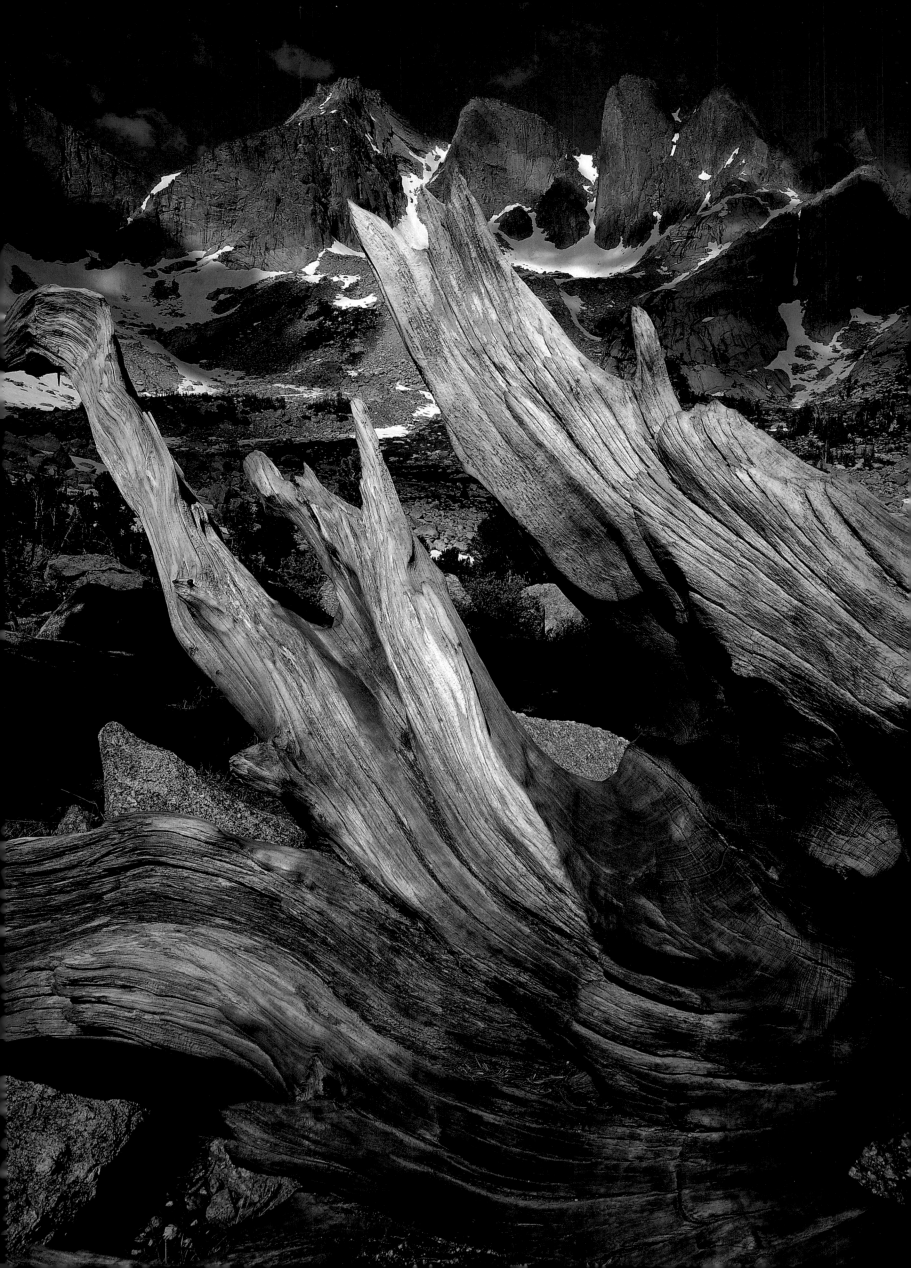

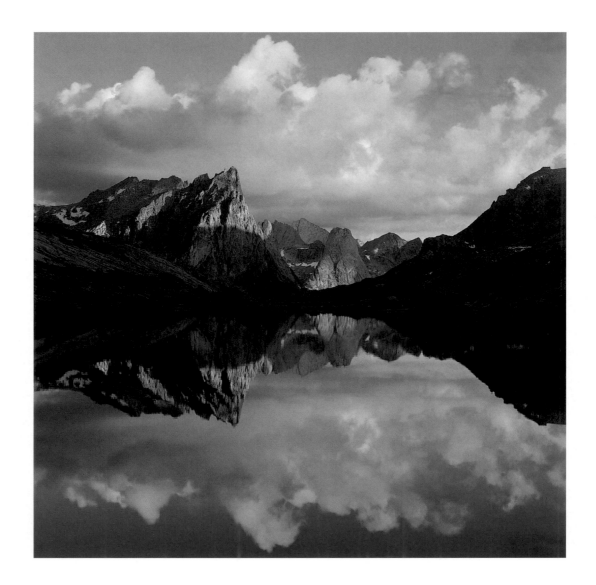

△ WARBONNET AND CIRQUE OF

THE TOWERS ARE REFLECTED BY

ONE OF MANY LAKES IN THE

BRIDGER WILDERNESS, WYOMING.

▷ (BACKGROUND) METAMORPHOSED

QUARTZ FAÇADE IS FROM COLORADO'S

HOLY CROSS WILDERNESS.

▷ (INSET) LONE PEAK CIRQUE—WITHIN

LONE PEAK WILDERNESS, UTAH'S FIRST

DESIGNATED WILDERNESS—OFFERS

AN ALPINE ENVIRONMENT

SURROUNDED BY GRANITE WALLS.

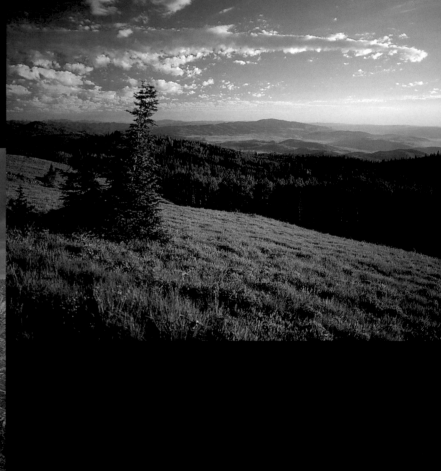

◁ ◁ THE STEEP WESTERN SLOPE

OF THE WASATCH MOUNTAINS RISES

SOME SIX THOUSAND FEET FROM

UTAH'S GREAT SALT LAKE,

CREATING UNUSUAL WEATHER.

◁ THE GENTLE EASTERN SLOPES OF

UTAH'S WASATCH MOUNTAINS OFFER A

CONTRASTING ENVIRONMENT.

△ CUMULUS CLOUDS COPY

PATTERNS OF SCATTERED BUSH

LUPINE ON THE WASATCH MOUNTAINS.

△ △ A SKIER WALLOWS IN THE

FAMOUS DEEP, DRY POWDER

OF THE ALTA SKI AREA, IN UTAH'S

LITTLE COTTONWOOD CANYON.

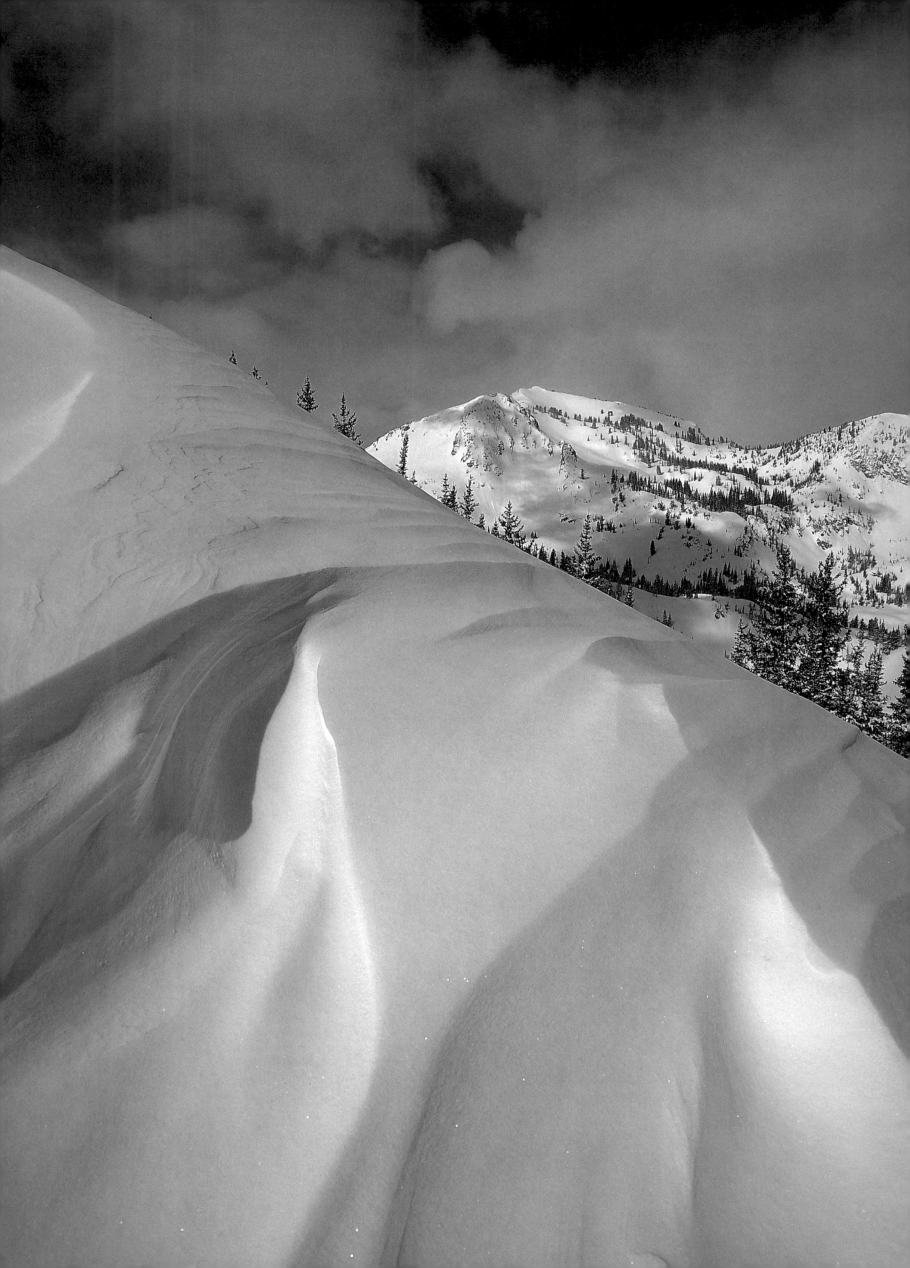

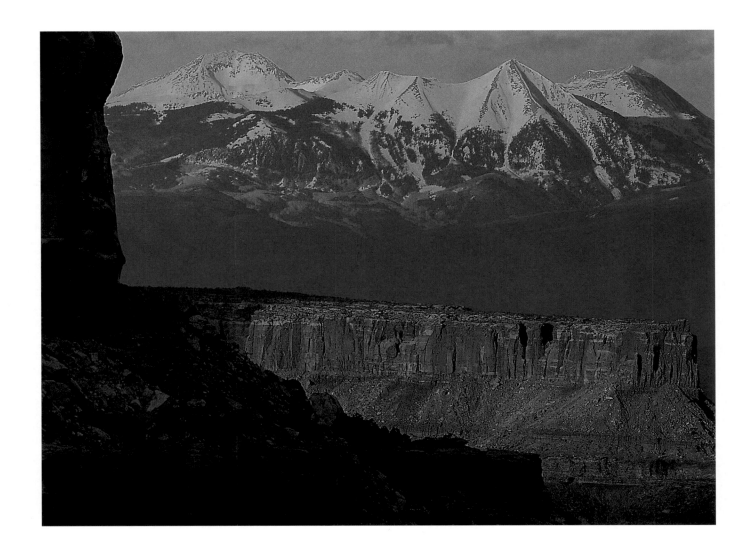

◁ TEN MONTHS OF THE YEAR

NEW SNOW CAN FALL ON THE TOPS

OF THE WASATCH MOUNTAINS OF

UTAH. HERE IN JANUARY, IT

COLLECTS ON THE HIGH SUMMITS

AND RIDGES BETWEEN LITTLE

COTTONWOOD CANYON AND

BIG COTTONWOOD CANYON.

△ SIERRA LA SAL PEAKS

TUKUHNIKIVATZ, MELLENTHIN,

AND PEALE TOWER ABOVE

PLATEAU RIMS IN UTAH'S

CANYONLANDS NATIONAL PARK.

SWAMPED BY BEAUTY, SWALLOWED BY SPACE

A JOURNEY THROUGH THE ROCKIES

by

James R. Udall

First impressions die hard. My earliest memories of the Rocky Mountains date back thirty-four years, to a horsepacking trip with my family in Glacier National Park. I was thirteen, a young actor in one of my mother's dramas. I don't know why she went to the trouble and expense of hauling five children into the wilderness, but in hindsight I owe her one.

I recall that trip as a procession of revelations. Each hour unveiled something new. There were three wranglers and twenty horses with terse names like Bud, Paint, Suds, Sal. The first day we reined out of a corral, up a trail, and into an ancient forest—damp, green, primeval. I remember passing bear tracks in chocolate mud and then a long climb, endless switchbacks, the horses lathered in sweat. Topping out, we stood in our stirrups, saddles creaking, to gaze speechlessly at a panorama of paradise. Then we started down, through a meadow of wildflowers, past frost-shattered gray slabs speared into the green tundra.

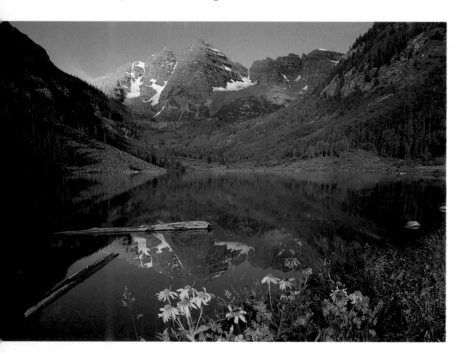

Each night, we camped by a different lake, where gullible trout rose to a boy's dry fly. Through binoculars, we watched mountain goats, four-legged ballerinas, dancing on cliffs rising to the sky. After dark, there was a fire, kindled camaraderie,

sparks of song. At dawn, snuggled in frosty sleeping bags, we heard the bell mare's jingle as the wranglers gathered their hobbled herd. They were sun-squinty, wiry outdoorsmen, gifted with humor and a light touch with kids. Wizards with a skillet, they slaked our ravenous appetites with pancakes, eggs, bacon, and Tang.

Some days were spiced with fear, an emotion which, in the Rockies, often comes with the territory. At one spot, where the rocky trail clung to a side slope above a yawning chasm, the surefootedness of one's mount came into bold relief. ("Do horses ever commit suicide?" my young brother quavered.) In another place, the trail crossed a steep snowfield left over from winter. Dismount, commanded the wranglers, let's lead the horses here. Kicking steps across an icy ledge, I held my reins lightly, praying that my loyal stead would not slip into yon abyss. Moments of danger honed our appreciation of beauty. One day, the trail bored straight through a mountainside. Into a pitch-black tunnel we rode. When we came out, there was a turquoise lake far below, a gemstone in a forest brooch.

The alpine world was sensual. The sky was a deep rich blue; the crisp air, an intoxicating ambrosia. There were new smells, exotic perfumes: *eau de tundra* and *woodsmoke on lakeshore.* The weather was impossibly fickle, fetching bright sunshine, a shivering wind, and jean-drenching rain all in a single day. Wildlife ran the gamut from the known to the novel. There was a furry marmot whistling on a rock and an enormous moose, neck deep in a boggy pond, at once ungainly and graceful. At one backcountry chalet, grizzlies arrived at dusk to feed on garbage. Even amid the trash cans, their shambling gait and pie-pan-shaped faces exuded wild power.

And, of course, there were mountains. The peaks came in all shapes—truncated cones, turrets, obelisks, and pyramids. They were dressed by weather's whim with cowls of gray or a dazzling mantle of fresh snow. At dusk, honeyed twilight sprayed over their shoulders from behind the clouds. After a few days in this rich, dizzying landscape, life came to operate not in three but in six dimensions. We rode through a rift in time into an aesthetic realm with a spiritual plane. The days blended together, and the trip seemed over before it had begun.

Born in Arizona's cactus country, I moved to Colorado, to the mountains, twenty-seven years ago. In all of that time, I haven't been out of the state for more than two consecutive months. I'm smitten—but by what?

In the Rockies, love is *not* blind. As I write, I can see through my window Mount Sopris, 12,953 feet high. Rising two

and one-half miles above sea level, twin summits hugging a snow-filled bowl, Sopris is a singularly attractive mountain. But it's nothing unusual; here in Colorado, close to a thousand peaks soar higher. (Whiling away an afternoon, geographer Robert MacArthur once calculated that to build just one ten-thousand-foot mountain in New Jersey would necessitate scraping together all the land above sea level in the entire state.) All across the Rockies, high peaks do-si-do with deep valleys. The difference in elevation between my desk and Sopris' summit five miles away is greater than that between any two points east of the Mississippi. What is most remarkable about this situation is that I could say nearly the same if I lived in Denver, Salt Lake City, Albuquerque, Jackson Hole, Missoula, or Calgary. Here, where Mother Earth meets Father Sky, the exceptional is commonplace.

The next time you encounter a three-dimensional map of North America, sweep your hand across the land. America's midsection is as flat as a pool table. To the west, though, the map gets as rough as a washboard. Corrugated ridges—the Rocky Mountains—jut out of the Great Plains. Each tiny wrinkle is an tremendous escarpment of peaks, two miles high. Fingering one, we can take a Braille hike: *Let's thread our way up this narrow valley to the cirque at its head. We'll pitch our tents beside this heart-shaped lake, fish the evening hatch, and cross that gunsight pass in the morning.* Such a journey is suggestive—but the scale is wrong. As much as I love maps, maps don't do mountains justice. You can't reduce the Rockies. They are a higher power, this continent's crowning glory.

The term itself—Rocky Mountains—is a clumsy abstraction for something too big to be grasped. I can tell you that the Rockies stretch farther than the Amazon, but how, really, do we come to grips with this mountain chain? Here's one way: hike the Continental Divide Trail. Starting in New Mexico's boot heel, ending in Glacier National Park, it traces North America's spine for thirty-one hundred miles. That's a daunting sum, but if you broke it down, averaged a mere eight or ten miles a day … why, no sweat.

Such an expedition has much to commend it. (Seriously. Call the boss! Quit your job! Go!) After a year on the trail, your body would be hard like a rock, your mind open like a flower. But you still wouldn't know the Rockies. Striding a linear transect across America in hopes of grasping the Rockies would be like climbing a single tree in hopes of knowing a forest.

But no matter. The thing to understand is that these are big-hearted mountains. The Rockies give much more than

they ask. They are a spiritual retreat with the power to bring humans back into harmony with the natural world, a great alpine cathedral with the architecture to invigorate our souls. They are an outdoor classroom where young and old alike can forge a bond with the earth. They are home to many of

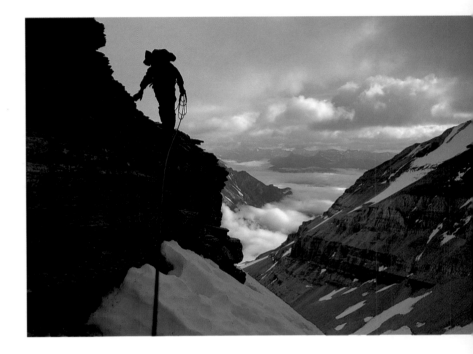

our wilderness icons and our most famous national parks. Offering a stunning variety of climates, scenery, and wildlife, this mountain chain is more than the sum of its parts. It has a synergy matched by few other places.

Since people see in the mountains what they are prepared to see, this dynamic landscape is also a "mindscape." Hydrologists, for example, view the Rockies as a "two ocean ridge"; like the bow of a ship cleaving a wave, the Continental Divide rations rainfall and snowmelt between Atlantic and Pacific. Biogeographers, who study the distribution of plants and animals, perceive the Rockies as a "high road" along which arctic flowers migrated south. Conservation biologists regard the Rockies as a "forest ark," one of the world's last strongholds for natural diversity.

In their interaction with the human mind, mountains are quick with a comeback; they have weather to match every emotion, a mirror for every mood. The Rockies subsume all adjectives. You can think of them as bountiful or barren, enchanted or haunted, magical or mundane, captivating or repellent, benign or murderous. Since the Rockies are all of these things, they really don't care what people think, nor should they. From a mountain's perspective, we are just pesky ants.

As a geographic province, a vertical frontier, the Rockies encompass approximately 250,000 square miles, parts of

EVERY STEP OF THE WAY IS THRILLING ON THE SUMMIT RIDGE OF MOUNT VICTORIA ABOVE LAKE LOUISE, IN ALBERTA. △

seven states, and three Canadian provinces. But don't envision the Rockies as a single, unbroken mountain chain. The peaks aren't ganged together like toy soldiers, shoulder to shoulder, an indivisible army astride the continent. Instead, this is a broken cordillera composed of many separate mountain ranges, each a lonely sentinel guarding its own private turf. The ranges are isolated by broad passes or shallow basins or deep gorges; they can be ten miles or a hundred miles apart. Idaho alone boasts eighty-one ranges; New Mexico, seventy-three; Colorado, a modest thirty-four. Although each range has its own stony history, they share three cardinal attributes. First, they are publicly owned. Second, they are either lightly populated or completely uninhabited. Third, they are wild and free.

Who owns the mountains? In one sense, no one does. There is no lien on the summits. But in another sense, all of us do. The tens of millions of acres of publicly owned land in the West is your alpine estate. The Rockies are yours, and, in a crowded world, their spaciousness is a precious legacy. Throughout Europe, there are three or four hundred people per square mile; here it's generally less than twenty. In the Rockies, it is easy to escape the grinding racket of civilization, the clangor and din, to be utterly alone in the wild.

There are thirty-eight wilderness areas in Colorado; New York has one. The mountain states together boast more than one hundred wilderness areas sprawling across sixteen million acres, or twenty-five thousand square miles. But this designated wilderness, as vast as it is, doesn't fully measure the wild and free. Wildness can't be corralled between arbitrary boundaries. It is deeper, more primal, more intrinsic. Wildness is within. As poet Gary Snyder puts it, there is a bobcat in the forest and one in the mind.

Sell your soul if you must; a summer in the Rockies is worth whatever it costs. Summer is a flirt, a ten-week fling. Arriving in mid-June, it is packed and gone by September. Like many summer romances, this one promises more than it can deliver. The problem is that there's too much to do and too little time in which to do it. Summer is a time to hike, mountain bike, photograph, sketch, gaze, and camp. Summer is also for firsts—a time to climb your first mountain perhaps, to run your first river, to see your first elk, to help your daughter catch and release her first trout.

Summer is also the best time to tour the crown jewels—Rocky Mountain, Grand Teton, Yellowstone, Glacier, Banff, and Jasper National Parks. More than twenty million people make this pilgrimage each year, so expect crowded roads.

Park scenery can be glimpsed at highway speeds, but in my view the park experience is best grasped in slow motion, on foot. Since typical visitors are tethered to their vehicles, rarely venturing more than a few hundred yards from the pavement, the backcountry is mostly vacant. A thirty-minute stroll puts you across the threshold.

Summer is also the season for falling in love with the tundra, the enchanting land above the trees. There are tens of thousands of square miles of tundra in the Rockies; Colorado alone has four thousand. By my lights, the tundra is Gaia's loveliest face. Making a date with this beauty is easy. On a weekend in July, drive to a trailhead. Fill a day pack with a water bottle, sunscreen, sunglasses, and plenty of warm clothing, just in case. Throw in binoculars, camera, and a flower guide if you wish. Hike uphill. Go slow, savor the views.

In Colorado, the tundra starts at about 11,400 feet, the upper limit for trees. In Europe, biologists call timberline the *kampfzone* or "zone of struggle." It's an apt term. Fierce

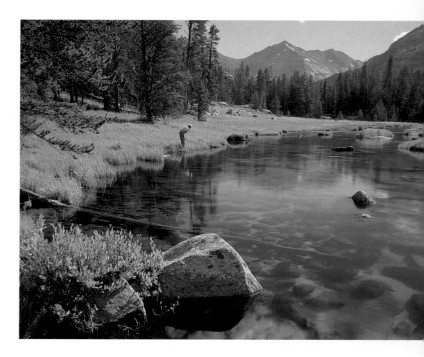

blizzards, battering winds, lightning—timberline trees must battle all of these. How ironic, then, that bristlecone pines, found in scattered pockets at timberline throughout the Rockies, are among the oldest trees in the world. These gnarled elders may live four thousand years. What's their secret? Some scientists suggest that the species' hardiness—its ability to take root in thin soils and survive killing temperatures of 30 below—gives it a competitive advantage over frailer organisms. In this view, the bristlecone achieves its astounding longevity by triumphing over extraordinary adversity. Is there a lesson here?

A HIKER ENJOYS BROWSING THE QUIET WATERS OF BIG SANDY RIVER IN THE WIND RIVER RANGE, WYOMING. △

By twenty-five million years ago, the mountains' rough edges had been worn sensual, and rivers traced lazy oxbows on fluvial plains. But then, like magic, the Rockies were levitated once again. Great rivers cut downward, creating Hells Canyon, Black Canyon, Lodore Canyon, the Grand Canyon—some of the deepest and narrowest canyons on Earth. Erosion, struggling to keep pace with the uplift, recruits a new ally—ice. As the climate cools, snow accumulates, hardens to frozen blue. The thin frosting gradually gets deeper, small glaciers glom into ice caps. Glaciers are brutes. Flowing downward they take no prisoners. As the ice sculpture continued, the mountains' inner essence was slowly revealed.

Thrice the climate warmed, and the brute lost traction, began to melt. And thrice the climate cooled, and the brute returned. (Along here, other pranks are played. A caldera in Yellowstone and one in New Mexico explode with the force of all the world's nuclear weapons being detonated at one time: the sky goes black for years, earth cools, the ice applauds.) But finally just fifteen thousand years ago, the frozen ogre is forced to retreat, temporarily or perhaps for good.

Icy, gravity, granite, time. The result is the exquisite landform of cirques and spires, turrets and tarns we see today. One of my favorite places to view the ice's handiwork is Wyoming's Wind River Range. Straddling the Continental Divide for 120 miles, these mountains are flung like a net across the sky. The net is thirteen thousand feet high, and it knocks down staggering amounts of snow. The range is achingly beautiful. But, unlike California's Sierra Nevada, to which it bears some resemblance, this is not a gentle wilderness. Fickle weather bedevils the hiker; the tortured terrain intimidates him. But it is the wind, forever plucking at your clothing and keening in your ear, which hones the range's brooding aura. The Wind Rivers' foreboding ambience is leavened by their grandeur. The combination is immensely seductive. Go once, you will crave to return. For though you may leave, the rapture remains, a fever in the blood.

I don't rock climb much anymore, but there's one route in the Wind Rivers I'll always remember. Some years ago I climbed it with my girlfriend. Since she was the better climber and chivalry is dead, I let her lead the desperate sections. In profile, the ridge is shaped like an upturned ski tip or, more fancifully, a howling wolf's head, nose skyward.

The route begins on a flat lane of granite, ten yards wide. As it steepens, the lane narrows to a sidewalk, then to a plank. The rock is studded with knobby handholds, and the climbing would be easy except for the stomach-turning drops to each side. For a dozen rope lengths you clamber along the knife edge, bypassing unclimbable gendarmes to the left and right, trying not to look down. The crux is a traverse across a steep, blank wall. As you inch out over the abyss, your hands run like spiders across the rock, but there's nothing there, not a single handhold. The only compensation is a deep crack at the level of your feet. So, heart in boots, you sidle out over eight hundred feet of air, look-ma-no-hands.

Why take the risk? The mountaineer is not after a summit so much as an ineffable feeling, a rare perspective. The poet Eunice Tietjens captured it in a few stanzas:

> I shall go down from this airy space, this
> swift white peace, this stinging exultation;
> And time will close about me, and my soul stir to
> the rhythm of the daily round.
> Yet, having known, life will not press so close,
> And always I shall feel time travel thin about me.
> For once I stood
> In the white windy presence of eternity.

Fifteen thousand years ago, as the Wind Rivers and other ranges shed their ice caps, meltwater poured into a gigantic lake in Utah nearly as big as Lake Michigan. Then a natural dam collapsed and released the second-largest flood known to have occurred in the history of the world. Five-ton boulders swept across Idaho at twenty miles an hour on a

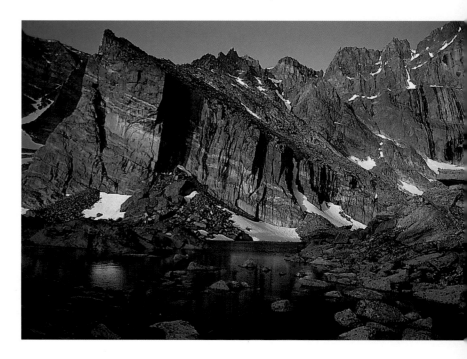

river fifty times bigger than the Mississippi. This Noah-scale flood was probably witnessed by *Homo sapiens*. Two million years after the birth of the species, human beings had finally reached the New World.

DIAMOND LAKE, BELOW COLORADO'S FOURTEEN-THOUSAND-FOOT LONGS PEAK, NESTLES BENEATH ACRES OF VERTICAL GRANITE WALLS. △

The People (for that's how they thought of themselves) had crossed from Siberia into Alaska, where an ice-free corridor channeled them southward into an amazing world. In its biological wealth, their world has no modern analog, save perhaps the game-rich savannahs of Africa. There were ground sloths, some as big as steers, some bigger, nine feet tall. There were condors scavenging six-ton mammoths. There were prides of lions stalking shrub oxen, wild horses, and llamas. There were short-faced bears, long-legged, fast as a race horse, approaching a ton in weight. Hard to imagine? Yes— but not impossible. Although my mind balks at being lofted into dinosaur time, these scenes probably exist today within the racial memory of living Native Americans. Fifteen millennia ago, their ancestors, whose blitzkrieg across this Ice Age Serengeti probably played a role in the extinction of its megafauna, were barbecuing mammoths and dreaming of the short-faced bear. What a world that must have been. I shiver to think of it!

Hollywood vacillates in its treatment of Native Americans. In some films they are depicted as red-skinned devils; in others, as copper-toned saints. Stampeding bison over cliffs, sparking wildfires, raiding other tribes, The People sometimes behaved more like petty vandals than "noble savages." But their mandate was survival, not manners. And give them their due! For fifteen thousand years they flourished in the shadow of the peaks, at home in the Rockies.

But what was the character of this relationship? The anthropological record offers suggestive clues. Fluted spear points, dating as far back as 10,000 B.C., have been found high in Colorado's Rocky Mountain National Park. Footpaths across the park's tundra appear to have been used at least that long. At the top of east-facing cliffs that capture the rising sun and command expansive views of sacred peaks, we find vision quest sites, places for young warriors to pray, fast, and confront the Great Being.

Stone Age people were, of necessity, intimately familiar with their biosphere. When it came to the next meal, ignorance was not bliss. Hunger demanded that they know every bit of terrain, work every angle. And yes, here and there on the tundra, we find rock walls, arranged in V formation, designed to help hunters stampede game herds into ambush pits. In 1804, Lewis and Clark found mountain goat hides in Shoshone tepees in Montana. If Indians were successfully stalking this bearded wraith, a cliff-dwelling beast the color of winter, difficult to hunt even with a high-powered rifle, then bighorn sheep, elk, and deer were staples, too. All the evidence together suggests that Native Americans were absolutely intimate with

their mountainous backyard, and that alpine beauty was part and parcel of their world.

A blizzard hurls into the Rockies. Skiers pray for powder, go to bed early, and set the alarm. At dawn they awake to a final few flakes hovering, a glittering halo in a navy blue sky. By the time we reach the gondola, a crowd has formed. Clad in colorful one-piece suits, goggles, and pile hats, brandishing skis like swords, they impatiently await the lift's 9:00 A.M. opening. Muffled explosions rain from above as the ski

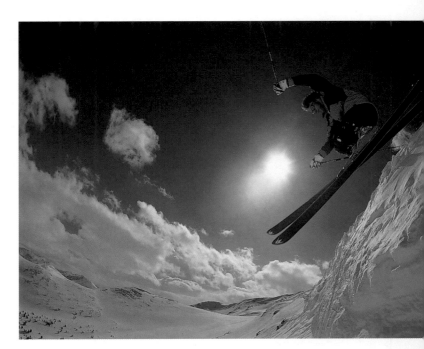

patrol dynamites suspect avalanche slopes. As the appointed time nears, the powder hounds begin baying, hungry for the first tracks.

If summer in the Rockies often seems like a mirage, there's nothing fleeting about winter. Winter is the main event. Winter has punch, staying power. Sometime in November, when the last orange-clad hunter has struck camp, as a pale sun slouches toward the solstice, winter arrives. The high valleys fall silent as jeep roads, littered with a mosaic of golden leaves, drift closed. For the next six months, snow takes command.

In a city, snow is a headache to be shoveled or plowed. But in the Rockies, snow is frozen lucre and sugared delight. In the last fifty years, nothing has had a bigger impact on the regional economy than the invention of the chairlift. Mining the white gold, ski resorts sell lift tickets, passports to joy. Although downhill skiing is the multi-billion-dollar mainstay, other winter sports are also exploding. Teenage children of baby boomers, scorning their parents, take up snowboarding in droves. Nordic skiers skate across golf courses. Snowmobile sales

COLORADO'S COPPER MOUNTAIN SKI AREA IS KNOWN FOR ITS NATURALLY DIVIDED TERRAIN. THIS IS A GREAT EXAMPLE OF COPPER'S EXPERT RUNS. △

have tripled in recent years, and more than 140,000 people now ride a snow machine into Yellowstone each winter.

In Colorado, fifty backcountry cabins provide shelter for more than twenty thousand cross-country skiers each year. So-called hut trips enable outdoor enthusiasts, including families with young children, to safely enjoy overnight trips, without lugging all the gear they'd need to sleep in the snow. In Idaho and Wyoming, outfitters guide skiers and snowshoers through the forest to luxurious yurts equipped with beds, carpets, and hot tubs.

Winter has two faces. For wildlife, deep snow can equal starvation. Snowshoeing, I once came across a majestic six-point bull elk, frozen as a rock. Ribs protruded from his chest like the bellows of an accordion. But the cruel season also has charisma. The first clear dawn after a storm presents a powdery panorama of plastered peaks and rimed trees. The sun is so laser bright, the snow so reflectively white, that to ski without sunglasses is to risk going snow-blind.

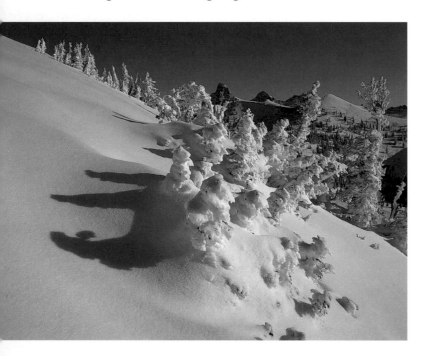

Snow is a magical medium. What else can make adults young again? One must admit, however, that many winter sports are just a little bit bizarre. Ice fishing? Ice climbing? What will they think of next? Well … elite athletes now compete in marathon races wearing snowshoes. Jeep enthusiasts, the tires of their customized chariots studded with inch-long spikes, race across ice-covered lakes. Then there's ski mountaineering, a high-risk calling if ever there was one. My friend Lou Dawson has earned a modicum of fame for being the first to ski all fifty-four of Colorado's fourteen thousand peaks; on some descents he rappelled over cliffs on ropes. Lou acts sane

enough, but considering his feat (his oft-fractured legs have been repaired with so much steel he could be sold for scrap), the line between audacious and crazy seems paper-thin.

Winter's dangers have long made it a forbidden fruit, but given a taste, many people like it. And with today's superb equipment, there's no reason an excursion in January can't be as comfortable as one in June. In 1975, with three friends, I skied through the Colorado Rockies for two hundred miles from Crested Butte to Steamboat Springs. In subsequent years, I linked other tours with the aim of skiing across Colorado, from its border with New Mexico to its one with Wyoming. I began this quest as a young bachelor dressed in woolen knickers. I finished it twenty years later, a Goretex geezer accompanied by my eleven-year-old daughter Tarn. Time flies, winter remains.

On a ski tour, most of your day is spent climbing, snaking through the spruce, meditating on the easiest route. The passes are windy, chilly, gazing stops. Nibble raisins and peanuts, gulp water, look backward, slide forward. Miles from nowhere, we ski cautiously downhill, our packs' weight a balance snare. When the powder is good, we play with a few turns, whoop and holler.

If summer has its flowerily fashions, winter has its frosty rules: keep moving, be prepared, and stay warm. A frigid arctic air mass once caught me out with a group of Outward Bound students above tree line in the Collegiate Range. As the mercury congealed, ski bindings broke, sleeping bag zippers froze, cooking stoves failed. On a warmer day, it would have been comic. But as hypothermia sapped our judgment and frostbite stole our toes, panic arose. Only a nearby snow cave, dug previously by another group, saved us. In truth, sleeping in a snowdrift often beats bunking in a motel. Outside the wind is furiously remaking the face of the world; in here, a candle burns without a flutter as I cradle a cup of steaming tea, reading a book barehanded, lying on a couch of snow.

Since most avalanche victims trigger the slide that kills them, one must be careful in the backcountry not to inadvertently commit suicide. One year, my party of four descended toward Waterdog Lake. At the top of a steep slope above the lake, we stopped to evaluate. Our destination was in plain view, tempting us down. But something about that slope was creepy and we contoured above it to a band of thick timber. As we descended through the trees, we heard a loud *Whoompf*. A six-foot fracture raced around the bowl, swallowing the spot where we had stood. Minivan-sized blocks of snow rocketed toward us. We scuttled deeper into the woods, safely out of reach.

△ THE GRAND TETONS IN WYOMING POKE UP ABOVE THE WINTER WONDERLAND THAT SURROUNDS THEM.

At first glance, a winter snowscape looks empty. But notice how quickly a fresh carpet of white acquires new tracks, as snowshoe hare and weasel play hide-and-seek. Above tree line, you may see trickster coyote trotting over wind-etched snow formations called *sastrugi.* Snug in their talus piles, guinea pig-like pikas munch hay they harvested in August. Inky black against the snow, ravens appear at curious times and places, unbidden messengers with indecipherable news.

Grouse-like ptarmigan (the "p" is silent) have feathers on their eyelids. Feathers on their nose. A foot so heavily feathered it works as a snowshoe. Exquisitely camouflaged, with winter plumage the color of cream, ptarmigan prefer to walk from danger than to fly. But ptarmigan can fly, fast, with rapid wing beats like quail, and for some reason they like sailing around during snowstorms when the visibility is nil. In these whiteout conditions, they'll make a piercing cry at twilight that will haunt your dreams all night. During blizzards, ptarmigan may burrow into the snow pack, to roost there until the storm ends, at which time they may be covered with a foot of fluff. If a cross-country skier then approaches, soaking up the quiet, sponging up the views, the birds will wait until the last possible second, then explode upward—a feathery flurry of bottle rockets threatening instant cardiac arrest.

Bears and marmots have an elegant strategy for outwitting winter. Hibernation is time travel, a nifty shortcut from

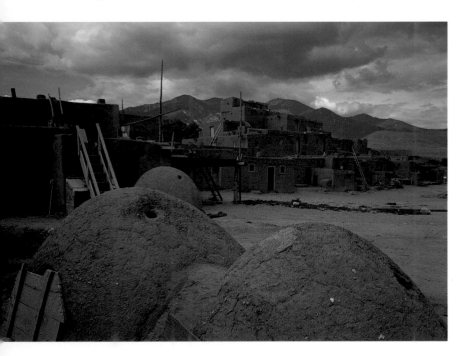

November to May. Early in November, a black bear goes into her den. Lies down. Goes to sleep. Sleeps through December. January. February, March, and April. For 180 days, she won't eat, drink, or urinate. In fact, due to changes in her digestive system, a good-sized steak would probably kill her. Unlike bed-ridden hospital patients, a bear's muscles don't weaken; at the end of six months she gets up and goes on her way as good as new. NASA is intrigued. If scientists could grasp how bears get into (and out of) hibernation, it might be possible to put astronauts into deep sleep on a lengthy space voyage.

Unlike bears, whose temperatures rarely dip below 90°F, marmots plunge to 35°F. (Some marmot researchers keep their woodchuck-sized charges in a refrigerator.) In suspended animation, they breathe just once a minute. In April, marmots rouse and tunnel to the surface. In snowy years, that first peek must be a rude awakening. On a spring ski tour, you'll sometimes see a marmot looking heartbreakingly forlorn: amid acres of white, a single brown dot, bushy tail wagging, awaiting a summer that's nowhere in sight.

About 1500 A.D., history accelerates, as if someone bumped the fast forward button. Anglos arrive in the Rockies. Forget what you learned in high school: the earliest entradas came not from the east but from the south. In 1540, the conquistador Coronado, hunting for a mythical, gold-leafed city, reached northern New Mexico to find pueblos plastered only with mud. In 1641, Santa Fe was founded, and in 1776, a pair of Spanish padres named Dominguez and Escalante rode a maze through Colorado and Utah searching (in vain) for a fast track to California. In 1793, the hardy British explorer Alexander Mackenzie crossed British Columbia to the Pacific Ocean. In some respects, Lewis and Clark's 1804 journey up the Missouri River to the Pacific was the culmination, not inauguration, of the exploratory era.

Since mountains meant delay at best, starvation at worst, early history went at right angles to them. But then, in 1807, came the fur trappers, whose occupation had a different geometry, whose work was not tangential to but congruent with the Rockies, and whose eyes were set on a different prize. The trappers went up the headwater streams, fixing for beaver. A mountain man had to be good or he was dead, which meant that the good ones got really good. Their physical exploits—Hugh Glass crawling a hundred miles after being mauled by a grizzly; Jim Bridger, stripped naked by the Blackfeet, racing barefoot for his life—are justly celebrated, but the trapper's life was also cerebral, the mind calculating all the tiny details that summed meant survival.

Saluting their craft, we should recognize that the trappers were pawns in a bloodthirsty game of international commerce, and that the "men to match the mountains" riff can be

△ THE BREAD OVENS OR HORNOS, STILL BAKE BREAD IN THE NORTH PUEBLO OF TAOS, BACKDROPPED BY TAOS MOUNTAIN.

overdone. In truth, mountain living has always demanded bravery—and not just from men. The solitary trappers often wintered with friendly tribes and sometimes married Indian women. But sleeping with a mountain man was probably as risky as being one. Here today, scalped tomorrow, these hirsute fellows were not the best providers. Giving birth in a snowbound tepee, raising children in a harsh climate—these accomplishments are not trivial for having been so common. In American hagiography, the fur trapper is Daniel Boone's scion. But Boone, wandering around the wilderness, had it easy compared to wife Rebecca, home alone with the kids.

Note, too, that the courage mountains command did not die 160 years ago. I think of Tom Kimbrough, a climbing ranger in Grand Teton National Park. Pushing sixty, he puts his life on the line every summer to rescue injured climbers from crevasses. I think of avalanche forecaster Denny Hogan, studying storm fronts on the Internet and rubbing his worry beads, trying to decide whether public safety warrants closing the highway over Red Mountain Pass. And I think of contemporary historian Patricia Limerick, drawing a bead on the old bulls of her profession, challenging their simplistic depiction of Western history as a story writ east to west, of John Wayne subjugating the savages.

Nature abhors a vacuum, and as late as 1845 that's what the Rockies were. But the emptiness wouldn't, couldn't, last. Here, it gets hard to keep the story straight, as newcomers funnel into the Rockies from all directions. This polyglot pageant featured Forty-niners racing to California's goldfields, settlers whipping oxen along the Oregon Trail, Mormons pushing wheelbarrows to their Utah Kingdom, British aristocrats (dressed as cattlemen wanna-bes, they were the original drugstore cowboys), Basque sheepherders, Croatian coal miners, Chinese coolies, mulatto ranch hands, and on and on.

The rush for a better life was grounded in hope and poverty, in desire and desperation, and, not surprisingly, in avarice and greed. Get in, get it, and get out—that was the credo. In 1872, there were perhaps fifteen million bison on the Great Plains. A decade later there would be fewer than a thousand. Miners sluiced away whole hillsides in the frenzied search for gold. As boom towns sprang up overnight (Virginia City, Montana, from zero to ten thousand in one summer), forests were slain for lumber and firewood. Poachers held contests to see who could slaughter the most game, the winners photographed by stacks of deer, elk, cougar, and black bear. Chief Joseph, the Nez Perce leader who saw it all happen, offered an epitaph: "The white men were many. We were

contented to let things remain as the Great Spirit made them. They were not, and would change the rivers and mountains if they did not suit them."

By 1900, the Rockies were a plundered province. The glittering veins of gold, the trees in the forest, the forage on

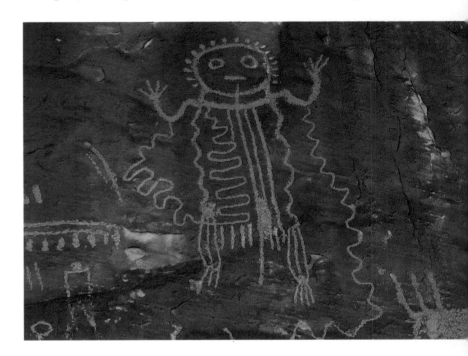

the range—all slicked off. But then something remarkable occurred. And just in the nick of time. As if threatened by a deadly virus, the Rockies spawned in the human mind an antibody, a concept called conservation. National parks and forests were established. Game laws and grazing limits were passed. Cushioned by new regulations, the Rockies demonstrated remarkable resiliency. Grass and forest sprouted anew. Game herds were slowly, painstakingly rebuilt, each state sharing its surplus with its neighbors. To pick a single example, the two hundred thousand elk in Colorado today are descended from a dozen brought from Yellowstone ninety years ago.

Indeed, what has occurred in the Rockies over the last century is one of the most heartening acts of restoration the natural world has ever witnessed. But the last chapter in this remarkable saga is still being writ. Protecting elk and deer is a no-brainer. They are enjoyable to watch, challenging to hunt, and nutritious to eat. But the current push to make room for the grizzly, to protect the cougar, and to return the wolf's howl to the wilderness speaks to a deeper need.

In 1986, two young biologists, Jay Tischendorf and Gary Koehler, set out to discover how the mountain lion was faring in Yellowstone National Park. Wolves and lions had been ruthlessly exterminated from the park in the early 1900s. The death sentence had come from Park Service administrators,

THE INTERIOR-LINE STYLE SHAMANIC FIGURE ON THE SANDSTONE WALL IS OF THE DINWOODIE TRADITION, WIND RIVER RANGE, WYOMING. △

playing God in an era when predators were unfashionable. Hounded, trapped, poisoned, and gassed, the wolf retreated to Canada. But the reclusive cougar hung on in Montana, and by the 1980s, barroom rumors suggested that the ghost cat had repopulated the remote canyons and rugged recesses of the park. Tischendorf and Koehler rented a house and proceeded to decorate it like a shaman's realm. There were tawny cougar skins on the wall, bleached cougar skulls on the mantle. Even their diet—whopping servings of venison and elk—mimicked that of their prey. After a month on skis, Tischendorf and Koehler had little to show for their efforts. But on February 10 and 11 their patience was rewarded. Entries from Tischendorf's journal suggest the flavor of the work:

1600 Gary spots tracks. They're smokin they're so fresh. This is when we'd turn the dogs loose, he says. If they hadn't already died of boredom, I respond, since only twice in twenty-eight days before we even had a chance of tree-ing a lion.

0745 Blacktail patrol cabin. Out the door, eight inches of powder await. Snowing hard, flakes sting face. Pure white landscape makes skiing difficult. Riding the powder is like ski-ing on a cloud.

0830 Yesterday we saw ravens, bald eagle, coyote, flush from an elk carcass. We ski in that direction and find a day-old carcass buried with snow. Gary notices cat tracks and in the dense falling snow they have to be fresh. Face aglow, he turns to me: "Let's see if we can put the spook on this cat, she's right here!"

0900 Gary wallows uphill, I cut through the ravine. Hasty moments later I hear a shout. "Jay, over here!" Gary com-mands. I move forward, then see him with his binoculars out. The lion has taken to a tree! I'm awed. She is complacent, silent, 20 feet up. Full belly, beautiful face.

Subsequent research confirmed that Yellowstone's cougars are flourishing. As for the wolf, in 1995, after decades of snarling debate, three packs were released in Yellowstone's Lamar Valley. With the wolf's return, the world's first national park has every mammal it had at the time whites came to the continent. Ponder that, for it is no small miracle. Farther south, the U.S. Fish and Wildlife Service has mounted an audacious effort to restore the Mexican wolf, the fabled lobo, to its former haunts in New Mexico. Although prospects for all these preda-tors remain deeply uncertain, their hold on public opinion is getting stronger every day. More and more Americans recog-nize that the Rockies are the last stronghold. If the great hunters can't make it here, they won't make it anywhere.

As America falls back on itself, rebounds from the coasts, the Rockies have become the final frontier. The region's allure has not gone unnoticed. Pontiac dubs its new minivan the "Montana," calls it a "rugged new breed," and claims that "life is more exciting in Montana." That's hype, of course, but it is remarkable how many sport utility vehicles strive to bask in the alpenglow. Ready to bust out of the sub-urbs in a go-anywhere four-by-four? Choose among Pathfinder, Explorer, Trooper, Expedition, Wrangler, and Mountaineer.

As the millennium approaches, "Bring on the twenty-first century!" is the regional battle cry. The Rockies have arrived. No longer a cow town, Denver boasts a new $5 billion airport. Salt Lake City is preparing to host the 2002 Olympics. High-tech, bio-tech, and computer companies are arriving in droves. Untethered by the telecommunications revolution, "modem cowboys" lasso new digs in chic mountain towns like Telluride, Park City, Sun Valley, and Jackson Hole. Lords of commerce snatch up trophy ranches. Ted Turner now owns a

chunk of the Rockies the size of Rhode Island. The "blue jean" industries—mining, logging, and ranching—may be strug-gling, but services, manufacturing, and tourism are booming. Sightseeing and outdoor recreation, the Kodak-and-lycra economy, is based on the Rockies' long suit—the charisma of its clean, spacious landscapes. There's an old cliché that "you can't eat the scenery," but today more and more tourists, including millions of foreigners, are happily paying for the privilege of feasting their eyes on the mountains.

But it's not just tourists. Growing numbers of people are coming to the Rockies to live, work, raise a family, or retire.

AN OWL TAKES A REST IN THE WINDOW OF A DESERTED BARN IN MONTANA. △

Just in the last five years, more than a million newcomers have settled in Idaho, Montana, Wyoming, New Mexico, Utah, and Colorado. This influx mirrors a much longer trend. In 1850, just two lifetimes ago, the six mountain states had fewer than one hundred thousand people. Now they are home to one hundred times as many, about ten million. What drives the pilgrimage? The stock answer is good jobs, affordable housing, outdoor recreation, the mountain lifestyle. But these generalities mask deeper emotions. Lately, I've been asking my friends, "Why did you move to Colorado?" Listening to their narratives, I've

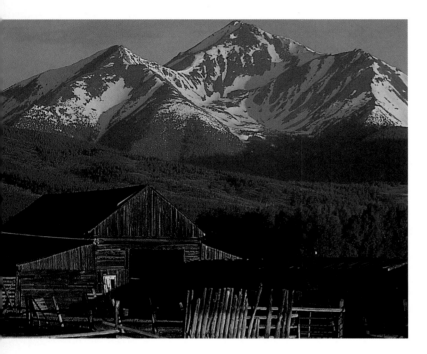

concluded that the Rockies are not just magnetic, they are infectious. A single exposure can haunt you for years.

John and Diane moved to western Colorado twelve years ago. Married, in their fifties, Diane is a nun-turned-potter; John, a counselor. Flatlanders for forty years, they can now see the pyramidal summit of a thirteen-thousand-foot peak through their living room window. Diane was twenty-seven years old when she saw her first mountain: "I almost swooned. After nine years in a Catholic convent, I came to Colorado and saw God. Two and a half miles above sea level, a girlfriend and I took photos of ourselves, standing in front of snowbanks as tall as a bus." John first came West in 1954, a twelve year old headed for summer camp. "Oklahoma summers were relent-less," he recalls, "Ninety-eight degrees, humidity to match. In bed, I'd suffocate in my sheets. In Colorado, it got cold at night. You could sleep."

In 1984, John and Diane loaded their belongings into a U-Haul truck and drove west. It was a conscious deci-sion to shift tracks, escape expectations, make a fresh start.

"I wanted out of the cloying suburbs," says John. "I wanted to live in a rural place, where I could walk out my door and hike to Alaska on public land. You can't do that in Missouri."

Despite the region's burgeoning population, the Rockies remain uncrowded. Settlement patterns preserve elbow room. People say they are "moving to the mountains," but most land in cities, not on ranchettes. Furthermore, there really aren't any cities in the mountains; Denver, Salt Lake, Albuquerque, and Calgary all recline on the plains. To fly low over the Rockies in a small airplane is to be struck at how vacant the province remains. There are still about as many antelope (470,000) as people in Wyoming, and some counties in Colorado have more elk than voters.

Given its harsh winters and stony soil, the Rockies are destined to always be a hinterland, lightly populated by a rugged and resourceful citizenry. For one thing, the higher elevations are uninhabitable. In Peru, peasants grow crops at fourteen thousand feet, but no one in Colorado lives much above ten thousand. Leadville, elevation 10,188 feet, the state's highest town, is a claustrophobic ice box, a voluntary prison with the inmates in charge. Based on personal experience, I posit nine thousand feet as the upper limit for psychological health, and this "shrink line" becomes lower as you move north.

After our first daughter was born, my wife Leslie and I spent a winter caretaking a dude ranch at ninety-four hundred feet. The secluded spread was lifted from a Marlboro ad: wood stacked on the porch, smoke spiraling from a stove pipe. Our inaugural month was idyllic. We skied the meadows with our daughter in a Snugli, baked bread, listened to music. But as snow banked to the eaves and the sun played peek-a-boo behind the ridges, life grew difficult. We began referring to our domicile as the "Arctic Research Station." Then it dawned on us that we were the experiment. The utter isolation, the somber quiet—what had seemed enchanting grew oppressive. In April, Leslie took her vague physical complaints to a neurologist. Watching her hop on one foot, he presented a diagnosis: stir crazy with a touch of cabin fever. We moved three thousand feet lower and a world away.

From Glacier National Park in Montana, the Rockies trend north-by-northwest for fifteen hundred spectacular miles. The Canadian Rockies reach their zenith a few hun-dred miles north of the U.S. border near Banff National Park. Established in 1885, this is the world's second-oldest national park—and a scenic juggernaut that attracts five million visitors and $4.4 billion in tourist business each year. With its

△ MOUNT YALE (14,196 FEET) RISES ABOVE A RUSTIC BARN IN THE UPPER ARKANSAS RIVER VALLEY OF COLORADO.

Ralph Lauren shop and Hard Rock Cafe, Banff offers cutting-edge kitsch. But there's nothing tacky about turquoise Lake Louise, one of the park's highlights.

Banff and nearby Jasper National Park, the largest park in the Rockies, offer something for everyone. There are luxurious

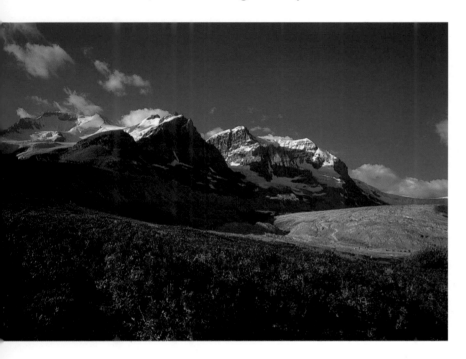

lodges, some of the most spectacular highways in the world, ice caps, verdant forests of western red cedar, a plethora of wilderness areas, and a panoply of wildlife. Big name mountaineers are drawn to Mount Robson and Mount Assiniboine, impregnable hatchets thrown at the sky, and to the Bugaboo's granitic fangs. I once saw a dramatic photograph of a climber glissading down a steep snowfield on Pigeon Spire. Jets of snow flew up from his boots as he skidded to a halt on the edge of a five-hundred-foot cliff. *There's a fellow with complete confidence in his ice ax,* I mused.

It saddens me to report that most of this fine country is destined to remain outside my ken, for I'd need another lifetime to explore the Canadian cordillera. Some years ago, however, I did have an opportunity to visit the fabled Brooks Range. A six-hundred-mile-long scimitar across Alaska, the Brooks Range is the northernmost major mountain range on the planet. Few people associate the Rockies with arctic Alaska, but geographers say it is here, less than fourteen hundred miles from the North Pole, that the range finally comes to an end.

The first thing I learned on that trip was that bush pilots don't worry about being hijacked. As we flew out of Fairbanks in an ancient DC-3, the pilot came on the horn: "Feel free to come up for a look." In a wink, three of us are crammed into the cockpit, awkwardly craning our necks to feast our eyes. As we skim along at nine thousand feet, shafts of sunlight dart through holes in the overcast to pick out soaring ridges and gullies traced by lingering snowdrifts. Hanging glaciers, their snouts guillotined by gravity, appear cradled in the cirques they have chiseled.

The ancient plane is rattling like a shop vac sucking nails, but it could be raining rivets for all we care because we're flying above the Arctic National Wildlife Refuge. Home to wolf, wolverine, gyrfalcon, snowy owl, tundra swan, barren ground grizzly, and the Porcupine caribou herd (160,000 strong), this natural haven is also America's most coveted petroleum prospect. Studies suggest there's a one-in-five chance that the refuge overlies $60 billion worth of oil. We land in Kaktovik, an Inuit village on the Beaufort Sea, cram into a Cessna like frat boys into a Volkswagon, then fly up a winding river valley, bouncing down on a rough gravel bar alongside the Hulahula River. Named by homesick Hawaiian whalers a century ago, this is the river our party has flown three thousand miles to run.

A-Whoosh! A-Whoosh! As I work the raft's foot pump, I gaze around. Gray, erosion-ravaged mountains rise six thousand feet to flank this U-shaped valley. From up there, I must look like a midget drowned in a vast bowl of golden twilight. The hillside across the way is alive with gamboling white dots. I pick up my binoculars, but the Dall sheep appear little larger at 7x than with the naked eye. This is disconcerting. Are they really that far away? My eye searches for something to gauge distance against. But there are no trees here—they've been pruned by an invisible isotherm on the south side of the range—and few rocks. The majestic scale of the land threatens to dwarf me. I feel vulnerable—in danger of being swallowed by space and swamped by beauty.

After dinner I spot a caribou bull, the first I have ever seen. Grabbing a camera, I jog downwind, then cut toward the bull's path and hide behind a willow. In minutes the bull approaches to within twenty yards. His upswept antlers are in velvet, his pelage in its prime. The camera shutter sounds like a rifle's bolt action closing; with a bucking snort, he flees.

Like many Alaskans, our guide Jim Campbell pays little heed to circadian rhythms. When others go to bed, he goes hiking. One night I go with him. For four hours we rove the tundra, relishing the lambent light. Animals and their sign are everywhere. I'm sleepwalking homeward when I spy a grizzled shape in the willows. Afraid it's a bear, I retreat. Jim comes up, we get binoculars out and identify it—porcupine. I'm incredulous. What's a porcupine doing two hundred miles north of

△ MOUNTS ANDROMEDA AND ATHABASCA TOWER ABOVE DWARF FIREWEED AND ATHABASCA GLACIER, JASPER NATIONAL PARK, ALBERTA.

the Arctic Circle? The answer is a marvel of zoogeography. All four genera of porcupines evolved in South America. Three genera expanded northward only as far as Central America. But the fourth, *Erethizon dorsatum*, has come five thousand miles farther to within waddling distance of the Beaufort Sea. The humble porky is a rodent Odysseus: the most distantly dispersed mammal of South American origin.

Three days later, as we're pitching the tents, we see our first tundra grizzly cavorting a thousand yards away. "Come closer," someone pleads. On cue, the bear makes a beeline toward us. He disappears behind a knoll. Reappearing only two hundred yards away, his aura buffets us like a gust of wind. We're trespassing. I turn to Jim and he says, "Maybe I ought to get my firecrackers." Some guides carry a rifle to protect against the world's largest terrestrial carnivore. Gentle Jim, though, travels unarmed, relying for protection on fireworks and what he calls "moral suasion." "Stand your ground," he instructs. "Tell him we won't hurt him. Remember, he's more afraid of you than you are of him."

"Yeah, right," my cousin Tom responds. As the bear continues to steam our way, Tom and I conclude that moral suasion might be more efficacious if we were on the other side of the river. Scrambling into a raft, the two of us paddle across, chased by Jim's shout: "You idiots! They swim like Mark Spitz!"

The next morning, Jim tells us we have been dilly-dallying. It's thirty-five miles to the takeout, and we must be there tonight. Paddling into a cutting wind off the sea ice, we battle our way downstream. At lunch, I'm smearing peanut butter on a biscuit when someone spots a herd of musk oxen. Cameras in hand, we go to greet them. Only eighty thousand of these animals grace the planet, and something about them rings a chord in me. I think about what they're born to endure—howling blizzards, shattering cold—and about the Ice Age predators they have outlasted, including *Canis dirus*, the fierce forerunner of the modern wolf, and *Smilodon*, the saber-toothed cat whose serrated fangs were eight inches long. When we get too close, the adults wheel together, shielding the calves from harm. They look at us with an air of resignation, eons of predation having made this drill so routine.

As we approach the ocean, the Hulahula braids its liquid rivers with lithic ones. When we fail to divine the deepest channel, the rafts go aground. Everyone curses, then we clamber into the frigid river and tug our guts out. By 5:00 P.M., we are weary; by 7:00, punch-drunk; at 9:00, shivering in exhaustion, we surrender and make camp miles short of our goal. We reach our takeout the next morning. Waiting for the bush

plane, I photograph rusty oil barrels abandoned on the tundra. The drums are empty, which I read as a portent.

"Take only photographs, leave only footprints" may be the wilderness wanderer's creed, but mountain travel is made possible by oil. Beginning about 1920, when petroleum came into wide use, oil has shrunk the continent, brought the Rockies within reach. By shrinking space, oil has also altered the feel of the mountains, made the wild appear tame. But now the golden century of oil is coming to an end. About three-fourths of all the oil that will ever be produced in the United States has already been burned. It's gone, finito. According to British Petroleum, world oil production is likely to peak by 2015. Thereafter, the petroleum tide will steadily ebb.

What does this bode for the Rockies? A change of this magnitude in the energy landscape will dramatically alter the West's economy. Although the new contours are impossible to predict, as oil becomes scarce and more expensive, the feel of the mountains may inflate again. In recent decades, hydrocarbon man has had the run of the planet's ranges. But minus our oil-fueled machines, human beings are no match for the mountains. By 2100, world oil production will be much, much smaller than it is today. And in that oil-short world, the Brooks Range may seem as remote as the back side of the moon.

For now, though, the Rockies remain accessible. And that's splendid news for my clan and for yours. Whatever

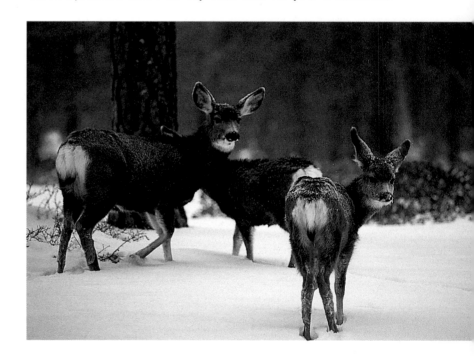

your interests, whatever your age—if you give them a chance, these mountains will stir your soul, hug you in a profound, unforgettable embrace. But please, don't take my word for this. Go see for yourself.

MULE DEER, HIGHLIGHTED WITH POWDERY SNOW ON THEIR FUR, CONGREGATE ALONG THE RIM AT BRYCE CANYON NATIONAL PARK, UTAH. △

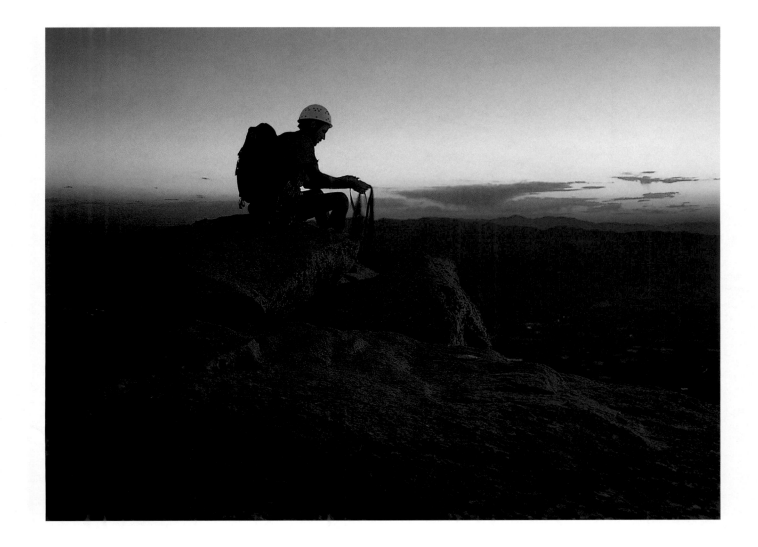

△ A CLIMBER GATHERS HIS

EQUIPMENT ON THE SUMMIT

OF LONE PEAK IN THE WASATCH

MOUNTAINS OF UTAH.

THE VIEW FROM THE TOP IS

ALWAYS A GREAT INCENTIVE

TO CLIMB MOUNTAINS.

▷ MOONSET COLORS THE

GRAND TETONS AT DAWN

IN WYOMING'S GRAND TETON

NATIONAL PARK.

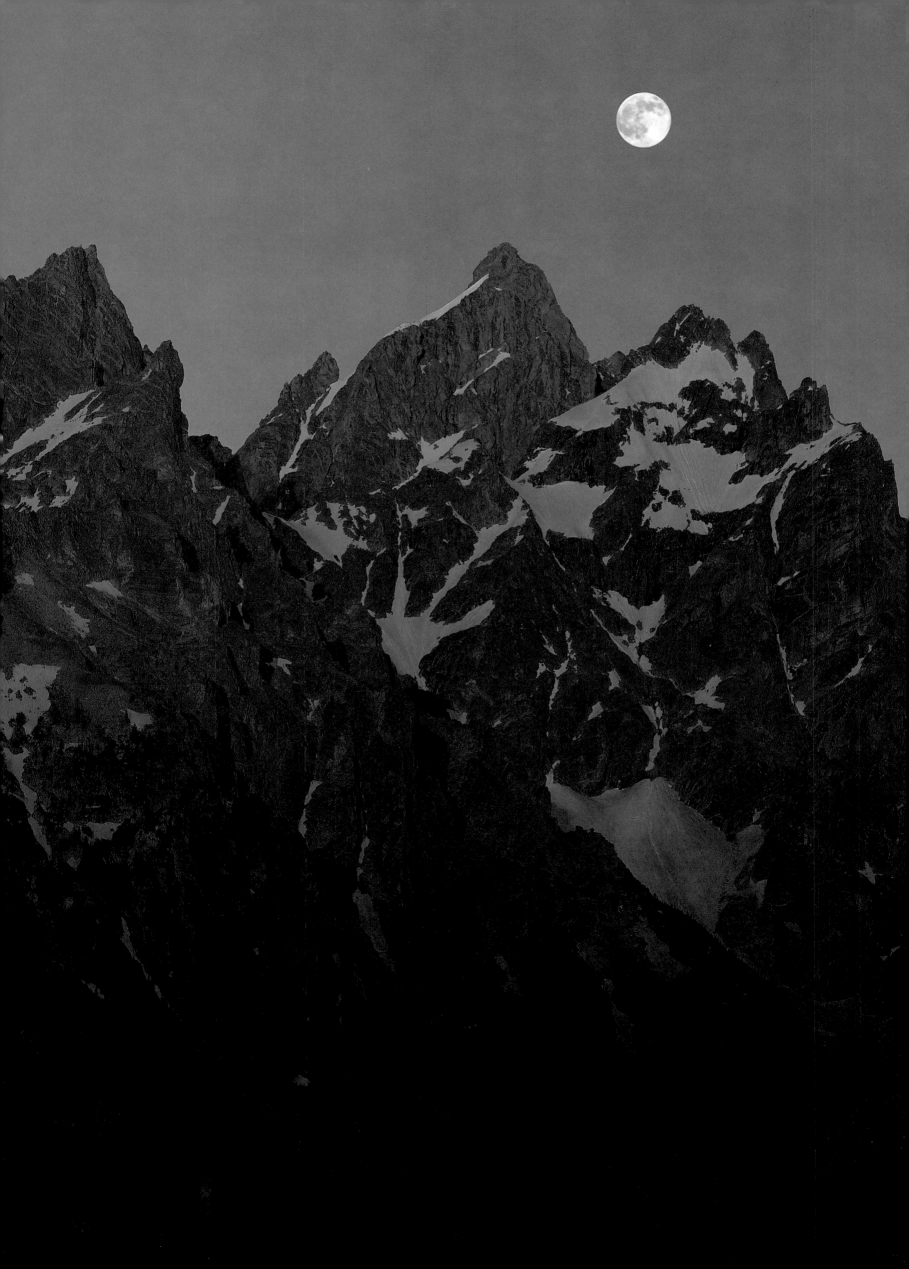

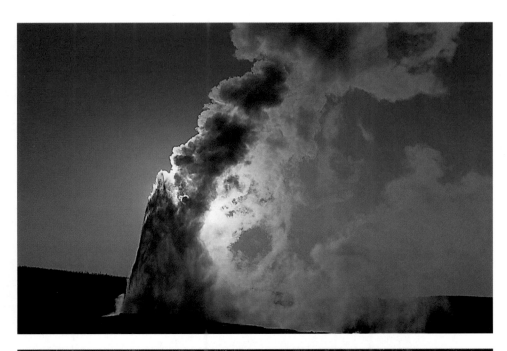

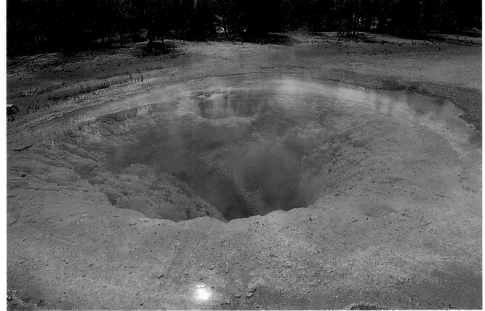

△ △ WYOMING'S OLD FAITHFUL

GEYSER IS ONE OF THE JEWELS OF

THE UPPER GEYSER BASIN,

YELLOWSTONE NATIONAL PARK.

△ MORNING GLORY POOL LIES IN

YELLOWSTONE'S UPPER GEYSER BASIN.

▷ DAWN CATCHES YELLOWSTONE

FALLS IN THE GRAND CANYON OF

YELLOWSTONE NATIONAL PARK.

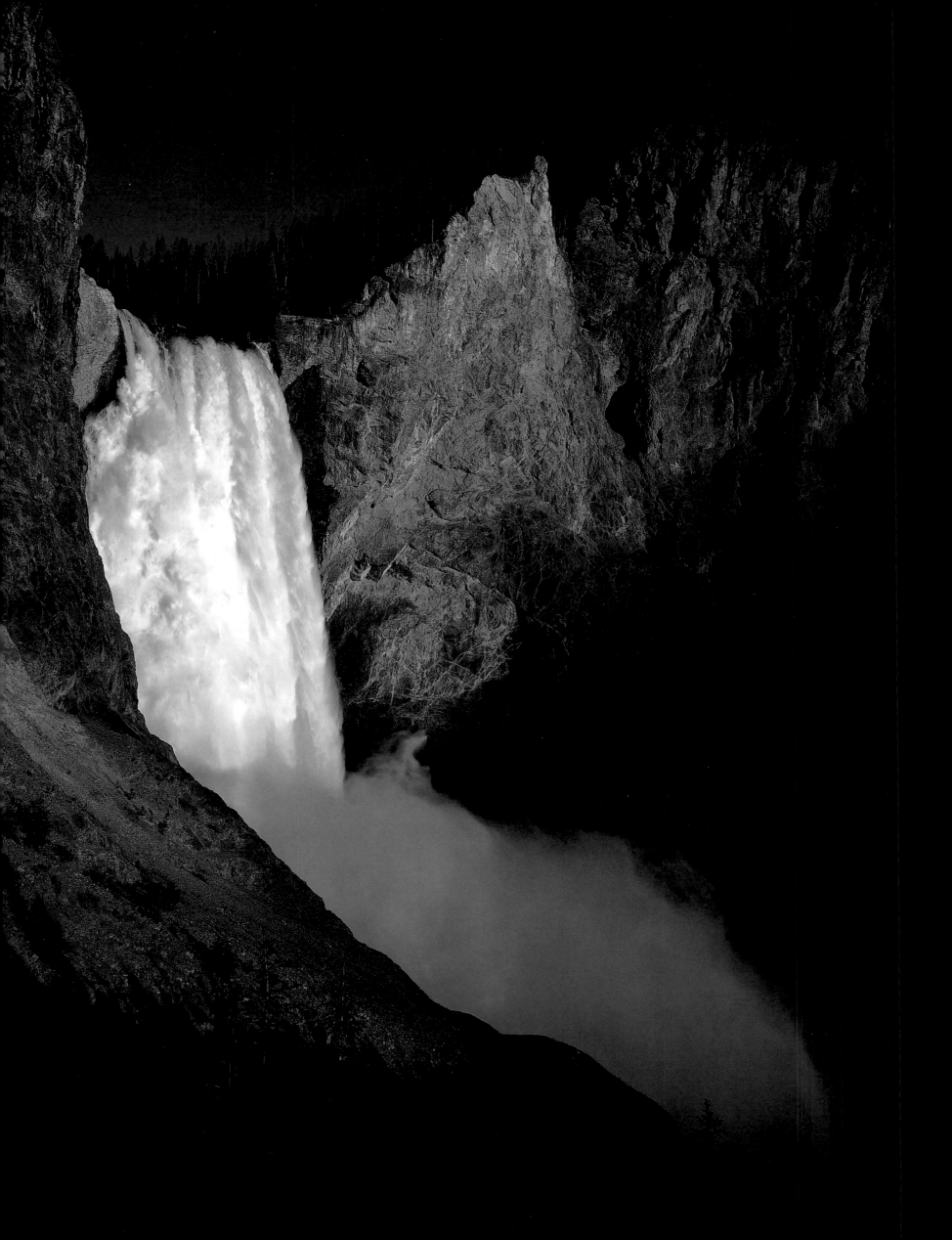

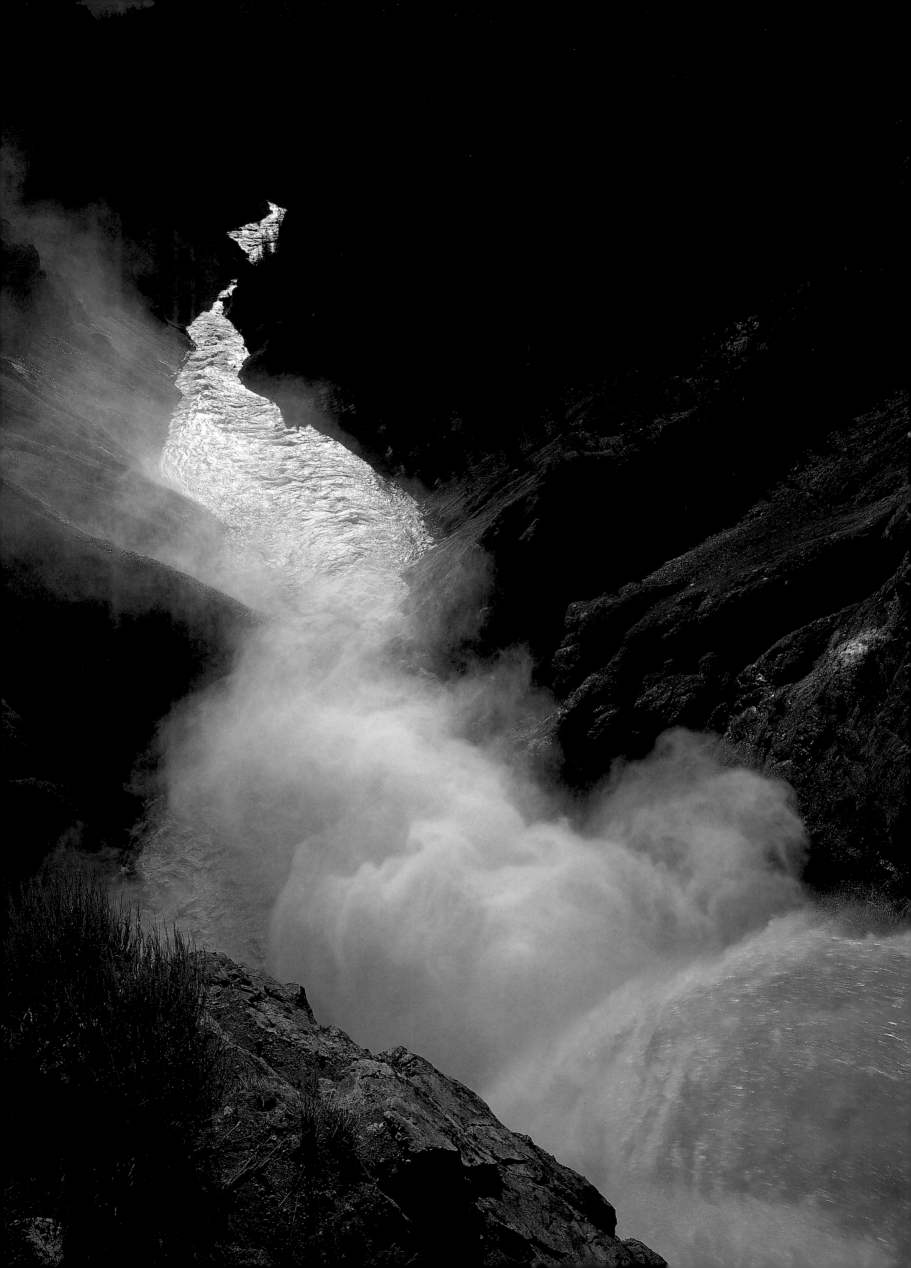

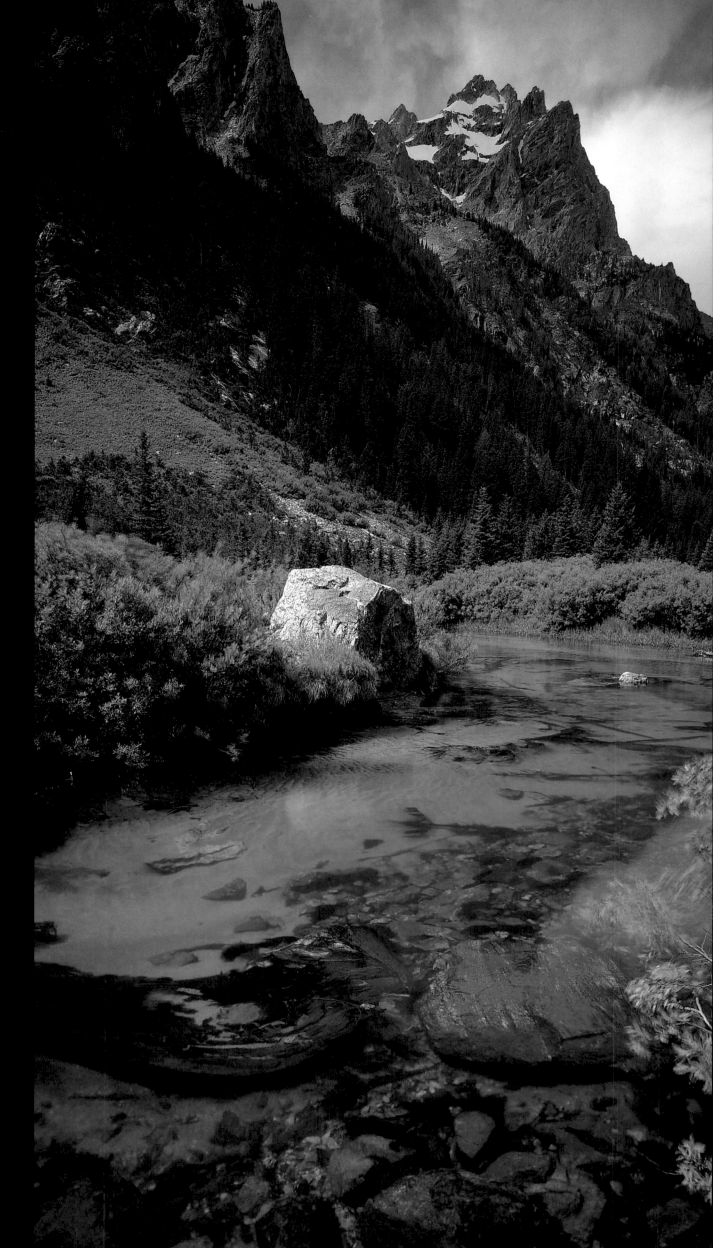

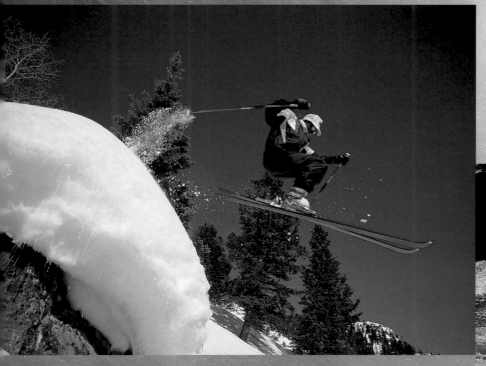

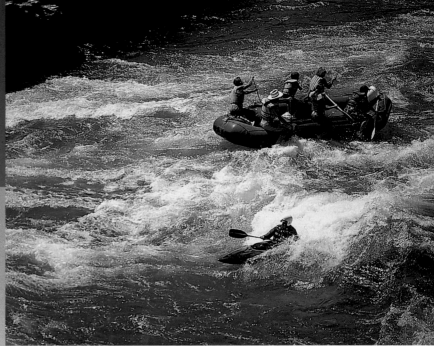

△ (BACKGROUND) A CASCADE.

△ △ A SKIER AT JACKSON HOLE

SKI AREA CATCHES SOME OF

THAT CLEAN WYOMING AIR.

△ THE FUN NEVER ENDS FOR

OUTDOOR ENTHUSIASTS IN

WYOMING'S SNAKE RIVER VALLEY.

▷ A KAYAKER RIDES A RAPID IN

THE SNAKE RIVER OF WYOMING.

▷ ▷ A CLIMBER RAPPELS

FROM A SUMMIT IN THE

GRAND TETONS OF WYOMING.

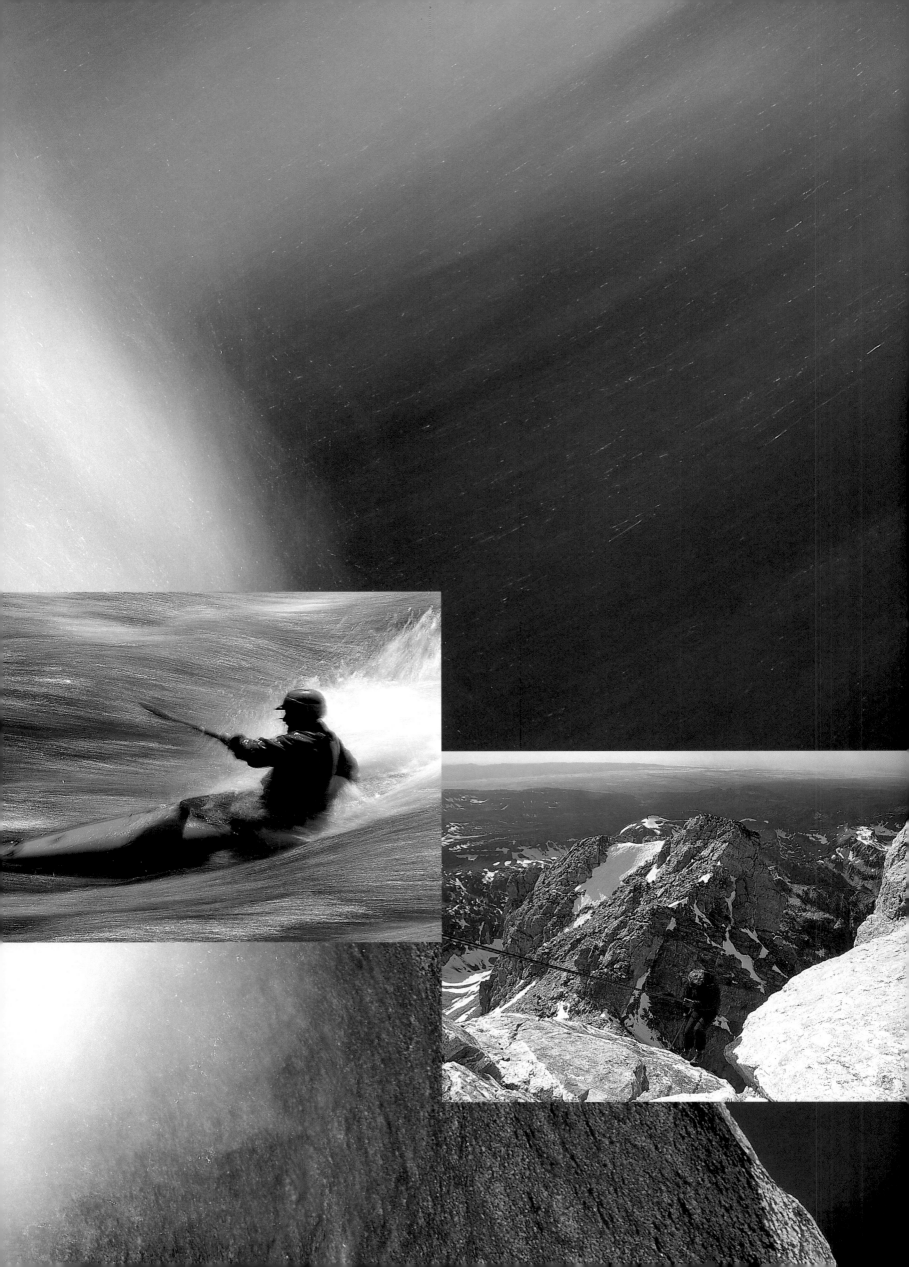

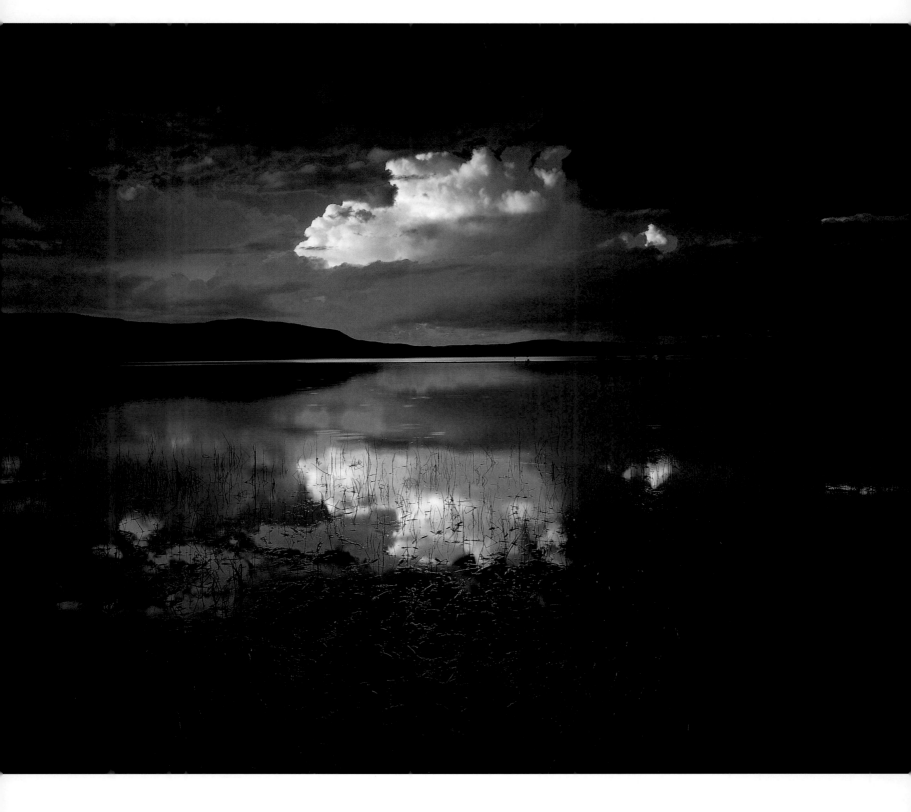

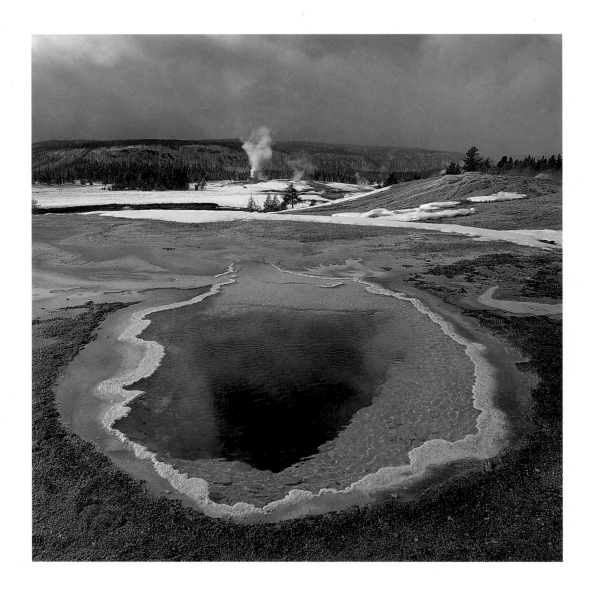

◁ LAKE YELLOWSTONE, IN WYOMING'S

YELLOWSTONE NATIONAL PARK, IS THE

LARGEST BODY OF WATER FOR MILES,

CREATING MANY HIDDEN BAYS, LIKE

THIS ONE ALONG THE WEST SHORE.

△ STEAM FROM A DISTANT GEYSER

RISES OVER THE UPPER GEYSER

BASIN. IN ADDITION TO OLD FAITHFUL

GEYSER, THERE ARE MANY OTHER HOT

POOLS AND ACTIVE GEYSERS NEAR

YELLOWSTONE'S OLD FAITHFUL LODGE.

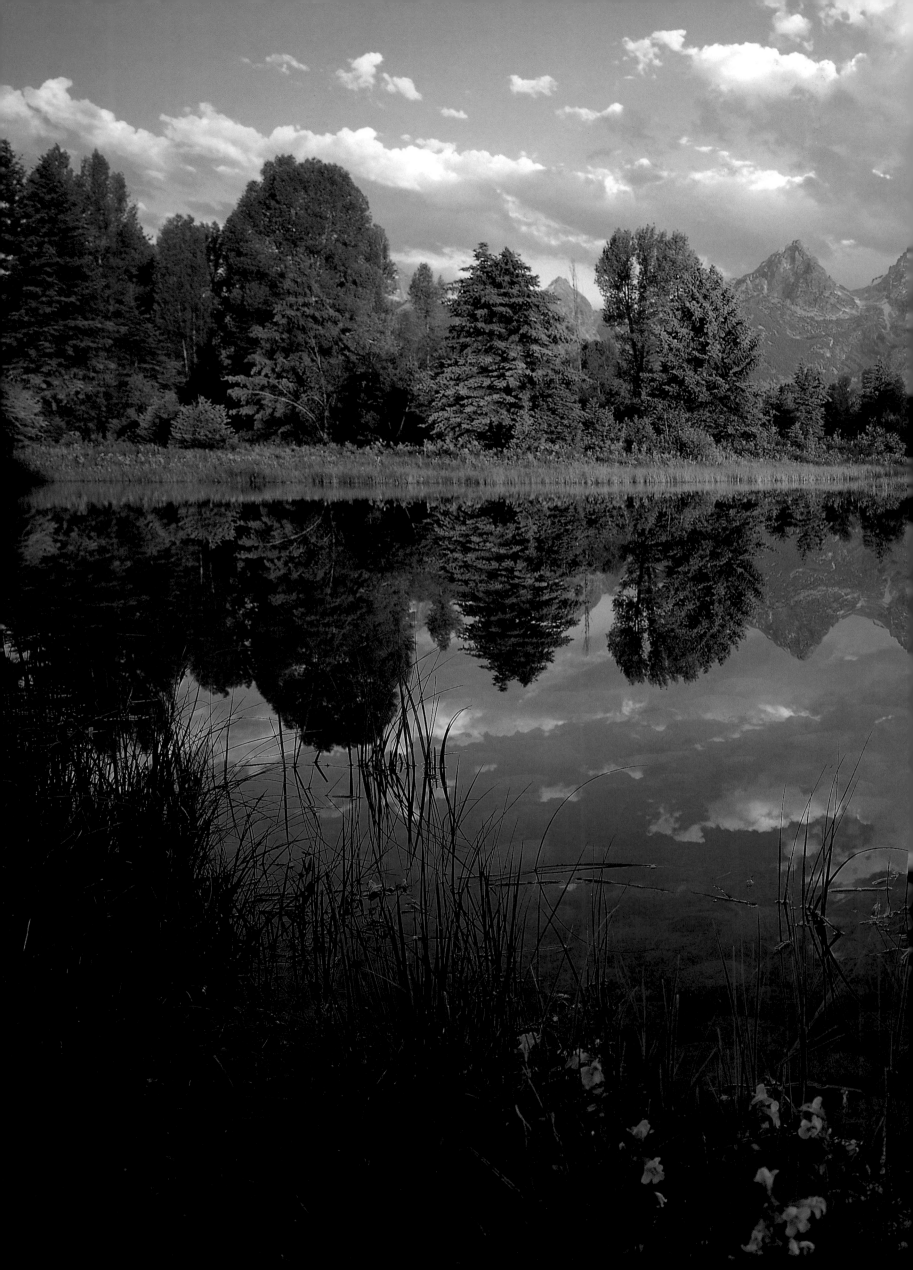

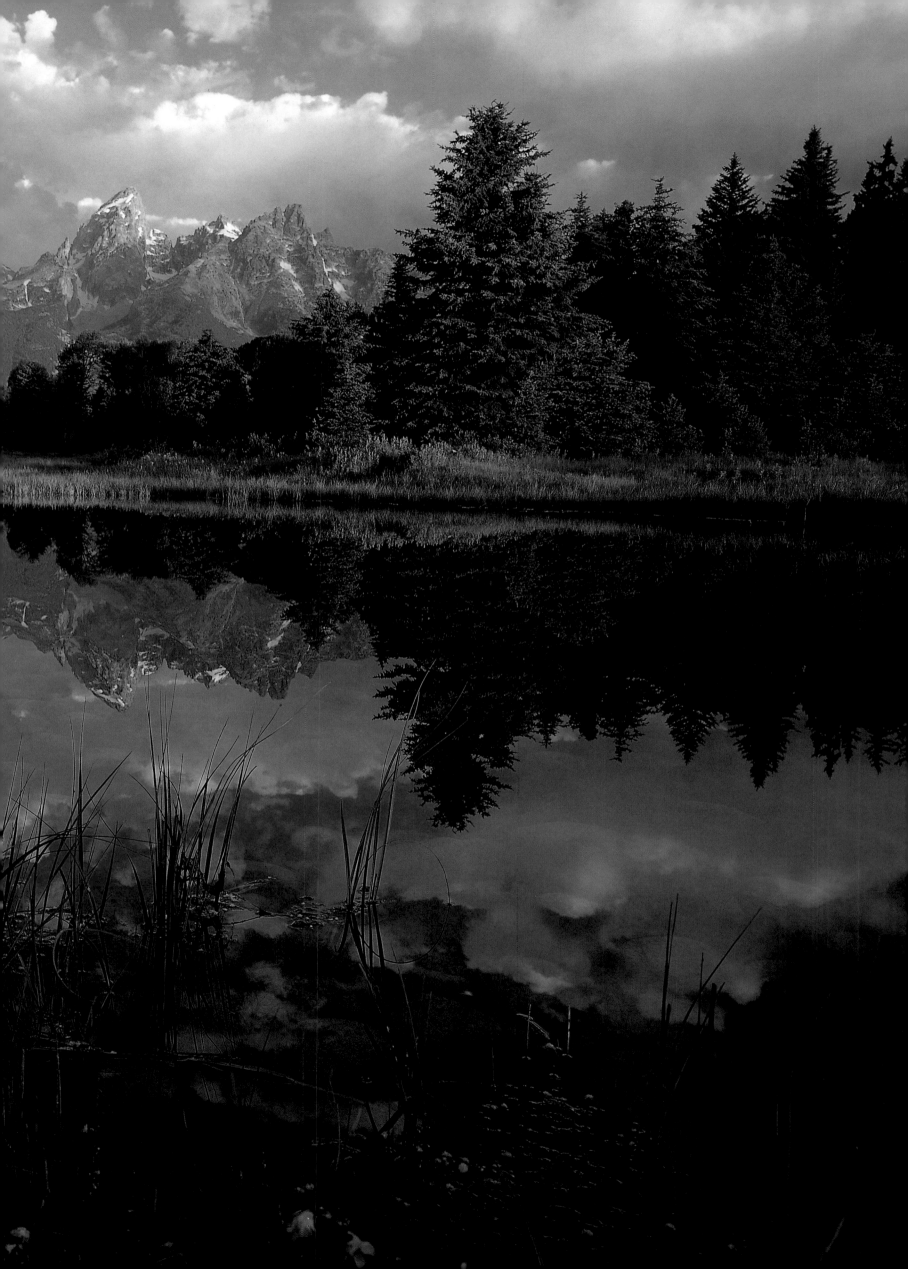

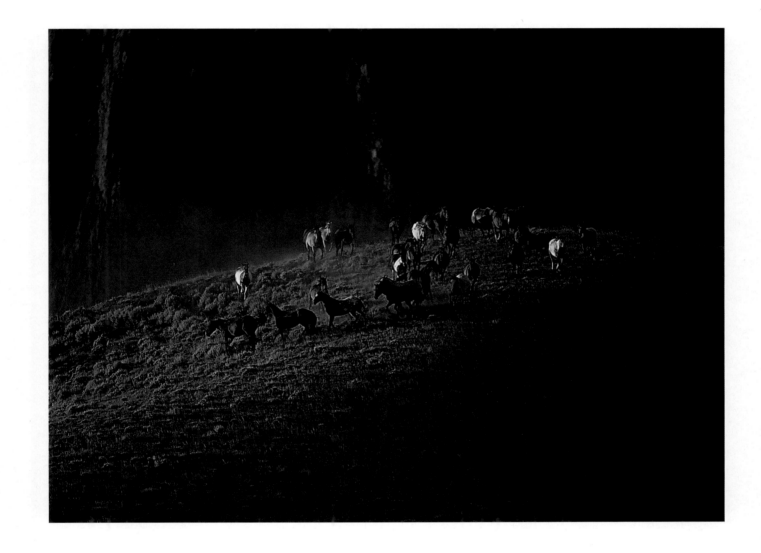

◁ ◁ A BEAVER'S DILIGENT EFFORTS

HAVE CREATED THIS REFLECTIVE

MOMENT IN A POND ALONG THE

SNAKE RIVER AT DAWN, GRAND

TETON NATIONAL PARK, WYOMING.

△ JUST OUTSIDE THE EAST

ENTRANCE OF YELLOWSTONE

NATIONAL PARK IN WYOMING, A HERD

OF HORSES RUNS OVER A HILL.

▷ FOG ADDS MYSTERY ALONG THE

YELLOWSTONE RIVER IN THE

HAYDEN VALLEY OF YELLOWSTONE

NATIONAL PARK IN WYOMING.

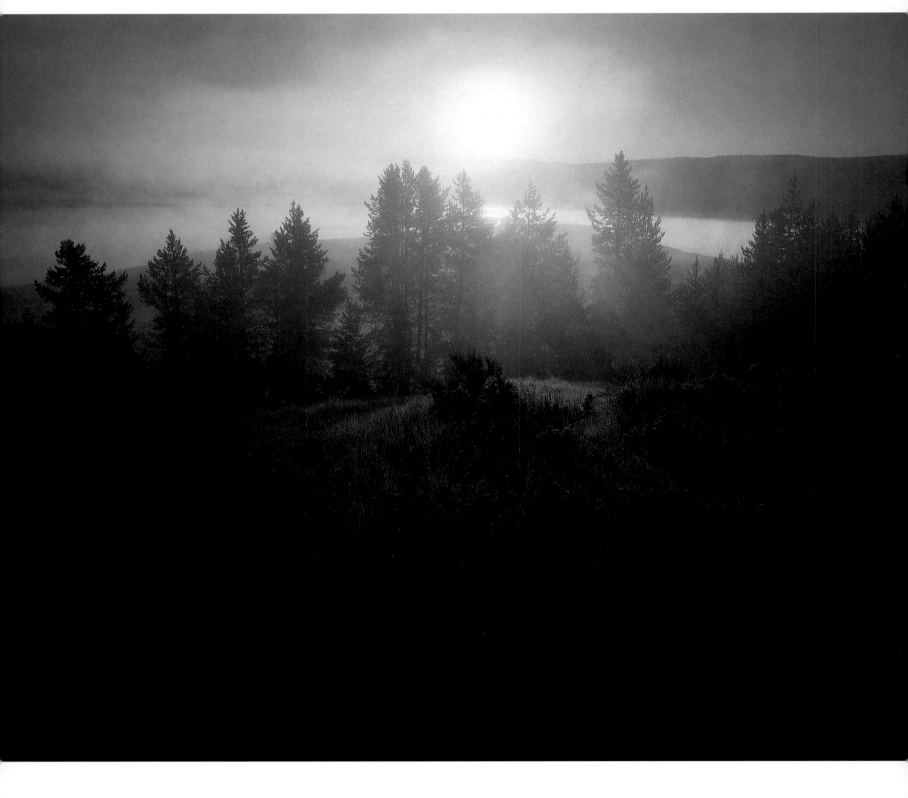

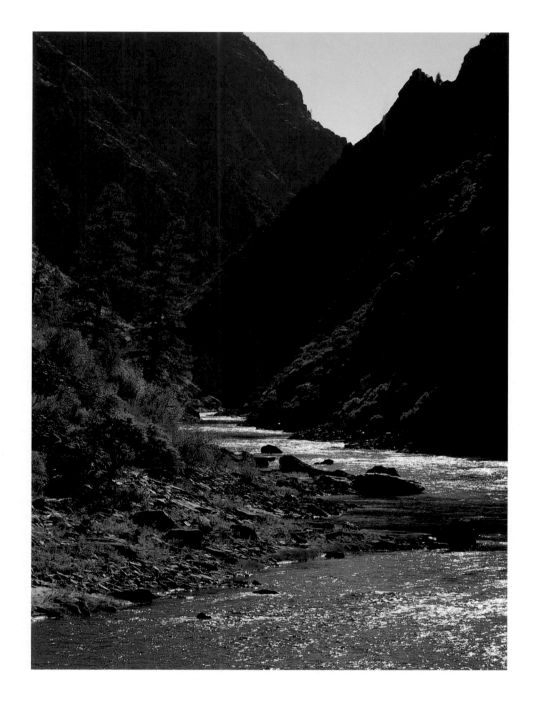

△ THE SALMON RIVER'S MIDDLE

FORK AND MAIN BRANCH JOIN

AT A CONVERGENCE OF ROCK WALLS

TO BECOME THE SALMON

WILD AND SCENIC RIVER, IDAHO.

▷ IDAHO'S SALMON RIVER PROVIDES

RECREATION AS IT DRAINS THOUSANDS

OF ACRES OF MELTING SNOW.

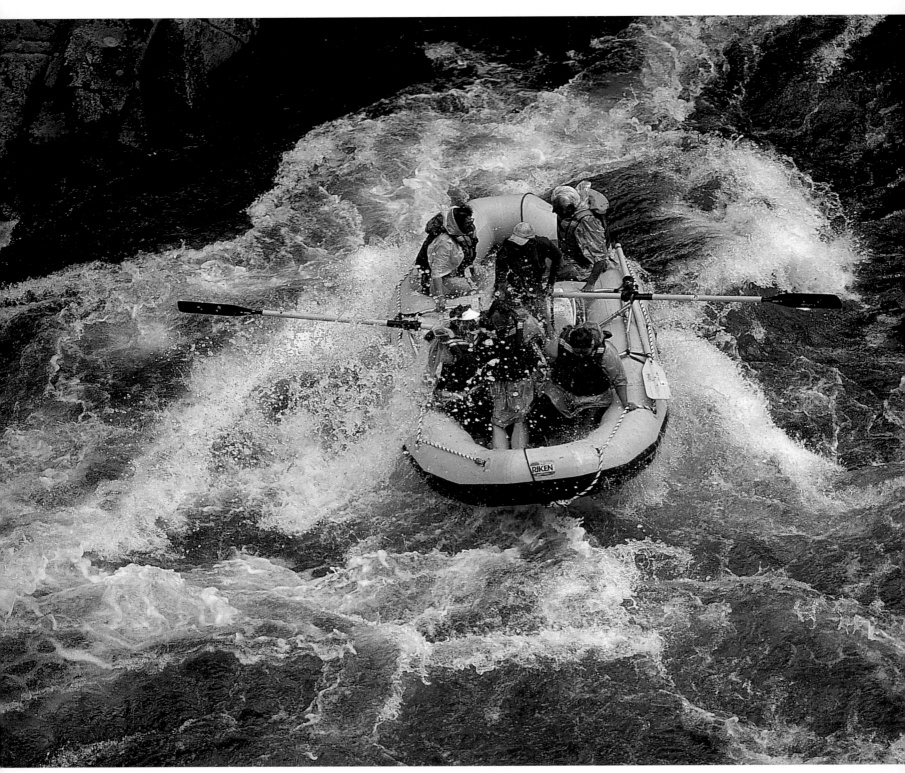

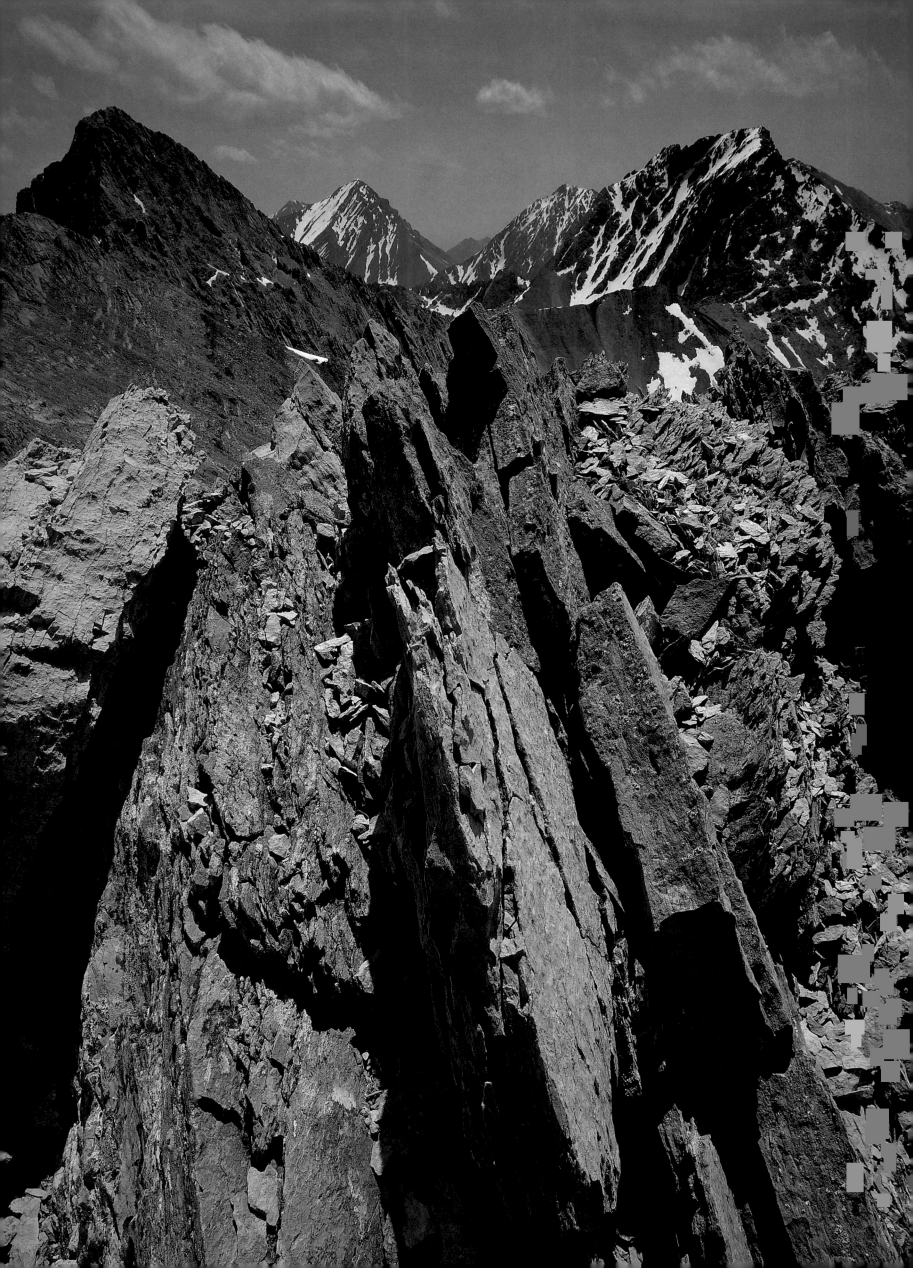

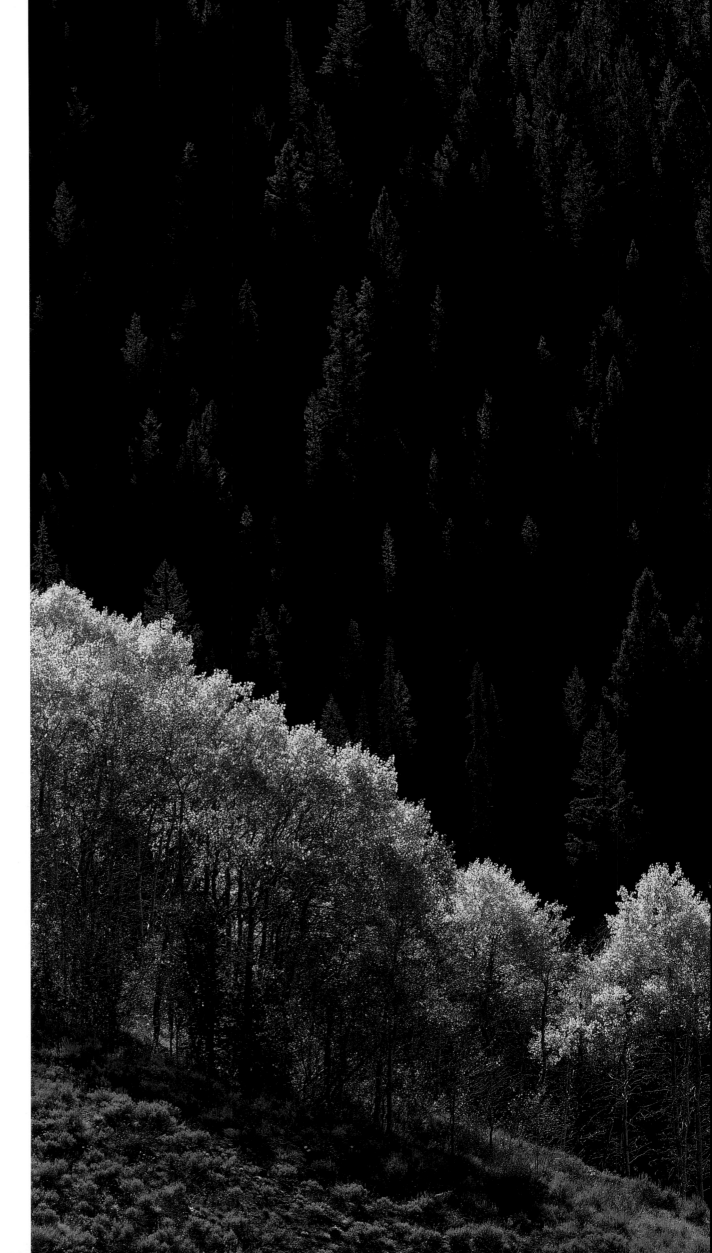

◁ FROST-FRACTURED TOPROCK

DESCRIBES THIS EXPOSED

FRAGILE CRESTLINE OF PEAKS

IN THE LOST RIVER RANGE.

THE VIEW INCLUDES LEATHERMAN

PEAK TO THE SOUTH FROM

BORAH PEAK (12,662 FEET), IDAHO.

▷ AUTUMN LIGHT ENTREATS

THE EYE TOWARD THE STEEP

SLOPES OF GALENA PEAK,

BOULDER MOUNTAINS, SALMON

RIVER HEADWATERS, IDAHO.

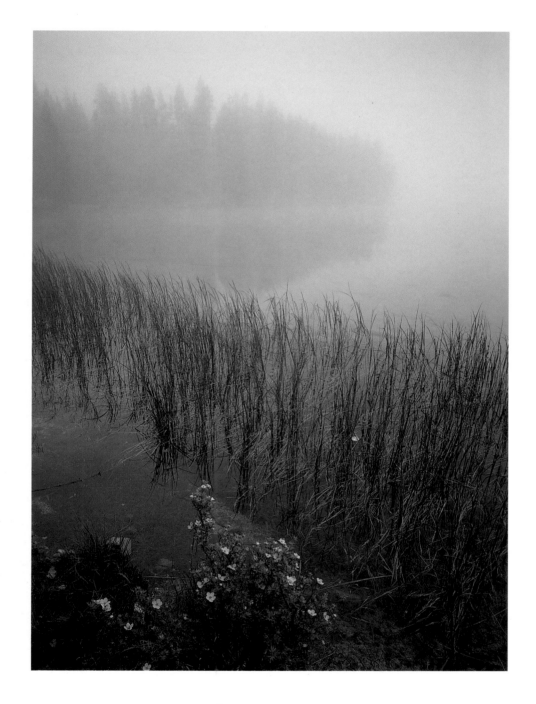

△ FOG ENVELOPES THE

SHORELINE OF LITTLE REDFISH LAKE,

SAWTOOTH RANGE, IDAHO.

▷ WHERE THE ROCKIES TAKE

A JOG TO THE WEST FROM THE

NORTH-SOUTH SPINE OF THE

RANGE LIE THE SAWTOOTH

MOUNTAINS OF IDAHO.

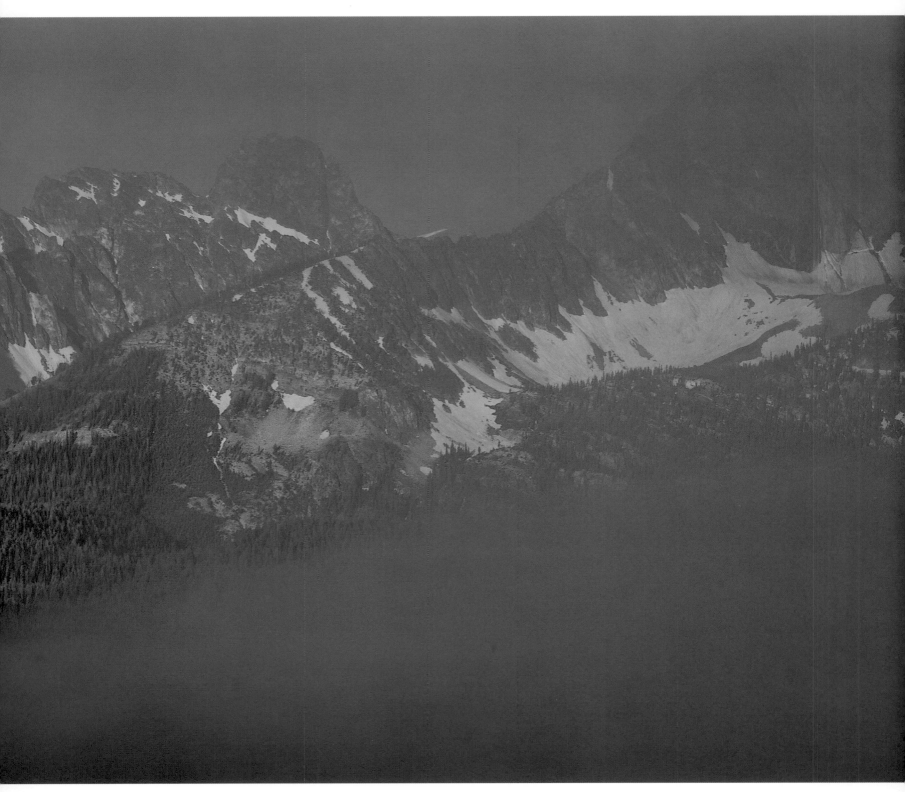

146

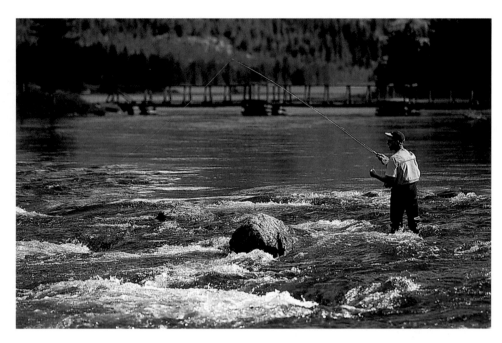

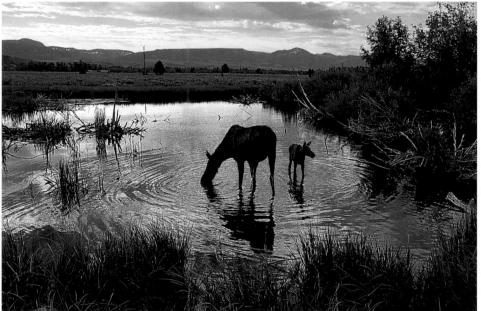

△ △ A FLY FISHERMAN CASTS

HIS FLY INTO THE EAST

ROSEBUD RIVER OF MONTANA.

△ A MOOSE AND HER CALF FEED

IN A SMALL POOL IN THE GRAND

TETON NATIONAL PARK, WYOMING.

▷ MOONSET IS REFLECTED

IN LITTLE REDFISH LAKE,

SAWTOOTH WILDERNESS, IDAHO.

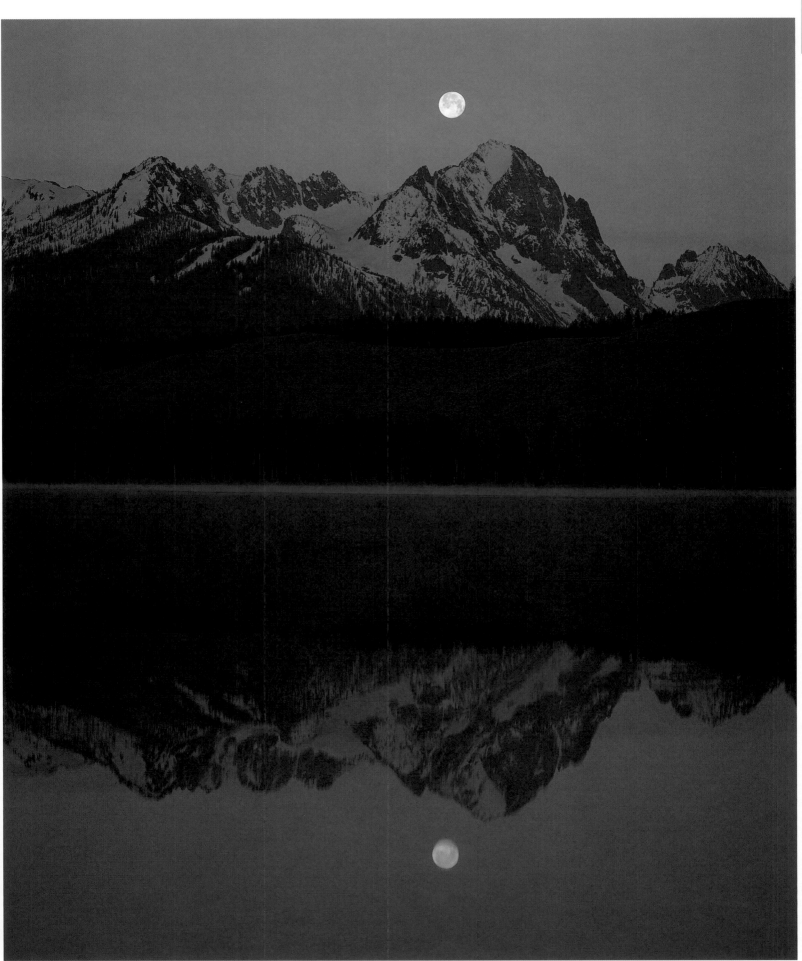

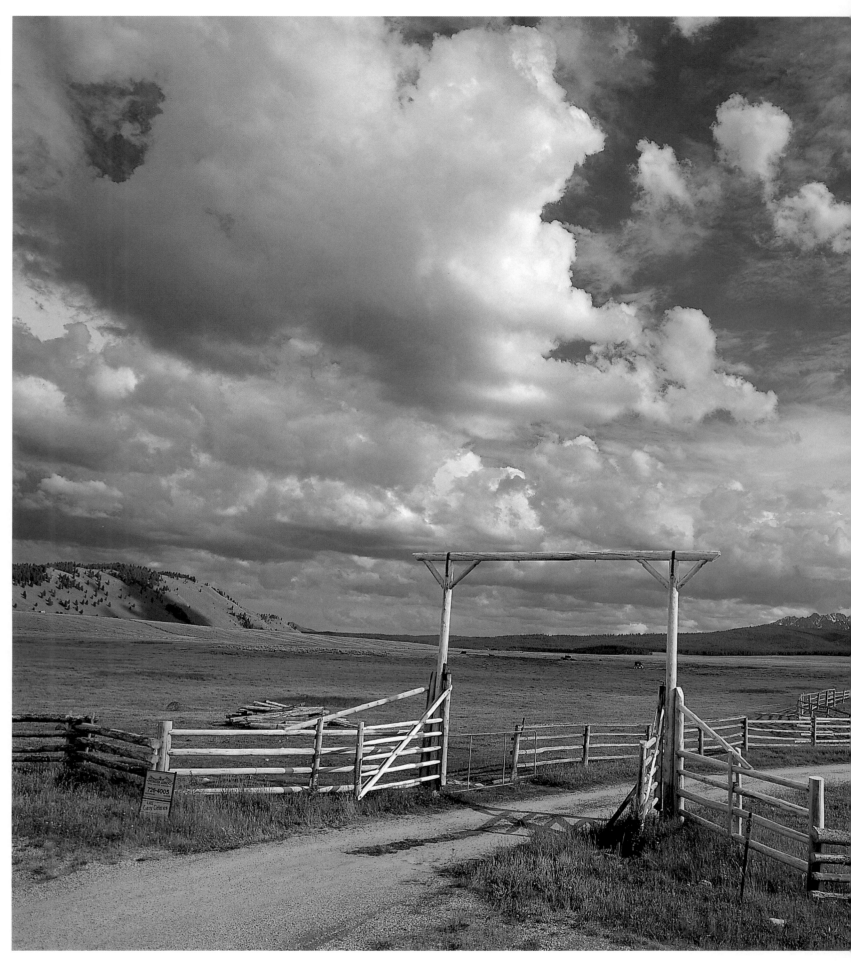

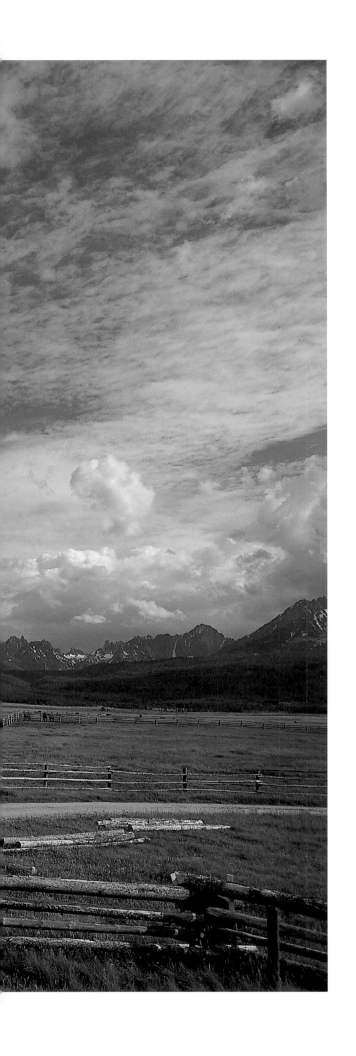

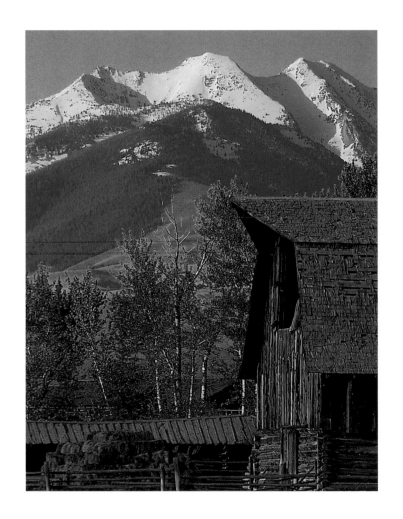

◁ STANLEY, IDAHO, IS

SURROUNDED BY RANCHES

WITH BIG SKIES JUST LIKE THOSE

OF ITS NEIGHBORING STATE.

△ THE PEAKS OF THE

BITTERROOT RANGE HOLD A

SPRING SNOWPACK ABOVE A BARN

NEAR SALMON, IDAHO.

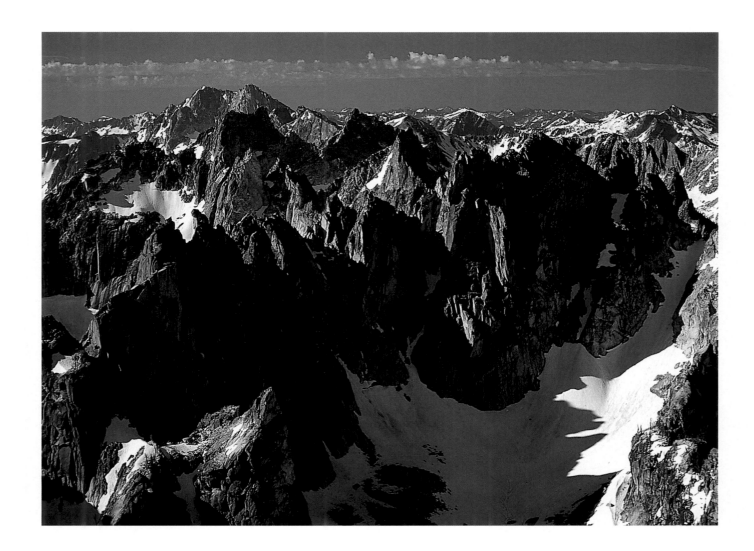

△ THE SPINE OF IDAHO'S

SAWTOOTH MOUNTAINS PROVES

THAT THIS RANGE WAS GIVEN

AN APPROPRIATE NAME.

▷ SIXTY-SEVEN AND ONE-HALF

MILES OF THE SNAKE RIVER

ARE PROTECTED AS

A WILD AND SCENIC RIVER IN

HELLS CANYON NATIONAL

RECREATION AREA, IDAHO.

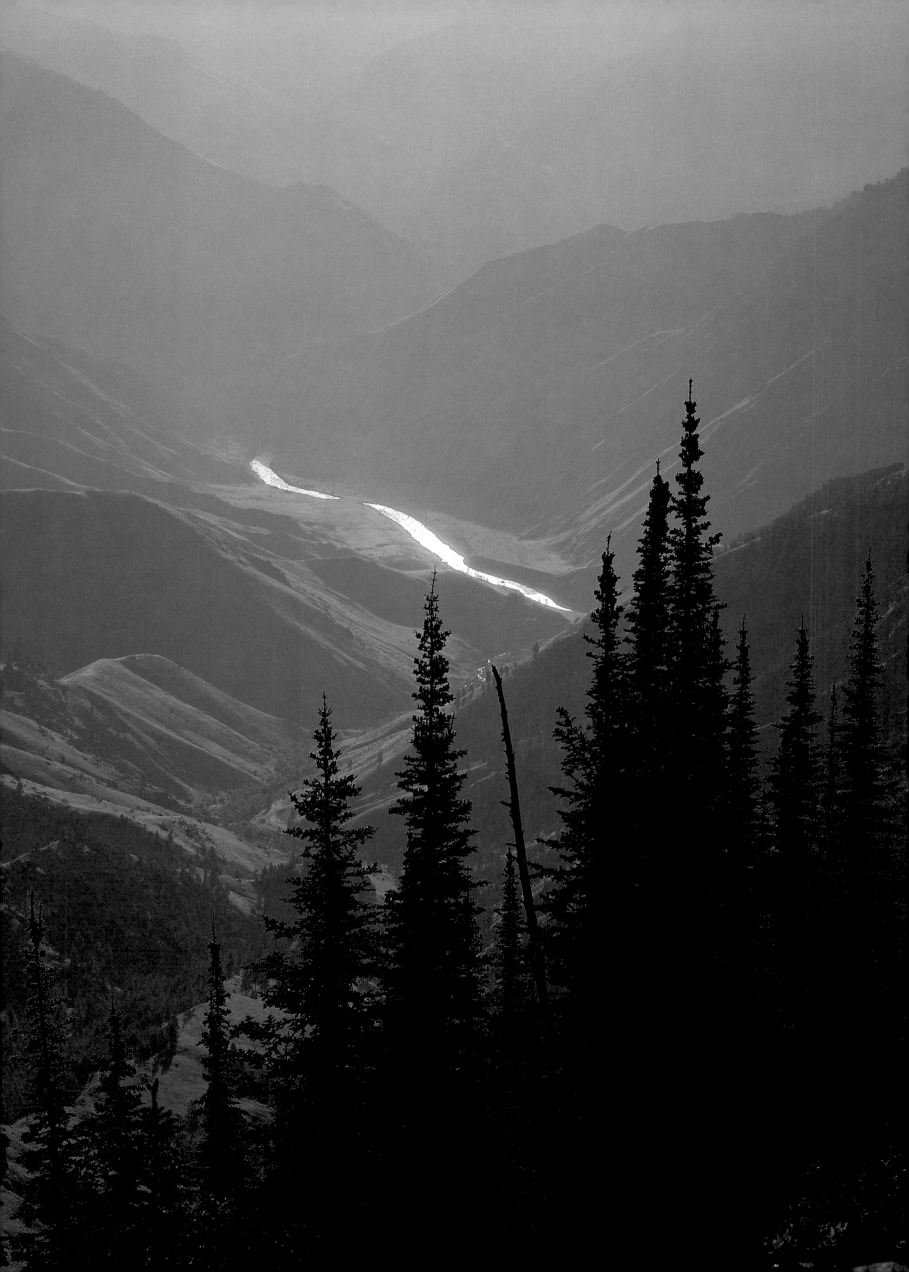

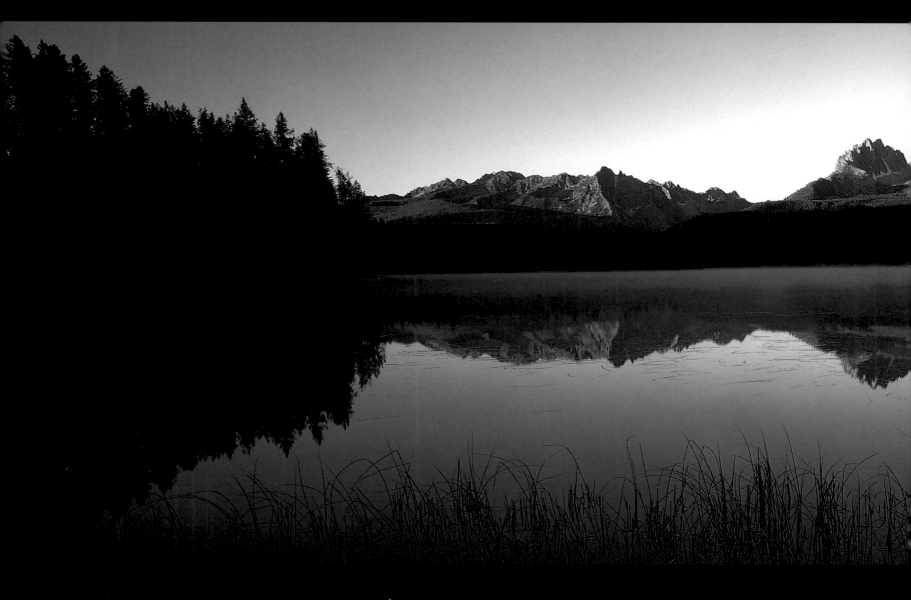

△ A DAWN PANORAMA REFLECTS

AN INTENSE SILENCE ON LITTLE

REDFISH LAKE WITH PEAKS OF THE

SAWTOOTH RANGE, IDAHO.

▷ BULL MOOSE ENJOY

A MOMENT OF COOL QUIET

AND PEACE FROM THE

MYRIAD BUGS IN LEWIS LAKE,

YELLOWSTONE NATIONAL

PARK, WYOMING.

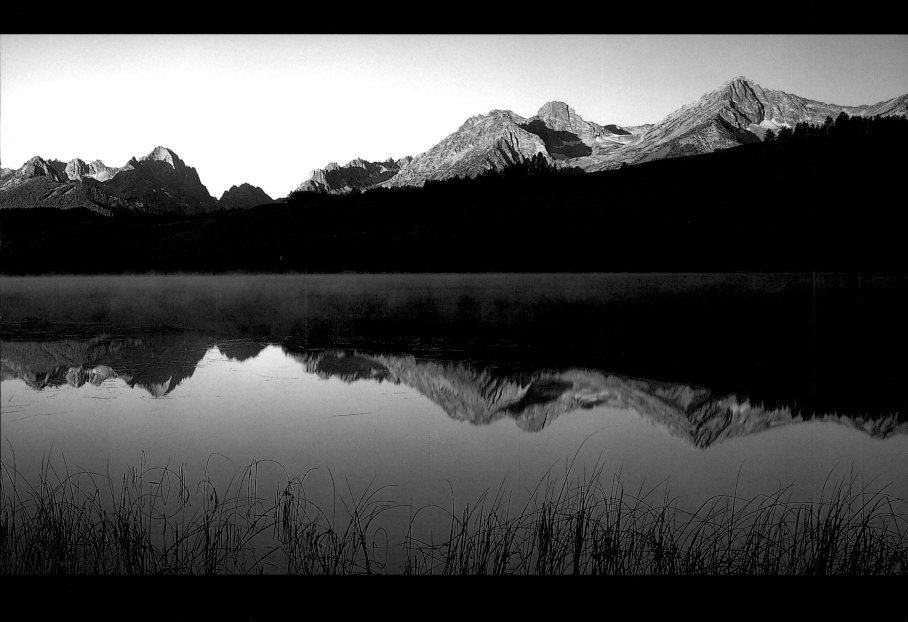

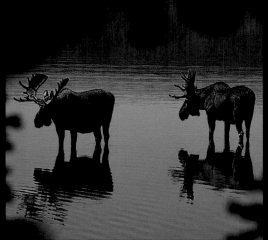

△ CORNICES LAST THROUGH

THE SUMMER IN MONTANA'S

BEARTOOTH MOUNTAINS, OFFERING

VISITORS A COOL SURPRISE.

▷ ALPINE TARNS REFLECT

A MORNING MOOD ABOVE

PEAKS OF THE BEARTOOTH

PLATEAU, ABSAROKA BEARTOOTH

WILDERNESS, MONTANA.

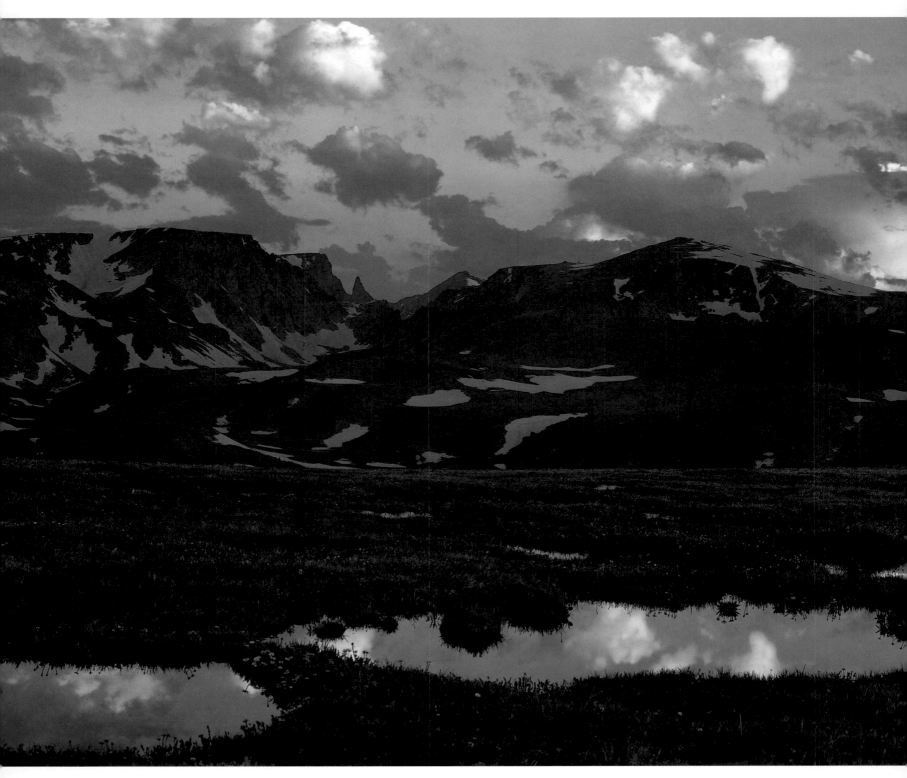

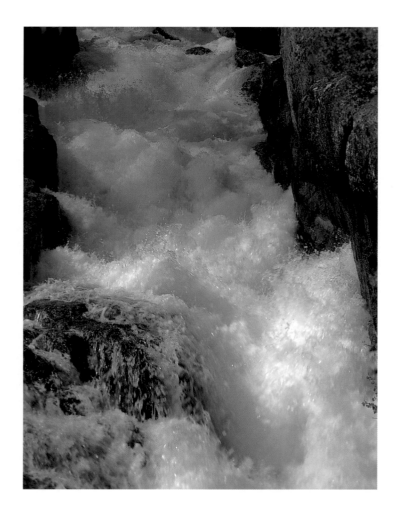

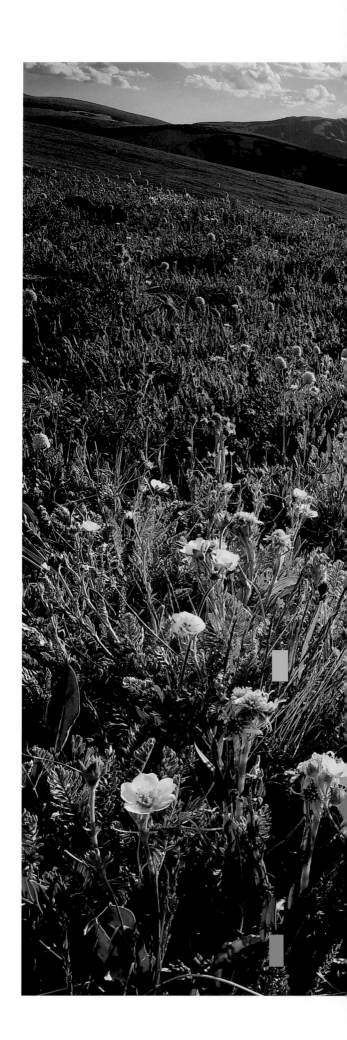

△ A CASCADE OF SNOWMELT
TUMBLES THROUGH A ROCK SLOT
HEADING FOR THE CLARKS FORK
OF YELLOWSTONE RIVER IN
WYOMING'S BEARTOOTH MOUNTAINS.
▷ A BOUQUET OF FLOWERS
CARPETS THE HIGH COUNTRY OF
THE BEARTOOTH MOUNTAINS, JUST
NORTH OF YELLOWSTONE NATIONAL
PARK IN SOUTHERN MONTANA.

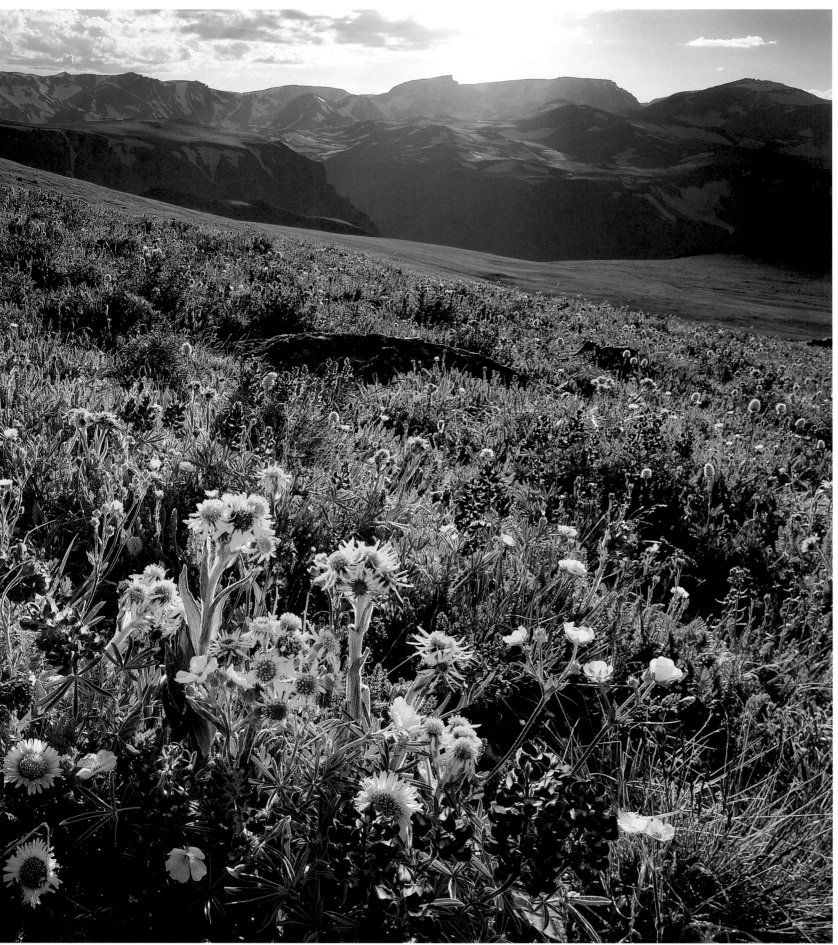

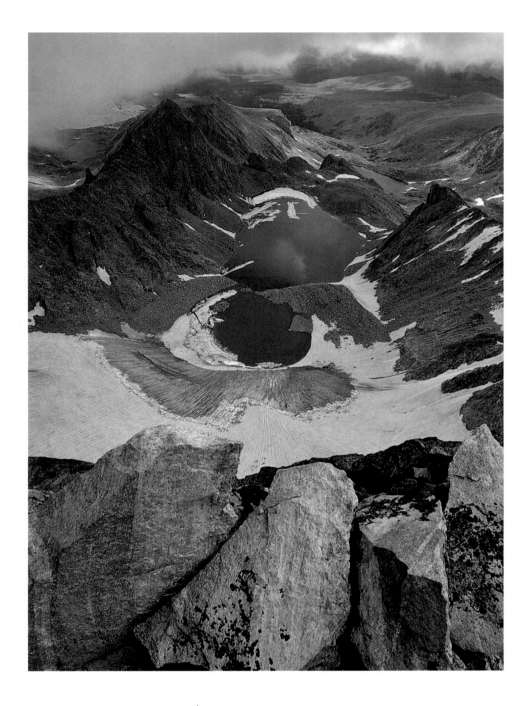

△ A SMALL GLACIER QUARRIES

AWAY ROCK BELOW THE TOPROCK

OF CLOUD PEAK (13,165 FEET)

IN WYOMING'S CLOUD PEAK

WILDERNESS, BIG HORN MOUNTAINS.

▷ ALPINE LAKES FILLED BY MELTED

SNOW DOT THE HIGH COUNTRY

BETWEEN MONTANA'S BEARTOOTH

AND ABSAROKA MOUNTAINS.

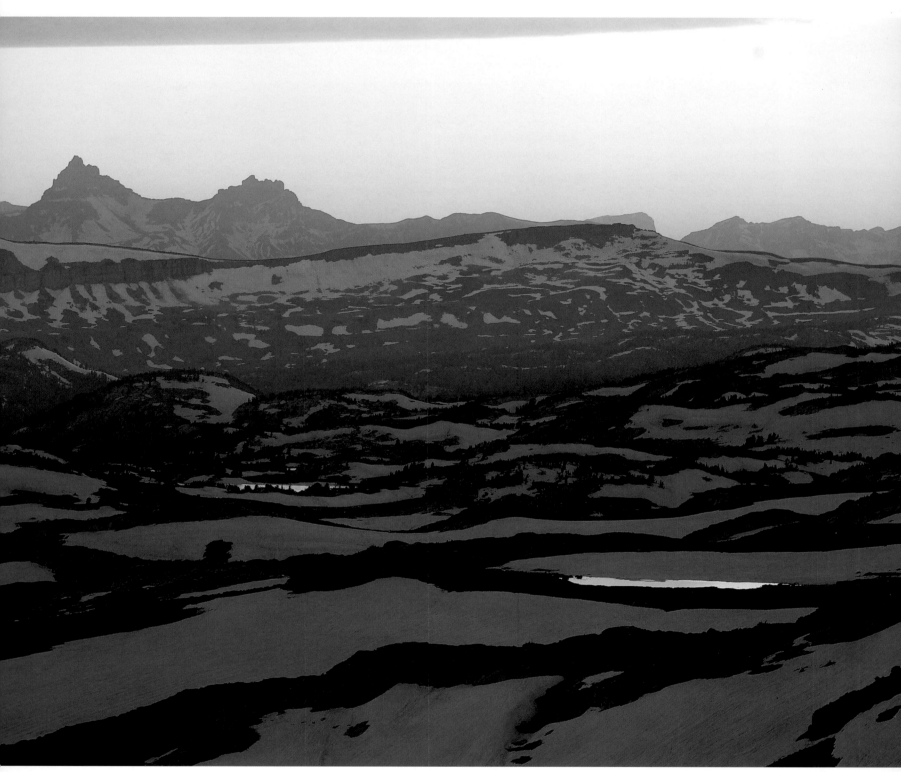

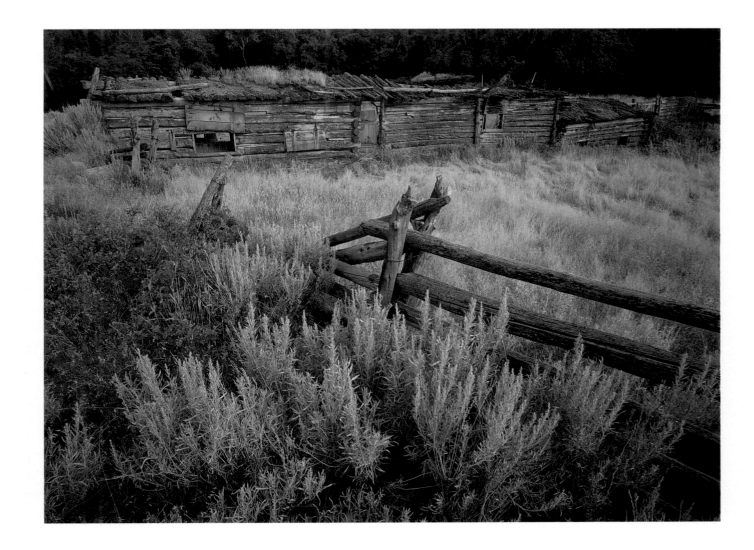

△ A HISTORIC BUILDING REMAINS

INTACT REPRESENTING ONE OF THE

LARGE OPEN-RANGE RANCHES AT THE

TURN OF THE NINETEENTH

CENTURY ALONG THE BAD PASS TRAIL

IN WYOMING'S BIGHORN CANYON

NATIONAL RECREATION AREA.

▷ EVEN THOUGH IT HAS NOT

SNOWED FOR DAYS, THE LOW ANGLE

OF SUNLIGHT AND SHORT WINTER

DAYS KEEP THE SNOW LOOKING

FRESH ALONG NORTHERN

MONTANA'S MISSION RANGE.

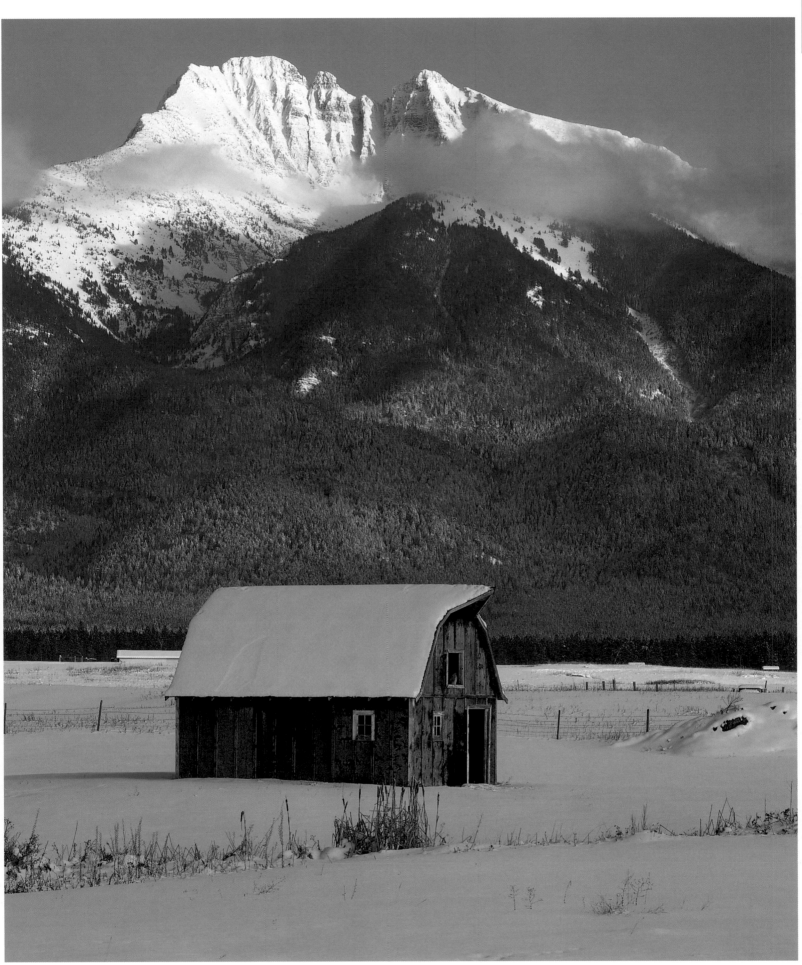

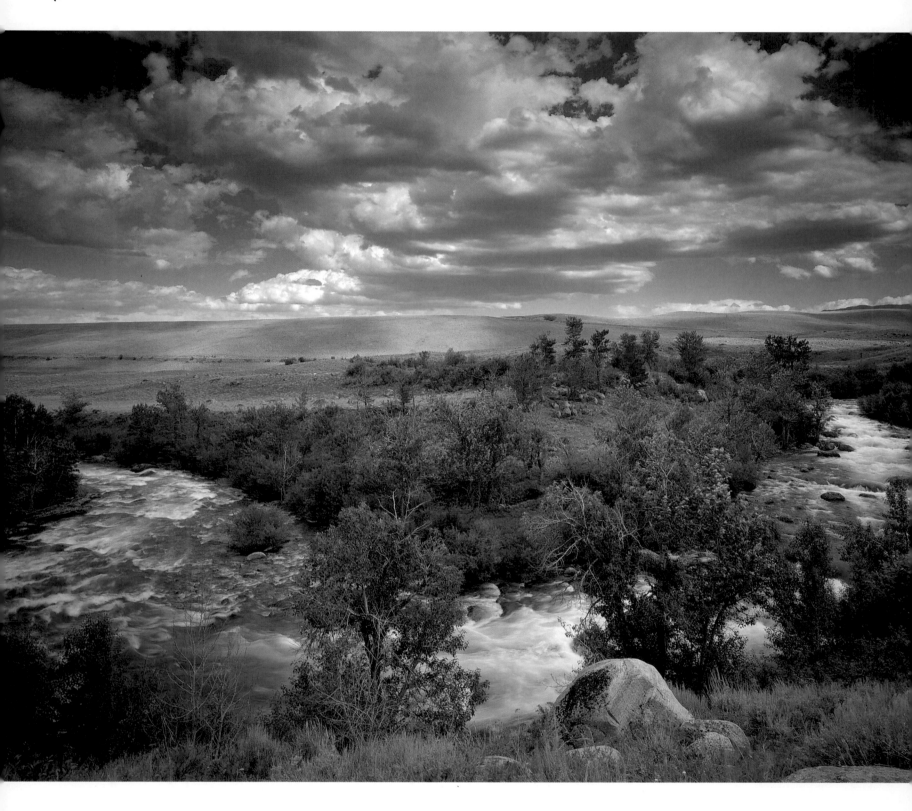

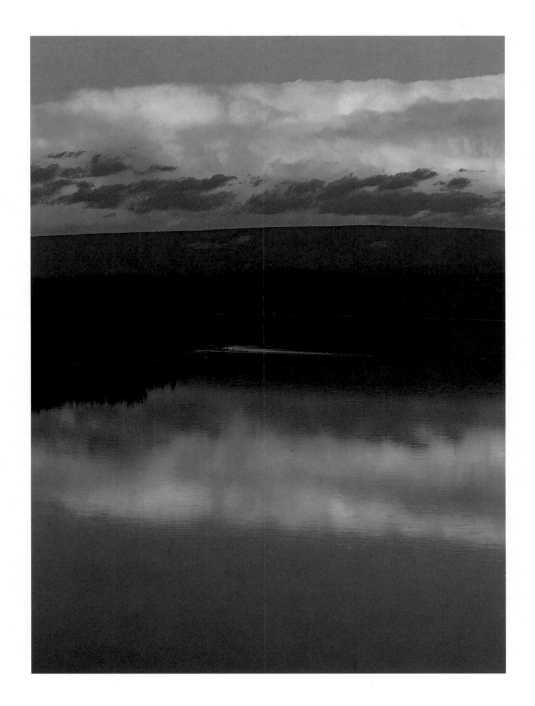

◁ GLACIAL ERRATICS, WILLOWS,

AND COTTONWOODS SURROUND

THE EAST ROSEBUD RIVER AS

IT WINDS DOWN THE FOOTHILLS OF

THE NORTH SIDE OF THE

BEARTOOTH RANGE, MONTANA.

△ A STORM GRACES THE EVENING

SKIES EAST OF SAINT MARY LAKE,

GLACIER NATIONAL PARK, MONTANA.

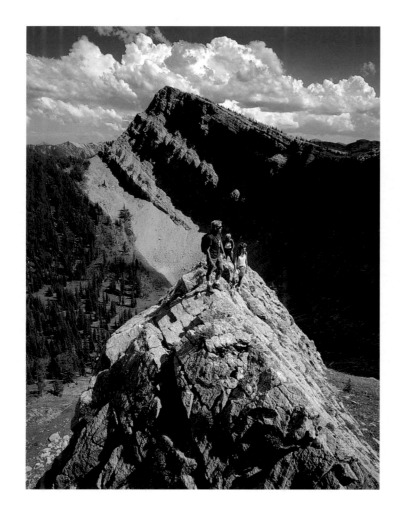

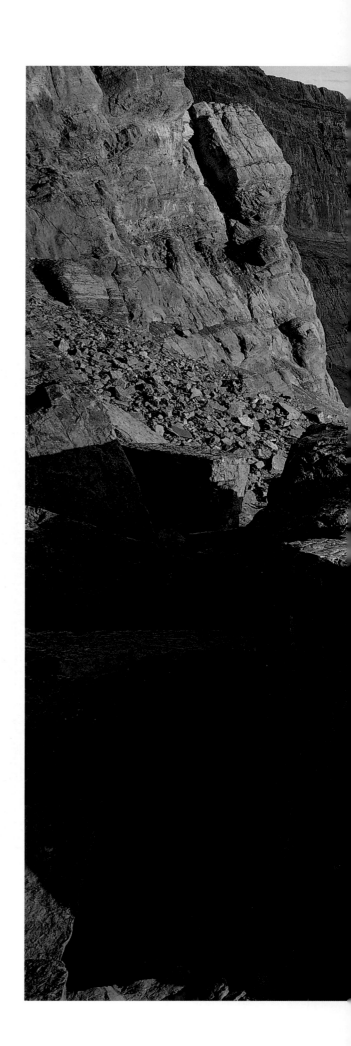

△ HIKERS ENJOY VIEWS ALONG

THE CONTINENTAL DIVIDE

AT TWIN PEAKS IN MONTANA'S

BOB MARSHALL WILDERNESS.

▷ GLACIERS HAVE CARVED AWAY

LAYERS OF LIMESTONE TO EXPOSE

THE CHINESE WALL IN MONTANA'S

BOB MARSHALL WILDERNESS.

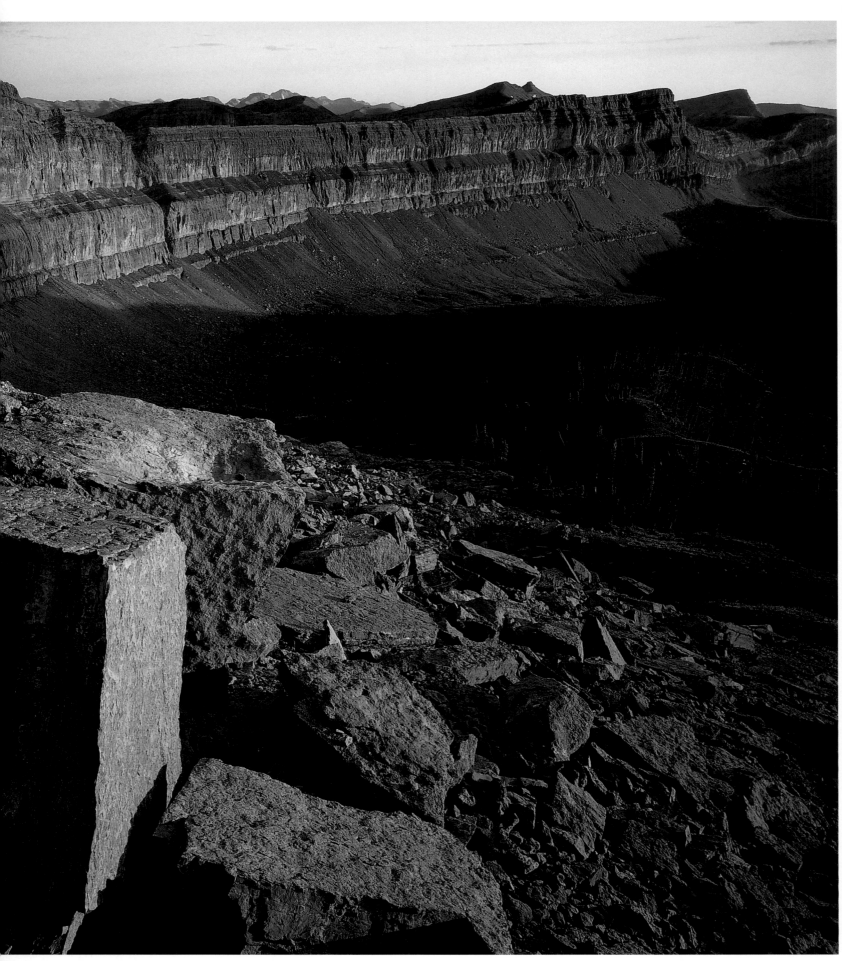

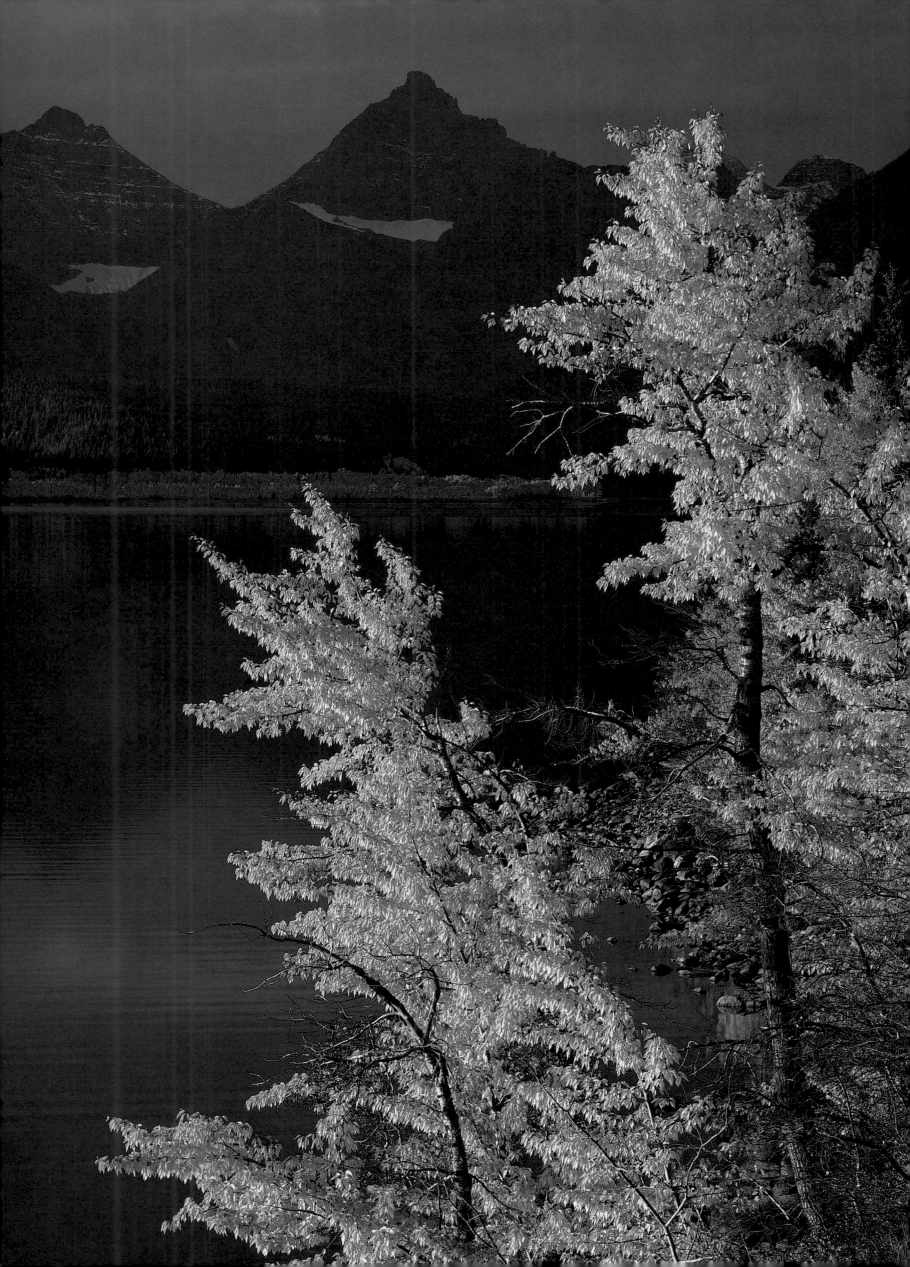

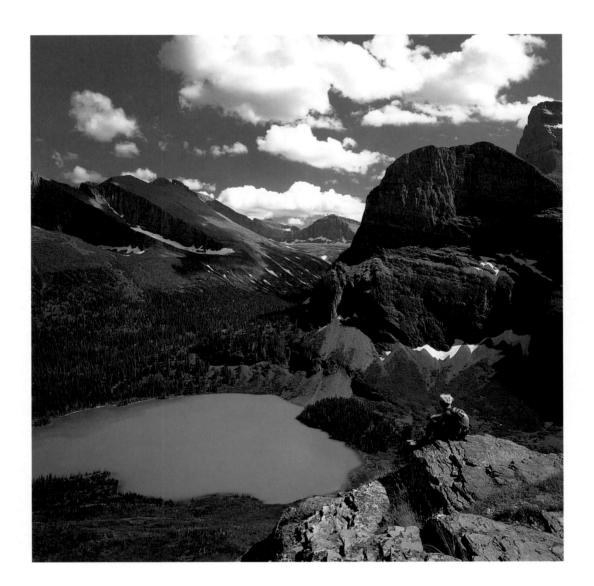

◁ COTTONWOODS GLOW IN AN

OCTOBER SUNRISE ALONG SAINT

MARY LAKE BEFORE SPLIT MOUNTAIN

AND TRIPLE DIVIDE PARK,

GLACIER NATIONAL PARK, MONTANA.

△ AN EXPANDING ALPINE VISTA

GREETS THE HIKER HIGH ALONG

THE TRAIL TO GRINNELL GLACIER.

THE GLACIER INCLUDES ANGEL WING

ABOVE GRINNELL LAKE,

GLACIER NATIONAL PARK, MONTANA.

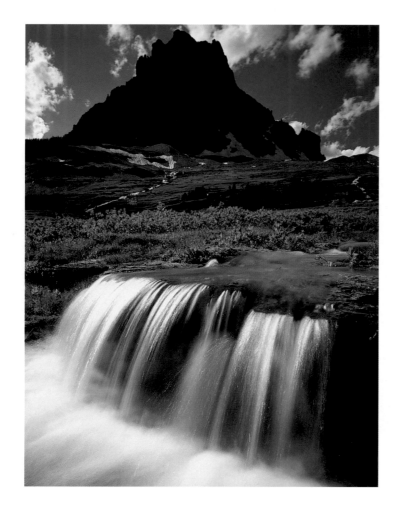

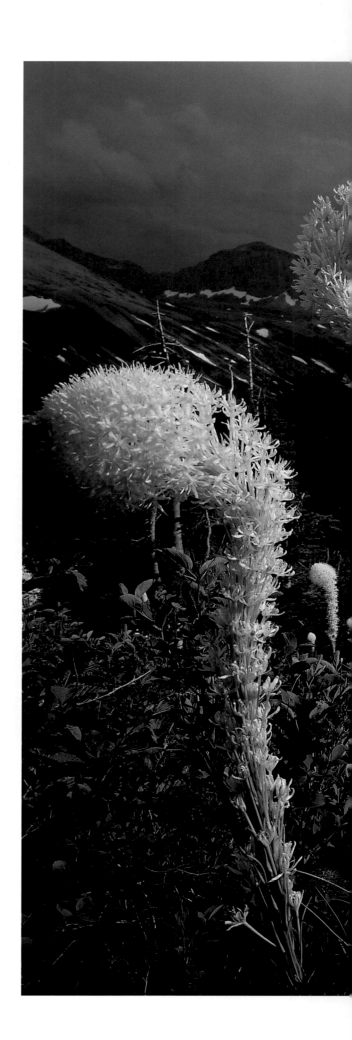

△ A SUMMER ALPINE STREAM
CASCADES THROUGH THE HANGING
GARDENS BELOW CLEMENTS
MOUNTAIN (8,760 FEET), LOGAN PASS,
GLACIER NATIONAL PARK, MONTANA.
▷ BEARGRASS PLUMES EXHIBIT
KNEE-LIKE CURVES. MOUNT GOULD
AND ANGEL WING ARE ABOVE IN
GLACIER NATIONAL PARK, MONTANA.

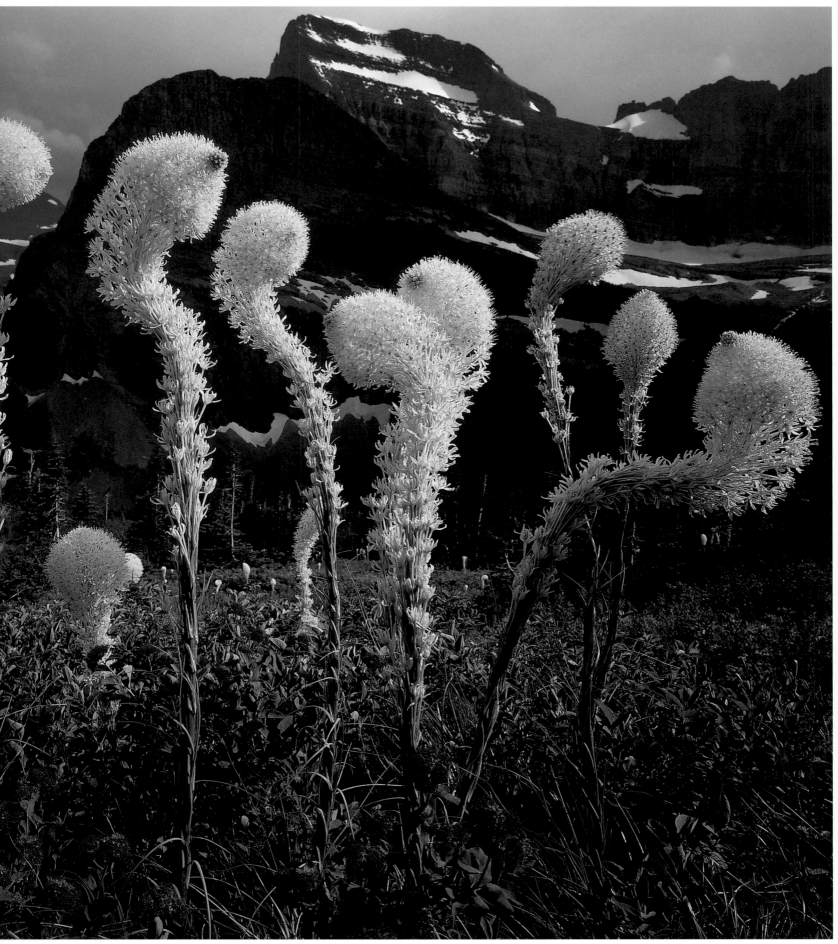

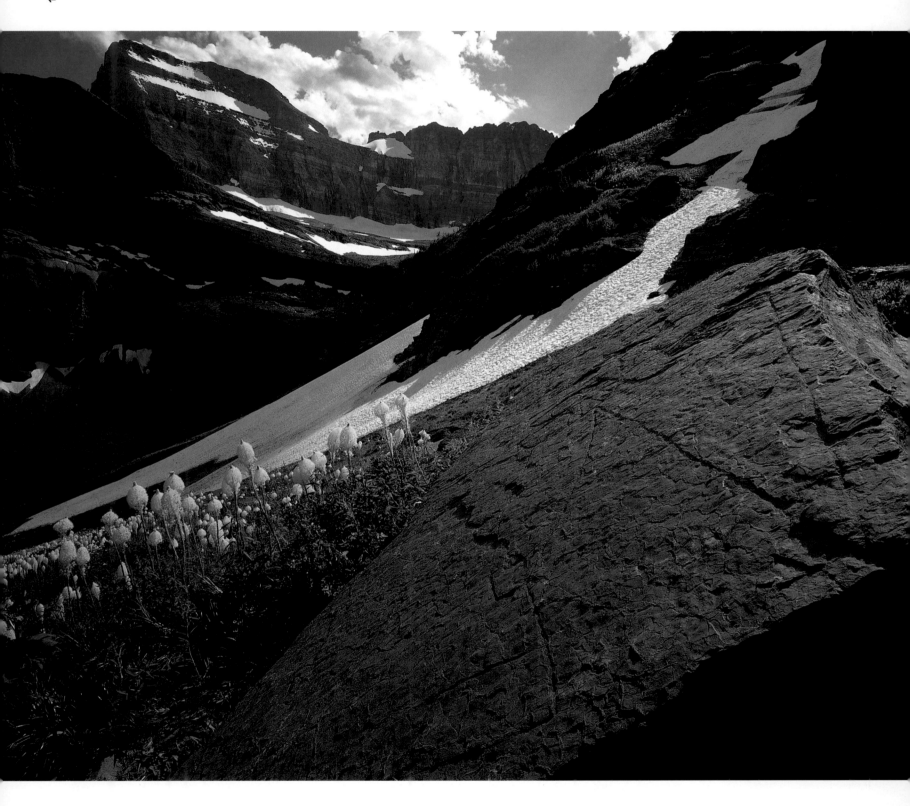

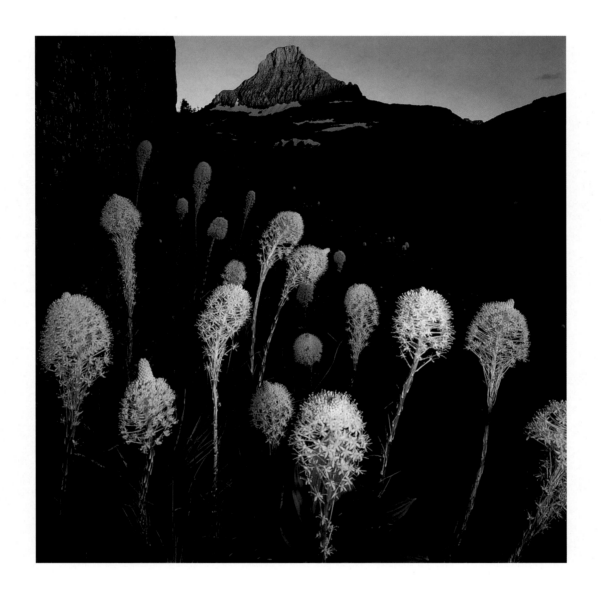

◁ A LIMESTONE SLAB DISPLAYS

AN ANCIENT INDIAN THUNDERBIRD

PETROGLYPH ON A TALUS SLOPE

IN VIEW OF MOUNT GOULD AND

GRINNELL GLACIER, GLACIER

NATIONAL PARK, MONTANA.

△ REYNOLDS MOUNTAIN (9,125

FEET) CATCHES THE EARLY MORNING

LIGHT WITH TORCH-LIKE CLUSTERS

OF BEARGRASS IN LOGAN PASS,

GLACIER NATIONAL PARK, MONTANA.

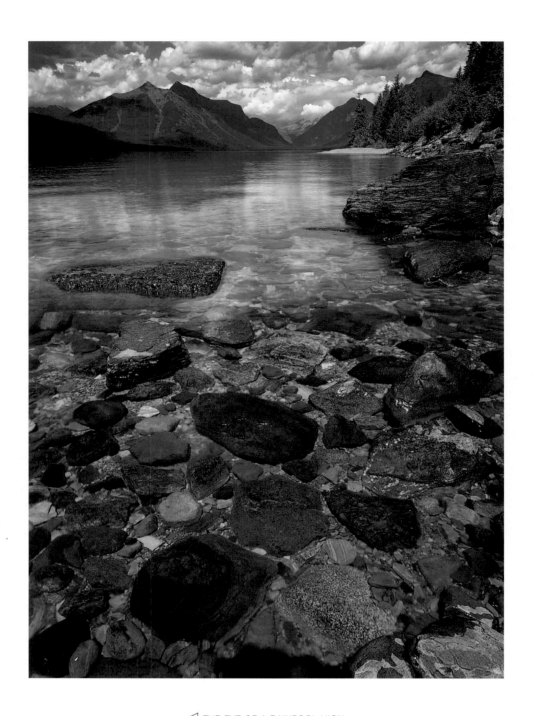

◁ THE EYE OF A RAINPOOL HIGH-

LIGHTS WET SOMBER MOODS IN A

WATER-WORN GORGE ALONG

AVALANCHE CREEK, GLACIER

NATIONAL PARK, MONTANA.

△ MULTI-HUED COBBLES OF ROCK

MAKE UP THE SHORELINE

ALONG LAKE McDONALD IN

GLACIER NATIONAL PARK, MONTANA.

△ A SMALL CREEK FLOWS OVER

A RED-HUED FORMATION IN

RED ROCK CANYON, WATERTON

NATIONAL PARK, ALBERTA.

▷ MORNING FOG LINGERS ALONG

SAINT MARY LAKE WITH RED EAGLE,

MAHTOTOPA, LITTLE CHIEF DUSTY

STAR, CITADEL, AND FUSILLADE

MOUNTAINS FORMING THE

SKYLINE TO THE WEST, GLACIER

NATIONAL PARK, MONTANA.

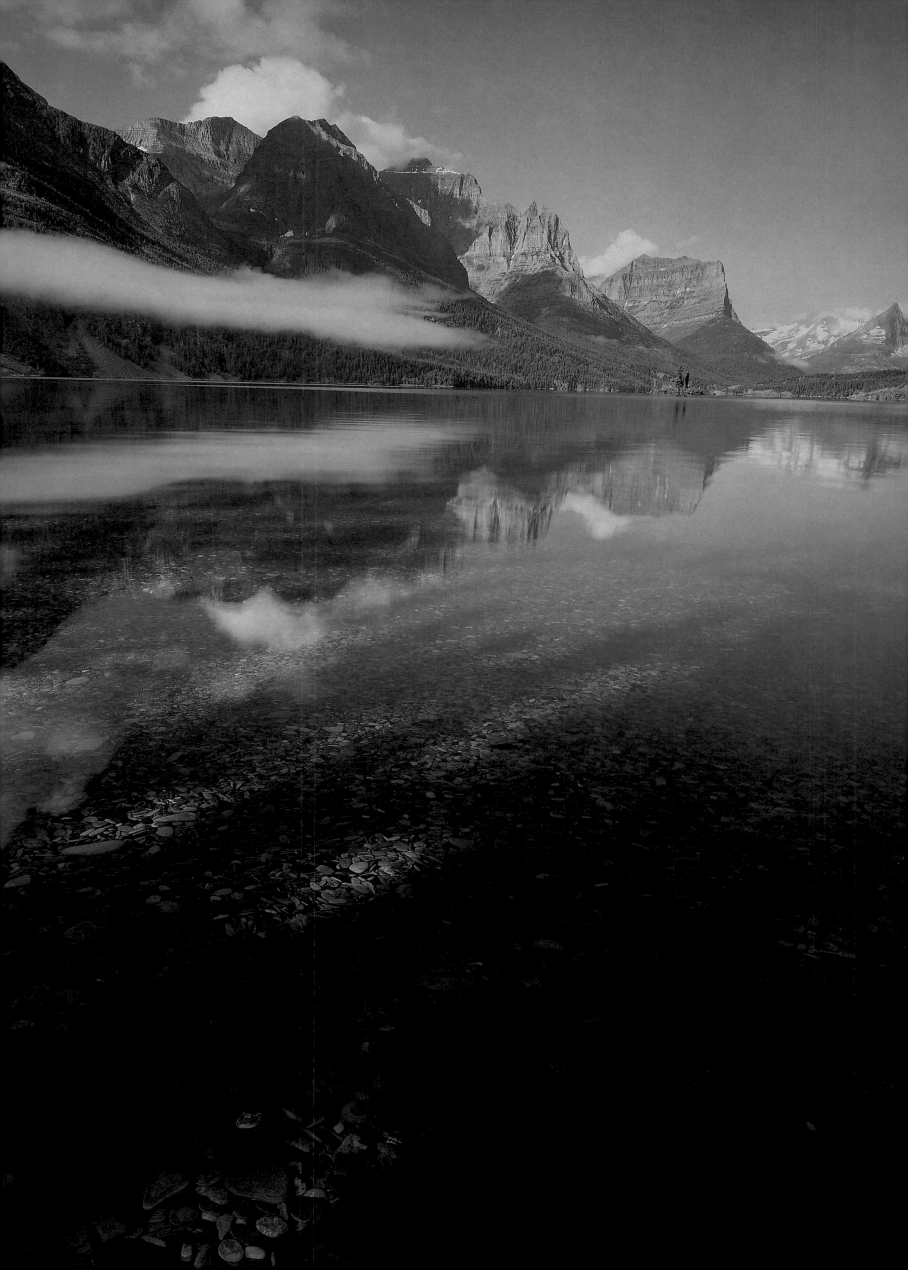

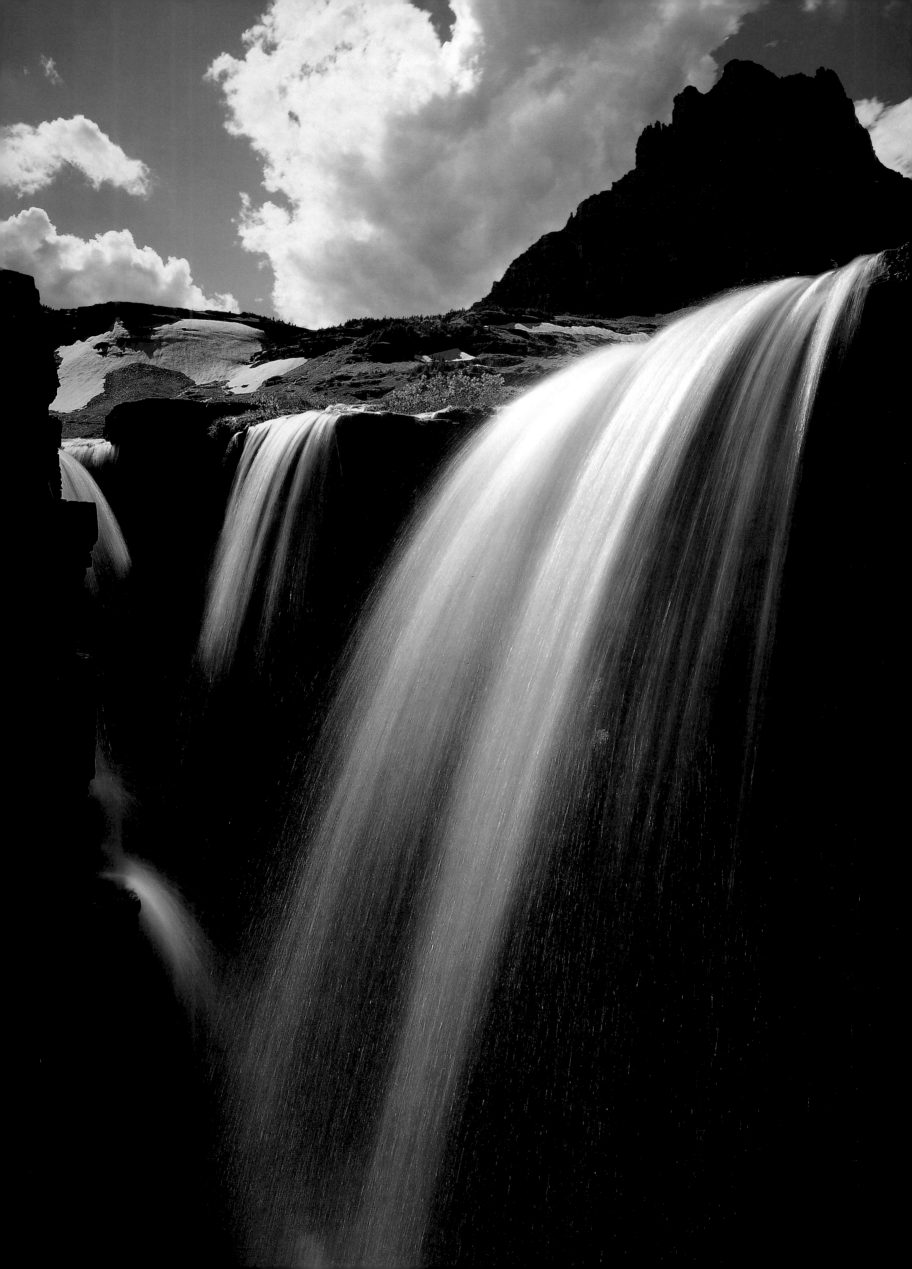

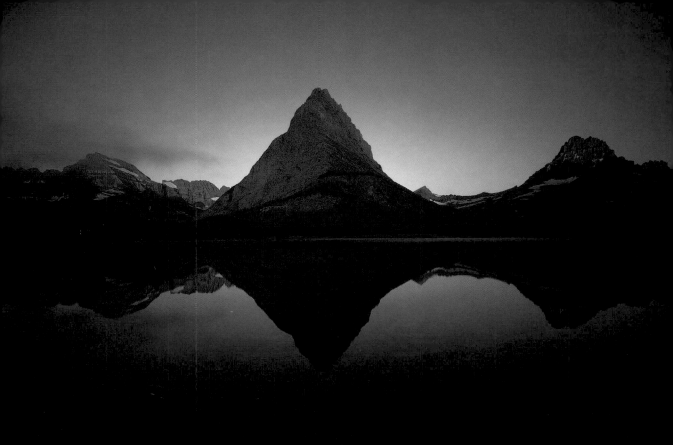

◁ STREAMS OF SNOWMELT

POUR INTO A CHASM BELOW

CLEMENTS MOUNTAIN IN THE

HANGING GARDENS, GLACIER

NATIONAL PARK, MONTANA.

△ MOUNT WILBER (9,321 FEET),

GRINNELL POINT, AND

MOUNT GOULD (9,553 FEET)

ARE REFLECTED IN SWIFTCURRENT

LAKE AT DAWN, MARY GLACIER

GLACIER NATIONAL PARK, MONTANA.

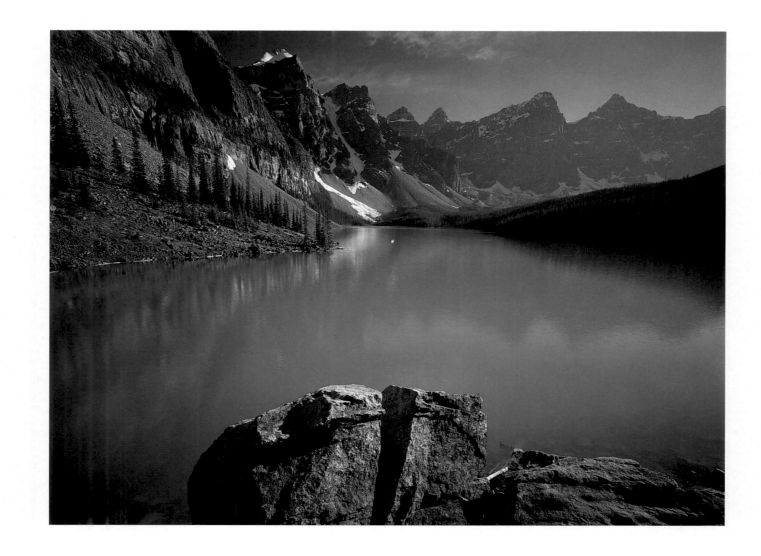

△ THE WENKCHEMNA PEAKS FORM

AN IMPRESSIVE SKYLINE BEHIND

MORAINE LAKE, UNEQUALED FOR

ITS RUGGED GRANDEUR,

BANFF NATIONAL PARK, ALBERTA.

▷ AN OCTOBER DUSTING OF

SNOW TRANSFORMS THE

OUTWARD BEAUTY OF THIS FAMOUS

SCENE OF LAKE LOUISE AND ITS

IMPOSING BACKDROP OF

MOUNT VICTORIA (11,362 FEET),

BANFF NATIONAL PARK, ALBERTA.

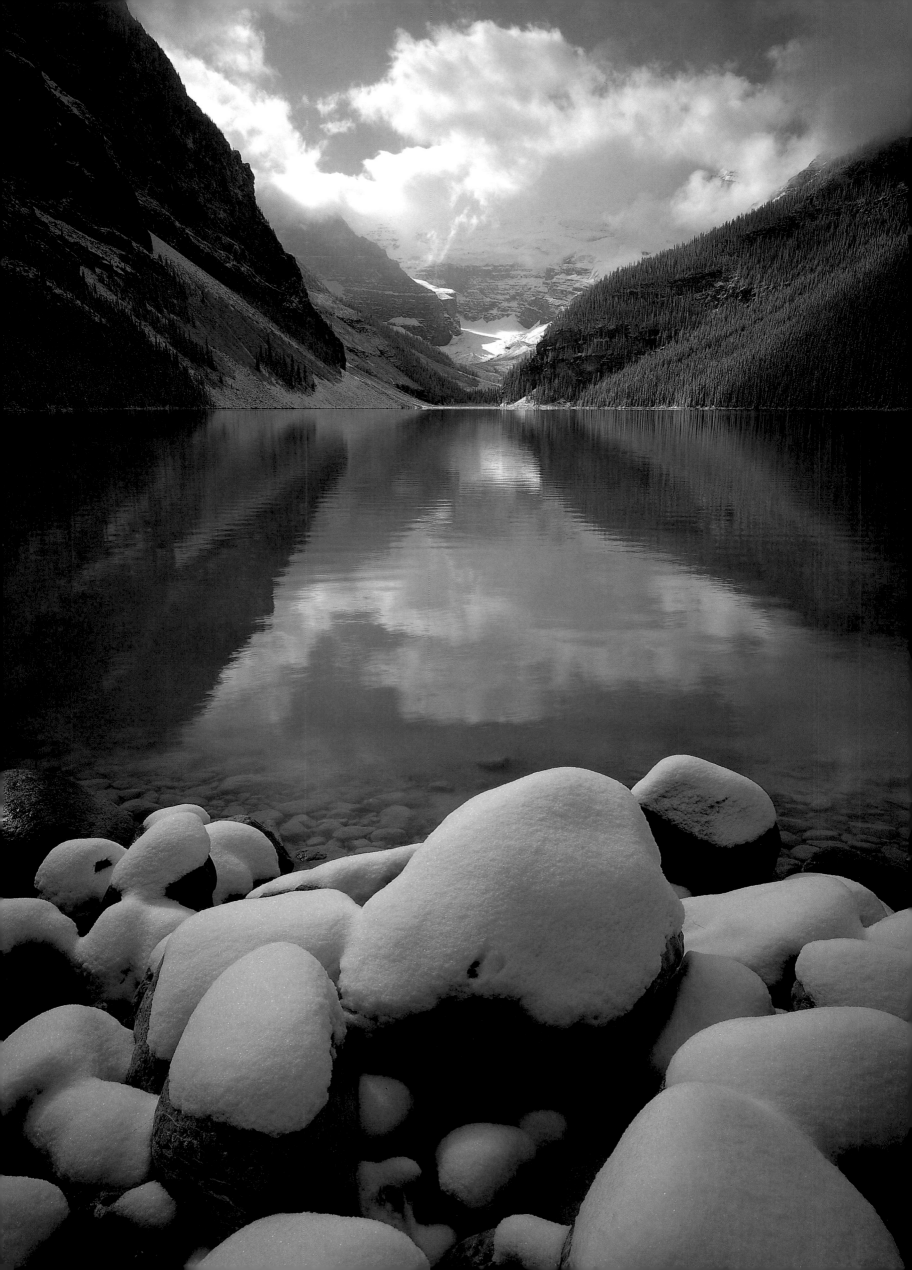

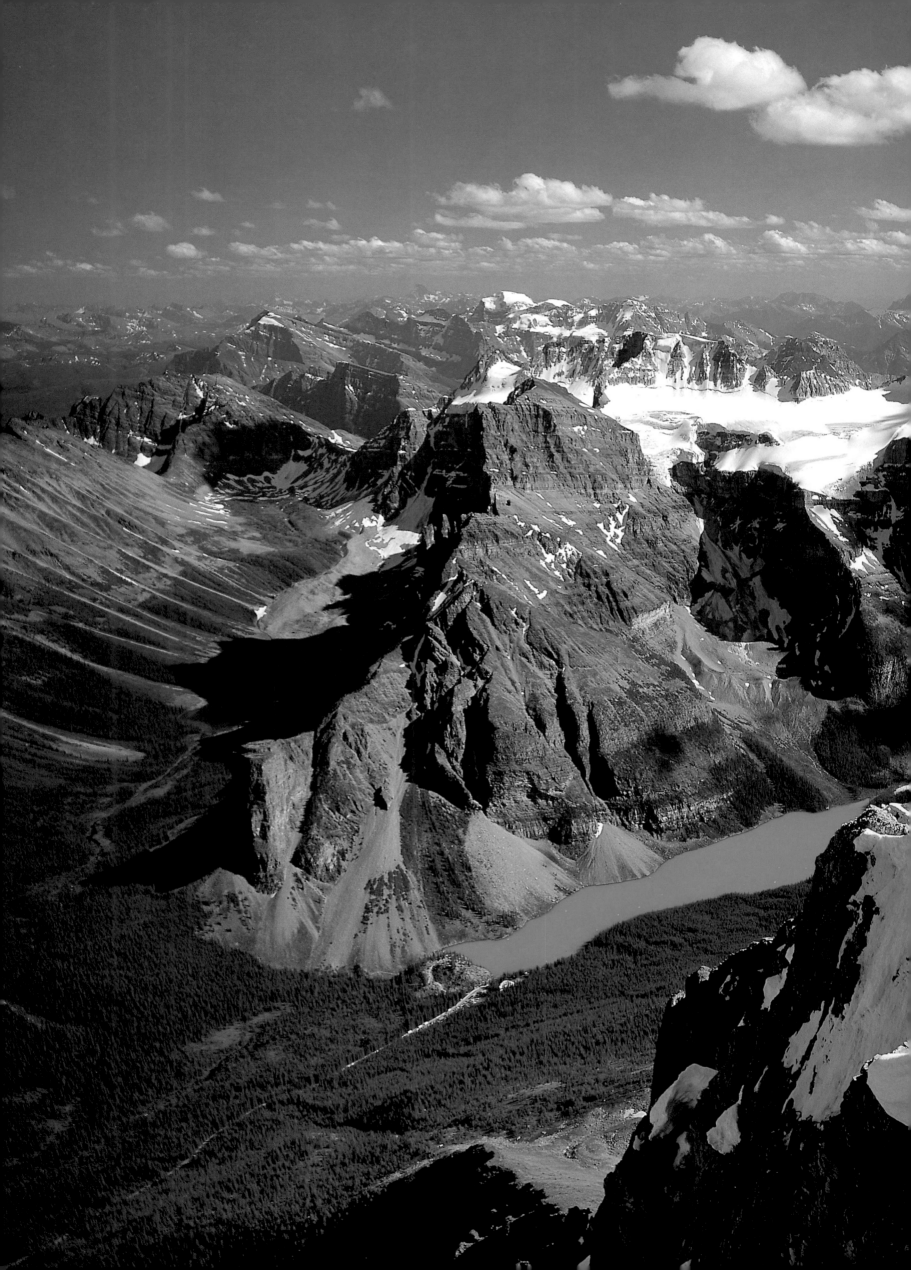

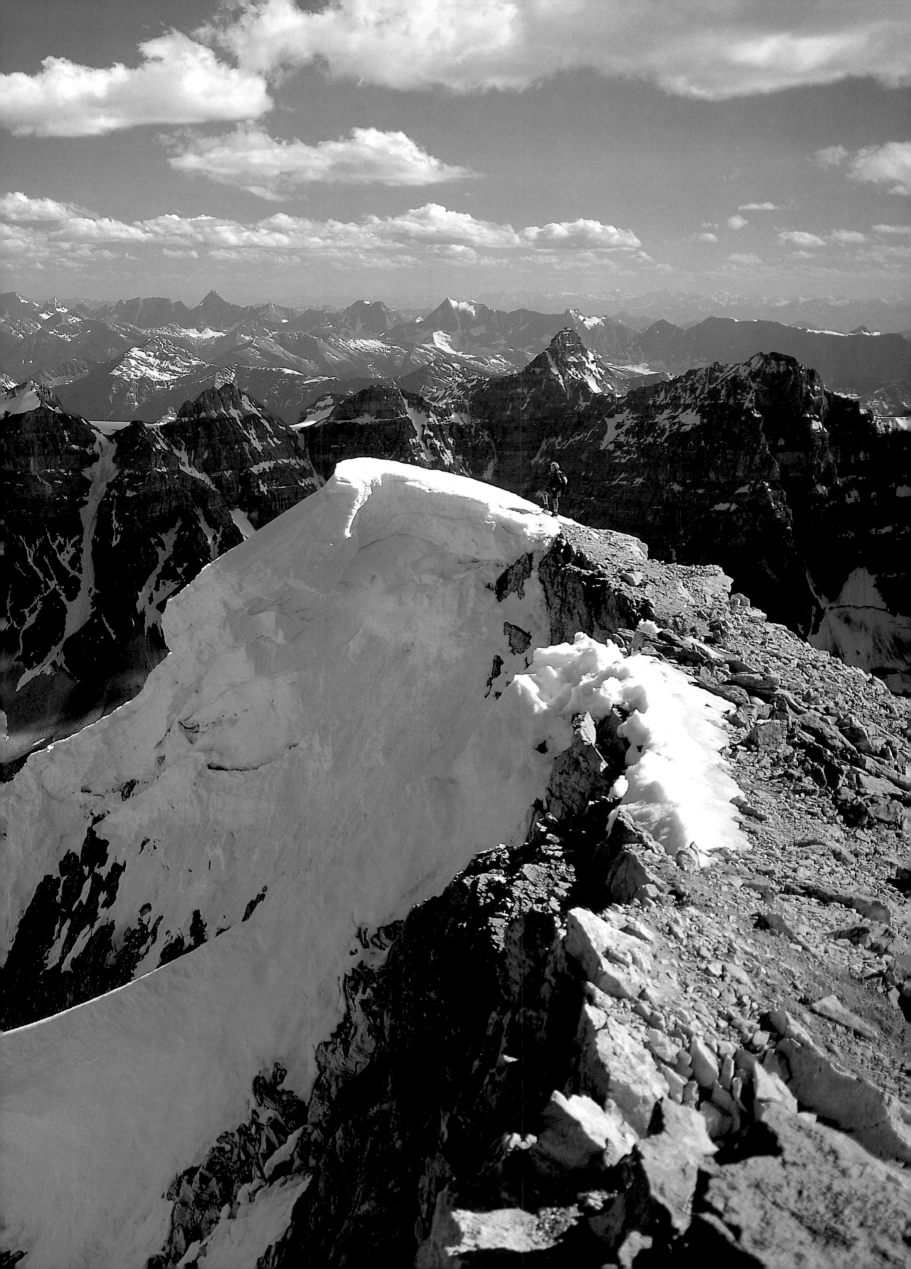

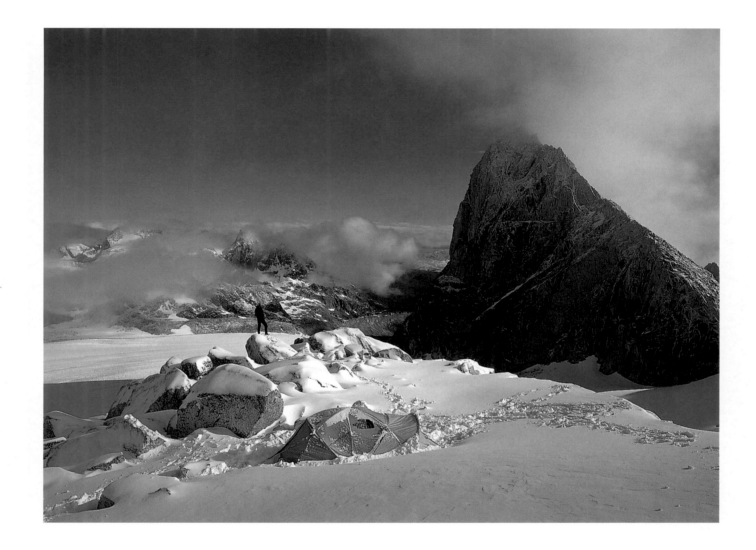

◁ ◁ DAVID MUENCH STANDS ON

MOUNT TEMPLE'S TOP RIDGE IN

ALBERTA'S CANADIAN ROCKIES;

THE VALLEY OF THE TEN PEAKS AND

MORAINE LAKE NESTLE BELOW.

△ A CLIMBER RETHINKS CLIMBING

BUGABOO SPIRE AFTER

A SUDDEN JULY STORM HITS

BRITISH COLUMBIA'S BUGABOOS.

▷ CLIMBERS ON ALBERTA'S

GRAND SENTINEL SPIRE CAN

BE SEEN FROM SENTINEL PASS,

THE HIGHEST MAINTAINED TRAIL IN

THE CANADIAN ROCKIES.

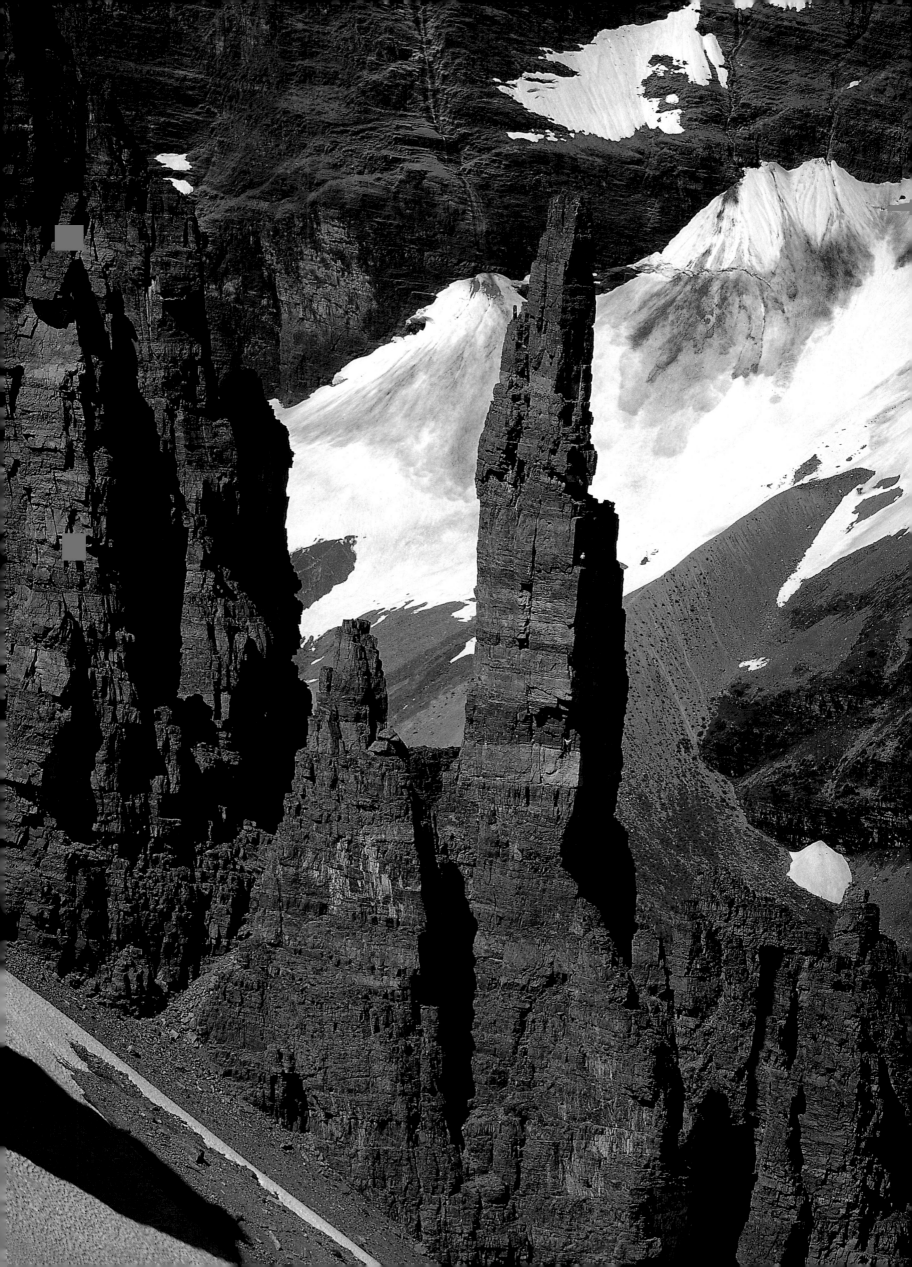

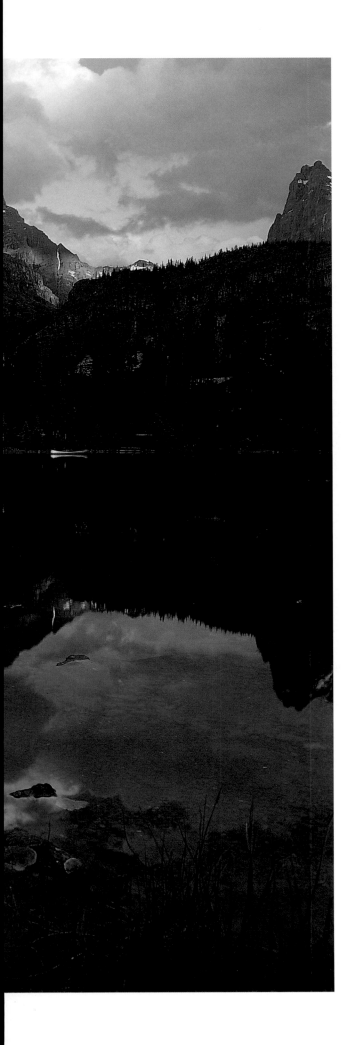

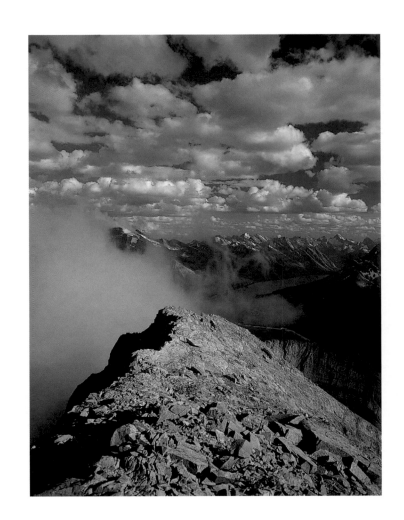

◁ LAKESIDE CABINS, LIKE THESE AT

THE LAKE O'HARA LODGE IN

YOHO NATIONAL PARK OF BRITISH

COLUMBIA, ARE POPULAR PLACES

FOR VISITORS TO STAY.

△ THE KANANASKIS COUNTRY

IS SEEN FROM THE

TOP OF THE BIG SISTER

MOUNTAIN IN ALBERTA.

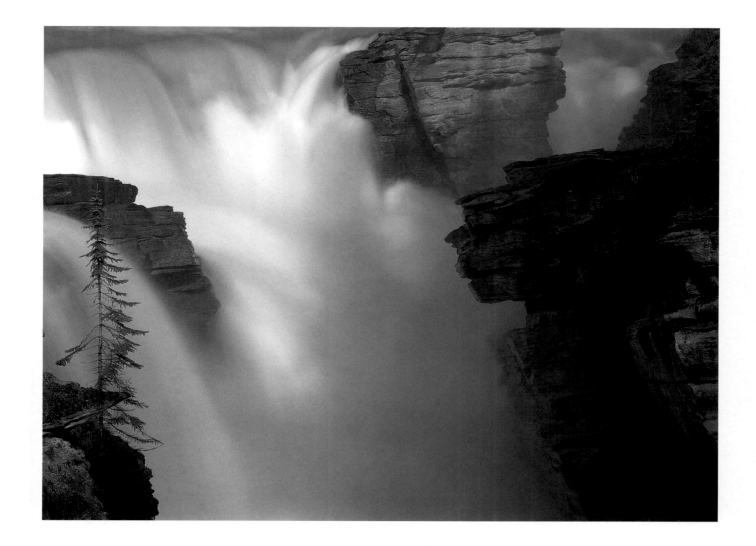

△ THE ROAR OF A CASCADE

MAKES THE GOG QUARTZITE ROCKS

SHUDDER AT ATHABASCA FALLS

ALONG THE ICE FIELDS PARKWAY

IN JASPER NATIONAL PARK, ALBERTA.

▷ A SOFT LIGHT BRINGS OUT AN

AUTUMN TRANSITION AROUND

A NATURAL BRIDGE IN THE

ONE-HUNDRED-FOOT-DEEP

LIMESTONE GORGE OF MARBLE

CANYON, KOOTENAY

NATIONAL PARK, BRITISH COLUMBIA.

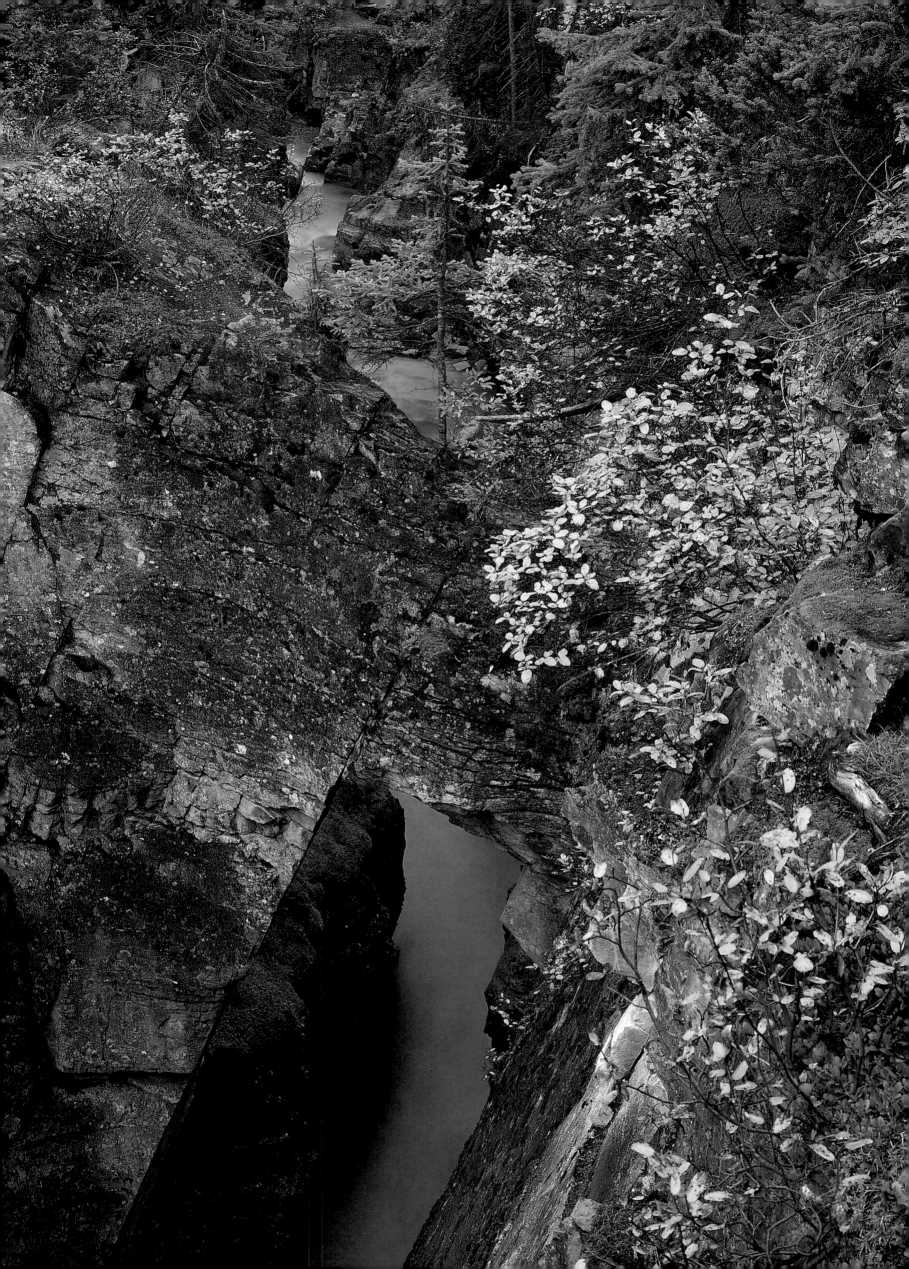

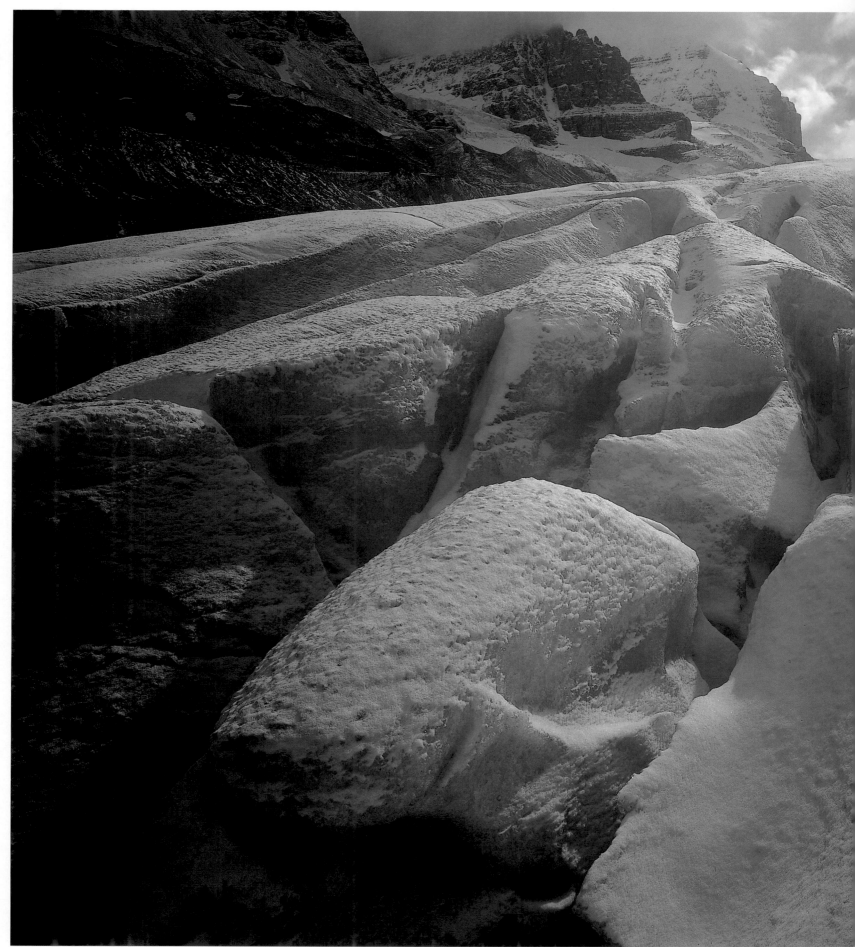

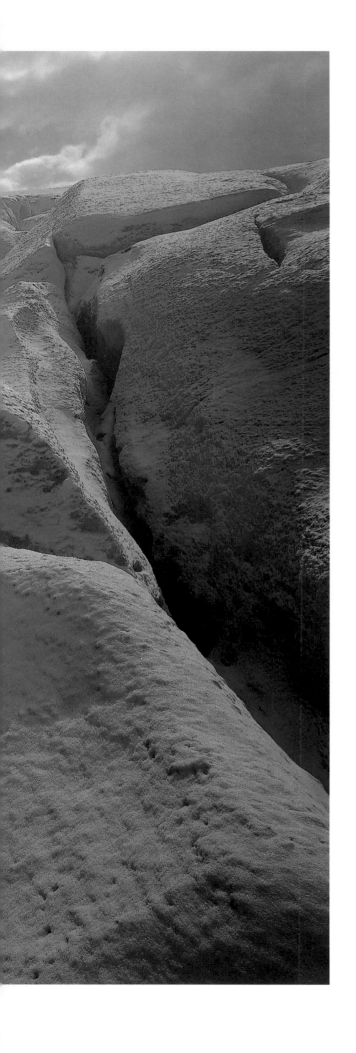

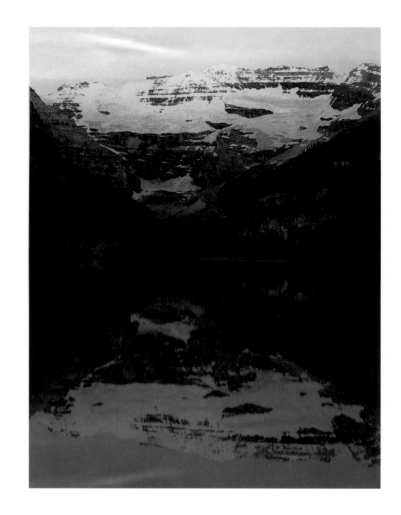

◁ THE 126-SQUARE-MILE

COLUMBIA ICE FIELD BREAKS

OFF WITH CREVASSES ON

THE TOE OF THE ATHABASCA

GLACIER, JASPER NATIONAL PARK,

ALBERTA. MOUNT ADROMEDA

(11,290 FEET) RISES ABOVE.

△ MOUNT VICTORIA (11,362 FEET)

DOUBLES ITS IMAGE IN PRISTINE-

APPEARING LAKE LOUISE, BANFF

NATIONAL PARK, ALBERTA.

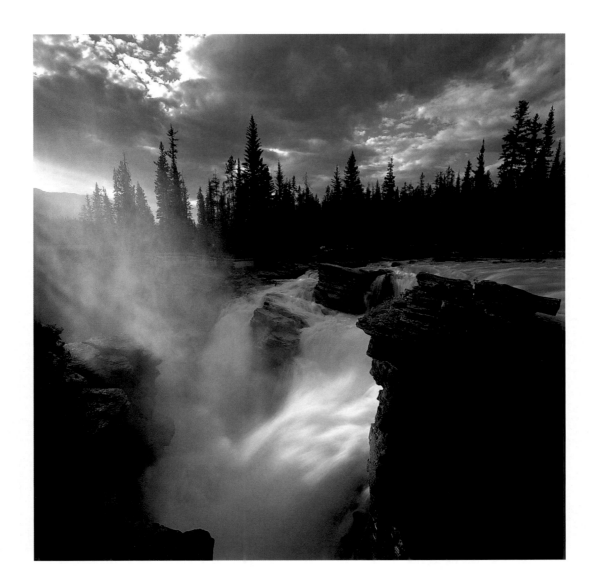

△ THE ATHABASCA RIVER DROPS

OVER A GLACIER ROCK STEP

IN HARD GOG QUARTZITE, CREATING

THE ATHABASCA FALLS IN

JASPER NATIONAL PARK, ALBERTA.

▷ AN OCTOBER LIGHT GRACES

MOUNT RANDLE, THE MOST

FAMOUS MOUNTAIN IN ALBERTA'S

BANFF NATIONAL PARK, WITH A

REFLECTION IN THE MONTANE

WETLANDS AND VERMILLION LAKES.

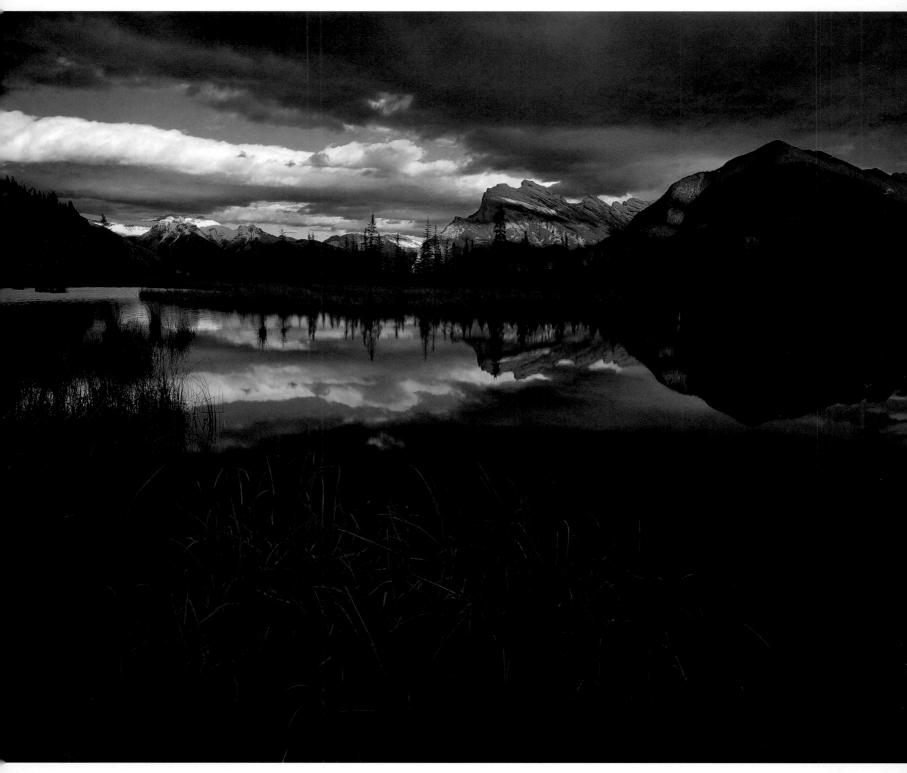

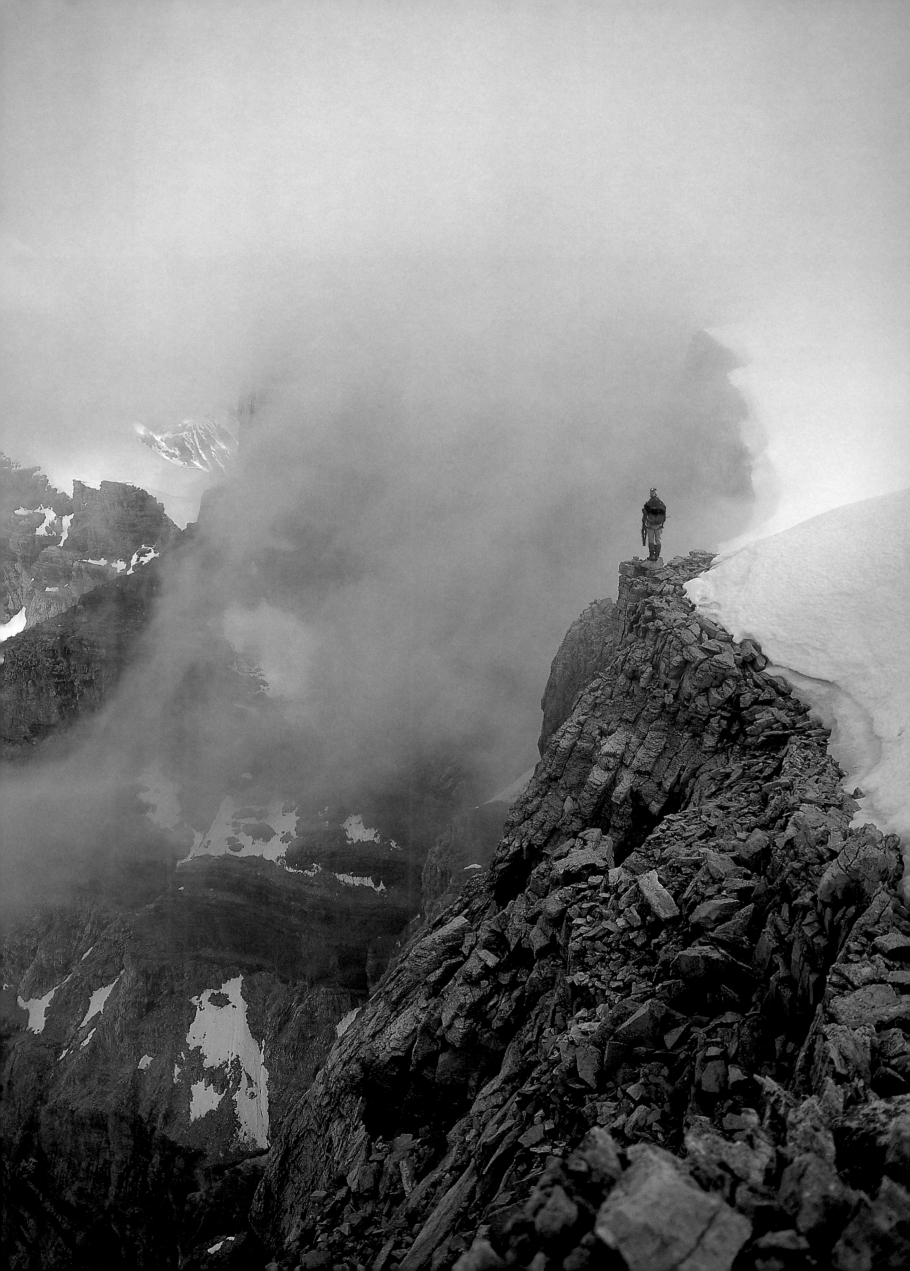

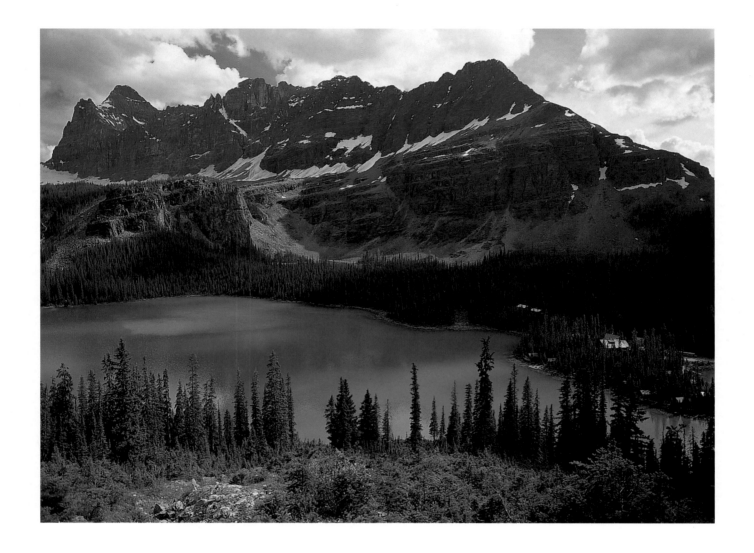

◁ A CLIMBER MAKES THE TRAVERSE

OUT TO MOUNT VICTORIA FROM

ABBOTS PASS HUT IN THE CANADIAN

ROCKIES ON THE BORDER OF

YOHO NATIONAL PARK IN

BRITISH COLUMBIA AND BANFF

NATIONAL PARK IN ALBERTA.

△ LAKE O'HARA, COLORED BY

THE GLACIERS ABOVE,

LIES BELOW MOUNT BIDDLE IN

YOHO NATIONAL PARK

OF BRITISH COLUMBIA.

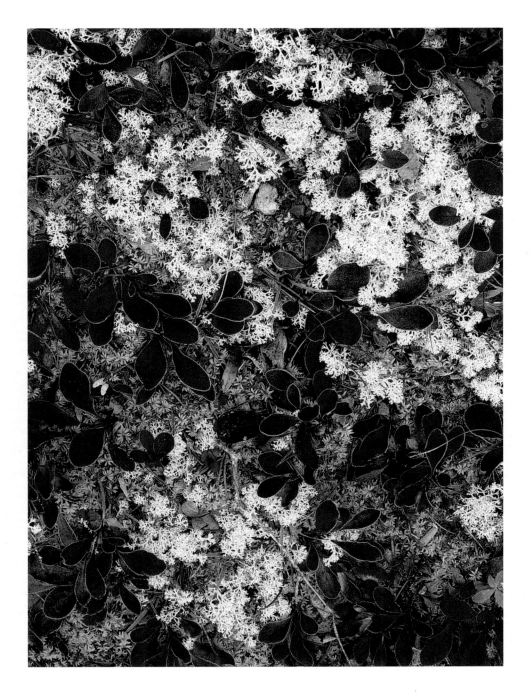

△ ALPINE BEARBERRY, REINDEER

LICHENS, AND OTHER TUNDRA

PLANTS DISPLAY AN AUTUMN TRANS-

FORMATION, VALLEY OF A THOUSAND

FALLS, MOUNT ROBSON PROVINCIAL

PARK, BRITISH COLUMBIA.

▷ THE THREE SISTERS RISE ABOVE

THE BOW RIVER VALLEY NEAR THE

TOWN OF CANMORE, ALBERTA.

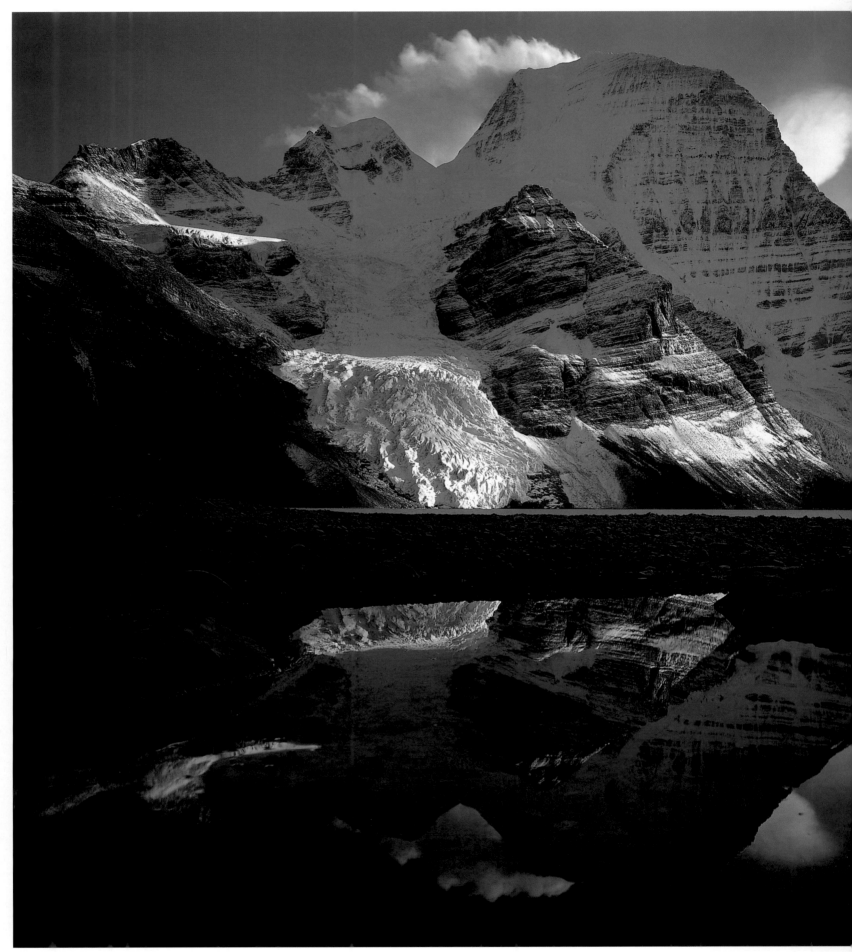

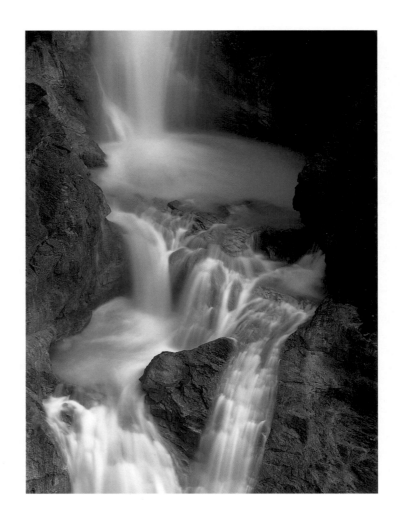

◁ OCTOBER EVENING LIGHT SETS A

MAGIC TONE AS THE GIANT OF THE

ROCKIES, MOUNT ROBSON (12,972 FEET),

AND BERG GLACIER ARE REFLECTED IN

BERG LAKE, MOUNT ROBSON

PROVINCIAL PARK, BRITISH COLUMBIA.

△ FALLS OF THE POOL CASCADES

DOWN OVER LIMESTONE WALLS IN

THE VALLEY OF A THOUSAND FALLS,

MOUNT ROBSON PROVINCIAL

PARK, BRITISH COLUMBIA.

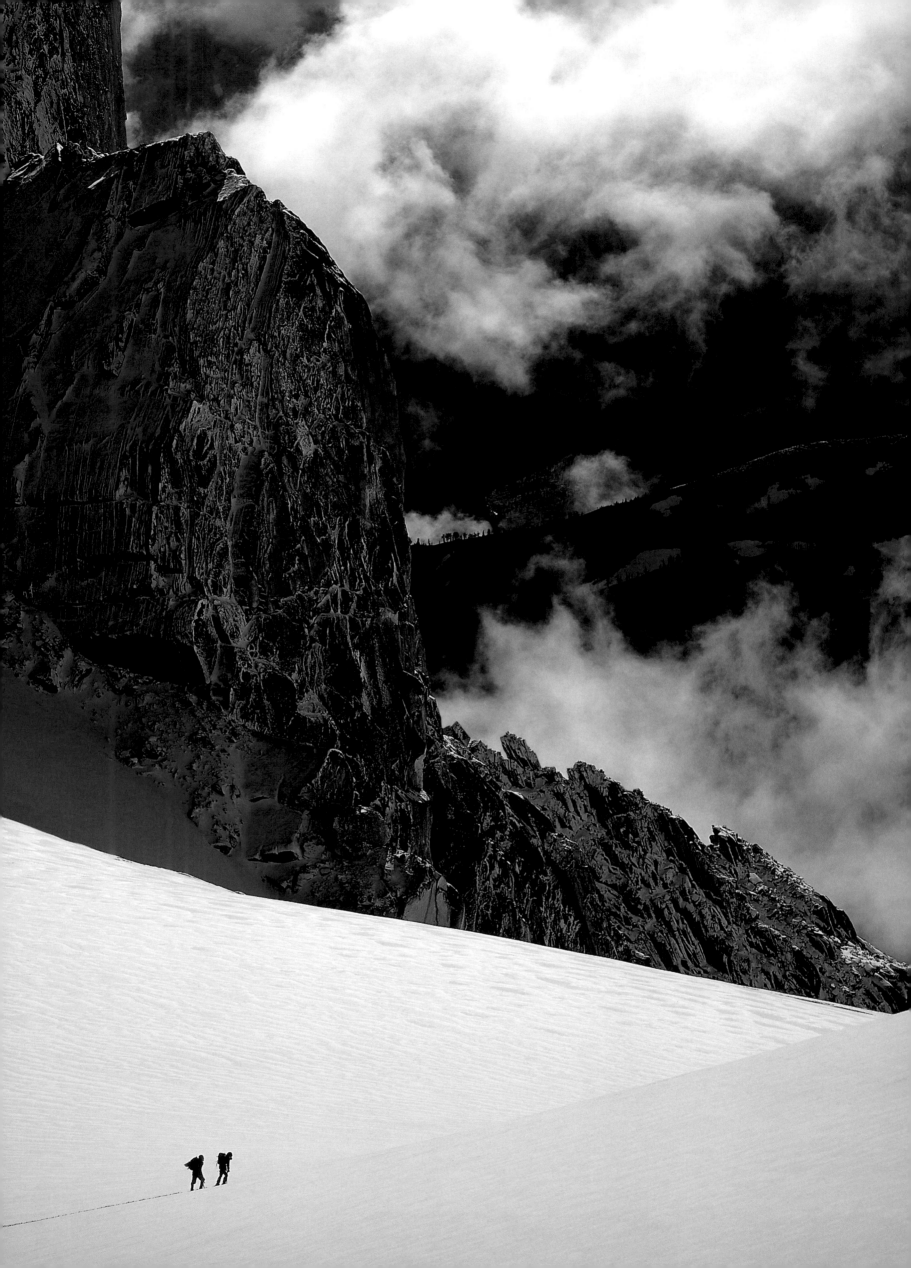

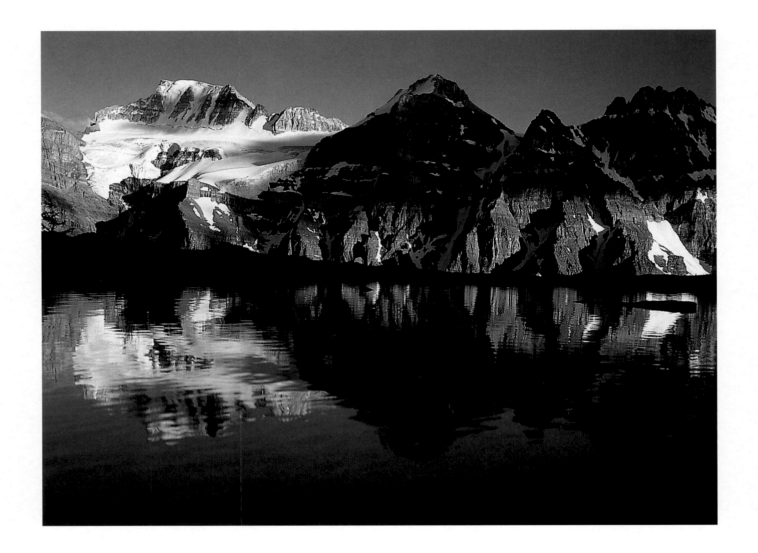

◁ DWARFED BY THE SOUTHERN

FLANKS OF SNOWPATCH SPIRE,

TWO CLIMBERS ASCEND THE

VOWELL GLACIER IN THE

BUGABCOS PROVINCIAL

PARK OF BRITISH COLUMBIA.

△ AN ALPINE POND IN

MINNESTIMMA LAKES REFLECTS

WENKCHEMNA PEAKS ABOVE.

THIS DRAMATIC SETTING IS IN

BANFF NATIONAL PARK, ALBERTA.

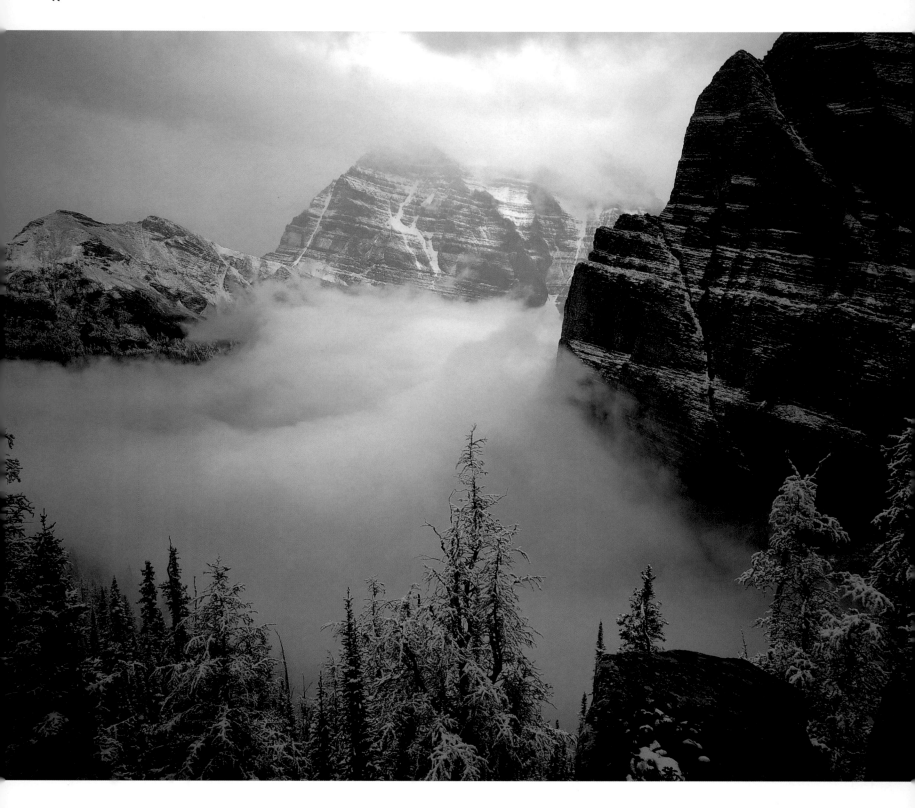

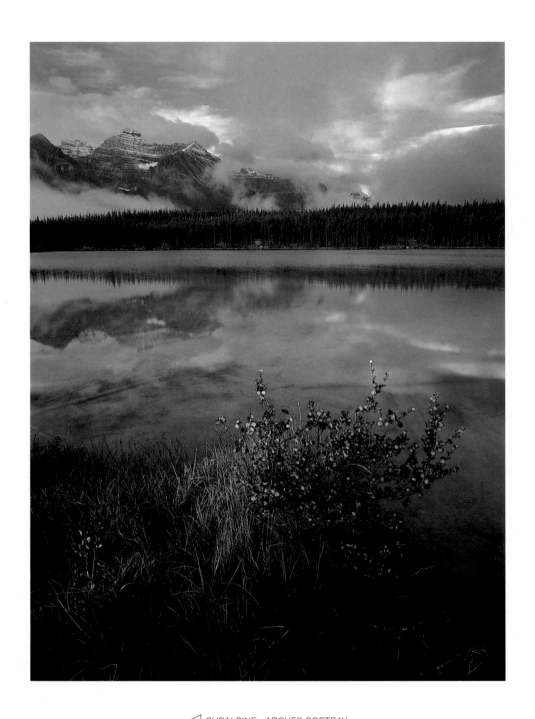

◁ SUBALPINE LARCHES PORTRAY

AN AUTUMN TRANSITION OF LIGHT

SNOW. MOUNT TEMPLE (11,621 FEET)

RISES ABOVE PARADISE VALLEY,

BANFF NATIONAL PARK, ALBERTA.

△ AUTUMN COMES TO HERBERT LAKE

IN THE BOW RIVER VALLEY NORTH OF

LAKE LOUISE, ICEFIELDS PARKWAY,

BANFF NATIONAL PARK, ALBERTA.

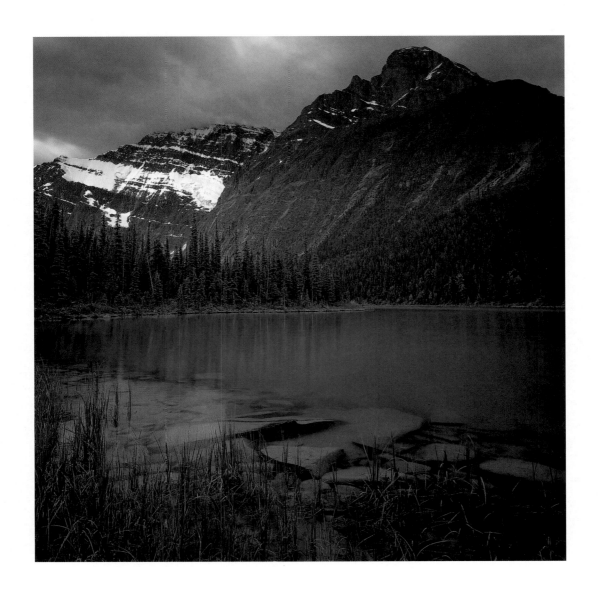

◁ ANGEL GLACIER, RECEDING UP

THE SLOPES OF MOUNT EDITH

CAVELL, HERE DISPLAYS ITS

DRAMATIC ICE TOE, JASPER

NATIONAL PARK, ALBERTA.

△ NAMED FOR A BRITISH NURSING

INSTRUCTOR WHO STAYED BEHIND IN

FALLEN BRUSSELS TO TREAT

WOUNDED SOLDIERS DURING

WORLD WAR I, MOUNT EDITH

CAVELL (11,047 FEET) HOVERS OVER

CAVELL LAKE IN JASPER

NATIONAL PARK, ALBERTA.

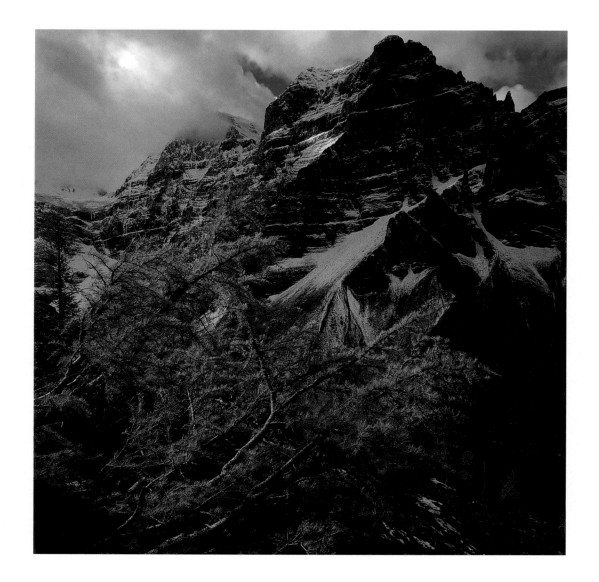

△ MOUNT BABEL (10,171 FEET)

AND MOUNT FAY (10,607 FEET),

WITH LIGHT OCTOBER SNOW,

CONTRAST THEIR ICE AND ROCK

WORLD WITH SUBALPINE LARCH

IN CONSOLATION VALLEY,

BANFF NATIONAL PARK, ALBERTA.

▷ THE WINGED SHAPE OF ANGEL

GLACIER CLINGS TO A CLIFF WALL

BELOW MOUNT EDITH CAVELL,

JASPER NATIONAL PARK, ALBERTA.

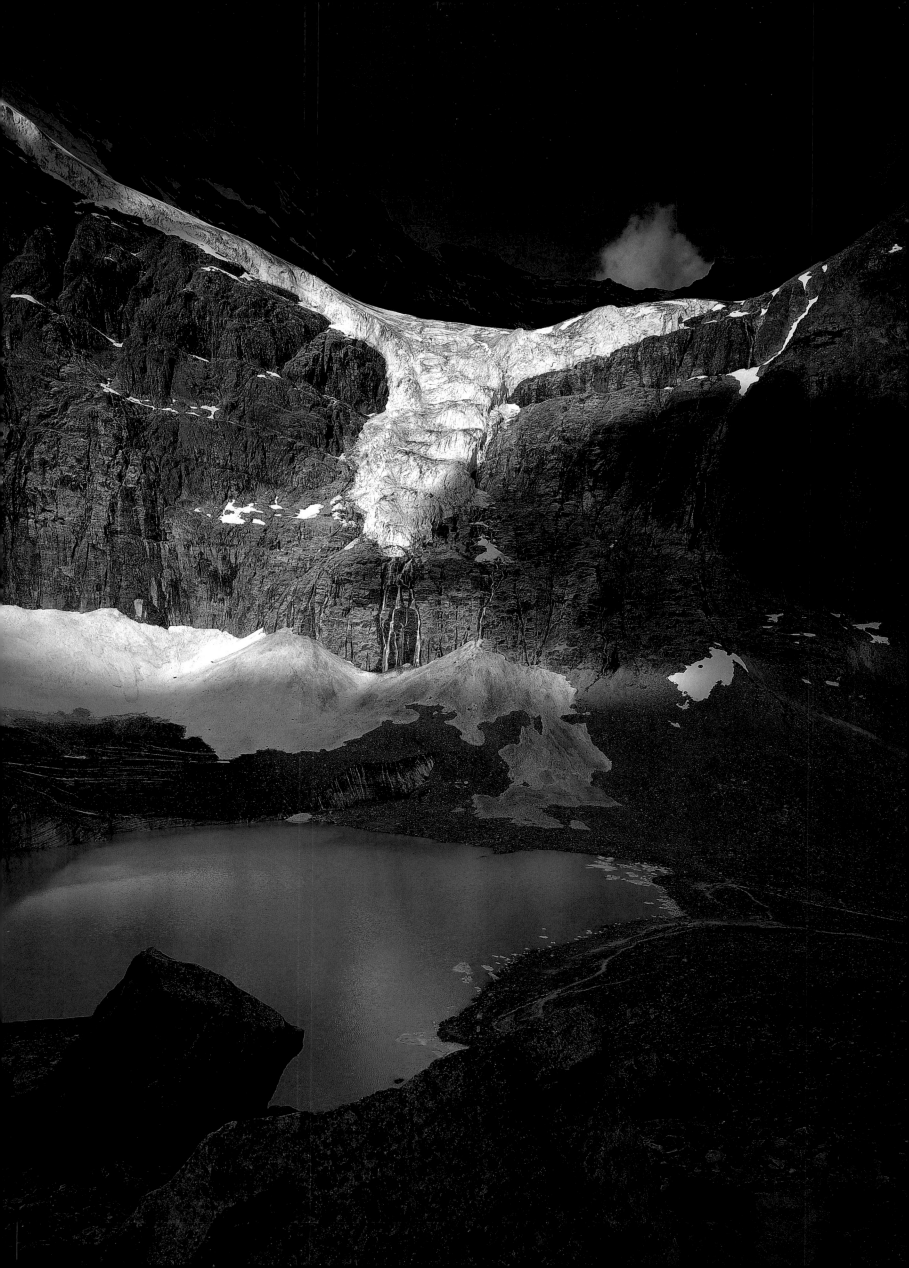

PHOTOGRAPHERS' NOTES

DAVID MUENCH

Many times I have entered into the wild and energetic landscape that is the Rocky Mountains, for it is the most emphatic geology in North America. It is the center image of our continent—elevated to its full height. One is brought to a keen sense of the original and pristine earth. Nothing is as exhilarating as standing on any of its peaks at dawn or evening and witnessing the world's slow, but persistent spinning in the universe.

The essence of things and events perceived has always tugged at my photographic directions. The direct confrontation with the elemental forces of the Rockies is a challenge, to seek out nature's transitory moments speaks to us of powerful changes through millenniums of time. A need for the primal beauty in our landscape has been, for me, a lifetime consuming search for personal identity, a metaphor of life. The photographs in this Rockies portfolio are clues along this pathway, a glimpse of place and image of our universe—a universe we all share together.

I am especially pleased and proud to share this photographic journey with my son, Marc. As you can see, his dramatic and outstanding images really convey, in a complementary vision, the love and devotion we both share for the Rockies. Together we have attempted to reach an affirmation and a harmony with the mountains in a never-ending quest for a landscape filled with natural rhythms, opposites, tolerance, mysteries—to achieve a "sense of place."

Being attached creatively to some of the magnificent primeval places has, of course, made us more sensitive to the obvious changes taking place. It would be nice to imagine a pristine world "escape" where ecosystems, if left alone, would achieve a perfect balance and harmony of relationships between the various entities. However, ecosystems are dynamic, forever changing, with a climate of change persistent. We really need to preserve natural areas in the Rockies in order to at least keep available some original complexity and natural values.

My heart and Marc's are in the wild places. Hopefully growth can be kept in balance with nature and held in a balance that is tolerable. The more we see the beauty through photographs, the more we realize the importance of holding on to it as part of our humanity.

Aldo Leopold once said, "This country has been swinging the hammer of development so long and so hard that it has forgotten the anvil of wilderness which gave values and significance to its labors—a new attitude needs to include an intelligent humility toward man's place in nature.

Films used are primarily Fujichrome Velvia and Provia. Cameras are primarily large format—Canon EOS IN, and Elan 11E. Focal lengths of lenses represented are 47mm through 500mm with 4 x 5 and 14mm through 500mm for the 35mm work. Exposures are calculated with a Gossen Luna Pro meter. Filters used are Pola Screen, 81EF, CC20R, CC20M, Neutral Density, along with split density filters for a better balance of light density control and enhancement. A tripod is used at all times with the large-format work and whenever possible with the small format.

MARC MUENCH

For many years I recall sharing the summits of the Rocky Mountains with my father, David. I remember a stormy day on the 14,000-foot summit of Uncompahgre Peak. Lightening flew, thunder crashed—and I screamed. At seven years of age I was not yet accustomed to the sounds of Mother Nature. Since those early days, I've become more familiar with the elements of the high altitudes. I have spent a great deal of time and money outfitting myself with appropriate equipment and camera gear to withstand the conditions, making my job somewhat easier. However, Mother Nature never fails to turn confidence into apprehension in the mountains.

A few years ago, my friend Brean Duncan, my dad, and I decided to climb the Grand Teton via the upper Exum Ridge. This is a classic, safe technical route within our grasp for the book project. Brean, now living in Florida, was eager to get back on the rock from a long respite, and my dad was eager to begin his first roped experience. We approached the lower saddle on a balmy day in late August. While setting up our tent, we met party after party of successful climbers who shared their summit experiences. At midnight, the wind began to jostle our nylon tent, and by 4 A.M. it was howling. Parties that had paid guides began to stroll by in the dark uttering phrases

like, "I hope this wind dies." We decided to wait a couple of hours, a decision that placed us behind for the rest of the day.

When we reached the beginning of the technical part called "Wall Street," the wind was gusting up to sixty miles per hour. We really wanted to make the summit, so we decided to take the less exposed Owen Spalding Route. The problem was that several slow parties were ahead of us by this time. After hours of waiting on ice-covered ledges, we were able to pass the parties ahead of us. Due to the late hour, they all rappelled down in spite of the partial clear and warm sun. We decided to attempt another pitch of climbing. In ten minutes, a thunder cloud had rolled in from the southwest, inundating us with rain, snow, lightening, and thunder—all signs of a defeated summit bid. We waited under a ledge until we could see beyond our noses and then we began the slow process of rappelling in the wind. I must have thrown the rope at least ten times before the wind let it fall past the ledge in front of us.

We were the only ones left on the mountain by then; the clouds had dissipated, leaving us with a somewhat tranquil feeling. All we had to do was descend about a thousand feet to our tent. During the next hour, my dad and I photographed several images that are in this photographic collection. The late light and the moody clouds made all the difference. In addition to the great images, our expectations of adventure had been fulfilled and we were all alive. Even though we never reached the summit, we got what we came for, and then some.

For the most part, photographing *The Rockies* was very similar to my earlier experience on The Grand Teton. What I was in search of was quite elusive and what images I ended up with were inspired by the beauty, energy, and spontaneity of the mountains.

To work successfully in the mountains, I use three different formats. I use a 35mm Canon EOS IN, with two zoom lenses, a 20-35, 2.8 and a 70-200, 2.8. I generally use this camera for action images with people or anything that requires quick response. I also use a Pentax 6 x 7. I carry two lenses, a 45mm 4.0 and a 300mm 4.0. I use this camera on backpacking trips or some mountaineering excursions. I sometimes use it for a fail-proof system when holders aren't loaded in the 4 x 5, or when I just want the image in a larger format than 35mm. The other camera I use is a Zone IV 4 x 5. I carry three lenses: a Rodenstock 75mm F4.5, an Osaka 210mm F6.8, and a Fujinon 450mm F12.5. All these lenses are very light weight. I shoot with Velvia ASA 50 film for the majority of my work. I also carry some Agfa 1000 for low light 35mm situations. My filter preference is to exaggerate what already exists. I sometimes use a 81EF and a 20 magenta. I also use a Polarizer to cut the haze or to saturate a scenic.

I wish to give special thanks to the following individuals for allowing their photographs to be taken for this book: Andy Henkes, page 51; Dave Porter, page 57; Brean Duncan, pages 103 and 126; Jim Conway, page 108; Marc Kriewaldt, page 71; Tofer Donahue, pages 71 and 75; Rob Orvig, page 162; Rudi Kranabitter, page 192 and back cover lower image. I also want to thank Stanley Air Taxi and Canadian Mountain Holidays for their services.

Marc Muench

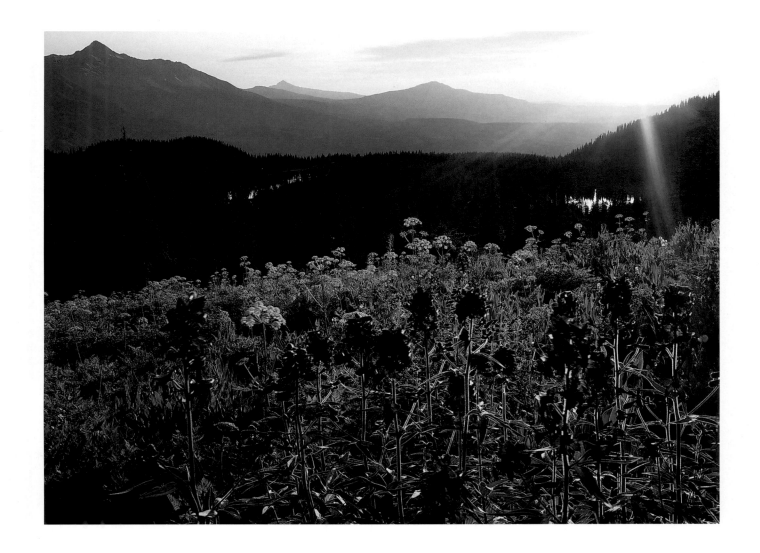

◁ ◁ AFTERNOON HAZE FILLS THE
BOW RIVER VALLEY IN ALBERTA
NEAR BANFF. MOUNT TEMPLE,
WHICH RISES ABOVE LAKE
LOUISE, IS SITUATED NEAR
THE CENTER OF THE HORIZON.
△ STRETCHING FORTY-SEVEN
HUNDRED MILES FROM MEXICO TO
ALASKA, THE ROCKIES ARE ONE
OF THE MAJOR DISTINGUISHING
FEATURES OF THE ENTIRE GLOBE.
HERE WE SEE BUSH LUPINE IN FULL
BLOOM ABOVE THE ALTA LAKES IN
COLORADO'S SAN JUAN MOUNTAINS.